Worlds of Women

Susan M. Socolow, Samuel Candler Dobbs Professor of
Latin American History, Emory University
Series Editor

The insights offered by women's studies scholarship are invaluable for exploring society, and issues of gender have therefore become a central concern in the social sciences and humanities. The Worlds of Women series addresses in detail the unique experiences of women from the vantage points of such diverse fields as history, political science, literature, law, religion, and gender theory, among others. Historical and contemporary perspectives are given, often with a cross-cultural emphasis. A selected bibliography and, when appropriate, a list of video material relating to the subject matter are included in each volume. Taken together, the series serves as a varied library of resources for the scholar as well as for the lay reader.

Volumes Published

Judy Barrett Litoff and David C. Smith, eds., *American Women in a World at War: Contemporary Accounts from World War II* (1997).
 Cloth ISBN 0-8420-2570-7 Paper ISBN 0-8420-2571-5
Andrea Tone, ed., *Controlling Reproduction: An American History* (1997). Cloth ISBN 0-8420-2574-X Paper ISBN 0-8420-2575-8
Mary E. Odem and Jody Clay-Warner, eds., *Confronting Rape and Sexual Assault* (1998). Cloth ISBN 0-8420-2598-7
 Paper ISBN 0-8420-2599-5
Elizabeth Reis, ed., *Spellbound: Women and Witchcraft in America* (1998). Cloth ISBN 0-8420-2576-6 Paper ISBN 0-8420-2577-4
Martine Watson Brownley and Allison B. Kimmich, eds., *Women and Autobiography* (1999). Cloth ISBN 0-8420-2702-5
 Paper ISBN 0-8420-2701-7
Judy Barrett Litoff and David C. Smith, eds., *What Kind of World Do We Want? American Women Plan for Peace* (2000).
 Cloth ISBN 0-08420-2883-8 Paper ISBN 0-8420-2884-6
Lucindy A. Willis, *Voices Unbound: The Lives and Works of Twelve American Women Intellectuals* (2003).
 Cloth ISBN 0-8420-2814-5 Paper ISBN 0-8420-2815-3

Voices
Unbound

Voices Unbound

The Lives and Works of Twelve American Women Intellectuals

by
Lucindy A. Willis
with Documents and Readings

WORLDS OF WOMEN
Number 7

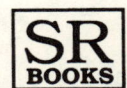

A Scholarly Resources Inc. Imprint
Wilmington, Delaware

© 2003 by Scholarly Resources Inc.
All rights reserved
First published 2003
Printed and bound in the United States of America

Scholarly Resources Inc.
104 Greenhill Avenue
Wilmington, DE 19805-1897
www.scholarly.com

Library of Congress Cataloging-in-Publication Data

Willis, Lucindy A., 1951–
 Voices unbound : the lives and works of twelve American women intellectuals / Lucindy A. Willis ; with documents and readings.
 p. cm. — (Worlds of women ; no. 7)
 Includes bibliographical references.
 ISBN 0-8420-2814-5 (alk. paper) — ISBN 0-8420-2815-3 (pbk. : alk. paper)
 1. Women intellectuals—United States—Biography. 2. Women in public life—United States—Biography. 3. United States—Intellectual life—History. I. Title. II. Series.

HQ1412 .W68 2002
305.4'092'273—dc21 2002070468

∞ The paper used in this publication meets the minimum requirements of the American National Standard for permanence of paper for printed library materials, Z39.48, 1984.

For Michael

(and Alden)

About the Author

LUCINDY WILLIS, Ph.D., teaches English Literature and Composition at North Carolina State University, Raleigh. She has received awards for teaching including the CHASS Outstanding Teacher (2000). She lives with her husband at Two Turtles Farm where she grows eight types of garlic and teaches yoga.

Acknowledgments

The original title of my book was *"On the Shoulders of Giants": Women Public Intellectuals in America*. Though the title has changed, I would like to begin by thanking Harriet Martineau, Charlotte Brontë, Anna Julia Cooper, and Gloria Anzaldúa, giants all, whose struggle and perseverance not only to endure but also to achieve their aspirations have served as an inspiration to me in times of need.

Thanks also must go to Professor E___ at UNC, composer of my graduate school rejection letter. She wrote that "there were women [such as myself] whose children had left home and wanted to return to school." The problem, she mused, "was how to make up for the lost years." Though angered at the time, I framed her letter, and even today, fifteen years later, I continue to find it a source of inspiration.

The idea for the book found its beginnings in my dissertation. I would like to thank the chair of my committee, Mary Ellis Gibson, for her support and advice during that arduous process of writing, teaching at two colleges, and commuting 160 miles daily.

Next (I am trying to move chronologically here), I would like to thank Sheryl Young, the acquisitions editor at Scholarly Resources, who e-mailed me to ask if I would be interested in taking a chapter of my dissertation and developing it into a book on women intellectuals in America as part of their Worlds of Women series. Sheryl left after the first year, but Matt Hershey took over her position and I thank him for staying with me during the long process of writing, revising, and, at times, revisioning the project.

In the process of writing this book, I met with Whitney Caine Leonard at the Third Place Café. Twice monthly over tea we critiqued each other's chapters. Her commentary proved invaluable.

I cannot say enough good words about the librarians at D. H. Hill Library, specifically those in Interlibrary Loan. Their unflagging support and interest in my project made the research process much easier. NCSU is lucky to have these librarians—Marihelen Stringham, Gary Wilson, Anne Rothe, and Mimi Riggs—on staff.

To the third outside reader of the manuscript: Whoever you are . . . thank you. You were the one respondent who really "got" what I was trying to do in the book, especially concerning race and women. I am tempted to frame your response as well. Thanks also to Ann Aydelotte,

copy editor at Scholarly Resources, who did a thorough job of reading through and marking the manuscript. Special thanks to Michelle Slavin, my project editor, who offered positive support and guidance during the final stages. A real professional, she was a delight to work with. Her sensitivity and gentle nudges made the last mile of a long marathon almost enjoyable.

There are friends and family who offered less direct but still vital support, as they responded to my whiny e-mails and phone calls. To Kenneth and Michelle Hill, Ed and Kathleen Shannon, Jean Jones, Deborah Hooker, Carol Liles, BB, Judy, and Mom. Thank you all.

I returned to graduate school when my children were of elementary- and middle-school age. My dissertation and this book were part of their growing up experience. Despite the fact that their mother revised chapters as she watched them play ball and cheer, their support never flagged. Their unwavering belief that I could accomplish whatever I set out to do, whether writing a book or sewing a bumble bee costume of forty-nine pieces, still amazes me. Allen's flowers and note before my final defense and Ashley's letter stuck to the bottom of my chair at graduation meant more to me than either can imagine. Allen, Ashley, and Mitzi, I love you.

My husband Michael asked that I dedicate this book to Alden, Allen and Mitzi's firstborn, and I really wanted to. Whom better to dedicate a book on women intellectuals than to my precious little granddaughter? I hope she will come to understand that she does not have to "invent the wheel again" but can be inspired by these women, past and present, as she moves to become whatever she wants to.

And yet . . . my book is dedicated to my husband Michael. It is really our book; for without Michael's emotional and financial support, *Voices Unbound* would never have seen print. He was my proof reader and my sounding board. He was my emotional cheerleader, who responded either with words of comfort or no words at all when I complained that the work was too much, that Professor E___ was correct, and that I hated either teaching, the book, or him. It gives me great pleasure to be able to present him with this small token of my deep love and appreciation.

Contents

Introduction—"On the Shoulders of Giants": Women Public Intellectuals in America, xiii

I **Pre-Civil War America 1**
 1 "Visionary of the New Age," 3
 MARGARET FULLER
 2 "First Woman in the Republic," 21
 LYDIA MARIA CHILD

II **Post-Civil War Era, 33**
 3 "Intellectual Architect of American Feminism," 35
 ELIZABETH CADY STANTON
 4 "A Mixed Legacy," 51
 CHARLOTTE PERKINS GILMAN
 5 The New Woman, 63
 ANNA JULIA COOPER
 6 "Citizen of the World," 77
 JESSIE REDMON FAUSET

III **The Interwar Years, 89**
 7 American Cassandra, 91
 DOROTHY THOMPSON
 8 An Unsuitable Job for a Woman, 103
 MARGARET MEAD

IV **Postwar America, 119**
 9 Keeping Memory Alive, 121
 CYNTHIA OZICK
 10 A Passionate Friend, 139
 SUSAN SONTAG

V **America at the Millennium, 153**
 11 A New Mestiza Consciousness, 155
 GLORIA ANZALDÚA

12 Talking Back, **173**
 BELL HOOKS

Afterthoughts, **187**

Selected Readings, **191**

Index, **215**

Introduction—"On the Shoulders of Giants": Women Public Intellectuals in America

> They have no past, no history, no religion of their own.
> —Simone de Beauvoir, *The Second Sex*

The term "intellectual" is a relatively new addition to the English language, having been introduced into the vocabulary less than two hundred years ago. One of the first writers to employ the term as we commonly use it today—that is, to describe a person who possesses not only a high degree of intelligence but who is also given to pursuits that exercise the intellect—was Lord Byron in *Don Juan* (1819). Byron's narrator in describing Doña Inez sarcastically notes:

> 'Tis pity learned virgins ever wed
> With persons of no sort of education,
> For gentlemen, who though well-born and bred,
> Grow tired of scientific conversation . . .
> But—oh! ye lords of ladies intellectual,
> Inform us truly, have they not hen-pecked you all? (1.xxii.311)

Interestingly, this early use of "intellectual" describes women, although the term is employed sardonically.

Although the word has been around for only two centuries, the embodiment of the intellectual has been an integral part of Western society for well over two thousand years. The philosophers of Ancient Greece, the poets of Ancient Rome, and the essayists of the late English Renaissance all were acknowledged as the great thinkers of their day. The introduction of the word "intellectual," however, marked a revision in the development of the thinker/philosopher. While the appellation is still employed in discussing Socrates, Virgil, and Francis Bacon, its appearance in nineteenth-century discourse connotes a distinct shift in perspective, making the concept less theoretical and more pragmatic. In the early nineteenth century the term was used primarily within a larger social context to describe individuals who generated,

applied, and dispensed culture (Lipset 1960, 311). Like great thinkers throughout history, public intellectuals of the early nineteenth century were philosophers of sorts, but they seemed to possess a more developed sense of audience. As did their predecessors, they viewed life in its broadest contexts—socially, politically, and economically—yet often took active roles in challenging contemporary social conditions.

This nineteenth-century shift from thinker to public intellectual occurred for a number of reasons. Economic, political, and cultural upheavals in the form of the Industrial, French, and American Revolutions altered the Western landscape both in England and in America. Industrial capitalism generated an increase in the urban population as rural people left the countryside in search of work in large towns. In addition, the rising middle classes, eager to lay claim to privileges unheard of only decades earlier, actively sought knowledge and guidance from those with better educations and more experience. At the same time, technological advances in the printing industry as well as the rising number of journals and magazines created a vehicle for marketing the goods of "knowledge" specialists. Intellectuals were needed, just as they are today, "to administer to a confused populace caught in the whirlwinds of societal crises, the cross fires of ideological polemics, and the storms of class, racial, and gender conflicts" (West 1989, 5–6).

And who were these knowledge specialists? In England, the place of a nascent intellectual tradition that soon, at least in part, found its way to nineteenth-century America, the intelligentsia—sages or "men of letters," as they were known—included such luminaries as Thomas Carlyle, Matthew Arnold, and John Stuart Mill. Carlyle, the group's representative spokesman, portrayed intellectuals such as himself as part of a "perpetual Priesthood, from age to age, teaching all Men that a God is still present in their life; that all 'Appearance,' whatsoever we see in the world, is but as a vesture for the Divine Idea of the World." The "true Literary Man," wrote Carlyle, followed in the footsteps of the prophets Elijah and Jeremiah; "he is the light of the world; the world's Priest,—guiding it, like a sacred Pillar of Fire, in its dark pilgrimage through the waste of Time" (1884, 5:157). Carlyle's description is gender-specific. The sage is part of an elite group of men who are *in* the world, but not *of* the world. In many ways, he transcends his audience, a move that gives his message divine authority and reveals him to be in possession of a higher moral vision than other members of society (Landow 1990, 32).

In America the development of the public intellectual took on more pragmatic overtones. Though strongly influenced by Carlyle—his friend, critic, and guide—Ralph Waldo Emerson, leader of the Tran-

scendentalist movement, laid the groundwork for a less dictatorial tradition than that offered by the Victorian sage preoccupied with predicating scholarship, systematizing education, and promoting traditional values. As a result, the intellectual tradition in America developed into a perpetual social dictum that interpreted culture for its citizens (West 1989, 5–6). And yet the American intellectual also emphasized the power of the individual. Viewing himself and others of his coterie (Bronson Alcott, Henry David Thoreau, and George Ripley) as explicitly democratic (Reynolds 1988, 6), Emerson attempted to establish a creative democracy in America through both intellectual and social actions (West 1989, 112). These men, according to Cornel West, were then to become active participators in the "life of the mind who revel in ideas and relate ideas to action by means of creating, constituting, or consolidating constituencies for moral aims and political purposes" (5–6). Despite Emerson's egalitarian ideals as well as the inclusion of women within the Transcendentalist circle of intellectual elite, a brief examination of America's history reveals this intellectual tradition to be part of a masculine domain.

That America continues to fail to recognize women's roles as public intellectuals was brought home to me early in preliminary research on my dissertation on this topic. I had asked a number of colleagues to name those persons whom they considered to be the most influential thinkers in American society. Responses varied, but only slightly, and the following names usually topped the list: Noam Chomsky, Edmund Wilson, Richard Rorty, William F. Buckley, Edward Said, Susan Sontag, and Henry Louis Gates Jr. Five white men, one woman, and an African American—so much for progress. Numerous social critics and historians, past and present, have failed to acknowledge the contributions of women intellectuals in America and Europe. Julian Benda's *The Treason of the Intellectual* (1928), John Holloway's *The Victorian Sage* (1953), George de Huszar's *The Intellectuals* (1960), which begins in Ancient Greece and ends in twentieth-century America, and Russell Jacoby's *The Last Intellectuals* (1987) are four of the more prominent studies. In these works, however, only one woman is discussed in great detail—George Eliot in *The Victorian Sage*—an intellectual who assumed a masculine nom de plume and whom critics have lauded for her "manly" style of writing.

The writings of these and other cultural critics, such as Edward Shils, Franklin Baumer, and Raymond Williams, have, for the most part, debarred women and other minority group members from their studies. Instead, their writings suggest that the pundits of the past two hundred years have been white and male. Even in recent years, women such as Paula Giddings and Gloria Anzaldúa have been given only a

passing nod at best. Yet, they, like Jessie Redmon Fauset and Dorothy Thompson and other women public intellectuals, have contributed significantly to the shaping of American culture and public opinion.

As we enter the new millennium, the American public intellectual has become a hot topic. One need look no further than magazines such as *The New Yorker* and the *Atlantic Monthly*, and writers from Harold Bloom to Camille Paglia to Eric Lott, to see the interest that the intellectual has aroused. The appearance of articles with ominous titles such as "Agonizing over the Intellectual" and "Intellectuals: The End of a Species?" appear in journals ranging from Australia's *24 hours* to New York's *Partisan Review*, making the topic of the intellectual an intriguing and often discomforting part of our social discourse. One reason for this interest is related to the times in which we live. As we spiral (in the most Yeatsian sense) into the twenty-first century, the need for public intellectuals to steer us through this transitional and often chaotic period has become critical to our survival. Writing in the 1970s, artist Guillermo Gómez-Peña argued that Americans were "living in a state of emergency . . . , our lives . . . framed by a sinister kind of Bermuda Triangle, the parameters of which are AIDS, the recession, and political violence" (Lacy 1995, 31). Thirty years later, our lives are still framed by a similar triangle bordered by AIDS, ethnic cleansing, and the World Trade Center bombing. For this reason, the concept of the public intellectual, especially as Victorian sage and academic elitist, must be revisioned. Brilliance is not enough; the intellectual must also be empathetic, socially committed, and actively involved (Giroux 1995, 198).

An article in *The New Yorker* suggests that this shift is already taking place. In "Public Academy," Michael Berubé points to a new generation of African American thinkers as the most dynamic voices in the nation's intellectual life today. According to Berubé, this group, led by Cornel West, Michael Eric Dyson, and Derrick Bell, is seeking to redefine the American public intellectual (1995, 73). Robert Boynton also writes of the ethical creativity and discriminating intelligence of an impressive group of African American writers and thinkers who are "moving beyond race" to voice what he describes as "the commonality of American concern" (1995, 53). Unlike Berubé, who references only one woman intellectual, Boynton includes June Jordan, bell hooks, Alice Walker, and Toni Morrison on his list. Disappointingly, however, he fails to make more than a passing reference to these African American women in his article.

Why has the intellectual sphere been considered almost exclusively masculine? Why have women historically been kept on the periphery of intellectual circles? Is it simply because the stereotype of the tradi-

tional intellectual as a rational, analytical, and reasoning (read *masculine*) being conflicts with the equally stereotypical view of woman's emotional and intuitive nature, as many nineteenth- and twentieth-century scientists would have us believe? Or is it due to the term's masculine construction by pundits such as Thomas Carlyle that many women and other minority members fail to fit within the traditional intellectual paradigm? For the most part, women such as Lydia Maria Child, Anna Julia Cooper, and Gloria Anzaldúa differ markedly from the *traditional* (male) intellectual (often described as a philosopher king) both in how they define themselves and their relationship to their audiences as well as in the focus of their work. Perhaps the answer is simply that in American society "work is valued by the social value of the worker." And once a field contains too many women, it becomes devalued (Steinem 1994, 210).

Women public intellectuals pervade American history although time has erased many of their names as well as their contributions. The purpose of *Voices Unbound: The Lives and Work of Twelve American Women Intellectuals* is twofold: to recover those names from the nation's rich past and to reintroduce these remarkable women and their writings to the American public. Hopefully, this study will mark an early step toward the development of a public intellectual tradition for American women. Some writers, however, warn of the difficulties in advancing such a tradition at this late date. Sharon Harris in *American Women Writers to 1800* (1996) explains her hesitation in tracing a tradition for American women poets: first, the term is "too easily essentialized; second, . . . much further study of the field of early women's writings will be necessary before we can begin to discern any such traditions, if they exist; and third, because to speak accurately of traditions we will need a compendium of preceding adjectives to distinguish exclusivity as well as inclusivity. That is, how can we speak of the 'tradition' of early women's poetry without distinguishing Native and European differences; oral and written differences; class, religion, racial and age differences?—the list is immense and far too important to be limited by the search for 'traditions' " (Harris 1996, 3).

In "Engorging the Patriarchy," Nina Auerbach writes that she opposes the development of any absolute definition of women's writing because "any form of discourse . . . perceived as separatist . . . [can become] an institutionalized enterprise, rigidly enforced and prohibiting the edge of difference from continuing to find its ever changing voice" (1987, 152). Another feminist critic, Elizabeth Ammons, insists that to develop traditions invites "ghettoization, erroneous generalizations, and complicity in the institutional structures and methods of thought that have helped achieve the marginalization of women,

men of color, and poor people in the United States." And yet, Ammons adds, "not to talk about excluded groups of writers separately . . . seems . . . equally if not more dangerous" (1991, 13). Tradition, it appears, is a two-edged sword.

Ellen Moers, writing in the 1970s, also struggled with the idea of creating a women's literary tradition:

> There is no single female tradition in literature; there is no single literary form to which women are restricted, not the novel or the letter or the poem or the play. All that is required to create a productive tradition for women in any of these forms is one great woman writer to show what can be done; and in the case of all those forms the ground was broken for women long ago. It is right for every woman writer of original creative talent to be outraged at the very thought that the ground needs to be broken especially for her, just because she is a woman; but it is wrong of the literary scholar and critic . . . to omit paying their humble toll of tribute to the great women of the past who did in fact break ground for literary women (Moers 1976, 62–63).

In the 1970s and 1980s, Ellen Moers, Elaine Showalter, Susan Gilbert, and Sandra Gubar attempted to trace women's literary history. What made their attempts problematic was their use of the mother/daughter metaphor. In any discussion on women and language and tradition, one is drawn to Audrey Lorde's famous statement that "the master's tools will never dismantle the master's house." Thus, in using the mother/daughter framework, extolled by feminist critics in the early 1970s, aren't we merely mirroring the father/son lineage? Therefore, this paradigm, too, appears to be doomed to recreate the same type of rigidly enforced, institutionalized structure that would lead each public intellectual to reject her mother as she plays out Harold Bloom's anxiety of influence. We cannot deny the connection between past and present women public intellectuals, but we must acknowledge that often these links are indirect and tangential.

Other ways of tracing one's family tree exist. In "Thinking Back through Our Aunts: Harriet Martineau and Tradition in Women's Writing," Virginia Blain contends that the complex relationships between women writers of different generations cannot easily be traced through the mother/daughter line. For sixty years the mother metaphor has successfully been used by writers such as Virginia Woolf, Elaine Showalter, Sandra Gilbert, Susan Gubar, and Margaret Homan to connect past and present women authors and poets. In the late twentieth century, however, the problematization of "maternal and sororal [sisterly] metaphors" used in discussing the "nature" of a female literary tradition has led Blain to reevaluate the mother/daughter paradigm (1990, 224).

Feminist scholars, Blain suggests, could consider other possible mechanisms to link generations of women writers, such as that which exists between the aunt and her niece. In producing new genealogical links that challenge the conventional rendering of "tradition," the aunt/niece paradigm allows for the representation of discrepancies as well as inherited traits that the mother/daughter and father/son archetypes fail to provide. In addition, this pattern of inheritance introduces a fresh perspective from which to examine women's relationships in their writing.

To think back through our mothers, as Virginia Woolf suggests in *A Room of One's Own*, presents a "false parallel" to the traditional father/son inheritance: "Where sons can inherit directly from their fathers..., Daughters can have no such unmediated link with their mothers under patriarchy. A mother-daughter model of literary inheritance by definition, therefore, implies the mediation (and legitimation) by men (fathers) to link the generations. It is a concept which, while appearing to subvert, ultimately mirrors a patriarchal and patrilineal model" (Blain 1990, 225). Since not every woman has one, a literary heritage traced through aunts would most likely appear discontinuous, fragmented, and filled with gaps and breaches (226). Yet these separate and distinct fragments, once loosely joined together, reveal interesting intertextual relationships and patterns (226).

Although I share Sharon Harris's concerns, I believe that the aunt/niece lineage makes the tracing of women's public intellectual history a realistic possibility. I also believe that efforts should be made to trace this lineage. Without a tradition of their own, history will continue to repeat itself, and, as Dale Spender has noted, "every fifty years women [will] have to reinvent the wheel" (Spender 1982, 13); they will have to rediscover their roles in America's public intellectual (or Chicana or Jewish or lesbian) history rather than add to links already established.

Perhaps Adrienne Rich best described what the focus of the feminist cultural critic and historian should be: "Revision—the act of looking back, of seeing with fresh eyes, of entering an old text from a new critical direction—is for women more than a chapter in cultural history: it is an act of survival. Until we can understand the assumptions in which we are drenched we cannot know ourselves" (1979, 35). One way to begin this task of entering old texts from a new critical direction is to point out common characteristics shared by these public intellectuals separated by time, class, race, and economic status.

And what traits might these women from the early nineteenth- to the late twentieth-century share? To answer this question, let us look to the works of two seemingly disparate individuals: bell hooks and

Edward Said. hooks, an African American and Distinguished Professor at City College in New York, is a prolific writer who has published a remarkable number of cultural critical writings in the last few years: *Outlaw Culture* (1994), *Teaching to Transgress* (1994), *Killing Rage: Ending Racism* (1995), *Art on My Mind: Visual Politics* (1995), *Real to Real: Race, Sex, and Class at the Movies* (1996), *Bone Black: Memories of Girlhood* (1996), *Wounds of Passion: A Writing Life* (1997), *Remembered Rapture: The Writer at Work* (1999), and *All about Love: New Visions* (2000). In an early work with Cornel West, *Breaking Bread* (1991), hooks explored specific problems facing African American women and men intellectuals; in *Teaching to Transgress* she ties theories presented in her earlier works to specific pedagogical practices that actively engage the academic intellectual with her students. In *Talking Back*, hooks puts theory into action by suggesting ways that intellectuals could escape their ivory towers and become actively involved in changing society.

Edward Said, an American of Palestinian descent and the Parr Professor of English and Comparative Literature at Columbia University, is best known for his controversial work *Orientalism* (1978), which explores how Western writers have stereotyped Arab cultures in a way that condones the exploitation of those cultures. Recent works include *Beginnings: Intentions and Method* (1997), *Out of Place: A Memoir* (1999), and *The End of the Peace Process: Oslo and After* (2000). In *Representations of the Intellectual* (1994), a compilation of his 1993 Reith Lecture series, Said insists that public intellectuals be held to a "universal" standard. Urging them to think globally while accepting their national situatedness, he encourages intellectuals to move beyond the comfortable certitude that national language and cultural history provides, as he sets forth a single standard for human conduct (1994, xii–iv). This single standard—freedom for each member of our global society—forces the world's great thinkers to reexamine their relationship with their audiences as well as with social, academic, religious, professional, and global institutions.

In sifting through the writings of bell hooks and Edward Said as well as those of Susan Sontag, Henry Giroux, Donna Haraway, Adrienne Rich, Elaine Showalter, Ellen Moers, and others, a working list may be compiled of characteristics that most of the women in this study share:

1) a position of marginality (usually due to gender and/or race). Socially imposed marginality, which significantly shapes one's childhood, education, and work experiences, permeates the writings and speeches of the women in this study. In *Representations of the Intellectual*, Said argued that all intellectuals can be divided into two groups:

"insiders and outsiders." The insiders, or "yea-sayers," flourish in society and avoid conflict and dissension (1994, 52). The "nay-sayers," however, are both unsettled and unsettling and often find themselves in conflict with social norms. Not surprisingly, society marginalizes nay-sayers, especially where issues of privilege, power, and honor are concerned (52–53). This condition of marginality results in a clarity of vision that enables intellectuals to "see things that are usually lost on minds that have never traveled beyond the conventional and the comfortable" (63). Paradoxically, their socially enforced peripheral position offers these women an odd sort of independence, freeing them to oppose rather than to accommodate those in power.

2) an interest in border-crossing. The field of expertise of each of these intellectuals—whether it be in economics, literature, critical theory, or politics—does not necessarily dictate the issues about which she writes. As Stanley Aronowitz points out, the job of the public intellectual involves examining all facets of society, including literary as well as sociopolitical and economic ones (1994, vii). Susan Sontag, for example, has advanced degrees in philosophy but has written extensively on art and photography. Although Barbara Ehrenreich has a doctorate in cell biology, her writings focus on issues of social and political concern. The women in this study have often defied social, intellectual, and scholarly codes by refusing to be bound to a particular profession or, in the case of nineteenth- and early twentieth-century women intellectuals, to their "proper sphere."

3) a non-hierarchical relationship with one's audience. Generally, these women speak to and with a wider, less exclusive audience than that of the traditional intellectual. The concerns of the people with whom they discourse (which includes members of oppressed groups) direct and inspire their writings and activities.

To more effectively communicate with their audience, many women public intellectuals such as Adrienne Rich and Gloria Anzaldúa have (re)formed a new language that allows for a more fluid form of communication. Their voices are rarely fixed and absolute; rather, they are constantly in a state of transformation. In support of this position, bell hooks has written that the most effective teachers/intellectuals are those who are willing to change their "performances" to meet the needs of particular audiences. If necessary, they alter their sense of voice or employ a flexible, malleable language to address more effectively specific situations (hooks 1994b, 11).

4) a similar purpose and/or mission. As Cynthia Ozick writes, "Public intellectuals know that history is where we swim, that we are *in* it, that we can't see over or around it, that it is our ineluctable task to go *through* it. . . . The difference, then, between public intellectuals

and others, must lie in activism" (1995, 355). Donna Haraway, cultural critic and science philosopher, describes the projects of public intellectuals as freedom projects. Interestingly, most of these freedom projects have literacy as their primary goal, since literacy is closely connected to projects of domination.

The women in this study also share a talent for writing, living, and delivering a message that speaks the truth to power while raising the critical consciousness of a people. Journalist Ida Tarbell did so when she tackled John D. Rockefeller in her series on the Standard Oil monopoly in the early 1900s. All of the women here, without exception, acknowledge the connection between education and freedom: Anna Julia Cooper, for example, made teaching her life's work, as has bell hooks. In their writings, other women public intellectuals examine cultural products and accompanying ideologies, questioning whether these products and ideas perpetuate or deconstruct the process of mental colonization that both entraps and oppresses individuals.

5) a journey toward self-redefinition. By self-redefinition, I do not mean self-aggrandizement. Rather, I am thinking of the concept of self-actualization that is described by psychologist Abraham Maslow as a process by which a self-directed individual comes to realize his or her purpose in life. Ideally, redefining enables an individual to loosen her or his ego and thus perceive other people, stations, and events with greater objectivity (Maslow 1968, 159). This act is necessary since public intellectuals and teachers are "healer[s]" in addition to being educators. hooks admits, however, to the difficulty in seeking wholeness in a culture that embraces the concept of a "mind/body split" or that promulgates and perpetuates "compartmentalization." In America's fragmented culture, the healing public intellectual finds herself internally and externally conflicted. Thus, to heal society, cultural critics such as Adrienne Rich and Gloria Anzaldúa have, by necessity, also committed themselves to a "process of self-actualization that promotes their own well-being" (hooks 1994b, 15–6).

American society constructs the individual and assigns him or her a role to play; therefore, it is only through self-redefinition that public intellectuals can lead others to free themselves from being socially defined and entrapped. The work of each public woman intellectual in this study entails more than simply a sharing of her personal journey; it involves a commitment to the growth of others as well as oneself (13). As Anzaldúa reveals in the preface to the second edition of *This Bridge Called My Back: Writings by Radical Women of Color*, "Many of us are learning to sit perfectly still, to sense the presence of the Soul and commune with Her. We are beginning to realize that we are not wholly at the mercy of circumstance, nor are our lives completely

out of our hands. . . . And those of us who have more of anything: brains, physical strength, political power, spiritual energies, are learning to share them with those that don't have" (1981, Preface).

It would be unrealistic to suggest that all the women in this study share each of these characteristics equally. It would be just as unrealistic to argue that no male intellectual fits within this paradigm. A case in point is linguist and activist Noam Chomsky or Cornel West—critical theorist, cultural critic, philosopher, and professor of religion at Princeton University—whose intellect and spirit have awakened us, in hooks's words, from the "slumber of indifference, narcissism, [and] obsession with material success" (hooks and West 1989, 26).

It should be noted that the selection process in choosing the intellectuals to include in this study proved difficult. I was unable to include many worthy women. Why select Anna Julia Cooper and leave out Frances Watkins Harper and Mary Terrell? Why bell hooks and not Alice Walker? Where are Gloria Steinem and Mary Daly? The characteristics of the public intellectual outlined here guided my selection, but, in truth, the final choices were personal. The individuals included are women whom I genuinely admire for a variety of reasons. Each one is as complex as she is influential, which can be difficult to fully relate in short chapters. Yet, overall, a surprising number of women public intellectuals throughout America's history have shared these characteristics, a fact which suggests that a nonconventional lineage does exist for those who do not fit neatly in the traditionally masculine, Aristotelean-Baconian-Arnoldian model.

Voices Unbound begins in nineteenth-century America at the inception of what we term the public intellectual. Part I reestablishes Margaret Fuller (1810–1850) as the "most important woman of the nineteenth century" (Urbanski 1980, 3). Fuller is the ideal starting point from which to launch a discussion on women intellectuals: first, because she was publicly recognized as an intellectual during her lifetime; and second, because of her close ties with the most famous male intellectuals of her day, including Emerson and Alcott. Fuller is best known as the first editor of *The Dial*, the Transcendentalist journal, and as the author of *Woman in the Nineteenth Century*, which has been described as "the intellectual foundation of the feminist movement" (3). Lydia Maria Child (1802–1880) is also included in this section. Though known primarily for her work in the abolitionist movement, Child was also a writer of fiction, nonfiction, and biography and edited Harriet A. Jacobs's classic, *Incidents in the Life of a Slave Girl*.

Part II of this study concentrates on the period in American history between the end of the Civil War and the early part of the twentieth century, when science, technology, and corporations were

transforming the American landscape. This section is divided into two subsections to represent the two major movements of the period: "Women's Issues" and "African American Issues." The women discussed include Elizabeth Cady Stanton (1815–1902), Charlotte Perkins Gilman (1860–1935), Anna Julia Cooper (1858–1964), and Jessie Redmon Fauset (1882–1961). As one of the most outspoken women's rights advocates, Stanton played a key role in organizing the earliest women's rights convention (1848) and, with Susan B. Anthony, led the women's rights movement. In addition, she helped produce the five-volume *History of Woman Suffrage*. Gilman—a writer, lecturer, feminist theorist, social reformer, and socialist—advocated the reformation of society through the "feminization" of America's political and educational institutions (Conrad 1976, 244). In her most famous work, *Women and Economics* (1898), she described how women's economic dependence on men resulted in a crippling emotional and physical dependence as well. Between 1909 and 1916, Gilman published a journal, *Forerunner*, in which she continued to address the complex gender issues of the period.

A former slave, Cooper received her doctorate from the Sorbonne and later became president of Frelinghuysen University in Washington, DC. A skilled rhetorician, Cooper ferreted out principles and convictions that made it possible for black women to be treated as slaves and then provided the foundation to radically transform these beliefs (Vogel 1966, 158). Although her best-known work, *A Voice from the South by a Black Woman of the South* (1892), marks the beginning of African American feminism, most of her writings and lectures focus on how racial and sexual tensions as well as capitalistic and patriarchal institutions bestowed one faction of society supremacy over other groups (158).

The 1920s marked the beginning of the Harlem Renaissance, which celebrated the literature and music of African Americans. Fauset was one of the midwives who brought the Harlem Renaissance into being. In addition, she served as literary editor for *Crisis: A Record of the Darker Races*, the official publication of the National Association for the Advancement of Colored People (NAACP), under the direction of W. E. B. Du Bois. Her four novels present a complicated critique of the racial conflicts of the period and their ideological bases (duCille 1993, 70).

Part III examines the war years, specifically World War II, and looks at the lives and writings of Dorothy Thompson (1894–1961) and Margaret Mead (1901–1978). Best known for her "On the Record" newspaper column, which ran for two decades, Thompson was also a foreign correspondent who reported on World War II and other global

and political issues. Her advice was sought by President Franklin D. Roosevelt and other dignitaries, and at the height of her career she was as well known as Eleanor Roosevelt. Mead, a feminist pioneer in anthropology, spoke out on a number of problematic issues confronting contemporary society. Her interests ranged from child rearing in New Guinea to American character and culture. In addition, she made her vast knowledge of science, sociology, psychology, and anthropology available to the general populace.

Cynthia Ozick (b.1928) and Susan Sontag (b.1933) are the focus of Part IV and represent the woman public intellectual of the 1950s, 1960s, and 1970s, although each woman is as prolific now as she was thirty years ago. Ozick is a writer whose work reflects her Jewish heritage. She is the author of four collections of essays—*Art and Ardor, Metaphor and Memory*, *Fame and Folly*, and *Quarrel and Quandary*—which examine art, literature and Judaism, but she is perhaps best known for her fiction in which she blends mystical realism, comedy, and Judaic tradition. An accomplished literary stylist, the strength of her art, writes Edmund White, is in the moral energy that drives her writing (1998, 87).

Sontag, America's most renowned woman public intellectual, is a novelist, screenwriter, director, activist, and polemicist. Her major works include *Against Interpretation, and Other Essays* (1966) and *The Volcano Lover* (1992). In addition, Sontag has boldly addressed two of the more frightening and controversial diseases of our age—cancer and AIDS—in *Illness as Metaphor* (1978) and *AIDS and Its Metaphors* (1989). In her play *Alice in Bed* (1993), she examines the problems that women intellectuals and artists—Alice James, Margaret Fuller, and Emily Dickinson—confronted in the nineteenth century.

The final section brings us teetering on the brink of the twenty-first century. True, Sontag and Ozick are productive writers who are actively involved in reshaping American culture and society, but Part V looks to public intellectuals writing today who are moving us into the twenty-first century. Although Gloria Anzaldúa (b.1942) and bell hooks (b.1952) published work prior to the 1980s and 1990s, they, in particular, are presenting new ways of looking at the public intellectual. Each woman is in the process of redefining and revisioning the role of the public intellectual for future generations. As Wallace Stevens reminds us, "The theatre [h]as changed/To something else. Its past [is] a souvenir."

Not surprisingly, Anzaldúa—poet, philosopher, essayist, fiction writer, and Third World lesbian feminist—has faced resistance to her revolutionary ideas, especially in the classroom, which she describes as a microcosm of the world. Though a member of academe and a

professor at the University of California-Santa Cruz, she has succeeded in blending scholarship and experience in a way that puts theory into action. In *Borderlands/La Frontera* (1987) and *This Bridge Called My Back: Writings by Radical Women of Color* (1981 co-edited with Cherrie Moraga), Anzaldúa blends English and Spanish languages as well as genres to reveal her own cultural situatedness as an Hispanic living in the United States trapped between two worlds, in the borderlands.

hooks sees herself as an intellectual whose role is not merely to affirm cultural practices already defined as "radical or transgressive, ... [but to cross] boundaries, to take another look, to context, to interrogate, and in some cases recover and redeem" (hooks 1994a, 5). In *Talking Back, Breaking Bread*, and *Outlaw Culture*, hooks urges feminists to move through and beyond feminism. She exhorts women academics to look beyond their self-contained universities and address political, social, racial, and economic issues outside the ivy-covered walls (207) and asks that they remove themselves from the "sphere of coercive hierarchical domination" (6) that privileges particular groups.

The discussion of each public intellectual includes a brief biographical sketch that places each woman historically and socially, outlining her education, the barriers she confronted in achieving intellectual freedom, and her reception by society as a public intellectual. Also included is a brief overview of her major works as well as the basic themes and issues addressed therein. Excerpts from her writings or speeches follow this discussion.

An analysis of the lives of women public intellectuals together with excerpts from their works reveals differences in sociopolitical stances but also discloses similarities in the strength of their social commitments and in their development of a rhetoric that reflects their own experiences. This study also emphasizes the larger issues surrounding the current assessment of women public intellectuals' contributions. Alice Walker correctly asserts that what is needed to connect women with their historical past is a larger worldview. America's narrowed and narrowing perspective of life often prevents us from seeing the "common thread, the unifying theme ..., a fearlessness of growth, of search, of looking, that enlarges the private and the public world" (Walker 1983, 5). *Voices Unbound* suggests that despite sociopolitical, religious, generational, and class differences, these women's lives and writings constitute a public intellectual heritage, albeit a nontraditional one.

A study such as this one raises numerous questions: What did/does it mean to be an American woman intellectual in the nineteenth, twenti-

eth, or even twenty-first century? How were/are women able to surmount the restrictive roles dictated by their respective societies? How did Anna Julia Cooper, a former slave, come to be recognized, at least among certain groups, as a public intellectual? And finally, how have time and history silenced the contributions that Dorothy Thompson made to the development of women's public intellectual history?

One would think that the contributions made by women such as Fuller, Cooper, and Thompson would have paved the way for women public intellectuals in late twentieth-century America. However, these women and their contributions have been forgotten, ignored, or covered up. Ida Tarbell, for example, was widely recognized for her journalistic efforts that contributed to the breakup of Rockefeller's oil conglomerate, but history texts expunged her name soon after her death, as they have successfully done to so many women public intellectuals in America's past. Germaine Greer describes this not uncommon practice as the "phenomenon of the transience of female literary fame" (1974, 784).

Gerda Lerner depicts the "long and slow advance of women intellectuals toward a group consciousness and toward a liberating analysis of their situation" as "spasmodic, uneven, [and] repetitious." This is because each generation of women has had to "think their way out of patriarchal and gender definitions . . . as though each of them was a lonely Robinson Crusoe on a desert island, reinventing civilization." While male intellectuals "gr[o]w taller by standing 'on the shoulders of giants,' each making his small or large contribution to building a common heritage," women and their "creations s[i]nk soundlessly into the sea, leaving barely a ripple. Succeeding generations of women [are then] left to cover the same ground others ha[ve] already covered before them" (1993, 220).

The overall aim of this study, then, is to strengthen women's position in the intellectual world by providing them not with giants but with aunts, nieces, and cousins. By examining the lives and works of women public intellectuals past and present, I hope to provide the models whom Alice Walker looked for in "Saving the Life That Is Your Own"—women from the past who can "enrich and enlarge one's view of existence" (1983, 4). By accepting and acknowledging what these women have to offer us, we can leave the isolation of Robinson Crusoe's desert island and begin building on their divergent literary and intellectual inheritance.

I am often reminded of a passage from *Woman and the Demon* in which Nina Auerbach speaks of the need "to provide women today with an unexpectedly empowering past" (1982, 4). Perhaps by seeing

Jessie Redmon Fauset and other women public intellectuals with fresh eyes, we can begin revisioning women's intellectual heritage and find unexpected strength and power that can be passed on to future generations.

I Pre-Civil War America

The greatest changes in America's political, economic, and social landscape perhaps occurred between 1785 and 1850. Slavery as well as the American and Industrial Revolutions dramatically altered every facet of life. Women had benefited from the nation's increasing wealth, urbanization, and industrialization (albeit indirectly via their husbands); however, their position in society, specifically in the realms of politics and economic production, differed markedly from that of men. Although their opportunities for education improved to a certain degree, specialization of professions as well as new licensing and educational requirements prevented women from entering many fields of employment. It was ironic, Gerda Lerner mused, that "new opportunities for men came in a form that closed options for women" (1979, 18), such as when new medical schools offered formal training only to men (20).

This exclusion also extended to voting rights. In the early 1800s women who had held voting rights in colonial times were disenfranchised. According to Lois Banner, as America's political scene became more democratized, it also became increasingly conservative in assigning women's roles in this democracy. As a result, men and women were separated into different spheres of behavior and presented with different rights and responsibilities (1984, 42).

Society assigned women their nature (feminine and therefore flawed), their position (at the moral core), and their power (over a domestic domain). If a woman were to break away from these constraints, she became the target of "ad feminam criticism" (Showalter 1977, 73), as represented by Nathaniel Hawthorne's oft-quoted complaint about "the d----d mob of scribbling women." In addition, other nineteenth-century critics insisted that women writers lacked intellect, creativity, self-discipline, and education (90). The ideal writer/intellectual, according to these same critics, was one who possessed a clear and open mind, broad knowledge, and authority (90), which, according to modern science, women physiologically could not claim.

The subjects of Part I of this study—Margaret Fuller and Lydia Maria Child—compelled other women to move from positions of oppression to one of power, from victims to agents. American women

public intellectuals in the first half of the nineteenth century addressed thorny issues, exerting pressure against a status quo that objectified and departmentalized their sex. Despite immense opposition, these women altered the landscape of postcolonial America.

1
"Visionary of the New Age"
~
Margaret Fuller

> The history of the Transcendentalist movement stretched along two hundred years, beginning with a woman's life and work in 1637, and ending with a woman's work and death in 1850. The arc which we call transcendental was subtended by a cord, held at first by Anne Hutchinson, and lost in the Atlantic waves with Margaret Fuller.
> —Caroline Dall, *Transcendentalism in New England*

Who is this woman whose death marked the end of Transcendentalism? In examining F. O. Matthiessen's groundbreaking work, *American Renaissance* (1941), and David S. Reynolds's *Beneath the American Renaissance* (1988), one finds scarce allusion to Margaret Fuller or her writings. In fact, only in the last twenty years, with the publication of Marie Urbanski's *Margaret Fuller's Woman in the Nineteenth Century* (1980), have critics begun to reconsider Fuller's contributions to American literary history. Yet, at her death, journalist Horace Greeley described her as "the most remarkable and, in some respects, the greatest woman America has yet known" (1850). Two decades later, Elizabeth Cady Stanton lauded Fuller as "the most influential woman in American History" (Stanton 1978, 1).

Born in Cambridgeport, Massachusetts, in 1810, the oldest of nine children, Margaret Fuller received an education unlike other young girls of the period. Her father, a Harvard-educated lawyer, took charge of his oldest child's schooling. With the exception of brief stints at two schools for young women, Fuller followed a strict and solitary study program set up by her father. This regimen included instruction in history, literature, science, religion, and mathematics as well as Latin (which she was able to read at the age of six), Greek, and other languages. In later years, Fuller recalled the loneliness and isolation she felt during this time: "The consequence was a premature development of the brain, that made me a 'youthful prodigy' by day, and by night a

victim of spectral illusions, nightmares, and somnambulism" (Fuller 1852, 1:15).

Her directed studies abruptly came to an end in 1835 with the death of her father. As the eldest child, Fuller took over the responsibility of providing for her mother and furnishing her six brothers with a Harvard education. She earned her living by teaching, first at Bronson Alcott's experimental Temple School in Boston and later at the Greene Street School in Providence, Rhode Island, while continuing self-directed studies in language, translations, and women's rhetoric.

While in Boston, Fuller was drawn to the precepts of Transcendentalism and became part of a discussion group that included Ralph Waldo Emerson, George Ripley, and George Putnam. Firmly rooted in Romanticism, Transcendentalism explored the marvels of science, reason, and social conventions and refused them all (Bartlett 1994, 17). This movement, like British Romanticism, sought permanence and beauty in the ideal by melding the divineness of all creation with self-reliance and perfectibility. Fuller embraced these abstract principles but concretized them and employed them in addressing such social issues as women's rights. However, she also questioned some of the basic tenets of the Transcendentalist philosophy, specifically those explaining the nature of the individual's existence. While Transcendentalism viewed one's physical nature as the source of sin, Fuller accepted the entire individual, body and spirit (Braun 1910, 97). She wrote: "No true philosophy will try to ignore or annihilate the material part of man, but will rather seek to put it in its place, as a servant and minister to the soul." For Fuller, real life and the loftiest thoughts are connected: the "one [and] only aim of our pilgrimage here is to . . . bring the lowest act of . . . life into sympathy with its highest thought" (Fuller 1852, 2:30–31).

Fuller viewed Emerson, the most prominent spokesman of the Transcendentalist movement, as her model and mentor, even in the face of his insistence that "woman should not be expected to write, fight, or build, or compose scores; she does all by inspiring man to do all." Fuller admired Emerson's writing, discipline, and self-restraint and served as both a sounding board and an inspiration to him. In turn, Emerson introduced Fuller to the concepts of self-culture and the role of Nature in structuring one's life. Theirs was a reciprocal relationship. In Fuller, Emerson found "a pure and purifying mind, self-purifying also, full of faith in men, & inspiring it." He also valued her friendship, at least in the beginning: "Beside her friendship other friendships seem trite: She excels other intellectual persons in this, that her sentiments are more blended with her life, so the expression of them has a greater steadiness & clearness" (Emerson 1960–82, 8:368–69).

Paradoxically, a few weeks before the publication of her *Memoirs*, which Emerson co-edited, he wrote that he had found Fuller's "amusing gossip . . . profane" and that her "pen was a non-conductor" (Emerson, Channing, and Clarke 1852, 1:294). Elaine Showalter observes that Emerson preferred the phallic pen. In his journal in 1841, he wrote: "Give me initiative, spermatic, prophesying, man-making words" (quoted in Showalter 1977, 317). It should be noted that in the process of editing Fuller's *Memoirs*, Emerson, William Channing, and James Clarke, as numerous critics have pointed out, rewrote Fuller's life and recreated her, in part by excising passages from letters and transmogrifying her language, all in an attempt to "protect" her reputation (Dickenson 1993, 6–10).

In 1839 the Transcendentalist group began publication of *The Dial: A Magazine for Literature, Philosophy and Religion* and named Margaret Fuller its editor. In its first issue (July 1840), she stated that the purpose of *The Dial* was to "give expression to that spirit which lifts men to a higher platform, restores to them the religious sentiment, brings them worthy aims and pleasures, . . . raising man to the level of nature" (Fuller et al. 1840, 4). Its mission, Fuller wrote in a letter, was to "quicken the soul [of its readers], that they may work from within outwards." In order to transform society, the individual first must be remade, internally and then externally, since "political freedom does not necessarily produce liberality of mind" (1983, 2:108). During her tenure as editor, Fuller contributed critical commentary and essays, including "The Great Lawsuit: Man *versus* Men: Woman *versus* Women." In all, she edited a total of eight issues before the editorship transferred to Emerson in 1842.

In the same year that *The Dial* began publication, Fuller launched a series of "Conversations" for Boston matrons. Its purpose, she wrote to her friend Sophia Ripley, was to "ascertain what pursuits are best suited to us [women] in our time and state of society, and how we may make best use of our means for building up the life and thought upon the life of action" (1983, 2:87). Over two hundred women participated in her Conversations, including educator Elizabeth Peabody, writer/abolitionist Lydia Maria Child, Elizabeth Cady Stanton, and Caroline Dall (von Mehran 1994, 34). Through these Conversations, which continued for over five years, Fuller sought to remedy the problem facing educated women by providing an outlet for them to "reproduce their knowledge." She maintained that "women are now taught, at school, all that men are; they run over, superficially, even *more* studies, without really being taught anything. When they come to the business of life, they find themselves inferior. . . . Men are called on, from a very early period, to reproduce all that they learn. Their college exercises,

their political duties, their professional studies, the first actions of life in any direction, call on them to put to use what they have learned. But women learn without any attempt to reproduce. Their only reproduction is for purposes of display" (1852, 1:329).

At these meetings, women discussed such topics as health, poetry, mythology, art, literature, ethics, and social issues. By refusing to isolate subjects into separate categories, Fuller conjoined disparate disciplines, thus eliminating "artificial boundaries" (Albert 1994, 200). In her talks, Fuller criticized traditional methods of education that transformed women into mere showpieces for their parents and husbands. Fuller, along with other participants in the series, received what she had hoped to get from Emerson and her father but did not: acceptance as a woman. Through her compassionate teaching, she began to find her way toward self-actualization as a woman and intellectual (Chevigny 1993, 214).

As she did in her Boston Conversations, Fuller in writing *Woman in the Nineteenth Century* (1845) employed conversational strategies, including parentheses, dashes, and question-and-answer pairs. Judith Bean writes that Fuller's use of self-revelation and dialogic methods gives *Woman in the Nineteenth Century* a conversational tone. Thus, Fuller's writing style instilled a sense of trust in her readers and established connections by accentuating proximity and connection among various voices (Bean 1997, 29).

This work, her major one, grew out of "The Great Lawsuit" first published in *The Dial*. *Woman in the Nineteenth Century* focuses on the importance of self-reliance and the development of women's intellectual life (Helsinger, Sheets, and Veeder 1983, 1:38, 43). Women, Fuller argued, should not be defined by their gender, nor should men. Feminine and masculine qualities were not mutually exclusive. Because both men and women possess qualities of each sex, they do not "represent the two sides of the great radical dualism," as many believed. Instead, men and women were part of "one creative energy, one incessant revelation" (Fuller 1845, 115–16).

Nature does not dictate gender differences; indeed, Nature suggests that the two are interdependent. The distinction between the two, according to Fuller, was socially constructed. In *Woman in the Nineteenth Century*, she not only renounced the notion of women's moral and intellectual deficiencies but also rejected the "man is the head and woman the heart" dichotomy. Social and religious institutions, she insisted, had prevented women from developing their true nature by dictating that "man is not born for the woman, only the woman for the man"; the "life of Woman must be outwardly a well-intentioned, cheerful dissimulation of her real life" (159). Abetting this proclamation,

the American justice system had left women with little legal or economic identity except through that of their husbands. Thus, women were at the mercy of unprincipled men who had the power to take their children from them (31–32). It should be noted, however, that Fuller was quick to acknowledge that these same institutions victimized men as well as women.

Woman in the Nineteenth Century was a controversial work published at a time when a man could beat his wife and escape punishment and at a time when the New York State legislature was debating whether a married woman should own property. Democracy was expanding, the economy was growing, and politicians were praising America's bounty; nevertheless, women's rights were ignored and their very essences debased (Russell 1983, 187). Although Fuller had few expectations concerning the reception of *Woman in the Nineteenth Century*, the first printing sold out in the first week, in part because it touched on the controversies of the day while simultaneously looking to the coming age. Margaret Fuller is considered by most feminist critics to be one of the "first great voices of American feminism" (Helsinger, Sheets, and Veeder 1983, 1:39), and *Woman in the Nineteenth Century* is deemed a feminist manifesto that greatly impacted the work of later American feminists.

The book, in spite of its remarkable success, was not an easy read. First, it joined a journalist's field notes to an extensive yet discriminating comprehension of American and European history and society (1:45). In addition, Fuller employed the pluralistic and noncoercive rhetorical style of Richard Whately, a rhetorician and the archbishop of Dublin. One of the major elements of Whately's rhetoric centered on the process of investigation, the purpose of which was to argue both sides of an argument to get to the truth rather than to persuade. Fuller, like Whately, also made a "distinction between 'convey[ing] instruction to those who are ready to receive it' [and] '*compel[ling]* the assent, or silenc[ing] the objections, of an opponent' " (Kolodny 1994, 370). Her nonaggressive style of argument employed small hints and suggestions rather than direct and persuasive tactics. Fuller's own description of her writing supports Kolodny's view. She pictured it as a natural flow that "sp[un] out beneath [her] hand" (1983–1988, 3:241).

Critics in Fuller's time did not know what to make of her writing style or of her remarkable intellect. Reviewer Orestes Brownson found *Woman in the Nineteenth Century* to be not a book but rather "a long talk on matters and things in general. . . . It has neither beginning, middle, nor end, and may be read backwards as well as forwards, and from the centre outwards each way, without affecting the continuity of thought or the succession of ideas" (1980, 19). Even Fuller was unsure

of how to describe it: "For all the tides that flow within me, I am dumb and ineffectual, when it comes to casting my thought into form. No old one suits me. If I could invent one, it seems to me the pleasure of creation would make it possible for me to write. What shall I do? . . . One should be either private or public. I love best to be a woman; but womanhood is at present too straitly-bounded to give me scope" (Emerson, Channing, and Clarke 1852, 1:297). Interestingly, feminist theorists today are calling for multivoiced discourses (Kolodny 1994, 356), yet few even now acknowledge Margaret Fuller's contribution to the development of pluralistic dialogue.

As were many critical responses to women intellectuals, attacks on Fuller's work were often personal. This harsh criticism could have been a response to her rejection of the socially accepted image of the professional woman writer in the nineteenth century, which might best be described as "literary domestic" (Fink 1999, 55). Responding to women intellectuals/authors in general, Nathaniel Hawthorne contended that "all women, as author's [sic], are feeble and tiresome. I wish they were forbidden to write, on pain of having their faces deeply scarified with an oyster shell." Brownson, in his vitriolic review, continued: "Miss Fuller does not know what she wants, any more than does many a fine lady, whom silks, laces, shawls, dogs, parrots, balls, routs, jams, watering-places, and despair of lover or husband and friends have ceased to satisfy" (1980, 20). Fuller responded objectively: "I shall not be discouraged nor take for final what [critics] say, but sift from it the truth, and use it" (Emerson, Channing, and Clarke 1852, 1:296).

In her two years as editor of *The Dial*, Fuller developed her journalism skills while formulating a theory of criticism that revisioned the role of the social and literary critic. In 1844, Horace Greeley hired Fuller, who was then transported from the world of New England to that of cosmopolitan New York. In her position as literary editor of the *New York Tribune*, she reshaped the very nature of American literature with her reviews and commentaries. Fuller organized reviewers and social analysts into three types: subjective, apprehensive, and comprehensive. The subjective critic emotionally responded to the work; the apprehensive critic was both idealistic and historical; and the comprehensive critic "enter[ed] into the nature of another being and judge[d] a work by its own laws" (Fuller 1846, 3). This approach predates Virginia Woolf's assertion, in "How Should One Read a Book?" that the critic should judge a work in relation to other works—touchstones, if you will. The critic's role, however, from Fuller's perspective, was not to control the reader but simply to "show us [the reader]

where to look and warn us not to overlook in learning to ju ourselves" (3).

Fuller served as the *Tribune*'s literary editor between De 1844 and July 1846, writing two literary reviews and one article of social interest each week. Interestingly, even in her literary reviews, Fuller combined her dual role as literary reviewer and social critic to comment on issues concerning immigrants, Native Americans, slaves, prostitutes, and women prisoners. Her review of *Narrative of the Life of Frederick Douglass* exemplifies this approach. Fuller described the work as an "excellent piece of writing . . . simple, true, coherent, and warm with genuine feeling." Her praise soon turned into an indictment of the clergy, those "slaveholding professors of religion" whose "blindness [was] but one form of that prevalent fallacy which substitute[d] a creed for a faith, a ritual for a life" (1995, 136–37). Although she served as literary editor of the newspaper for less than two years, her contributions to the field of critical theory and journalism were substantial.

In 1846, Greeley sent Fuller overseas, thus making her the first American woman foreign correspondent. Due in great part to her efforts together with advances in printing processes, the *Tribune* had become an international publication. Her European dispatches began as travel letters as she journeyed throughout England and France; however, once in Italy, they became an emotional retelling of what Larry Reynolds and Susan Smith describe as the "most widespread political upheaval in modern history" (1991, 1). While in England Fuller had met Giuseppe Mazzini, the leader of the Italian Unification Movement, who was then in exile. During her stay in Italy, she fell in love with one of Mazzini's lieutenants, the Marchese Giovanni Angelo Ossoli. Ossoli's family had served the Papal government for centuries, but Giovanni became a Republican and fought in the Revolution. Though it is not clear whether they ever married, in 1848 they did have a child, Angelo Eugene. In that same year, Italian revolutionaries had declared war on Austrian troops stationed in Italy and established the Roman Republic. Although the Republic would ultimately suffer defeat, Fuller embraced its democratic ideals. She extended her stay in Rome, despite imminent danger, to be an eyewitness to and for the Revolution.

In her dispatches supporting the revolutionaries, Fuller openly criticized her own government's lack of commitment to the ideals of the Republic. It was clear that little could be done to help the Republic at this point; nonetheless, she pleaded with the American populace, in a dispatch dated August 11, 1849, to aid future efforts to set up

democratic governments: "I pray you do something; let it not end in a mere cry of sentiment. . . . Friends, countrymen, and lovers of virtue, lovers of freedom, lovers of truth!—be on the alert; rest not supine in your easier lives, but remember: 'Mankind is one/And beats with one great heart' " (1856, 421).

Margaret Fuller's contributions to American literary and social history are even more remarkable when one considers that she drowned in a shipwreck at the age of forty, along with her husband and two-year-old child, while fleeing Italy after the fall of the Roman Republic to return to the United States. During a career that was cut short, Fuller helped to shape American literature through her reviews; she wrote the American feminist manifesto for the nineteenth century; she introduced a rhetoric that was both polyvocal and noncoercive; and she left a legacy for future women journalists, travel writers, and intellectuals.

To the oft-asked question, "What did she do?" Paula Blanchard responds that though Fuller "should be remembered more for what she was rather than what she did," she still went further than any other woman of her time "in forcing an unwilling public to accept the idea of a woman as a major intellectual figure. The effect she had on women's ability to believe in themselves is immeasurable and her thinking on . . . vocational equality is still vital today" (1978, 342). Despite economic, educational, social, and political restrictions, Fuller attained international fame and found ready approval as an intellectual in European societies, unlike her Transcendentalist colleagues. Still, she has rightly been called the most important woman of the nineteenth century. Of all her contributions, however, perhaps her greatest legacy was her persistent and honest quest for self-discovery, which continued until her tragic death (Albert 1994, 233). In a letter dated two years prior to that fateful voyage, Fuller writes: "I have wished to be natural and true, but the world was not in harmony with me—nothing came right for me. I think the spirit that governs the universe must have in reserve for me a sphere where I can develop more fully, and be happier" (qtd. in Blanchard 1978, 289).

Woman in the Nineteenth Century*

Of all [the] banners [in the movement for social justice], none has been more steadily upheld, and under none have more valor and will-

*From Margaret Fuller, "We Would Have Every Arbitrary Barrier Thrown Down," in *Woman in the Nineteenth Century* (London: Clarke, 1845).

ingness for real sacrifices been shown, than that of the champions of the enslaved African. And this band it is, which, partly from a natural following out of principles, partly because many women have been prominent in that cause, makes, just now, the warmest appeal in behalf of woman.

Though there has been a growing liberality on this subject, yet society at large is not so prepared for the demands of this party, but that they are and will be for some time, coldly regarded as the Jacobins[1] of their day.

"Is it not enough," cries the irritated trader, "that you have done all you could to break up the national union, and thus destroy the prosperity of our country but now you must be trying to break up family union, to take my wife away from the cradle and the kitchen hearth to vote at polls, and preach from a pulpit? Of course, if she does such things, she cannot attend to those of her own sphere. She is happy enough as she is. She has more leisure than I have, every means of improvement, every indulgence."

"Have you asked her whether she was satisfied with these *indulgences*?"

"No, but I know she is. She is too amiable to wish what would make me unhappy, and too judicious to wish to step beyond the sphere of her sex. I will never consent to have our peace disturbed by any such discussions."

" 'Consent—you?' it is not consent from you that is in question, it is assent from your wife."

"Am not I the head of my house?"

"You are not the head of your wife. God has given her a mind of her own."

"I am the head and she the heart."

"God grant you play true to one another then. I suppose I am to be grateful that you did not say she was only the hand. If the head represses no natural pulse of the heart, there can be no question as to your giving your consent. Both will be of one accord, and there needs but to present any question to get a full and true answer. There is no need of precaution, of indulgence, or consent. But our doubt is whether the heart does consent with the head, or only obeys its decrees with a passiveness that precludes the exercise of its natural powers, or a repugnance that turns sweet qualities to bitter, or a doubt that lays waste the fair occasions of life. It is to ascertain the truth, that we propose some liberating measures."

Thus vaguely are these questions proposed and discussed at present. But their being proposed at all implies much thought and suggests more. Many women are considering within themselves, what they need

that they have not, and what they can have, if they find they need it. Many men are considering whether women are capable of being and having more than they are and have, *and*, whether, if so, it will be best to consent to improvement in their condition.

This morning, I open the Boston "Daily Mail," and find in its "poet's corner," a translation of Schiller's "Dignity of Woman." In the advertisement of a book on America, I see in the table of contents this sequence, "Republican Institutions. American Slavery. American Ladies."

I open the *Deutsche Schnellpost* published in New-York, and find at the head of a column, *Juden und Frauen-emancipation in Ungarn*. Emancipation of Jews and Women in Hungary.

The past year has seen action in the Rhode-Island legislature, to secure married women rights over their own property, where men showed that a very little examination of the subject could teach them much; an article in the "Democratic Review" on the same subject more largely considered, written by a woman, impelled, it is said, by glaring wrong to a distinguished friend having shown the defects in the existing laws, and the state of opinion from which they spring; and an answer from the revered old man J. Q. Adams, in some respects the Phocion[2] of his time, to an address made him by some ladies. To this last I shall again advert in another place.

These symptoms of the times have come under my view quite accidentally: one who seeks, may, each month or week, collect more.

The numerous party, whose opinions are already labelled and adjusted too much to their mind to admit of any new light, strive, by lectures on some model-woman of bride-like beauty and gentleness, by writing and lending little treatises, intended to mark out with precision the limits of woman's sphere, and woman's mission, to prevent other than the rightful shepherd from climbing the wall, or the flock from using any chance to go astray.

Without enrolling ourselves at once on either side, let us look upon the subject from the best point of view which to-day offers. No better, it is to be feared, than a high house-top. A high hill-top, or at least a cathedral spire, would be desirable.

It may well be an Anti-Slavery party that pleads for woman, if we consider merely that she does not hold property on equal terms with men; so that, if a husband dies without making a will, the wife, instead of taking at once his place as head of the family, inherits only a part of his fortune, often brought him by herself, as if she were a child, or ward only, not an equal partner.

We will not speak of the innumerable instances in which profligate and idle men live upon the earnings of industrious wives; or if the wives leave them, and take with them the children, to perform the

double duty of mother and father follow from place to place, and threaten to rob them of the children, if deprived of the rights of a husband, as they call them, planting themselves in their poor lodgings, frightening them into paying tribute by taking from them the children, running into debt at the expense of these otherwise so overtasked helots.[3] Such instances count up by scores within my own memory. I have seen the husband who had stained himself by a long course of low vice, till his wife was wearied from her heroic forgiveness, by finding that his treachery made it useless, and that if she would provide bread for herself and her children, she must be separate from his ill fame. I have known this man come to instal himself in the chamber of a woman who loathed him and say she should never take food without his company. I have known these men to steal their children whom they knew they had no means to maintain, take them into dissolute company, expose them to bodily danger, to frighten the poor woman, to whom, it seems, the fact that she alone had borne the pangs of their birth, and nourished their infancy, does not give an equal right to them. I do believe that this mode of kidnapping, and it is frequent enough in all classes of society, will be by the next age viewed as it is by Heaven now, and that the man who avails himself of the shelter of men's laws to steal from a mother her own children, or arrogate any superior right in them, save that of superior virtue, will bear the stigma he deserves, in common with him who steals grown men from their motherland, their hopes, and their homes.

I said, we will not speak of this now, yet I have spoken, for the subject makes me feel too much. I could give instances that would startle the most vulgar and callous, but I will not, for the public opinion of their own sex is already against such men, and where cases of extreme tyranny are made known, there is private action in the wife's favor. But she ought not to need this, nor, I think, can she long. Men must soon see that, on their own ground, woman is the weaker party; she ought to have legal protection, which would make such oppression impossible. But I would not deal with "atrocious instances" except in the way of illustration, neither demand from men a partial redress in some one matter, but go to the root of the whole. If principles could be established, particulars would adjust themselves aright. Ascertain the true destiny of woman, give her legitimate hopes, and a standard within herself; marriage and all other relations would by degrees be harmonized with these.

But to return to the historical progress of this matter. Knowing that there exists in the minds of men a tone of feeling towards women as towards slaves, such as is expressed in the common phrase, "Tell that to women and children," that the infinite soul can only work

through them in already ascertained limits; that the gift of reason, man's highest prerogative, is allotted to them in much lower degree; that they must be kept from mischief and melancholy by being constantly engaged in active labor, which is to be furnished and directed by those better able to think, &c. &c.; we need not multiply instances, for who can review the experience of last week without recalling words which imply, whether in jest or earnest, these views or views like these; knowing this, can we wonder that many reformers think that measures are not likely to be taken in behalf of women, unless their wishes could be publicly represented by women?

That can never be necessary, cry the other side. All men are privately influenced by women; each has his wife, sister, or female friends, and is too much biased by these relations to fail of representing their interests, and, if this is not enough, let them propose and enforce their wishes with the pen. The beauty of home would be destroyed, the delicacy of the sex violated, the dignity of halls of legislation degraded by an attempt to introduce them there. Such duties are inconsistent with those of a mother; and then we have ludicrous pictures of ladies in hysterics at the polls, and senate chambers filled with cradles.

But if, in reply, we admit as truth that woman seems destined by nature rather for the inner circle, we must add that the arrangements of civilized life have not been, as yet, such as to secure it to her. Her circle, if the duller, is not the quieter. If kept from "excitement," she is not from drudgery. Not only the Indian squaw carries the burdens of the camp, but the favorites of Louis the Fourteenth accompany him in his journeys, and the washerwoman stands at her tub and carries home her work at all seasons, and in all states of health. Those who think the physical circumstances of woman would make a part in the affairs of national government unsuitable, are by no means those who think it impossible for the negresses to endure field work, even during pregnancy, or the sempstresses [seamstresses] to go through their killing labors.

As to the use of the pen, there was quite as much opposition to woman's possessing herself of that help to free agency, as there is now to her seizing on the rostrum or the desk; and she is likely to draw, from a permission to plead her cause that way, opposite inferences to what might be wished by those who now grant it.

As to the possibility of her filling with grace and dignity, any such position, we should think those who had seen the great actresses, and heard the Quaker preachers of modern times, would not doubt, that woman can express publicly the fulness of thought and creation, without losing any of the peculiar beauty of her sex. What can pollute and tarnish is to act thus from any motive except that something needs to

be said or done. Women could take part in the processions, the songs, the dances of old religion; no one fancied their delicacy was impaired by appearing in public for such a cause.

As to her home, she is not likely to leave it more than she now does for balls, theatres, meetings for promoting missions, revival meetings, and others to which she flies, in hope of an animation for her existence, commensurate with what she sees enjoyed by men. Governors of ladies' fairs are no less engrossed by such a change, than the Governor of the state his; presidents of Washingtonian societies no less away from home than presidents of conventions. If men look straitly to it, they will find that, unless their lives are domestic, those of the women will not be. A house is no home unless it contains food and fire for the mind as well as for the body. The female Greek, of our day, is as much in the street as the male to cry, What news? We doubt not it was the same in Athens of old. The women, shut out from the market place, made up for it at the religious festivals. For human beings are not so constituted that they can live without expansion. If they do not get it one way, they must another, or perish.

As to men's representing women fairly at present, while we hear from men who owe to their wives not only all that is comfortable or graceful, but all that is wise in the arrangement of their lives, the frequent remark, "You cannot reason with a woman," when from those of delicacy, nobleness, and poetic culture, the contemptuous phrase "women and children," and that in no light sally of the hour, but in works intended to give a permanent statement of the best experiences, when not one man, in the million, shall I say? no, not in the hundred million, can rise above the belief that woman was made *for man*, when such traits as these are daily forced upon the attention, can we feel that man will always do justice to the interests of woman? Can we think that he takes a sufficiently discerning and religious view of her office and destiny, *ever* to do her justice, except when prompted by sentiment, accidentally or transiently, that is, for the sentiment will vary according to the relations in which he is placed. The lover, the poet, the artist, are likely to view her nobly. The father and the philosopher have some chance of liberality; the man of the world, the legislator for expediency, none.

Under these circumstances, without attaching importance, in themselves, to the changes demanded by the champions of woman, we hail them as signs of the times. We would have every arbitrary barrier thrown down. We would have every path laid open to woman as freely as to man. Were this done and a slight temporary fermentation allowed to subside, we should see crystallizations more pure and of more various beauty. We believe the divine energy would pervade nature to a degree

unknown in the history of former ages, and that no discordant collision, but a ravishing harmony of the spheres would ensue.

Yet, then and only then, will mankind be ripe for this, when inward and outward freedom for woman as much as for man shall be acknowledged as a right, not yielded as a concession. As the friend of the negro assumes that one man cannot by right, hold another in bondage, so should the friend of woman assume that man cannot, by right, lay even well-meant restrictions on woman. If the negro be a soul, if the woman be a soul, appareled in flesh, to one Master only are they accountable. There is one law for souls, and if there is to be an interpreter of it, he must come not as man, or son of man, but as son of God.

Were thought and feeling once so far elevated that man should esteem himself the brother and friend, but nowise the lord and tutor of woman, were he really bound with her in equal worship, arrangements as to function and employment would be of no consequence. What woman needs is not as a woman to act or rule, but as a nature to grow, as an intellect to discern, as a soul to live freely and unimpeded, to unfold such powers as were given her when we left our common home. If fewer talents were given her, yet if allowed the free and full employment of these, so that she may render back to the giver his own with usury she will not complain; nay I dare to say she will bless and rejoice in her earthly birth-place, her earthly lot. Let us consider what obstructions impede this good era, and what signs give reason to hope that it draws near. . . .

In this regard of self-dependence, and a greater simplicity and fullness of being, we must hail as a preliminary the increase of the class contemptuously designated as old maids.

We cannot wonder at the aversion with which old bachelors and old maids have been regarded. Marriage is the natural means of forming a sphere, of taking root on the earth; it requires more strength to do this without such an opening; very many have failed, and their imperfections have been in everyone's way. They have been more partial, more harsh, more officious and impertinent than those compelled by severer friction to render themselves endurable. Those, who have a more full experience of the instincts, have a distrust, as to whether they can be thoroughly human and humane, such as is hinted in the saying, "Old maids' and bachelors' children are well cared for," which derides at once their ignorance and their presumption.

Yet the business of society has become so complex, that it could now scarcely be carried on without the presence of these despised auxiliaries; and detachments from the army of aunts and uncles are wanted to stop gaps in every hedge. They rove about, mental and moral

Ishmaelites,[4] pitching their tents amid the fixed and ornamented homes of men.

In a striking variety of forms, genius of late, both at home and abroad, has paid its tribute to the character of the Aunt, and the Uncle, recognizing in these personages the spiritual parents, who had supplied defects in the treatment of the busy or careless actual parents.

They also gain a wider, if not so deep existence. Those who are not intimately and permanently linked with others, are thrown upon themselves, and, if they do not there find peace and incessant life, there is none to flatter them that they are not very poor and very mean.

A position which so constantly admonishes, may be of inestimable benefit. The person may gain, undistracted by other relationships, a closer communion with the one. Such a use is made of it by saints and sybils. Or she may be one of the lay sisters of charity, a Canoness, bound by an inward vow! Or the useful drudge of all men, the Martha, much sought, little prized! Or the intellectual interpreter of the varied life she sees; the Urania of a half-formed world's twilight.[5]

Or she may combine all these. Not "needing to care that she may please a husband," a frail and limited being, her thoughts may turn to the centre, and she may, by steadfast contemplation entering into the secret of truth and love, use it for the use of all men, instead of a chosen few, and interpret through it all the forms of life. It is possible, perhaps, to be at once a Priestly servant, and a loving muse.

Saints and geniuses have often chosen a lonely position in the faith that if, undisturbed by the pressure of near ties, they would give themselves up to the inspiring spirit, it would enable them to understand and reproduce life better than actual experience could.

How many old maids take this high stand, we cannot say: it is an unhappy fact, that too many who have come before the eye are gossips rather, and not always good-natured gossips. But if these abuse, and none make the best of their vocation, yet it has not failed to produce some good results. It has been seen by others, if not by themselves, that beings, likely to be left alone, need to be fortified and furnished within themselves, and education and thought have tended more and more to regard these beings as related to absolute Being, as well as to other men. It has been seen that, as the breaking of no bond ought to destroy a man, so ought the missing of none to hinder him from growing. And thus a circumstance of the time, which springs rather from its luxury than its purity, has helped to place women on the true platform.

Perhaps the next generation, looking deeper into this matter, will find that contempt is put upon old maids, or old women at all, merely because they do not use the elixir which would keep them always young. Under its influence a gem brightens yearly which is only seen to more

advantage through the fissures Time makes in the casket. No one thinks of Michael Angelo's Persican Sibyl, or Saint Theresa, or Tasso's Leonora, or the Greek Electra, as an old maid, more than of Michael Angelo or Canova as old bachelors, though all had reached the period in life's course appointed to take that degree.

See a common woman at forty; scarcely has she the remains of beauty, of any soft poetic grace which gave her attraction as woman, which kindled the hearts of those who looked on her to sparkling thoughts, or diffused round her a roseate air of gentle love. See her, who was, indeed a lovely girl, in the coarse full-blown dahlia flower of what is commonly called matron-beauty, fat, fair, and forty, showily dressed, and with manners as broad and full as her frill or satin cloak. People observe, "how well she is preserved"; "she is a fine woman still," they say. This woman whether as a duchess in diamonds, or one of our city dames in mosaics charms the poet's heart no more, and would look much out of place kneeling before the Madonna. She "does well the honors of her house," "leads society," is, in short, always spoken and thought of upholstery-wise.

Or see that care-worn face, from which every soft line is blotted, those faded eyes from which lonely tears have driven the flashes of fancy, the mild white beam of a tender enthusiasm. This woman is not so ornamental to a tea party; yet she would please better, in picture. Yet surely she, no more than the other, looks as a human being should at the end of forty years. Forty years! have they bound those brows with no garland? shed in the lamp no drop of ambrosial oil?

Not so looked the Iphigenia in Aulis.[6] Her forty years had seen her in anguish, in sacrifice, in utter loneliness. But those pains were borne for her father and her country; the sacrifice she had made pure for herself and those around her. Wandering alone at night in the vestal solitude of her imprisoning grove, she has looked up through its "living summits" to the stars, which shed down into her aspect their own lofty melody. At forty she would not misbecome the marble.

Not so looks the Persica. She is withered, she is faded; the drapery that enfolds her has, in its dignity and angularity, too, that tells of age, of sorrow, of a stern composure to the *must*. But her eye, that torch of the soul, is untamed, and in the intensity of her reading, we see a soul invincibly young in faith and hope. Her age is her charm, for it is the night of the Past that gives this beacon fire leave to shine. Wither more and more, black Chrysalid! thou dost but give the winged beauty time to mature its splendors.

Not so looked Victoria Colonna,[7] after her life of a great hope, and of true conjugal fidelity. She had been, not merely a bride, but a wife, and, each hour had helped to plume the noble bird. A coronet of

pearls will not shame her brow; it is white and ample, a worthy altar for love and thought.

Even among the North American Indians, a race of men as completely engaged in mere instinctive life as almost any in the world, and where each chief, keeping many wives as useful servants, of course looks with no kind eye on celibacy in woman, it was excused in the following instance mentioned by Mrs. Jameson.[8] A woman dreamt in youth that she was betrothed to the Sun. She built her a wigwam apart, filled it with emblems of her alliance, and means of an independent life. There she passed her days, sustained by her own exertions, and true to her supposed engagement.

In any tribe, we believe, a woman, who lived as if she was betrothed to the Sun, would be tolerated, and the rays which made her youth blossom sweetly, would crown her with a halo in age.

There is, on this subject, a nobler view than heretofore, if not the noblest, and improvement here must coincide with that in the view taken of marriage.

We must have units before we can have union, says one of the ripe thinkers of the times.

Notes

1. Members of a radical political group during the French Revolution.
2. Equitable Athenian statesman and general (c. 402–317 BCE).
3. Serf or slave; from a class of people owned by the state in ancient Sparta.
4. Wanderers; outcasts (see Genesis 21:9–21).
5. *Martha*, friend of Jesus, sister of Lazarus and Mary; a houseworker (Luke 10:40); *Urania*, muse of astronomy.
6. In Greek legend, the daughter of Agamemnon and Clytemnestra, sacrificed by her father at Aulis to Artemis. Artemis rescued her and made her a priestess.
7. Vittoria Colonna (1492–1547); Italian noblewoman and poet known for sonnets about her dead husband.
8. Irish writer Anna Brownell Jameson's (1794–1860) 1838 story about a Chippewa (Indian) woman.

2
"First Woman in the Republic"
~
Lydia Maria Child

> In this case, renown is out of the question, and ridicule is a matter of indifference.
> —Lydia Maria Child

At the time Margaret Fuller became editor of *The Dial*, Lydia Maria Child had already published numerous works. In addition to juvenile novels and short stories, she had penned *Hobomok, A Tale of Early Times* (1824), a novel on intermarriage; *The First Settlers of New-England* (1829), which addressed the Indian Question; *The Frugal Housewife* (1829), a book of advice for women of all classes; *An Appeal in Favor of That Class of Americans Called Africans* (1833), an antislavery treatise; and *The History of the Condition of Women, in Various Ages and Nations* (1835).

During a writing career that spanned five decades, Child wrote forty-seven books and over two thousand letters. Carolyn Karcher rightly describes her as a "trailblazer" who in the 1820s helped construct the American short story and historical novel. Her contribution to the nation's literary and intellectual history came in a variety of genres, including children's novels (which she employed as a venue for fighting racism and bigotry) and short stories (ranging from science fiction to realism). In addition she helped to establish a new genre, the journalistic sketch.

The famous abolitionist, William Lloyd Garrison, deemed her "the first woman in the republic" (1829, 85). Historian Edward Crapol has described Child as "a female critic who through the power of her ideas and the force of her actions played . . . [a] role in American foreign policy" (1987, vii). As a scholar, researcher, activist, and woman of letters, Child participated in many of the major reform movements of the nineteenth century. Moreover, she was a first-rate journalist who

contributed weekly columns—to the *New York Tribune* and later the *Boston Courier*—on such controversial issues as the role of the Native American, slavery and racism, religion, and the role of women in society.

Hobomok, New England's first historical novel to address the Indian Question, was published in 1824 when Child was only twenty-two. In the story, Hobomok, a "noble savage," falls in love with a white woman, Mary Conant, after her white lover is supposedly drowned at sea. Conant marries Hobomok, and they have a child. Two years later, the lover returns. Willingly sacrificing his own happiness, Hobomok leaves his wife to her former lover and leaves for the western frontier. The book is remarkable not only for the interracial plot line but also for the way in which Child appropriated "the narrative authority of Puritan chroniclers." Substituting her own language for the words spoken by the male narrator and incorporating her own knowledge of the seventeenth century, she wrote a history that included an impassioned appeal for racial and religious tolerance (Karcher 1986b, xx–xxiv).

Lydia Maria Child continued her deconstruction of Puritan history and her campaign against Indian removal in *The First Settlers of New-England: or, Conquest of the Pequods, Narragansets and Pokanokets, as related by a mother to her children*, which, like *Hobomok*, is a revisionist retelling of the colonial period (Karcher 1994, 86). *The First Settlers of New-England* did not romanticize the early colonists, as did most writings of the early 1800s; instead, it points the "finger of scorn" at them for their mistreatment of Native Americans, which "has been, and continues to be, in direct violation of the religion and civil institutions . . . by which we profess to be governed" (Child 1829a, iii–iv). In this story, an Anglo mother reads New England history to her young daughters. Child uses the mother's responses to her children's questions to deconstruct and rewrite the colonial beginnings to protest the government's policy for Indian removal (Baym 1995, 39). For example, when daughter Caroline asks whether "it is possible that a belief so monstrous [that Native Americans should be killed] can be embraced by rational beings," her mother replies: "I wonder not at your incredulity or surprise; but I can assure you, that . . . the first settlers of this country had been bred up in the school of controversy, and their feelings were of course adverse to the doctrines of peace and mercy which form the basis of Christianity, from having been accustomed to defend the crude notions . . . of scripture [passages], (without any regard to their connection,) which favored their opinions . . . ; but an evil of still greater magnitude was the vain belief of their being a chosen people, and like the Israelites, authorized by God to destroy

or drive out the heathens, as they styled the Indians" (Child 1829a, 31–32).

Not only was *The First Settlers of New-England* part of Child's campaign against Indian removal, but it was also an indictment raised against Columbus for his "base ingratitude and cruelty" toward indigenous people (186). Moreover, Child used the work to question foreign policy, asking why we should "lavish our charities on foreigners" when we should be fulfilling our "sacred obligations to people who owe to us their ruin" (277).

Long after other writers had moved on to consider the slavery issue, Lydia Maria Child continued to debate the Indian Question. She could find no inherent boundary that separated Native Americans from whites. For Child, the barrier between the two groups had no basis in reality. Thus, the answer to racial tensions was simple: full assimilation. Intermarriage was the only solution, the only bridge that could unite the two races (Karcher 1994, 551). Though continuing to confront the Indian Question throughout her long career, Child's meeting with William Lloyd Garrison in the late 1820s redirected her career and altered forever "the whole pattern of [her] life-web" (Child 1982, 558). Describing their encounter, she wrote that Garrison "got hold of the strings of my conscience and pulled me into reforms" (255).

In 1833, Child wrote *An Appeal in Favor of That Class of Americans Called Africans*, which explored religious, social, political, and racial facets of the slave controversy. The first book by an American to call for immediate emancipation, it traces the history of slavery, details the horrors of the slave ships, and examines the deleterious effects of the slave trade on both the bondsmen and their masters (Baer 1964, 66). Most writers of the period had avoided any direct discussion of the atrocities caused by slavery, but Child specifically detailed the ways in which the institution debased both the slave and the slave owner. While careful not to criticize the Constitution itself, she nonetheless argued that America had suffered from the "constitutional compromise" that had created slavery and called for immediate emancipation of all African Americans (Baym 1995, 62–63).

Child did more than simply expose the horrors of slavery, including the rape of slave women. She also offered a solution to this most pressing social problem. Carolyn Karcher writes that Child believed the key to the abolition of slavery would come through freedom groups that worked for interracial solidarity and justice for all people (1996, ix). The logic of Child's argument moves the reader/listener from past to present, from history to political economy, from fact to argument, from problem to solution (xxxiv). In her campaign against slavery,

Child often included African American perspectives to allow the slaves to be their own witnesses. These "new narratives of slavery" presented portraits of African Americans who in the past had been censored or denounced as false (Mills 1994, 47).

To say *An Appeal* was not popularly received is an understatement. After its publication, a number of factions sought to censure Child. The Boston Athenaeum Library refused her admittance, and sales of her books sharply declined. Readers canceled their subscriptions to *Juvenile Miscellany*, her children's journal. This negative response came as no surprise to Child. In the preface to *An Appeal*, she had beseeched her readers "not to throw down this volume as soon as you have glanced at the title." She acknowledged, "I am fully aware of the unpopularity of the task I have undertaken; but though I expect ridicule and censure, it is not in my nature to fear them." Despite violent protests against the book, *An Appeal* brought new recruits into the abolitionist movement and influenced the thinking of its greatest leaders, including William Ellery Channing and Transcendentalist Thomas Wentworth Higginson (Karcher 1997, xlvii).

In addition to writing novels and promoting the works of African American writers, between 1841 and 1842 Child served as editor of the *National Anti-Slavery Standard*. Her relationship, however, with other members of the abolitionist movement was an uneasy one; many took umbrage with her editorial policy. Though dedicated to the abolitionist cause, Child did not countenance violence and refused to print articles that did. Her goal as editor was to gain the ear of intelligent and judicious people on behalf of antislavery (Child 1982, 194). Regrettably, divisiveness within the abolitionist camp resulted in her resignation and separation from the movement. In a letter dated March 1843, Child vowed never again to "join any association for any purpose," a promise that she kept for the rest of her life (1982, 193).

In addition to fighting racial bigotry, Child addressed other reform issues. As did Margaret Fuller, she took advantage of new technological advances in printing as well as newspapers' broadening readership to write opinion pieces on social justice, gender politics, domestic life, the arts, and women's issues. First appearing in *The National Anti-Slavery Standard* and the *Boston Courier* and later compiled into a book entitled *Letters from New York* (1843), her essays, according to Karcher, "publicized the plight of the urban poor; spoke out against capital punishment and the imprisonment of women for prostitution; called for prison reform including humane treatment, rehabilitation programs and job placement after release, and argued that only eliminating poverty could solve the problem of crime" (Tingley 1997, 3).

Stephanie Tingley writes that in *Letters from New York*, Lydia Maria Child established a legacy for American women essayists (1997, 42). These sketches introduced an essay form that was more flexibly structured, more open, and more accessible than the traditional editorial essays. In addition, they are characterized by dialogic techniques that focused on the specific rather than the abstract (46). *Letters from New York* offered a new way of looking at urban America and in the process inaugurated a new genre that Margaret Fuller would continue to refine and develop (Karcher 1994, 306).

The central focus of Child's writings on the Woman Question shifted over the years. *The Frugal Housewife* (1829), a best-seller that went through forty editions, was a domestic guide for women who were "not ashamed of industry and economy" (Child 1829b, 6). Previously published household texts had been directed to the wealthy. By the early 1800s a few conduct manuals had begun to address a wider spectrum of society, although Child believed that even these books were ultimately directed to affluent readers. *The Frugal Housewife*, however, had been written, according to its author, "for the poor."

As did British intellectual Harriet Martineau, Child viewed herself as a pragmatic writer whose mission was to educate the masses. Thus, in her introduction she writes that she had "no apology to offer for this cheap little book of economic hints, except [her] deep conviction that such a book [was] needed" (6). Although filled with cooking instructions, home remedies, and other advice, *The Frugal Housewife* also contained a moral message: "In tracing evils . . . in society, . . . the great cause of all mischief [is] mismanagement in education; and this remark applies with peculiar force to the leading fault of the present day, viz.: extravagance. . . . If young men and young women are brought up to consider frugality contemptible, and industry degrading, it is vain to expect they will at once become prudent and useful" (94). Unconcerned with bolstering the standards of respectability, Child gave practical advice to housewives of limited means on how best to care for their families.

"The Equality of the Sexes," written nearly fifty years after *The Frugal Housewife*, addressed women's lack of enfranchisement and the issue of their natural inferiority. Though acknowledging that at the present time women are not men's physical or intellectual equals, hundreds of years "impeded growth" (1876, 252). She asserted: "If women have physical or intellectual strength sufficient to earn property, and consequently be taxed for it, they have intellect enough to vote concerning the use that shall be made of their taxes; and if they have sense and feeling enough to suffer from the effects of corrupt or imbecile legislation, they have sense enough to improve it." Child's demands

are straightforward: "perfect liberty to choose our own spheres of action, and a fair, open chance to do whatsoever we can do well" (252).

Women writers such as Child and Fuller faced a unique set of problems that their male counterparts did not have to consider. First, in the early nineteenth century, many people believed that it was wrong for women to publish their writings; hence, women writers were forced to do so anonymously. Second, women who did write were encouraged to choose topics within "woman's sphere," such as domestic fiction, children's stories, and conduct manuals. Last, women who did find careers in writing were not only grossly underpaid but the moneys that they earned, as well as the copyright to their works, legally belonged to their husbands or fathers (Holland 1981, 157).

Decades before Margaret Fuller embarked on her career, Lydia Maria Child had already achieved critical acclaim (157). At twenty-five, Lydia Maria befriended a precocious sixteen-year-old Margaret. Their career paths crossed at several points before Fuller's death in 1850, yet their lives and the progression of their respective professions were quite different. Despite this fact, Child's ideals strongly influenced Fuller, who patterned her own career as writer and social activist on that of the older woman (Karcher 1994, 325–26). Child, on her part, encouraged Fuller's career by publishing advance reviews of *Woman in the Nineteenth Century* and praising her dynamic writing style, which, she said, Fuller used to address issues most "women dare[d] not approach" (Child 1845, 97). Although Margaret Fuller begins this book, Lydia Maria Child should be considered Fuller's earliest mentor.

Child's writings impacted children as well as adults. Her *Juvenile Miscellany* articles examined a number of controversial topics, including racial bigotry among young people. Both Caroline Healey Dall and Louisa May Alcott were counted among her young supporters (Karcher 1994, 170). As an adult, Dall would recall that many young people acknowledged Child as a major influence in their early lives. As for her adult fans, Angelina Grimké, a well-known intellectual of the period, wrote that Child's *An Appeal* "brought [her] into deep and solemn exercise of mind" on the slavery issue. Elizabeth Cady Stanton described *The Progress of Religious Ideas* as "the pillar of light [for her and others] through the wilderness of doubt" (quoted in Karcher 1994, 383).

Despite the accolades, Child spent her life "struggling to find a place where she belonged, a place where she could be respected as a whole woman" (Clifford 1992, 2). Both socially and economically ostracized at different points in her career, at times she was threatened with mob violence. Many abolitionists, for whose cause she worked

for most of her life, censured her. Because of her political views, publishers refused to print her work (Karcher 1986a, 285). As a result, Child lived most of her life in near poverty.

Writing after her death in 1880, John Greenleaf Whittier described Child's life as "a battle—A constant rowing hard against the stream of popular prejudice and hatred. And through it all—pecuniary privation, loss of friends and position, the painfulness of being suddenly thrust . . . into the bitterest and sternest controversy of the age—she bore herself with patience, fortitude, and unshaken reliance upon the justice and ultimate triumph of the cause she espoused. Her pen was never idle. . . . It is not exaggeration to say that no man or woman at that period rendered more substantial service to the cause of freedom or made such a 'great renunciation' in doing it" (Whittier 1882, x).

A Letter from L. Maria Child: Emancipation and Amalgamation*

To the Editor of the N.Y. Tribune.

Sir: A gentleman in Maryland, to whom I sent my Tract on West India Emancipation, entitled "The Right Way the Safe Way," replied:

> On the wisdom of emancipation; and as proving that the right way is the safe way, I think your pamphlet is unanswerable. But here other things than wisdom are to be met. One of the most foolish and yet most potent assertions is that negroes and whites will amalgamate if the slaves are freed. My own belief, founded on very sufficient reasons, is that slavery, and not freedom, is the fruitful source of amalgamation; but I have no figures or evidence of any kind to prove this, other than what I see around me. If you have any statistics on this subject, which you think would be useful to the cause of Emancipation, you would much oblige me by forwarding them.

In reply, I wrote as follows:

> I am not aware that any statistics are on record concerning the subject of your inquiry. The outcry about future amalgamation is merely one of the artful dodges by which slaveholders and their allies seek to evade the main question. Of course, anybody who knows anything about slavery is well aware that amalgamation is the universal and inevitable result of that system. Gen. Lafayette, during his last

*From Lydia Maria Child, "Emancipation and Amalgamation: A Letter From L. Maria Child," *New York Daily Tribune* (September 3, 1862).

visit to this country, remarked upon the *great change of complexion* that had taken place among the slaves since the period of our Revolution. I could furnish you with innumerable advertisements from Southern papers describing runaway slaves with "sandy hair," "blue eyes," "ruddy complexion," "easily passing for a white man," etc., to say nothing of "yellow boys" and "light mulattoes." But this is unnecessary; for your letter admits that slavery is a fruitful source of amalgamation.

Whether amalgamation would take place *legally*, as it now does *illegally*, if the slaves were freed, is not a question susceptible of *proof*. It must of course, remain a matter of *opinion* till experience furnishes evidence. But it seems to me quite superfluous to trouble ourselves about it. If there *is* an instinctive antipathy between the races, it will take care of itself, as natural antipathies and attractions are always sure to do. If there is *not* any natural antipathy, then the horror of amalgamation has no rational foundation. My own opinion is that there is *not* a natural antipathy between white and colored people. My reason for thinking so is that wherever the two classes have been brought into vicinity they have invariably mixed extensively; and, in view of their relative positions, it must be admitted that the mixture has been sought by the *whites*.

My own belief also is that prejudice against complexion is entirely founded upon pride, and grows out of the debased and degraded condition in which our laws and customs keep the colored people. This is sufficiently proved by the fact that slaveholders have the utmost horror of *legalized* amalgamation, while they have none at all of *illegal*. They would consider their families disgraced forever if a son should *marry* the most beautiful and intelligent of quadroons, but are quite undisturbed by his brood of illegitimate mulatto children, owning some "Coal-black Rose"[1] for their mother.

From all the information I can obtain, I should judge that there is much *less* mixture of white and colored in the British West Indies than there was before emancipation. The bad habits formed in slavery still cling to them in a considerable degree; for generations must be educated under better influences before the corrupt effects of a system so thoroughly unclean can be washed out of the character of a people. But the colored inhabitants of those islands are gradually acquiring habits of self-respect, and they more and more discountenance neglect of the marriage ceremony. Marriages have occurred between white and colored, and in some cases they have been persons of high position. Some judges and lawyers of distinction in the West Indies have married handsome, intelligent and well-educated mulatto ladies, and nothing has occurred to make them ashamed of their choice; for their

wives preside over their households in a manner so graceful and dignified as to command respect even from *American* guests. But such cases are exceptional. Prejudices wear out slowly, and finally disappear, without violent collisions with the changing state of things. Carlyle said, very wisely [about a snake]: "Be not dismayed. The old skin never falls off till a new skin has formed under it." We may safely trust to this law of nature. Legalized amalgamation can never become common so long as there is a prevailing prejudice against color; and when that "phantom dynasty" passes away with the centuries, its disappearance will harm no one, and posterity will wonder at the power it once exercised, as we now marvel at the terror our ancestors had of witchcraft. It is the duty of our day to obey the plain dictates of justice and humanity, which are also the dictates of enlightened policy. God will not fail in his promise that "the effects of righteousness shall be peace."[2]

This outcry about amalgamation, as the result of emancipation, is simply ridiculous, in view of the swarms of mulattoes, quadroons and octoroons, produced by slavery; but in view of the momentous issues now at stake in this country, it is worse than ridiculous, it is heartless, wicked trifling with the destinies of a great nation.

Candid, reflecting, disinterested men, all over the civilized world, agree that slavery is a bad system, injurious to *all* parties connected with it. Statistics abundantly prove that agriculture, commerce, manufactures, morals, education and internal improvements of all sorts, are rapidly advanced by free institutions. There is ample evidence of this in the comparative progress of different States in this country. Virginia furnishes one of these instructive illustrations. She surpasses other States in richness of soil, attractions of scenery and climate, wealth of mineral resources, noble rivers, and commodious harbors. At the time of the Revolution, her commerce was four times that of New York; but in 1853 the imports into New York were valued at $180,000,000, while those of Virginia were less than $400,000. "Lands in Virginia, capable of producing from 25 to 30 bushels of wheat to the acre, and only 24 hours by rail from New York, are to be had for one-fortieth the price of similar land in New York itself." Such was the comparative value of land in those two States in 1856.

The prosperity of any State depends very largely on an intelligent, thriving *middle class*. Where slavery exists, society inevitably arranges itself into two classes, very widely separated from each other, and mutually deteriorated in character by the pernicious system which gives them no interests in common. The masters are unenterprising and indolent, from pride and inertia produced by the habit of living on another's earnings; while the slaves are lazy and shiftless, because they

have no hope of bettering their condition by exertion. Slavery endangers our republican institutions by rendering impossible that enlightened middle class, which forms the solid foundation of republics. Freedom of speech, freedom of the press and free extension of knowledge, are the bulwarks of liberty; but slavery annuls them all, because their exercise is incompatible with its own safety. The phrase, "irrepressible conflict,"[3] merely expresses the *moral* antagonism, which *must*, in the very nature of things, exist between slavery and freedom. Slavery cannot preserve its own existence without undermining and eventually destroying that on which the very life of free institutions depends. On the other hand, free institutions cannot carry out the principles on which they are founded, without bringing the permanence of slavery into peril, even where there is no such intention. The principles of slavery, or the principles of freedom, *must* inevitably rule in this country. Is there anything so lovely, so beneficial or so reputable in slavery, that men should be willing to sacrifice this republic for the sake of preserving it?

It was formerly asserted that emancipation would produce massacres, fires, and all sorts of horrors. But England, France, the Dutch, the Swedes and the Danes successively emancipated their slaves, and not a throat was cut, or a building fired, in consequence. That pretext being taken away, slaveholders now say: "The two races cannot live together in freedom. If we emancipate, universal amalgamation will be the consequence." What a laughable contradiction there is between the two propositions! If there is such imminent *danger* of mixture. what becomes of the alleged *natural antipathy* of the races?

I presume you are aware that slavery has forced even the United States census into its service; making use of *compulsory* labor, as usual. In order to prove that freedom produces insanity in colored people, it returns an extraordinary number of colored lunatics in the free States: but, as often happens to dealers in falsehood, a hole is left in the bag, through which the cat's head and claws peep out; for some places represented as encumbered with colored lunatics had not a single colored resident. Mr. De Bow,[4] the unscrupulous champion of slavery, gives no particular statistics of amalgamation; but in his Compendium of the United States Census for 1850 he makes a remark apparently intended to show that where the colored people are free, amalgamation increases. He says: "While nearly half of the colored population in the non-slaveholding States are mulatto, only about one-ninth in the slaveholding States are mulatto." His own tables, in the same census, show that less than one-third of the colored population of the free States are mulattoes. If you carefully cipher out these tables, you will find

that in the free States there is a considerable fraction less than *one* mulatto to every two hundred whites; while in the slave States there are more than *eleven* mulattoes to every two hundred whites. A careful computation of the proportions shows thirteen times more amalgamation at the South than in the North; but in making this estimate an important fact is kept out of view, viz: that very many of our colored citizens originated in the South, and a large proportion came to us already bleached to various shades of brown or yellow, by plantation processes. This is meagre information in answer to your request for statistics on the subject, but it is all I can furnish.

With the hope that Maryland will ere long be blessed with free institutions,

I am respectfully yours.

L. Maria Child.

Notes

1. A popular minstrel song.
2. Isaiah 32:17: "And the work of righteousness shall be peace; and the effect of righteousness quietness and assurance for ever."
3. "The Irrepressible Conflict" was the title of a famous 1858 speech by Republican William Henry Seward (1801–1872), Lincoln's secretary of state.
4. James Dunwoody Brownson De Bow (1820–1867) founded and edited the proslavery journal, *De Bow's Commercial Review*. He was appointed superintendent of the U.S. census in 1853.

II Post-Civil War Era

> What is the chief end of man?—to get rich.
> In what way?—dishonestly if we can; honestly if we must.
> —Mark Twain (1871)

From the Civil War's end to the first decades of the twentieth century, America quickly evolved into a consumer-oriented society. From the Gilded Age to the Progressive Era, industry grew exponentially; coal production increased tenfold, while iron and steel output expanded even more dramatically. Industrialization not only brought enormous wealth to one small segment of the nation's population, but it also generated a new labor force. In 1880 women made up 16 percent of the work force, and by 1920 the number had risen to 23 percent. Progress and new developments in technology and industrial development gave women a wider selection of job opportunities, including food processing, paper-box making, and printing, and as clerical workers and switchboard operators. Nonetheless, at the beginning of the twentieth century most women were still employed as domestic servants (one in four by 1910), and many careers were closed to them. In addition, economic instability caused by rapid expansion was leading to a greater division between classes.

The foci of two major reform movements during this period had their beginnings before the Civil War. First, women's suffrage continued to be an issue, although it suffered through a dormant period between 1890 and 1901. However, World War I drove the movement to its logical conclusion as millions of women took over jobs for men who had gone to war. Second, proposals were made to uplift the freed slaves. Despite the efforts of individuals such as W. E. B. Du Bois and Booker T. Washington, racism continued to escalate. The fields of history, sociology, genetics, and psychology fueled racial fears as pseudo-scientific theories claimed proof of the black race's supposed inferiority. Some sociologists and scientists argued that blacks had not yet evolved as fully as Caucasians. With these growing tensions came an increase in the number of lynchings (the *Chicago Tribune* reported that mobs murdered 241 blacks in 1892) and a resurgence of the Ku Klux Klan.

Because of the importance of these two movements, Part II is subdivided into two sections devoted to women intellectuals involved in each movement. Elizabeth Cady Stanton and Charlotte Perkins Gilman attempted to address some of the more pressing issues confronting women during this difficult period in American history. Gilman sought to free women from economic and domestic shackles, while Stanton was one of the organizers and driving forces behind the first women's rights convention at Seneca Falls, New York, in 1848. She too was a reformer who devoted herself most notably to the suffrage movement.

Anna Julia Cooper and Jessie Redmon Fauset focused on African American women's concerns. Cooper, who has been called the mother of black feminism, sought to raise African American consciousness in the nation through education. In addition to being a poet, novelist, and essayist, Fauset played a vital role in the Harlem Renaissance by introducing new writers and artists to the public. At the height of this literary movement, Fauset served as editor of *Crisis*, an African American journal, and was instrumental in publishing the works of such writers as Langston Hughes.

As in the previous period, these women carried a double burden; and in the case of Cooper and Fauset, one might even say it was tripled. Yet, as did their "Aunt" Margaret and "Aunt" Lydia, these women intellectuals resituated themselves. They moved from positions of oppression and even slavery to positions of power to make significant contributions to American society.

3

"Intellectual Architect of American Feminism"

~

Elizabeth Cady Stanton

> Woman will always be dependent until she holds a purse of her own.
> —Elizabeth Cady Stanton

Only a small percentage of past women public intellectuals have aligned themselves with the feminist movement. In the early 1900s, Virginia Woolf wrote that given the choice between a room of one's own (with an income of £500 per year) and enfranchisement, she would take the independence that money afforded. Although the Women's Rights Movement was not officially organized until 1848 at Seneca Falls, some women public intellectuals from the mid-1800s to the present did not directly participate.

Several reasons suggest themselves. Perhaps the women feared limiting their readership. Another reason might be linked to the organization's early years. For some public intellectuals, especially in the mid-1800s and early 1900s, the scope of the women's movement was narrowly defined. This case was most certainly true for Lydia Maria Child, who devoted her life to the causes of oppressed ethnic groups and who consciously separated her writings on women's history from the women's movement until the 1870s (Conrad 1976, 103). Assuredly there were valid reasons why women intellectuals avoided membership in this group; however, Elizabeth Cady Stanton did not add to them. Indeed, one might argue that she was an anomaly, for Stanton devoted her entire career to gaining freedom and the vote for women. Not surprisingly, Susan Conrad describes her as the "chief intellectual architect of American feminism" (1976, 102–3).

Of the three intellectuals examined in this section, Stanton received the best education. She was born in 1815 into a wealthy family in upstate New York. In her reminiscences as well as in later biographies,

much has been made of her lawyer father's desire for male heirs. Four of Daniel Cady Stanton's five sons died in childbirth, and the lone survivor died at the age of twenty. In her autobiography, Stanton writes of her father's grief at her brother's death: "With my head resting against his [her father's] beating heart, we both sat in silence.... At length he heaved a sigh and said: 'Oh, my daughter, I wish you were a boy!' Throwing my arms about his neck I replied, 'I will try to be all my brother was' " (1898, 21).

Consequently, Stanton spent her childhood attempting to be "manly" and brilliant in order to gain her father's approval. She was tutored at home in Greek, mathematics, philosophy, debating, and the equestrian arts (Griffith 1984, 8). As a young woman, she read extensively from her father's library, debated with his law clerks, and attended court sessions. Later she attended Johnstown Academy and took courses in mathematics and Greek. Upon graduation, Stanton studied logic and physiology at Troy Female Seminary in New York. Even after her marriage to Henry Stanton in 1840, she continued her studies in history, political economics, and law.

In London, Stanton found the focus for her life's work when she and her husband attended the international meeting of the American Anti-Slavery Society as delegates in 1840. At the sessions, male delegates sat in chairs placed on the main floor while women were seated in a partitioned-off section on the side. At some point during the proceedings, the discussion of the seating segregation supplanted that of the slavery issue. While on the sidelines, Stanton made the acquaintance of another representative and leader in the abolitionist movement, Lucretia Mott, twenty-two years her senior. In part, due to their and other women's marginalized treatment at the convention as well as their shared interest in the abolitionist cause, the two joined forces to work for women's rights.

Eight years later, in 1848, Stanton and Mott organized the first women's rights convention in America at Seneca Falls, New York. According to the advertisement in the *Seneca County Courier*, the two-day convention would focus on domestic, political, religious, and social issues confronting women. Its resolutions were modeled on the Declaration of Independence, since Stanton believed that this format would help legitimize the group's proclamation. The *Declaration of Sentiments*, as it was called, was divided into three parts: a preamble, a slate of grievances, and a list of resolutions. Its opening lines declared: "We hold these truths to be self-evident, that all men and women are created equal; that they are endowed by their Creator with certain unalienable rights; that among these are life, liberty, and the pursuit of happiness.... The history of mankind is a history of repeated injuries

and usurpations on the part of man toward woman, having in direct object the establishment of an absolute tyranny over her. To prove this, let facts be submitted to a candid world" (Stanton and Anthony 1981, 1:70).

Their grievances, however, were not targeted at King George but rather at the patriarchal establishment. For this reason, each statement begins with the masculine pronoun: "He has never permitted her to exercise her inalienable right to the elective franchise. He has compelled her to submit to laws, in the formation of which she has no voice. . . . He has made her, if married, in the eye of the law, civilly dead. He has taken from her all right in property, even to the wages she earns. . . ." (1:70–71). The twelve resolutions alleged that laws which marginalized and oppressed women were in direct opposition to the "great precept of Nature and therefore of no force or authority." The same could be said of laws that conflicted "with the true and substantial happiness of woman." Therefore, the *Declaration* demanded for women the same freedoms rightly afforded men, including the "sacred right to the elective franchise" (1:71).

Public response to the *Declaration of Sentiments* shocked Stanton: "All the journals from Maine to Texas seemed to strive with each other to see which could make our movement appear the most ridiculous" (Stanton 1898, 149). In what Susan Conrad describes as a "counterattack" to negative public sentiment, Stanton organized meetings patterned on Margaret Fuller's Conversations that she had attended years earlier. Their purpose was to give men and women a place to expand their knowledge on politics, religion, and the law as well as science and history (Conrad 1976, 137). For fifty years, Stanton accepted a position of leadership in the women's movement, organizing groups, designing programs and campaign strategies, drafting speeches for herself and Susan B. Anthony, and running for the U.S. House of Representatives, the first woman to do so. (Ironically, in 1866, although women did not have the right to vote, they were not barred from running for office.)

The year 1866 found Stanton, along with Anthony, engaged in a campaign to make the National Woman's Rights Convention's program less exclusive and to expand their platform to include rights for African Americans. At the time, however, some members worried that combining the two campaigns would weaken the efforts of each one. Most abolitionists opposed Stanton's and Anthony's proposal, insisting that the period in American history following the Civil War belonged to African Americans. Thus, the central focus should be on their enfranchisement (Miller 1995, 25). Stanton disagreed with the general consensus and continued her efforts on behalf of both groups. Despite her

perseverance, however, the Fourteenth and Fifteenth Amendments to the Constitution were ratified in 1868 and 1870, respectively, granting citizenship and enfranchisement to black males but not to women, black or white.

Interestingly, the ratification of the Fourteenth and Fifteenth Amendments split the women's movement in two. One faction, led by Stanton, included feminists who had tirelessly worked for decades in abolitionist, temperance, and women's rights campaigns. After the Civil War, they had expected abolitionists and Republican legislators to support their agenda—female enfranchisement—but such was not the case. Disappointed with and disheartened by the lack of support from politicians who they believed had violated their trust, Stanton's group called for immediate work on a national suffrage amendment. The other faction, led by Lucy Stone and composed of the movement's most conservative members, maintained that the Republican Party had not purposely violated women's trust (Marzolf 1977, 225). In response, Stone's group formed the American Woman Suffrage Association (AWSA). The newly formed AWSA refused to campaign for a national suffrage amendment but, rather, hoped to gain the vote through individual state referenda. Consequently, in 1869, Stanton and Anthony founded the National Woman's Suffrage Association (NWSA). The group had one primary goal: the next Constitutional amendment would give women the vote.

During this critical period, Stanton began writing for *Revolution*, a journal founded and financed by George Francis Train, who opposed giving African Americans the right to vote. The journal, which ran for only two years (1868–1870), campaigned for women's enfranchisement, divorce reform, and better jobs and higher salaries for women. Its masthead read: "Principle, Not Policy: Justice, Not Favors." Bitterness and frustration led Stanton to make racist comments about African Americans in articles written for *Revolution* as well as in her lectures. She described the wording of the Fourteenth and Fifteenth Amendments as a "legal humiliation" of women, since earlier amendments had not employed the term "male."

Stanton denounced the Fifteenth Amendment in a tone and language that was both harsh and condescending: "If woman finds it hard to bear the oppressive laws of a few Saxon Fathers of the best orders of manhood, what may she not be called to endure when all the lower orders, natives and foreigners, Dutch, Irish, Chinese and African, legislate for her and her daughters? . . . Think of Patrick and Sambo and Hans and Yung Tank, who do not know the difference between a Monarchy and a Republic, who never read the Declaration of Independence or Webster's spelling book, making law for Lydia Maria Child" (Stanton

1868, 392). In her speech on "Educated Suffrage," Stanton took her argument one step further and argued that the vote should be granted only to educated men and women: "Cry 'halt' on 'male suffrage' for the present, especially in the immense increasing foreign element, chiefly male and all dead weight against women" (Stanton 1991, 354). Her comments were part of a rhetoric that emphasized the importance of women's rights. However, her attack also revealed, as more than one critic has noted, condescending views about African Americans and immigrants.

Despite her racist comments, Stanton long campaigned for the education of all peoples, for she viewed literacy as a social equalizer. She also advocated free adult education and shorter work weeks (Griffith 1984, 206). For Stanton, the period of Reconstruction offered opportunities for the elimination of racial and gender disparities, which would positively affect all facets of American life (Miller 1995, 25–26). In their efforts to erase class lines, Stanton and Anthony founded the Working Woman's Association, the goal of which was to create female labor unions in industries that hired women.

As editor of *Revolution*, Stanton used her position, as Margaret Fuller and Lydia Maria Child had done, to support a number of controversial causes. Her editorials covered issues ranging from marriage reform to prison reform and from child rearing to government policies. In many ways more outspoken than Fuller, Stanton's editorials "declare[d] war to the death on the idea that woman was made for man," proclaiming instead "the higher truth that, like man, she was created by God for Individual Moral Responsibility and progress here and forever, and that the physical conditions of her earthly life are not to be taken as a limitation of the evidence of the Divine intention respecting her as an immortal being" (quoted in Marzolf, 1977, 227).

After *Revolution* folded, Stanton was elected president of the NWSA and traveled with Susan B. Anthony across the United States on speaking engagements. However, conflicts arose between NWSA members and their president. On the one hand, Stanton, the radical conscience of the movement, wanted to expand its focus to include personal and social issues beyond the scope of suffrage. On the other hand, most of the new leaders of the NWSA held a narrower view (Banner 1980, 116). Stanton feared that some of the more conservative members viewed suffrage as a step toward a more religious social agenda, something she vehemently opposed. Ultimately, Stanton resigned from the presidency, stating that she no longer thought she could "sit on the door just like Poe's raven, and sing suffrage nevermore." She wrote that she was "deeply interested in *all* the live questions of the day" (quoted in Lutz 1974, 296). In her view, all patriarchal

institutions—civil, social, economic, political, and religious—must be reformed for women's situation in America to be improved.

Stanton's last three major projects—a work on women's history, a rewriting of the Bible, and her autobiography—reveal three varied approaches to addressing women's issues. The first project, the three-volume *History of Woman Suffrage*, chronicled the first forty years of the woman's movement, noting both its successes and failures. In this ambitious work, Stanton, Anthony, and Matilda Joslyn Gage began the task of recording the lives, activities, and ideas of women in American history. Dale Spender has stressed the importance of their task, noting that without the book's publication "our belief in the women and their struggle of the past might be little short of an act of faith, for we would never be able fully to substantiate our belief . . . that there were many, many women, thinking, writing, arguing and protesting about male power, but because of the biases in historiography we know nothing about them" (1982, 266).

The second project, *The Woman's Bible*, was Stanton's most controversial work and, arguably, her most courageous and outrageous freedom project (Griffith 1984, 111). Despite or perhaps because of its controversial nature, it quickly became a best-seller. Not surprisingly, the religious branded Stanton a heretic; young suffragists, too, condemned the project, asserting that it would harm their chances for gaining the vote (111–12). Even Anthony was unable to wholly defend her friend, although she did contend that a woman had the right to "interpret and twist the Bible to [her] own advantage as men have always [done] to theirs" (Anthony 1898–1902, 2:856).

The Woman's Bible was controversial for one simple reason: it questioned Biblical authority and condemned the narrow-minded and inflexible piety of conservatives. Gerda Lerner describes the work as one in which Stanton took on the Bible as well as the Founding Fathers (1986, 227). Perhaps the Bible *was* inspired by God, Stanton argued, but it was written by men who sought to establish and maintain patriarchal control. Thus, she criticized any religious dogma that denigrated and oppressed women. In her introductory comments, Stanton wrote that "the canon and civil law, church and state, priests, and legislators, all political parties and all religious denominations have alike taught that woman was made after man, of man, and for man, an inferior being, subject to man. Creeds, codes, Scriptures, and statutes are all based on this idea." How, she questioned, could this doctrine have been viewed in "harmony with the spirit of all good" (Stanton 1974, 1:iv).

Originally, Stanton's plan was to create a Revising Committee, composed of Latin, Greek, and Hebrew scholars, who would undertake to

translate the Bible along feminist lines (Waggenspack 1989, 37). However, most women scholars either feared professional repercussions for their association with such a controversial project or viewed the act of revising the Bible as a sacrilege. Although twenty-five women are listed on her Revising Committee, Stanton did most of the work. She was, however, no Latin or Greek scholar, although she did closely examine English commentaries and critical texts. Thus, *The Woman's Bible* is a polemical work, not a scholarly one.

In the preface to her autobiography entitled *Eighty Years and More*, Stanton wrote that since one could trace in her earlier works, specifically the *History of Woman Suffrage*, the history of the women's movement, her autobiography would be the story of "my private life as the wife of an earnest reformer, as an enthusiastic housekeeper, . . . and as the mother of seven children" (1898, Preface). In order to legitimize her personal story, Stanton began her autobiography by describing her roles as a wife and mother, for she wanted her readers to view her as an ordinary woman and not the stereotypical "virgin Spinster" (Smith 1992, 87). Through her use of amusing anecdotes, she endeavored to counteract her critics' portrayal of her as an austere, shrewd, argumentative, and tireless reformer from a wealthy family. Situating her commentary within the context of her everyday life, she focused on its positive aspects and avoided any discussion of incidents, such as that of African American enfranchisement, that might damage the cause of women's rights (83–4). What she did, instead, was to continue pressing for reform.

The autobiographical narrative may have professed to be about Stanton and her roles as wife and mother, but in truth it was the story of the life of a feminist (Smith 1992, 88). The purpose of *Eighty Years and More*, then, was to lead young women toward greater self-awareness and independence both in their domestic and public lives (1992, 121). Although the beginning chapters give an account of her early childhood and first years of marriage, in the later ones both husband and children are virtually absent (Jelinek 1986, 108).

The challenge that confronted Stanton in her autobiography and throughout her life was how to convince her readers that the patriarchal ideas that professed freedom and equality were, in fact, founded on incongruities, logical fallacies, and outdated ideas. Her approach was to ground her arguments in the basic principles and ideals on which America was founded. Looking at Stanton's works as a whole, one finds a common thread that runs throughout her writings: an attempt to free society from "false perceptions, outmoded customs, illogical laws, and false religious doctrine" (Stanton 1898, 32–33).

Address to the New York State Legislature, 1860*

GENTLEMEN OF THE JUDICIARY:

There are certain natural rights as inalienable to civilization as are the rights of air and motion to the savage in the wilderness. The natural rights of the civilized man and woman are government, property, the harmonious development of all their powers, and the gratification of their desires. There are a few people we now and then meet who, like Jeremy Bentham, scout the idea of natural rights in civilization, and pronounce them mere metaphors, declaring that there are no rights aside from those the law confers. If the law made man too, that might do, for then he could be made to order to fit the particular niche he was designed to fill. But inasmuch as God made man in His own image, with capacities and powers as boundless as the universe, whose exigencies no mere human law can meet, it is evident that the man must ever stand first; the law but the creature of his wants; the lawgiver but the mouthpiece of humanity. If, then, the nature of a being decides its rights, every individual comes into this world with rights that are not transferable. He does not bring them like a pack on his back, that may be stolen from him, but they are a component part of himself, the laws which insure his growth and development. The individual may be put in the stocks, body and soul, he may be dwarfed, crippled, killed, but his rights no man can get; they live and die with him.

Though the atmosphere is forty miles deep all round the globe, no man can do more than fill his own lungs. No man can see, hear, or smell but just so far; and though hundreds are deprived of these senses, his are not the more acute. Though rights have been abundantly supplied by the good Father, no man can appropriate to himself those that belong to another. A citizen can have but one vote, fill but one office, though thousands are not permitted to do either. These axioms prove that woman's poverty does not add to man's wealth, and if, in the plenitude of his power, he should secure to her the exercise of all her God-given rights, her wealth could not bring poverty to him. There is a kind of nervous unrest always manifested by those in power, whenever new claims are started by those out of their own immediate class. The philosophy of this is very plain. They imagine that if the rights of this

*From Elizabeth Cady Stanton, Address to the New York State Legislature, 1860.

new class be granted, they must, of necessity, sacrifice something of that they already possess. They can not divest themselves of the idea that rights are very much like lands, stocks, bonds, and mortgages, and that if every new claimant be satisfied, the supply of human rights must in time run low. You might as well carp at the birth of every child, lest there should not be enough air left to inflate your lungs; at the success of every scholar, for fear that your draughts at the fountain of knowledge could not be so long and deep; at the glory of every hero, lest there be no glory left for you. . . .

If the object of government is to protect the weak against the strong, how unwise to place the power wholly in the hands of the strong. Yet that is the history of all governments, even the model republic of these United States. You who have read the history of nations, from Moses down to our last election, where have you ever seen one class looking after the interests of another? Any of you can readily see the defects in other governments, and pronounce sentence against those who have sacrificed the masses to themselves; but when we come to our own case, we are blinded by custom and self-interest. Some of you who have no capital can see the injustice which the laborer suffers; some of you who have no slaves, can see the cruelty of his oppression; but who of you appreciate the galling humiliation, the refinements of degradation, to which women (the mothers, wives, sisters, and daughters of freemen) are subject, in this the last half of the nineteenth century? How many of you have ever read even the laws concerning them that now disgrace your statute-books? In cruelty and tyranny, they are not surpassed by any slaveholding code in the Southern States; in fact, they are worse, by just so far as woman, from her social position, refinement, and education, is on a more equal ground with the oppressor.

Allow me just here to call the attention of that party now so much interested in the slave of the Carolinas, to the similarity in his condition and that of the mothers, wives, and daughters of the Empire State. The negro has no name. He is Cuffy Douglas or Cuffy Brooks, just whose Cuffy he may chance to be. The woman has no name. She is Mrs. Richard Roe or Mrs. John Doe, just whose Mrs. she may chance to be. Cuffy has no right to his earnings; he can not buy or sell, or lay up anything that he can call his own. Mrs. Roe has no right to her earnings; she can neither buy nor sell, make contracts, nor lay up anything that she can call her own. Cuffy has no right to his children; they can be sold from him at any time. Mrs. Roe has no right to her children; they may be bound out to cancel a father's debts of honor. The unborn child, even by the last will of the father, may be placed under the guardianship of a stranger and a foreigner. Cuffy has no legal existence; he is subject to restraint and moderate chastisement. Mrs. Roe

has no legal existence; she has not the best right to her own person. The husband has the power to restrain, and administer moderate chastisement.

Blackstone declares that the husband and wife are one, and learned commentators have decided that that one is the husband. In all civil codes, you will find them classified as one. Certain rights and immunities, such and such privileges are to be secured to white male citizens. What have women and negroes to do with rights? What know they of government, war, or glory?

The prejudice against color, of which we hear so much, is no stronger than that against sex. It is produced by the same cause, and manifested very much in the same way. The negro's skin and the woman's sex are both *prima facie* evidence that they were intended to be in subjection to the white Saxon man. The few social privileges which the man gives the woman, he makes up to the negro in civil rights. The woman may sit at the same table and eat with the white man; the free negro may hold property and vote. The woman may sit in the same pew with the white man in church; the free negro may enter the pulpit and preach. Now, with the black man's right to suffrage, the right unquestioned, even by [Saint] Paul, to minister at the altar, it is evident that the prejudice against sex is more deeply rooted and more unreasonably maintained than that against color. As citizens of a republic, which should we most highly prize, social privileges or civil rights? The latter, most certainly.

To those who do not feel the injustice and degradation of the condition, there is something inexpressively comical in man's "citizen woman." It reminds me of those monsters I used to see in the old world, head and shoulders woman, and the rest of the body sometimes fish and sometimes beast. I used to think, What a strange conceit! but now I see how perfectly it represents man's idea! Look over all his laws concerning us, and you will see just enough of woman to tell of her existence; all the rest is submerged, or made to crawl upon the earth. Just imagine an inhabitant of another planet entertaining himself some pleasant evening in searching over our great national compact, our Declaration of Independence, our Constitution, or some of our statute-books; what would he think of those "women and negroes" that must be so fenced in, so guarded against? Why, he would certainly suppose we were monsters, like those fabulous giants or Brobdingnagians of olden times, so dangerous to civilized man, from our size, ferocity, and power. Then let him take up our poets, from Pope down to Dana; let him listen to our Fourth of July toast, and some of the sentimental adulations of social life, and no logic could convince him that this creature of the law, and this angel of the family altar, could be one and the same being. Man is in such a labyrinth of contradictions

with his marital and property rights; he is so befogged on the whole question of maidens, wives, and mothers, that from pure benevolence we should relieve him from this troublesome branch of legislation. We should vote, and make laws for ourselves. Do not be alarmed, dear ladies! You need spend no time reading Grotius, Coke, Puffendorf, Blackstone, Bentham, Kent, and Story to find out what you need. We may safely trust the shrewd selfishness of the white man, and consent to live under the same broad code where he has so comfortably ensconced himself. Any legislation that will do for man, we may abide by most cheerfully. . . .

But, say you, we would not have woman exposed to the grossness and vulgarity of public life, or encounter what she must at the polls. When you talk, gentlemen, of sheltering woman from the rough winds and revolting scenes of real life, you must be either talking for effect, or wholly ignorant of what the facts of life are. The man, whatever he is, is known to the woman. She is the companion, not only of the accomplished statesman, the orator, and the scholar; but the vile, vulgar, brutal man has his mother, his wife, his sister, his daughter. Yes, delicate, refined, educated women are in daily life with the drunkard, the gambler, the licentious man, the rogue, and the villain; and if man shows out what he is anywhere, it is at his own hearthstone. There are over forty thousand drunkards in this State. All these are bound by the ties of family to some woman. Allow but a mother and a wife to each, and you have over eighty thousand women. All these have seen their fathers, brothers, husbands, sons, in the lowest and most debased stages of obscenity and degradation. In your own circle of friends, do you not know refined women whose whole lives are darkened and saddened by gross and brutal associations? Now, gentlemen, do you talk to woman of a rude jest or jostle at the polls, where noble, virtuous men stand ready to protect her person and her rights, when alone in the darkness and solitude and gloom of night, she has trembled on her own threshold, awaiting the return of a husband from his midnight revels?—when, stepping from her chamber, she has beheld her royal monarch, her lord and master—her legal representative—the protector of her property, her home, her children, and her person, down on his hands and knees slowly crawling up the stairs. Behold him in her chamber—in her bed! The fairy tale of "Beauty and the Beast" is far too often realized in life. Gentlemen, such scenes as woman has witnessed at her own fireside, where no eye save Omnipotence could pity, no strong arm could help, can never be realized at the polls, never equaled elsewhere, this side of the bottomless pit. No, woman has not hitherto lived in the clouds, surrounded by an atmosphere of purity and peace—but she has been the companion of man in health, in sickness,

and in death, in his highest and in his lowest moments. She has worshipped him as a saint and an orator, and pitied him as a madman or a fool. In Paradise, man and woman were placed together, and so they must ever be. They must sink or rise together. If man is low and wretched and vile, woman can not escape the contagion, and any atmosphere that is unfit for woman to breathe is not fit for man. Verily, the sins of the fathers shall be visited upon the children to the third and fourth generation. You, by your unwise legislation, have crippled and dwarfed womanhood, by closing to her all honorable and lucrative means of employment, have driven her into the garrets and dens of our cities, where she now revenges herself on your innocent sons, sapping the very foundations of national virtue and strength. Alas! for the young men just coming on the stage of action, who soon shall fill your vacant places—our future Senators, our Presidents, the expounders of our constitutional law! Terrible are the penalties we are now suffering for the ages of injustice done to woman.

Again, it is said that the majority of women do not ask for any change in the laws; that it is time enough to give them the elective franchise when they, as a class, demand it.

Wise statesmen legislate for the best interests of the nation; the State, for the highest good of its citizens; the Christian, for the conversion of the world. Where would have been our railroads, our telegraphs, our ocean steamers, our canals and harbors, our arts and sciences, if government had withheld the means from the far-seeing minority? This State established our present system of common schools, fully believing that educated men and women would make better citizens than ignorant ones. In making this provision for the education of its children, had they waited for a majority of the urchins of this State to petition for schools, how many, think you, would have asked to be transplanted from the street to the school-house? Does the State wait for the criminal to ask for his prison-house? the insane, the idiot, the deaf and dumb for his asylum? Does the Christian, in his love to all mankind, wait for the majority of the benighted heathen to ask him for the Gospel? No; unasked and unwelcomed, he crosses the trackless ocean, rolls off the mountain of superstition that oppresses the human mind, proclaims the immortality of the soul, the dignity of manhood, the right of all to be free and happy.

No, gentlemen, if there is but one woman in this State who feels the injustice of her position, she should not be denied her inalienable rights, because the common household drudge and the silly butterfly of fashion are ignorant of all laws, both human and Divine. Because they know nothing of governments, or rights, and therefore ask nothing, shall my petitions be unheard? I stand before you the rightful rep-

resentative of woman, claiming a share in the halo of glory that has gathered round her in the ages, and by the wisdom of her past words and works, her peerless heroism and self-sacrifice, I challenge your admiration; and, moreover, claiming, as I do, a share in all her outrages and sufferings, in the cruel injustice, contempt, and ridicule now heaped upon her, in her deep degradation, hopeless wretchedness, by all that is helpless in her present condition, that is false in law and public sentiment, I urge your generous consideration; for as my heart swells with pride to behold woman in the highest walks of literature and art, it grows big enough to take in those who are bleeding in the dust.

Now do not think, gentlemen, we wish you to do a great many troublesome things for us. We do not ask our legislators to spend a whole session in fixing up a code of laws to satisfy a class of most unreasonable women. We ask no more than the poor devils in the Scripture asked, "Let us alone." In mercy, let us take care of ourselves, our property, our children, and our homes. True, we are not so strong, so wise, so crafty as you are, but if any kind friend leaves us a little money, or we can by great industry earn fifty cents a day, we should rather buy bread and clothes for our children than cigars and champagne for our legal protectors. There has been a great deal written and said about protection. We, as a class, are tired of one kind of protection, that which leaves us everything to do, to dare, and to suffer, and strips us of all means for its accomplishment. We would not tax man to take care of us. No, the Great Father has endowed all His creatures with the necessary powers for self-support, self-defense, and protection. We do not ask man to represent us; it is hard enough in times like these for man to carry backbone enough to represent himself. So long as the mass of men spend most of their time on the fence, not knowing which way to jump, they are surely in no condition to tell us where we had better stand. In pity for man, we would no longer hang like a millstone round his neck. Undo what man did for us in the dark ages, and strike down all special legislation for us; strike the words "white male" from all your constitutions, and then, with fair sailing, let us sink or swim, live or die, survive or perish together.

At Athens, an ancient apologue tells us, on the completion of the temple of Minerva, a statue of the goddess was wanted to occupy the crowning point of the edifice. Two of the greatest artists produced what each deemed his masterpiece. One of these figures was the size of life, admirably designed, exquisitely finished, softly rounded, and beautifully refined. The other was of Amazonian stature, and so boldly chiselled that it looked more like masonry than sculpture. The eyes of all were attracted by the first, and turned away in contempt from the

second. That, therefore, was adopted, and the other rejected, almost with resentment, as though an insult had been offered to a discerning public. The favored statue was accordingly borne in triumph to the place for which it was designed, in the presence of applauding thousands, but as it receded from their upturned eyes, all, all at once gazed upon it, the thunders of applause unaccountably died away—a general misgiving ran through every bosom—the mob themselves stood like statues, as silent and as petrified, for as it slowly went up, and up, the soft expression of those chiselled features, the delicate curves and outlines of the limbs and figure, became gradually fainter and fainter, and when at last it reached the place for which it was intended, it was a shapeless ball, enveloped in mist. Of course, the idol of the hour was now clamored down as rationally as it had been cried up, and its dishonored rival, with no good will and no good looks on the part of the chagrined populace, was reared in its stead. As it ascended, the sharp angles faded away, the rough points became smooth, the features full of expression, the whole figure radiant with majesty and beauty. The rude hewn mass, that before had scarcely appeared to bear even the human form, assumed at once the divinity which it represented, being so perfectly proportioned to the dimensions of the building, and to the elevation on which it stood, that it seemed as though Pallas [Athena] herself had alighted upon the pinnacle of the temple in person, to receive the homage of her worshippers.

The woman of the nineteenth century is the shapeless ball in the lofty position which she was designed fully and nobly to fill. The place is not too high, too large, too sacred for woman, but the type that you have chosen is far too small for it. The woman we declare unto you is the rude, misshapen, unpolished object of the successful artist. From your stand-point, you are absorbed with the defects alone. The true artist sees the harmony between the object and its destination. Man, the sculptor, has carved out his ideal, and applauding thousands welcome his success. He has made a woman that from his low stand-point looks fair and beautiful, a being without rights, or hopes, or fears but in him—neither noble, virtuous, nor independent. Where do we, in Church or State, in school-house or at the fireside, see the much talked-of moral power of woman? Like those Athenians, we have bowed down and worshipped in woman, beauty, grace, the exquisite proportions, the soft and beautifully rounded outline, her delicacy, refinement, and silent helplessness—all well when she is viewed simply as an object of sight, never to rise one foot above the dust from which she sprung. But if she is to be raised up to adorn a temple, or represent a divinity—if she is to fill the niche of wife and counsellor to true and noble men, if she is to be the mother, the educator of a race of heroes or

martyrs, of a Napoleon, or a Jesus—then must the type of womanhood be on a larger scale than that yet carved by man.

In vain would the rejected artist have reasoned with the Athenians as to the superiority of his production; nothing short of the experiment they made could have satisfied them. And what of your experiment, what of your wives, your homes? Alas! for the folly and vacancy that meet you there! But for your club-houses and newspapers, what would social life be to you? Where are your beautiful women? your frail ones, taught to lean lovingly and confidingly on man? Where are the crowds of educated dependents—where the long line of pensioners on man's bounty? Where are all the young girls, taught to believe that marriage is the only legitimate object of a woman's pursuit—they who stand listlessly on life's shores, waiting, year after year, like the sick man at the pool of Bethesda, for some one to come and put them in? These are they who by their ignorance and folly curse almost every fireside with some human specimen of deformity or imbecility. These are they who fill the gloomy abodes of poverty and vice in our vast metropolis. These are they who patrol the streets of our cities, to give our sons their first lessons in infamy. These are they who fill our asylums, and make night hideous with their cries and moans.

The women who are called masculine, who are brave, courageous, self-reliant and independent, are they who in the face of adverse winds have kept one steady course upward and onward in the paths of virtue and peace—they who have taken their gauge of womanhood from their own native strength and dignity—they who have learned for themselves the will of God concerning them. This is our type of womanhood. Will you help us raise it up, that you too may see its beautiful proportions—that you may behold the outline of the goddess who is yet to adorn your Temple of Freedom? We are building a model republic; our edifice will one day need a crowning glory. Let the artists be wisely chosen. Let them begin their work. Here is a Temple to Liberty, to human rights, on whose portals behold the glorious declaration, "All men are created equal." The sun has never yet shone upon any of man's creations that can compare with this. The artist who can mold a statue worthy to crown magnificence like this, must be godlike in his conceptions, grand in his comprehensions, sublimely beautiful in his power of execution. The woman—the crowning glory of the model republic among the nations of the earth—what must she not be?

4

"A Mixed Legacy"

~

Charlotte Perkins Gilman

> To swallow and follow, whether old doctrine or new propaganda, is a weakness still dominating the human mind.
> —Charlotte Perkins Gilman

There is no question that Charlotte Perkins Gilman was widely acknowledged as "the major intellectual leader for the women's rights movement during the first two decades of the twentieth century" (Degler 1956, 22). Not only was she one of its primary spokespersons, but she was also its leading theorist. "Women and Economics" has been described as the bible of the early feminist movement (Duckworth 1991, 483), and her short story, "The Yellow Wallpaper," as the feminist manifesto. Her journal, *Forerunner* (1906–1916), was deemed by editor Madeleine Stern to be a great feat in that it combined a campaign for women's rights with a call for a socialistic society (Kessler 1991, 105). Gilman spent her life battling, both in print and at the podium, the confining patriarchal social codes that restricted women.

Although ahead of her time in formulating feminist and social theories, Gilman was also a woman *of* her time with a mind and vision molded by the scientific, political, economic, and philosophical ideas of the day (Duckworth 1991, 483). She applied current scientific, pedagogical, and social theories to reconceive the idea of womanhood. Moreover, she played a vital role in the development of the New Woman, a figure whom she perceived as rational, cultivated, educated, and reflective and who actively worked for social change. Deborah De Simone suggests that Gilman's vision of the New Woman confronted not only the "cult of true womanhood" but also the basic values that Americans hold dear: hearth, society, spirituality, and freedom (De Simone 1995, 1).

Gilman's ideas and theories appeared in a variety of forms: autobiography, poetry, short stories, novels, and essays. However, the primary issue at the core of nearly all of her writings was the servile position of women in American society. In her autobiography, *The Living of Charlotte Perkins Gilman*, she challenged the marginality of women with the claim that woman's life, too was a topic worthy of study (Lane 1980, xi). In her short stories and novels as well as in her autobiography, Gilman used her life story to re-envision herself and to inspire others (xxi).

The oft-anthologized "The Yellow Wallpaper" is one such work in which fiction mirrors real life. The protagonist is a nameless woman suffering from postpartum depression. Her physician husband, after consulting with specialist S. Weir Mitchell, prescribes a three-month rest cure for his wife. As a result, she is kept in an isolated room in which the windows are barred and the bed is bolted to the floor. In the end, the woman goes mad as she comes to believe that another woman is trapped behind the wallpaper in her cell.

In 1884, Charlotte Perkins married Charles Walter Stetson, an artist. Following the birth of their child, she too suffered from depression. Leaving her husband and child, Perkins traveled to California to visit family and friends. There, her depression lifted, but, upon returning home, she once again became despondent. In 1887 she consulted Dr. S. Weir Mitchell, the same real-life specialist mentioned in "The Yellow Wallpaper," who also prescribed a "rest cure"—one month of total inactivity. The treatment, as it turned out, was worse than the neurasthenia, and Gilman came close to having a complete breakdown. Soon afterward, she and her husband separated and later divorced in 1894.* In "Why I Wrote 'The Yellow Wallpaper,' " Gilman explained matter-of-factly that she penned the story "to save people from being driven crazy" (Gilman 1913, 271).

Many of her social theories are concretized in fiction, which she chose because it "is the most popular form in which this world-food [thoughts and ideas] is taken" and therefore "teach[es] not by preaching but by truly re-presenting" (Gilman 1910, 21). Gilman scholar Carol Kessler writes that Gilman believed literature could transform the world by offering alternatives as effectively as the essay or public lecture could do (1995, 6).

*In 1897, Charlotte Stetson sought legal advice from her cousin, Houghton Gilman. He was an attractive man, seven years her senior, kind and intelligent. Three years later they married. The marriage, it seemed, "neither hampered her work nor eroded her feminist perspective" (Karpinski 38).

Gilman's nonfiction fleshed out the ideas and theories presented in her stories and novels and attempted to discredit traditional views of women's roles in society and in the home. Using the ideas of evolutionist Charles Darwin and social evolutionist Lester Frank Ward, she explored the devastating consequences of social conditioning in a patriarchal society while offering specific solutions to the problem of gender inequality. The solution, for Gilman, lay in emotional, financial, and intellectual independence, in education, and in a redefinition of woman's role in marriage and motherhood.

The first step to autonomy, according to Gilman, was developing emotional independence. In her autobiography, she describes that defining moment in her own life. When she was a young girl, her mother had asked her to apologize to a neighbor for something that she had not done: " 'You must do it,' said Mother, 'or you must leave me.' . . . So I sat there and made answer, slowly, meaning to say the first part, and the last part saying itself: 'I am not going to do it,—and I am not going to leave you—and what are you going to do about it?' " Her mother struck her, but Gilman "did not care in the least. . . . I was realizing with an immense illumination that neither she, nor any one, could make me do anything. One could suffer, one could die if it came to that, but one could not be coerced. I was born" (Gilman 1935, 34). For her, as for most women at the turn of the century, emotional independence was made more difficult in a domestic sphere that stunted her growth by "limiting her ideas, her information, her thought-processes, and power of judgment" (1898, 66).

Gilman argued that attaining financial independence was more important for women than the right to vote. In America, at the turn of the century, all that a woman could hope to achieve came through "a single channel and a single choice. Wealth, power, social distinction, fame—not only these, but home and happiness, reputation, ease and pleasure, her bread and butter—all, must come to her through a small gold ring" (1898, 71). In depending solely on their husbands for support, women put themselves at peril. On this issue, Gilman spoke from experience. As a child of divorced parents, she had known poverty. Because of their dire financial situation, her mother had been forced to move her and her brother nineteen times in eighteen years to fourteen different cities.

Charlotte Perkins Gilman believed, as did Anna Julia Cooper, that women were the key to social progress. The focus of their training, therefore, should be on developing critical and analytical thought and not on sharpening their domestic skills. Only through this type of instruction would women gain economic, emotional, and intellectual independence. Influenced in Chicago by Jane Addams while visiting

Hull House, Gilman came to see education as central to democracy (De Simone 1995, 1).

Gilman and Cooper identified themselves as teachers, but Gilman's students were not found in the high-school classroom, as were Cooper's, but rather in the world at large. "My business," she wrote in her autobiography, "was to find out what ailed society and how most easily and naturally to improve it" (Gilman 1935, 182). Though lecturing frequently on college campuses, she distanced herself from academia, even declining the offer of an academic position (Deegan 1997, 10-11). Perhaps rejection had to do with the fact that Gilman was a self-educated intellectual. Her formal schooling was sporadic—a variety of schools over a four-year period, which ended at the age of fifteen (Gilman 1935, 12). She did, however, complete a two-year course of study at the Rhode Island School of Design. Perhaps her own experiences led her to criticize the current state of education in America, describing it as "heavily encumbered with vestigial rudiments, with ancient prejudices, with slow, stiff, creaking disability of unused powers." Teachers, she asserted, conveyed ideas that were "not only mummies but fossils" (Gilman 1912b, 103). These educators acquired knowledge not for their own edification but for the "sole purpose of teaching it to others—that they may teach it to others—forever and ever, none of this knowledge ever touching earth as it were. Such education never 'comes out' at all; it merely flows on from mind to mind, like endless generations of unborn children" (Gilman 1912a, 218).

For this reason, Gilman called for a reconceptualization of "learning" and "teaching," since their original meanings had been lost, bogged down by "technical associations." Learning would refer to the taking in of new ideas, and teaching would be defined as the dispensation of knowledge: "If education were normal we would find it a wide, free, subtly adjusted system of transference of knowledge wherein each and all could delightedly bring their minds to be fed, life-long; and wherein those most gifted as teachers, i.e., most enjoying the active side of that transference, could delightedly do the feeding" (219).

Gilman sought to redefine not only such concepts as teaching and learning but woman's domestic role as well. Once married, a woman was forced into what only could be described as domestic bondage, a situation in which her character became more narrowly defined to the point that she lost her ability to function in a public role (Berkson 1990, 108). After taking their wedding vows, men and women were no longer equal partners; the wife was totally dependent upon her husband for her very existence. Little more than a "sex parasite" and a "gold digger" (Gilman 1931, 265, 267), woman as wife was transformed into "the priestess of the temple of consumption." The result

of the transformation, however, had a negative social impact, since a wife's economic influence would eventually become "reactionary and injurious" (1898, 120).

Inspired by Charles Darwin's theories of evolution, Gilman maintained that social evolution could only occur if *both* men and women were productive. Although notable exceptions existed, Gilman asserted that social "progress has been almost exclusively male. Men have grown through all the stages of industrial development, of religious, artistic, scientific, mechanistic, political, legal, and educational development, while women until quite recently have remained [at the] stage of squaw-labour, lightened by the inventions of men" (1931, 268–69). One could not help but wonder, she mused, "what kind of progress [could] be expected in a race of animals where the female ma[de] none? What civilization [could] endure which [was] made and practiced by one sex only?" (272).

Gilman's solution to domestic bondage involved a paradigm shift in perspectives of cause and effect. Biology, she argued, did not determine men and women's roles; social environs did. Thus, for social evolution and progress to continue, women must be recognized first as human beings with rights equal to those of men. Gilman, however, wanted to do more than gain equal rights for women; she also wanted to transform America from a patriarchal to a matriarchal society, which she was able to accomplish, at least fictionally. Blending Lester Ward's gynocentric theories on sexual differentiation with her own political and social ideologies, she authored three utopian novels: *Moving the Mountain* (1911), *Herland* (1915), and *With Her in Ourland* (1916). The most famous of the three, *Herland*, tells the story of three American men discovering a country inhabited only by females who procreate through parthenogenesis. In this utopian matriarchal world, mothering is viewed as a social activity in which all members participate.

Clearly, Gilman's ideas for creating an ideal society are intricate and, at times, conflicted. Still, all of the women in this study thus far have offered controversial and often complex advice for restructuring woman's role in society. And yet, of all the women included here, Charlotte Perkins Gilman has been the most problematic because of the racist, ethnocentric, and anti-Semitic views that inform her social thought, including her ideas about Darwin's theories of evolution and child care (Scharnhorst 2000, 67). Interestingly, until recently, critics and historians have neglected this less-than-flattering aspect of Gilman. One is forced to ask how, then, could a woman who was so sensitive to the oppression of white women be so blind to the sufferings of African Americans and the poor? In addressing this dilemma, Thomas Peyser acknowledges that "when we encounter figures from the past whose

writings contain ideas we like along with those we hate, our first impulse is to suppose that things we like belong to the 'progressive' part of the writer's thought, that this part can be detached intact, as it were, from the ideas we find objectionable" (1998, 74).

Carol Kessler, however, reminds Gilman's readers that no matter how ahead of her time Gilman's ideas on women's issues might be, her thoughts on race placed her firmly within the time in which she lived (1995, 47). As a social Darwinist, she accepted the concept of racial evolution and thus perpetuated in her writings the concept of the inferior African American. In "A Suggestion on the Negro Problem" (1908), she asks, "What can we do to improve [the Negro]?" (79). Her answer was forced conscription: that is, to enlist all African Americans "below a certain standard of citizenship" in an industrial army. The cadets would be housed on large farms where they would be trained as workers since, according to Gilman, most blacks were "best suited to agricultural labor" (81).

As a social Darwinist, Gilman was also deeply concerned with immigration and its effect on American culture. In "Women and Economics" she linked gender and economics, asserting the logical necessity of equality between the sexes. If one sex is superior (intellectually, socially, etc.) to another, she argued, the result would be "a race of psychic hybrids, and the moral qualities of hybrids [racially mixed marriages] is well known" (Gilman 1898, 331). The races, therefore, must be kept separate and pure, even if it meant the "enforced sterilization of grossly injurious types" (1929, 122).

Although she wanted to improve the lives of African Americans and other minority groups, Gilman subjugated their needs to those of white, middle-class women. While late twentieth-century scholars are discovering Gilman's darker side—her racist views and hatred of foreigners—one must necessarily acknowledge that treatises such as "Women and Economics" assisted women of all races by questioning the historical and economic soundness of their subordination to men. In addition, Gilman was brilliantly able to convey the ideas of the great thinkers of her day to the general populace (Golden and Zangrando, 2000, 12).

"My business," Gilman wrote in her autobiography, "was to find out what ailed society and how most easily and naturally to improve it" (1935, 182). And this is what she did for women in America. According to historian Carl Degler, writing in 1956, if "America in the last fifty years has basically altered its attitude toward the working woman, then Charlotte Perkins Gilman must be assigned a significant part in the accomplishment of that change" (1956, 39).

Locked Inside*

She beats upon her bolted door,
With faint weak hands;
Drearily walks the narrow floor;
Sullenly sits, blank walls before;
Despairing stands.

Life calls her, Duty, Pleasure, Gain—
Her dreams respond;
But the blank daylights wax and wane,
Dull peace, sharp agony, slow pain—
No hope beyond.

Till she comes a thought! She lifts her head,
The world grows wide!
A voice—as if clear words were said—
"Your door, O long imprisoned,
Is locked inside!"

Women and Economics†

Primitive man and his female were animals, like other animals. They were strong, fierce, lively beasts; and she was as nimble and ferocious as he, save for the added belligerence of the males in their sex-competition. In this competition, he, like the other male creatures, fought savagely with his hairy rivals; and she, like the other female creatures, complacently viewed their struggles, and mated with the victor. At other times she ran about in the forest, and helped herself to what there was to eat as freely as he did.

There seems to have come a time when it occurred to the dawning intelligence of this amiable savage that it was cheaper and easier to fight a little female, and have it done with, than to fight a big male every time. So he instituted the custom of enslaving the female; and

*From Charlotte Perkins Gilman, "Locked Inside," in *Suffrage Songs and Verses* (New York: Charlton, 1911), 3–4.
†From Charlotte Perkins Gilman, "Women and Economics," in *Political Economy*.

she, losing freedom, could no longer get her own food nor that of her young. The mother ape, with her maternal function well fulfilled, flees leaping through the forest,—plucks her fruit and nuts, keeps up with the movement of the tribe, her young one on her back or held in one strong arm. But the mother woman, enslaved, could not do this. Then man, the father, found that slavery had its obligations: he must care for what he forbade to care for itself, else it died on his hands. So he slowly and reluctantly shouldered the duties of his new position. He began to feed her, and not only that, but to express in his own person the thwarted uses of maternity: he had to feed the children, too. . . .

When man began to feed and defend woman, she ceased proportionately to feed and defend herself. When he stood between her and her physical environment, she ceased proportionately to feel the influence of that environment and respond to it. When he became her immediate and all-important environment, she began proportionately to respond to this new influence, and to be modified accordingly. In a free state, speed was of as great advantage to the female as to the male, both in enabling her to catch prey and in preventing her from being caught by enemies; but, in her new condition, speed was a disadvantage. She was not allowed to do the catching, and it profited her to be caught by her new master. Free creatures, getting their own food and maintaining their own lives, develop an active capacity for attaining their ends. Parasitic creatures, whose living is obtained by the exertions of others, develop powers of absorption and of tenacity,—the powers by which they profit most. . . .

With the growth of civilization, we have gradually crystallized into law the visible necessity for feeding the helpless female; and even old women are maintained by their male relatives with a comfortable assurance. But to this day—save, indeed, for the increasing army of women wage-earners, who are changing the face of the world by their steady advance toward economic independence—the personal profit of women bears but too close a relation to their power to win and hold the other sex. From the odalisque with the most bracelets to the débutante with the most bouquets, the relation still holds good,—woman's economic profit comes through the power of sex-attraction.

When we confront this fact boldly and plainly in the open market of vice, we are sick with horror. When we see the same economic relation made permanent, established by law, sanctioned and sanctified by religion, covered with flowers and incense and all accumulated sentiment, we think it innocent, lovely, and right. . . .

The transient trade we think evil. The bargain for life we think good. But the biological effect remains the same. In both cases the female gets her food from the male by virtue of her sex-relationship to

him. In both cases, perhaps even more in marriage because of its perfect acceptance of the situation, the female of genus homo, still living under natural law, is inexorably modified to sex in an increasing degree.

Followed in specific detail, the action of the changed environment upon women has been in given instances as follows: In the matter of mere passive surroundings she has been immediately restricted in her range. This one factor has an immense effect on man and animal alike. An absolutely uniform environment, one shape, one size, one color, one sound, would render life, if any life could be, one helpless, changeless thing. As the environment increases and varies, the development of the creature must increase and vary with it; for he acquires knowledge and power, as the material for knowledge and the need for power appear. . . . The human female has been restricted in range from the earliest beginning. Even among savages, she has a much more restricted knowledge of the land she lives in. She moves with the camp, of course, and follows her primitive industries in its vicinity; but the war-path and the hunt are the man's. He has a far larger habitat. The life of the female savage is freedom itself, however, compared with the increasing constriction of custom closing in upon the woman, as civilization advanced, like the iron torture chamber of romance. Its culmination is expressed in the proverb: "A woman should leave her home but three times,—when she is christened, when she is married, and when she is buried."

To reduce so largely the mere area of environment is a great check to race-development; but it is not to be compared in its effects with the reduction in voluntary activity to which the human female has been subjected. Her restricted impression, her confinement to the four walls of the home, have done great execution, of course, in limiting her ideas, her information, her thought-processes, and power of judgment; and in giving a disproportionate prominence and intensity to the few things she knows about; but this is innocent in action compared with her restricted expression, the denial of freedom to act. . . .

But in the ever-growing human impulse to create, the power and will to make, to do, to express one's spirit in new forms,—here she has been utterly debarred. She might work as she had worked from the beginning,—at the primitive labors of the household; but in the inevitable expansion of even those industries to professional levels we have striven to hold her back. To work with her own hands, for nothing, in direct body-service to her own family,—this has been permitted,—yes, compelled. But to be and do anything further from this she has been forbidden. Her labor has not only been limited in kind, but in degree. Whatever she has been allowed to do must be done in private and alone, the first-hand industries of savage times.

Our growth in industry has been not only in kind, but in class. The baker is not in the same industrial grade with the house-cook, though both make bread. To specialize any form of labor is a step up: to organize it is another step. Specialization and organization are the basis of human progress, the organic methods of social life. They have been forbidden to women almost absolutely. The greatest and most beneficent change of this century is the progress of women in these two lines of advance. The effect of this check in industrial development, accompanied as it was by the constant inheritance of increased racial power, has been to intensify the sensations and emotions of women, and to develope great activity in the lines allowed. The nervous energy that up to present memory has impelled women to labor incessantly at something, be it the veriest folly of fancy work, is one mark of this effect. . . .

It is painfully interesting to trace the gradual cumulative effect of these conditions upon women: first, the action of large natural laws, acting on her as they would act on any other animal; then the evolution of social customs and laws (with her position as the active cause), following the direction of mere physical forces, and adding heavily to them; then, with increasing civilization, the unbroken accumulation of precedent, burnt into each generation by the growing force of education, made lovely by art, holy by religion, desirable by habit; and, steadily acting from beneath, the unswerving pressure of economic necessity upon which the whole structure rested. These are strong modifying conditions, indeed. . . .

To the young man confronting life the world lies wide. Such powers as he has he may use, must use. If he chooses wrong at first, he may choose again, and yet again. Not effective or successful in one channel, he may do better in another. The growing, varied needs of all mankind call on him for the varied service in which he finds his growth. What he wants to be, he may strive to be. What he wants to get, he may strive to get. Wealth, power, social distinction, fame,—what he wants he can try for.

To the young woman confronting life there is the same world beyond, there are the same human energies and human desires and ambition within. But all that she may wish to have, all that she may wish to do, must come through a single channel and a single choice. Wealth, power, social distinction, fame,—not only these, but home and happiness, reputation, ease and pleasure, her bread and butter,—all must come to her through a small gold ring. This is a heavy pressure. It has accumulated behind her through heredity, and continued about her through environment. It has been subtly trained into her through education, till she herself has come to think it a right condition, and pours its influence upon her daughter with increasing impetus. Is it any won-

der that women are over-sexed? But for the constant inheritance from the more human male, we should have been queen bees, indeed, long before this. But the daughter of the soldier and the sailor, of the artist, the inventor, the great merchant, has inherited in body and brain her share of his development in each generation, and so stayed somewhat human for all her femininity.

The inevitable trend of human life is toward higher civilization; but, while that civilization is confined to one sex, it inevitably exaggerates sex-distinction, until the increasing evil of this condition is stronger than all the good of the civilization attained, and the nation falls. Civilization, be it understood, does not consist in the acquisition of luxuries. Social development is an organic development. A civilized State is one in which the citizens live in organic industrial relation. The more full, free, subtle, and easy that relation; the more perfect the differentiation of labor and exchange of product, with their correlative institutions,—the more perfect is that civilization. To eat, drink, sleep, and keep warm,—these are common to all animals, whether the animal couches in a bed of leaves or one of eiderdown, sleeps in the sun to avoid the wind or builds a furnace-heated house, lies in wait for game or orders a dinner at a hotel. These are but individual animal processes. Whether one lays an egg or a million eggs, whether one bears a cub, a kitten, or a baby, whether one broods its chickens, guards its litter, or tends a nursery full of children, these are but individual animal processes. But to serve each other more and more widely; to live only by such service; to develop special functions, so that we depend for our living on society's return for services that can be of no direct use to ourselves,—this is civilization, our human glory and race-distinction.

All this human progress has been accomplished by men. Women have been left behind, outside, below, having no social relation whatever, merely the sex-relation, whereby they lived. Let us bear in mind that all the tender ties of family are ties of blood, of sex-relationship. A friend, a comrade, a partner,—this is a human relative. Father, mother, son, daughter, sister, brother, husband, wife,—these are sex-relatives. Blood is thicker than water, we say. True. But ties of blood are not those that ring the world with the succeeding waves of progressive religion, art, science, commerce, education, all that makes us human. Man is the human creature. Woman has been checked, starved, aborted in human growth; and the swelling forces of race-development have been driven back in each generation to work in her through sex-functions alone.

This is the way in which the sexuo-economic relation has operated in our species, checking race-development in half of us, and stimulating sex-development in both.

5

The New Woman

~

Anna Julia Cooper

The cause of freedom is not the cause of a race or a sect, a party or a class—
it is the cause of humankind, the very birth right of humanity.
—Anna Julia Cooper

The 1890s marked a new era that was best exemplified by the New Woman (1890–1920). This icon was depicted by the media as a radical social ideal—a woman, intellectually acute, who was independent and bold and who saw herself as man's equal. In addition, she was a self-defined individual who made full use of her talents *outside* the home.

While America's obviously white and middle-class New Woman enjoyed her freedom, African American women and men continued to be victims of a systematic assault, a backlash to the Emancipation Proclamation. Legal disfranchisement, court-sanctioned segregation, and incidents of lynching increased in number and inaugurated the Jim Crow era (1880–1964), a period in which laws and customs were used to segregate African Americans and deny them their freedoms (Alexander 1997, 61). Women intellectuals, such as Anna Julia Cooper, Frances Watkins Harper, and Mary Terrell used their liberty to educate themselves and others and sought to move African Americans from slavery to freedom. Singularly and together, they created women's clubs, settlement houses, schools, and self-help groups for the purpose of uplifting the black race.

Anna Julia Cooper was the model for the New Black Woman. Her photograph graced the cover of *Black Women of America* (Lemert 1998, 1). She was also a complex individual who reflected the conflicted status of African American women at the end of the nineteenth century. "The colored woman of today," Cooper wrote in 1892, "occupies

... a unique position in this country. During this transitional and unsettled period, her status seems one of the least ascertainable and definitive of all the forces which make for our civilization. She is confronted by both a woman question and a race problem" (1892, 134, 28). Yet, confronted with these same forces, Cooper rose to the challenge and led a heroic life by refusing to be compartmentalized (Lemert 1998, 3).

Cooper's remarkable life began in Raleigh, North Carolina, where she was born in 1858 to Hannah Stanley, a slave woman, and George Washington Haywood, a prominent lawyer and her mother's white master. A precocious child, Cooper was already driven by a desire to teach by the age of five. Her early career choice was met by her equally early acceptance into St. Augustine's Normal School and Collegiate Institute, a college for emancipated slaves. In 1868 she became a student teacher when she was not yet ten years of age. Nine years later, Cooper married a ministerial student, George Cooper. He died two years later in 1879. Anna Julia Cooper then left Raleigh to attend Oberlin College in Ohio, where she received a Master of Arts degree in mathematics in 1887, the same year that she accepted a teaching post in Washington, DC, at M Street High School (which would become Dunbar High School in 1916). She later became its principal.

At this time, Booker T. Washington's vocational and industrial training model was the accepted program in African American schools. Nonetheless, Cooper challenged both Washington's curriculum and that of her white supervisors by advancing her own program at Dunbar, which she believed better prepared students for higher education. Her approach was highly successful—some of her students went on to attend Harvard, Brown, Yale, and Dartmouth. Yet, despite her students' successes, Percy Hughes, Cooper's supervisor, disapproved of her teaching program and sought to destroy both her career and her reputation.

Charges, filed in 1906, accused Cooper of refusing to use the recommended textbook, of showing leniency with weak students, and of failing to maintain discipline. She was also accused of having an affair with one of her foster children, John Love. The formal hearing led to her dismissal from Dunbar. Annette Eaton describes Cooper's expulsion as an act of racism: "It only took her daring in having her students accepted and given scholarships at Ivy League schools to know that the white power structure would be out to get her for any reason or for no reason" (quoted in Washington 1987, xxxiv). Unwilling to accept the school board's ruling, Cooper fought for reinstatement. In 1910, four years after her expulsion, she was allowed to return to Dunbar as a teacher but not as principal.

In her introduction to *A Voice from the South*, Mary Helen Washington retells the story of Cooper's struggle to complete her doctorate. Cooper began working at Columbia University on her graduate degree in 1914 and on her course work a year later. However, she was unable to fulfill the one-year residency requirement because she had adopted her half-brother's five orphaned children, aged 6 months to 12 years. As a result, Cooper moved with her new family to Washington, DC. Some years later, she transferred to the Sorbonne in Paris to pursue her graduate work during the summer school break. After requesting sick leave from Dunbar in 1924, she left for Paris to complete the Sorbonne's residency requirements. Dunbar supervisors, however, refused to grant her leave and insisted that she return to the school within ten days or be fired (thus losing her retirement benefits as well as her job). Cooper returned. One year later, however, she successfully defended her dissertation and received her doctorate from the University of Paris—at the age of sixty-seven.

From 1930 to 1941, Cooper served as president of Frelinghuysen University in Washington, DC. Frelinghuysen, with its low tuition rates and night courses, was designed for working-class African Americans. Though no longer able to confer degrees by the time Cooper had become president, the school did offer instruction in professional studies as well as the trades.

When we look over her long life of 105 years, it is difficult to choose one approach with which to explore Cooper's writings. Most critics emphasize her work as a feminist, but that is only one facet of this remarkable woman's career. Cooper believed there were many paths to self-actualization. The New Woman may have possessed a sexual freedom unknown in earlier times, but women were not, according to Cooper, "compelled to look to sexual love as the one sensation capable of giving tone and relish, movement and vim to the life [a woman] leads. Her horizon is extended" (quoted in Giddings 1984, 108–9). Faced with awesome responsibilities that included "keep[ing] intelligently and sympathetically *en rapport* with all the movements of her time," black women had a promising future: "For she stands now at the gateway of this new era of American civilization. In her hands must be molded the strength, the wit, the statesmanship, the morality, all the psychic force, the social and economic intercourse of that era. To be alive at such an epoch is a privilege, to be a woman then is sublime" (Cooper 1892, 143). There was little reason, Cooper wrote, to "look on the masterly triumphs of nineteenth century civilization with that blasé world weary look which characterized the old washed out and worn out races which have already, so to speak, seen their best days" (117).

For women's roles to change, Cooper insisted, men's perspectives on women must also change. It is absurd, she argued, "to quote statistics showing the Negro's bank account and rent rolls, to point to the hundreds of newspapers edited by colored men, and lists of lawyers, doctors, professors, . . . etc. while [colored women] . . . are subject to the taint and corruption of the enemy's camp. . . . A stream cannot rise higher than its source" (25, 29). African American men could only benefit from women's social and educational progress, as would all races: "The cause of freedom is not the cause of a race or a sect, a party or a class. It is the cause of human kind, the very birthright of humanity. . . . Woman's strongest indication for speaking [is] that *the world needs to hear her voice*. It would be subversive of every human interest that the cry of one-half of the human family be stifled" (120–21).

Cooper did more than encourage women to find and use their voices. She employed her own voice as a social critic, reformer, and activist to openly criticize a number of groups that contributed to the oppression of African Americans. She reprimanded the white patriarchy for denying black men and women their rights as Americans; she indicted white feminists for excluding black women from their organizations; she lashed out at black leaders for ignoring the plight of African American women.

In addressing white males who believed the black race to be not only inferior but bestial, she reversed their own argument: "If the cultivated black man cannot endure the white man's barbarity—the cure, it would seem to me, would be to cultivate the white man" (210). An outspoken advocate for African American rights, Cooper rejected outright the traditional portrayals of blackness, revealing, instead, the irony underlying the stereotypes. Moreover, she leveled her comments directly to white men, specifically to writers and journalists (McLendon 1995, 3). Cooper argued that it was "an insult to humanity and a sin against God to publish any such meager and superficial information. . . . Were I not afraid of falling myself into the same error that I am condemning, I would say it seems an Anglo-Saxon characteristic to have such overweening confidence in his own power of induction that there is no equation which he would acknowledge to be indeterminate, however many unknown quantities it may possess" (1998, 203–4).

Cooper also admonished those white feminists who excluded African American women from the Congress of Representative Women at the 1893 Columbian Exposition (World's Fair) in Chicago: "the colored woman feels that woman's cause is one and universal: and that not till the . . . universal title of humanity to life, liberty and the pursuit of happiness is conceded to be inalienable to all; not till then is

woman's lesson taught and woman's cause won—not the white woman's, nor the black woman's, nor the red woman's, but the cause of every man and every woman who has writhed silently under a mighty wrong" (1998, 205). This speech was Cooper's response to Fannie Barrier Williams, a major speaker at the Congress. Both women employed Burkean rhetorical strategies to identify with their mainly white female audience. Williams connected with her hearers by noting the similarities between women, black and white. Cooper did the same and urged the Congress to create a policy for inclusion (Logan 1999, 99).

In *"We Are Coming": The Persuasive Discourse of Nineteenth-Century Black Women*, Shirley Logan describes the "funnel approach" that Cooper used in her speeches by first grouping both races of women together and then, after the connections had been made, allowing herself to focus on her "special cause" (1999, 125). Occasionally she would open her speech with a reversal. She once began by describing the impossibility of women's advancement only thirty years after the Emancipation Proclamation but then continued to enumerate schools that had been established and educators who had been procured together with the successes of African American students and the accomplishments of specific African American women (113).

Cooper carried her message throughout America and Europe. She was one of two women speakers at the first Pan-African Conference in London in 1900, where she lectured on "The Negro Problem in America" (Hines 1993, 227). Five years earlier, she had spoken at the First National Conference of Colored Women on the need for a national organization. As a member of this group, Cooper served as chairperson of the Committee to Study the Georgia Convict System and actively participated in the women's suffrage movement.

Above all, however, Cooper was an educator. Her attitude was similar to that expressed by W. E. B. Du Bois in "The Talented Tenth" (1903), in which he exhorted educated African Americans to "uplift" the race: "If you do not lift them up, they will pull you down. Education and work are the levers to uplift a people. Work alone will not do it unless inspired by the right ideals and guided by intelligence. Education must not simply teach work—it must teach life. The Talented Tenth of the Negro race must be made leaders of thought and missionaries of culture among their people" (Du Bois 1989, 29). Often, Cooper directed her comments on black women's rights to education to "the talented tenth": black, educated males (Tate 1992, 58).

Karen Johnson writes that Cooper, along with Nannie Helen Burroughs, challenged current pedagogical approaches (1977, 19). As we know, Cooper formulated her own theories and put them into practice at M Street High School, which strengthened the curriculum and

raised educational standards. However, despite her training and erudition, Cooper did not limit herself to the high-school and university classrooms, for her credo was "Education for Service." She was one of the founding members and a supervisor of what would later be called the Southwest Settlement House in Washington, DC (220–21). The members of this group included educated men and women who volunteered to live in less affluent areas of the city with the goal of uplifting the poor through education, socialization, and personal interaction (Harley 1982, 262).

A Voice from the South (1892), Cooper's best-known work, is a collection of essays that not only examines educational issues confronting African Americans (including racism, gender, and education) but also explores the life and thoughts of its author. In the Foreword to the 1988 edition, Henry Louis Gates Jr. describes *A Voice from the South* as "one of the original texts of the black feminist movement" (xii). Mary Helen Washington deemed it "the most precise, forceful, well-argued statement of black feminist thought to come out of the nineteenth century" (1988, li), while Charles Lemert calls it "the first *systematic* working out of the insistence that no one social category can capture the reality of the colored woman" (1998, 14).

The publication of *A Voice from the South* marks the beginning of the African American intellectual tradition at the turn of the nineteenth century and reveals Cooper as the "first African-American womanist theorist of record" (Bates 1997). Each of the first four chapters of *A Voice from the South* begins with *soprano obligato*, an Italian phrase meaning "the necessary voice" (usually a woman's), and each chapter addresses the issue of gender inequality for black women living in a white patriarchal culture. The final essays, however, begin with the phrase *tutti ad libitum*, which means "all at pleasure," and address a number of different topics, although all are related to race. Here, she examines the ways in which African Americans are portrayed in literature and then refutes the idea of inherent black inferiority. In the final chapter, she criticizes organized religion, arguing that it is a catalyst for racism (Baham 1997, 2–3).

As Chicana intellectual Gloria Anzaldúa would do one hundred years later, Cooper employed various genres—poetry, history, speeches, autobiography, and literary criticism—to convey her message. Such a varied structure was the most effective way to incorporate the conflicts faced by African American women who were struggling to create an intellectual identity from the tools at hand. Similarly, Cooper's use of the first person reveals how her own life experiences informed her argument as well as her feminist writing style (Alexander 1997, 62). In *A Voice from the South*, Cooper created a hybrid discourse that

combined the language of the patriarchy, her African American heritage, and her own experiences together with a plural life led in what Anzaldúa would describe as the borderlands. The development of this discourse, then, reveals the double and even triple bind that women of color experience due to gender, race, and economic factors.

Although her life and writings reveal a variety of interests and commitments, Cooper was clear about her life's purpose: "I may say honestly and truthfully that my one aim is and has always been . . . to hold a torch for the children of a group too long exploited and too frequently disparaged in its struggling for the light. . . . In the simple words of the Master, spoken for another nameless one, my humble career may be summed up to date—'She hath done what she could' " (quoted in Lemert 1998, 34). "What she could" not only involved teaching but also working with the poor by taking an active part in the social settlement movement, the Negro Women's Club movement, and other social programs (7). Perhaps Cooper's most meaningful legacy was her unwavering faith in the ability of education to liberate women and provide them with the skills they would need to change the world (Guy-Sheftall 1994, 165).

Nonetheless, Cooper had no delusions about how her contributions would be remembered. In *A Voice from the South*, she knowingly writes that "the thinker who enriches his country by a thought estimable and precious is given neither bread nor a stone. He is too often left to die in obscurity and neglect" (1892, 136). Yet Cooper's voice *has* survived and continues to challenge Americans at the beginning of the twenty-first century. Her belief still rings true that black women represent their entire race since they are the only true measure of racial progress: "Only the BLACK WOMAN can say when and where I enter, . . . then and there the whole *Negro race enters with me*" (31).

The Higher Education of Women*

In the very first year of our century, the year 1801, there appeared in Paris a book by Silvain Maréchal, entitled "Shall Woman Learn the Alphabet." The book proposes a law prohibiting the alphabet to women, and quotes authorities weighty and various, to prove that the woman who knows the alphabet has already lost part of her womanliness. The

*From Anna Julia Cooper, "The Higher Education of Women," in *A Voice from the South by a Black Woman of the South* (Oxford: Oxford University Press, 1892).

author declares that women can use the alphabet only as Molière predicted they would, in spelling out the verb *amo*; that they have no occasion to peruse Ovid's *Ars Amoris*, since that is already the ground and limit of their intuitive furnishing; that Madame Guion would have been far more adorable had she remained a beautiful ignoramus as nature made her; that Ruth, Naomi, the Spartan woman, the Amazons, Penelope, Andromache, Lucretia, Joan of Arc, Petrarch's Laura, the daughters of Charlemagne, could not spell their names; while Sappho, Aspasia, Madame de Maintenon, and Madame de Stael could read altogether too well for their [own] good; finally, that if women were once permitted to read Sophocles and work with logarithms, or to nibble at any side of the apple of knowledge, there would be an end forever to their sewing on buttons and embroidering slippers.

Please remember this book was published at the *beginning* of the Nineteenth Century. At the end of its first third, (in the year 1833) one solitary college in America decided to admit women within its sacred precincts, and organized what was called a "Ladies' Course" as well as the regular B.A. or Gentlemen's course.

It was felt to be an experiment—a rather dangerous experiment—and was adopted with fear and trembling by the good fathers, who looked as if they had been caught secretly mixing explosive compounds and were guiltily expecting every moment to see the foundations under them shaken and rent and their fair superstructure shattered into fragments.

But the girls came, and there was no upheaval. They performed their tasks modestly and intelligently. Once in a while one or two were found choosing the gentlemen's course. Still no collapse; and the dear, careful, scrupulous, frightened old professors were just getting their hearts out of their throats and preparing to draw one good free breath, when they found they would have to change the names of those courses; for there were as many ladies in the gentlemen's course as in the ladies', and a distinctively Ladies' Course, inferior in scope and aim to the regular classical course, did not and could not exist.

Other colleges gradually fell into line, and to-day there are one hundred and ninety-eight colleges for women, and two hundred and seven coeducational colleges and universities in the United States alone offering the degree of B.A. to women, and sending out yearly into the arteries of this nation a warm, rich flood of strong, brave, active, energetic, well-equipped, thoughtful women—women quick to see and eager to help the needs of this needy world—women who can think as well as feel, and who feel none the less because they think—women who are none the less tender and true for the parchment scroll they bear in their hands—women who have given a deeper, richer, nobler

and grander meaning to the word "womanly" than any one-sided masculine definition could ever have suggested or inspired—women whom the world has long waited for in pain and anguish till there should be at last added to its forces and allowed to permeate its thought the complement of that masculine influence which has dominated it for fourteen centuries.

Since the idea of order and subordination succumbed to barbarian brawn and brutality in the fifth century, the civilized world has been like a child brought up by his father. It has needed the great mother heart to teach it to be pitiful, to love mercy, to succor the weak and care for the lowly.

Whence came this apotheosis of greed and cruelty? Whence this sneaking admiration we all have for bullies and prize-fighters? Whence the self-congratulation of "dominant" races, as if "dominant" meant "righteous" and carried with it a title to inherit the earth? Whence the scorn of so-called weak or unwarlike races and individuals, and the very comfortable assurance that it is their manifest destiny to be wiped out as vermin before this advancing civilization? As if the possession of the Christian graces of meekness, non-resistance and forgiveness, were incompatible with a civilization professedly based on Christianity, the religion of love! Just listen to this little bit of barbarian brag:

> As for Far Orientals, they are not of those who will survive. Artistic, attractive people that they are, their civilization is like their own tree flowers, beautiful blossoms destined never to bear fruit. If these people continue in their old course, their earthly career is closed. Just as surely as morning passes into afternoon, so surely are these races of the Far East, if unchanged, destined to disappear before the advancing nations of the West. Vanish, they will, off the face of the earth, and leave our planet the eventual possession of the dwellers where the day declines. Unless their newly imported ideas really take root, it is from this whole world that Japanese and Koreans, as well as Chinese, will inevitably be excluded. Their Nirvana is already being realized; already, it has wrapped Far Eastern Asia in its winding sheet.—*Soul of the Far East*—P. Lowell.

Delightful reflection for "the dwellers where the day declines." A spectacle to make the gods laugh, truly, to see the scion of an upstart race by one sweep of his generalizing pen consigning to annihilation one-third of the inhabitants of the globe—a people whose civilization was hoary headed before the parent elements that begot his race had advanced beyond nebulosity.

How like Longfellow's Iagoo, we Westerners are, to be sure! In the few hundred years we have had to strut across our allotted territory and bask in the afternoon sun, we imagine we have exhausted the

possibilities of humanity. Verily, we are the people, and after us there is none other. Our God is power; strength, our standard of excellence, inherited from barbarian ancestors through a long line of male progenitors, the Law Salic [sic] permitting no feminine modifications.

Says one, "The Chinaman is not popular with us, and we do not like the Negro. It is not that the eyes of the one are set [on the] bias, and the other is dark-skinned; but the Chinaman, the Negro is weak—*and Anglo Saxons don't like weakness.*"

The world of thought under the predominant man-influence, unmollified and unrestrained by its complementary force, would become like Daniel's fourth beast: "dreadful and terrible, and *strong* exceedingly"; "it had great iron teeth; it devoured and brake in pieces, and stamped the residue with the feet of it"; and the most independent of us find ourselves ready at times to fall down and worship this incarnation of power.

Mrs. Mary A. Livermore, a woman whom I can mention only to admire, came near to shaking my faith a few weeks ago in my theory of the thinking woman's mission to put the tender and sympathetic chord in nature's grand symphony, and counteract, or better, harmonize the diapason of mere strength and might.

She was dwelling on the Anglo-Saxon genius for power and his contempt for weakness, and described a scene in San Francisco which she had witnessed.

The incorrigible animal known as the American small-boy, had pounced upon a simple, unoffending Chinaman, who was taking home his work, and had emptied the beautifully laundried contents of his basket into the ditch. "And," said she, "when that great man stood there and blubbered before that crowd of lawless urchins, to any one of whom he might have taught a lesson with his two fists, *I didn't much care.*"

This is said like a man! It grates harshly. It smacks of the worship of the beast. It is contempt for weakness, and taken out of its setting it seems to contradict my theory. It either shows that one of the highest exponents of the Higher Education can be at times untrue to the instincts I have ascribed to the thinking woman and to the contribution she is to add to the civilized world, or else the influence she wields upon our civilization may be potent without being necessarily and always direct and conscious. The latter is the case. Her voice may strike a false note, but her whole being is musical with the vibrations of human suffering. Her tongue may parrot over the cold conceits that some man has taught her, but her heart is aglow with sympathy and loving kindness, and she cannot be true to her real self without giving out these elements into the forces of the world.

No one is in any danger of imagining Mark Antony "a plain blunt man," nor Cassius a sincere one—whatever the speeches they may make.

As individuals, we are constantly and inevitably, whether we are conscious of it or not, giving out our real selves into our several little worlds, inexorably adding our own true ray to the flood of starlight, quite independently of our professions and our masquerading, and so in the world of thought, the influence of thinking woman far transcends her feeble declamation and may seem at times even opposed to it.

A visitor in Oberlin once said to the lady principal, "Have you no rabble in Oberlin? How is it I see no police here, and yet the streets are as quiet and orderly as if there were an officer of the law standing on every corner."

Mrs. Johnston replied, "Oh, yes; there are vicious persons in Oberlin just as in other towns—*but our girls are our police.*"

With from five to ten hundred pure-minded young women threading the streets of the village every evening unattended, vice must slink away, like frost before the rising sun: and yet I venture to say there was not one in a hundred of those girls who would not have run from a street brawl as she would from a mouse, and who would not have declared she could never stand the sight of blood and pistols.

There is, then, a real and special influence of woman. An influence subtle and often involuntary, an influence so intimately interwoven in, so intricately interpenetrated by the masculine influence of the time that it is often difficult to extricate the delicate meshes and analyze and identify the closely clinging fibers. And yet, without this influence—so long as woman sat with bandaged eyes and manacled hands, fast bound in the clamps of ignorance and inaction, the world of thought moved in its orbit like the revolutions of the moon; with one face (the man's face) always out, so that the spectator could not distinguish whether it was disc or sphere.

Now I claim that it is the prevalence of the Higher Education among women, the making it a common everyday affair for women to reason and think and express their thought, the training and stimulus which enable and encourage women to administer to the world the bread it needs as well as the sugar it cries for; in short it is the transmitting the potential forces of her soul into dynamic factors that has given symmetry and completeness to the world's agencies. So only could it be consummated that Mercy, the lesson she teaches, and Truth, the task man has set himself, should meet together: that righteousness, or *rightness*, man's ideal,—and *peace*, its necessary "other half," should kiss each other.

We must thank the general enlightenment and independence of woman (which we may now regard as a *fait accompli*) that both these forces are now at work in the world, and it is fair to demand from them for the twentieth century a higher type of civilization than any attained in the nineteenth. Religion, science, art, economics, have all needed the feminine flavor; and literature, the expression of what is permanent and best in all of these, may be gauged at any time to measure the strength of the feminine ingredient. You will not find theology consigning infants to lakes of unquenchable fire long after women have had a chance to grasp, master, and wield its dogmas. You will not find science annihilating personality from the government of the Universe and making of God an ungovernable, unintelligible, blind, often destructive physical force; you will not find jurisprudence formulating as an axiom the absurdity that man and wife are one, and that one the man—that the married woman may not hold or bequeath her own property save as subject to her husband's direction; you will not find political economists declaring that the only possible adjustment between laborers and capitalists is that of selfishness and rapacity—that each must get all he can and keep all that he gets, while the world cries *laissez faire* and the lawyers explain, "it is the beautiful working of the law of supply and demand"; in fine, you will not find the law of love shut out from the affairs of men after the feminine half of the world's truth is completed.

Nay, put your ear now close to the pulse of the time. What is the keynote of the literature of these days? What is the banner cry of all the activities of the last half decade? What is the dominant seventh which is to add richness and tone to the final cadences of this century and lead by a grand modulation into the triumphant harmonies of the next? Is it not compassion for the poor and unfortunate, and, as Bellamy has expressed it, "indignant outcry against the failure of the social machinery as it is, to ameliorate the miseries of men!" Even Christianity is being brought to the bar of humanity and tried by the standard of its ability to alleviate the world's suffering and lighten and brighten its woe. What else can be the meaning of Matthew Arnold's saddening protest, "We cannot do without Christianity," cried he, "and we cannot endure it as it is."

When went there by an age, when so much time and thought, so much money and labor were given to God's poor and God's invalids, the lowly and unlovely, the sinning as well as the suffering—homes for inebriates and homes for lunatics, shelter for the aged and shelter for babes, hospitals for the sick, props and braces for the falling, reformatory prisons and prison reformatories, all show that a "mothering" influence from some source is leavening the nation.

Now please understand me. I do not ask you to admit that these benefactions and virtues are the exclusive possession of women, or even that women are their chief and only advocates. It may be a man who formulates and makes them vocal. It may be, and often is, a man who weeps over the wrongs and struggles for the amelioration: but that man has imbibed those impulses from a mother rather than from a father and is simply materializing and giving back to the world in tangible form the ideal love and tenderness, devotion and care that have cherished and nourished the helpless period of his own existence.

All I claim is that there is a feminine as well as a masculine side to truth; that these are related not as inferior and superior, not as better and worse, not as weaker and stronger, but as complements—complements in one necessary and symmetric whole. That as the man is more noble in reason, so the woman is more quick in sympathy. That as he is indefatigable in pursuit of abstract truth, so is she in caring for the interests by the way—striving tenderly and lovingly that not one of the least of these "little ones" should perish. That while we not unfrequently see women who reason, we say, with the coolness and precision of a man, and men as considerate of helplessness as a woman, still there is a general consensus of mankind that the one trait is essentially masculine and the other is peculiarly feminine. That both are needed to be worked into the training of children, in order that our boys may supplement their virility by tenderness and sensibility, and our girls may round out their gentleness by strength and self-reliance. That, as both are alike necessary in giving symmetry to the individual, so a nation or a race will degenerate into mere emotionalism on the one hand, or bullyism on the other, if dominated by either exclusively; lastly, and most emphatically, that the feminine factor can have its proper effect only through woman's development and education so that she may fitly and intelligently stamp her force on the forces of her day, and add her modicum to the riches of the world's thought.

6

"Citizen of the World"

~

Jessie Redmon Fauset

> Citizen of the world, that's what I'll be.
> And now I go home.
> —Jessie Redmon Fauset, "The Sleeper Wakes"

In addition to two world wars and the Great Depression, another major event that occurred in the first half of the twentieth century was the literary and artistic movement in New York City known as the Harlem Renaissance. In the 1920s and 1930s, a group of talented African American writers and artists, including Langston Hughes, Jean Toomer, Alain Locke, and Arno Bontemp, created a large volume of work that hailed the advent of the "New Negro." Locke, one of the Harlem Renaissance organizers, described the movement as no less than a spiritual rebirth and liberation. Self-defined and self-motivated, these New Negroes, while revisioning their identity and their race, were at the same time celebrating their American-ness (Wall 1995, 2).

Along with Locke, another of the movement's organizers was Jessie Redmon Fauset, although historians have failed to recognize her contributions. In fact, some critics cite the banquet that marked the publication of her first novel, *There Is Confusion* (1924), as the movement's formal beginning. Fauset launched the careers of many of the Harlem Renaissance's best-known writers and artists, including Hughes, Toomer, and Laura Wheeler Waring, and supported the work of such African American women writers as Nella Larsen and Angelina Weld Grimké.

Jessie Redmon Fauset was born on April 27, 1882, the daughter of the Reverend Redmon Fauset, a black African Methodist Episcopal minister. Her mother died when she was a child, as did four of her seven brothers and sisters. As a young girl, Fauset lived with her middle-class family in a predominantly white neighborhood in Philadelphia

and attended an all-white high school. Graduating with honors, she then applied to a number of teachers' colleges but was rejected. The president of Bryn Mawr also turned down her application, in part, for fear of offending the school's white southern students (Sylvander 1981, 28). Fauset was finally accepted at Cornell, where she was the only African American in a student body of over 3,000. Although she graduated Phi Beta Kappa in 1905, she was unable to secure a teaching position in her hometown of Philadelphia because her credentials, she was told, were "not good enough." Instead, she went to Baltimore and then to M Street (later Dunbar) High School in Washington, DC, the most prestigious African American high school in the country, where for ten years she taught French and Latin. (Anna Julia Cooper had left the school only a year earlier [Wall 1995, 42]). In 1919, Fauset earned a Master of Arts degree in French from the University of Pennsylvania and, a few years later, was hired by W. E. B. Du Bois as literary editor of his journal *Crisis: A Record of the Darker Races*.

Fauset first made contact with Du Bois in 1903 when she wrote to him for help in finding a summer job. He soon became her mentor and friend and found her a teaching position at Fisk. Some time later, Fauset began contributing to Du Bois's journal. *Crisis*, the official voice of the NAACP, published reviews, political and social commentaries, literary criticism, biographies, and historical documents as well as original stories and poems.

From 1919 to 1926, Fauset served as literary editor and also as managing editor when Du Bois traveled. In addition to writing columns and reviews, she also submitted poetry and short stories for publication, yet even her short stories concentrated on social concerns such as segregation, racial stereotyping, and gender roles (Allen 1998, 49). One such story, "The Sleeper Awakes," examines the ways in which movies not only stereotyped African Americans and women but also negatively impacted young women's sense of self, a subject of special interest today (53, 61). The story's young protagonist, Amy, succumbs to the movies' subliminal messages. After viewing a movie, Amy shops for clothes similar to those worn by the actresses in the film. When she returns home, her guardian warns her: " 'You'd better stop seeing pretty girl pictures, . . . They're not always true to life' " (1920a, 169).

Fauset used her novels, poetry, and poems as vehicles for addressing national and global issues; she also used her role as literary editor to shape and influence the development of African American literature. She was part of the elite trio (along with Locke and Du Bois) that "midwifed," in Hughes's words, the Harlem Renaissance (Hughes 1993, 218). In addition to being the first to publish Hughes's poetry, she also

encouraged other fledgling writers, including Arno Bontemp and Countee Cullen, by printing their works.

While literary editor of *Crisis*, Fauset accepted the job of managing editor of *The Brownies' Book*, a children's magazine, also founded by Du Bois. *The Brownies' Book*, Du Bois and Fauset hoped, would present to children a culture that reflected the African American experience (Harris 1986, 254). Though shortlived (1920–21), it was the first magazine designed specifically for African American children. At the time of the publication of *The Brownies' Book*, most white children's literature stereotyped African Americans as black sambos—innocent savages. Du Bois and Fauset planned to use the journal to educate young readers about their heritage, to present them with concrete examples of proper social conduct, and to provide them with the necessary skills to live, work, and thrive in a racist and oppressive society. In the process of instructing these young people, Du Bois and Fauset also reshaped children's literature in America.

In the first issue, Du Bois sketched out the goals for *The Brownies' Book*: to help young people realize that being "colored" is a "normal beautiful thing"; to familiarize children with "the history and achievements of the Negro race"; and to give children African American role models and teach them "a delicate code of honor and action in their relations with white children" (Du Bois 1919, 286). The overall aim was to give black children a strong sense of self-confidence and self-worth in a society that shamed and debased them. The magazine was remarkable not only in its overall concept but also in the quality of its workmanship. Langston Hughes's poem, "Fairies," first appeared in *The Brownies' Book*, as did the early paintings and drawings of such artists as Laura Wheeler Waring. As she did in *Crisis*, Fauset published and encouraged the work of African American women writers, including Georgia Douglass Johnson and Effie Lee Newsome, and launched the careers of a number of other writers and artists.

In her monthly column for *The Brownies' Book*, entitled "The Judge," Fauset offered political and social commentary as well as advice to children who wrote to the magazine about their day-to-day problems (Wall 1995, 54). Her column clearly laid out Fauset's educational philosophy, although a letter to Du Bois dated fifteen years earlier reveals that she had already begun its formulation: "[Do you] not believe it to be worthwhile to teach our colored men and woman [*sic*] *race* pride, *self*-pride, self-sufficiency (the right kind) and to living our lives . . . *absolutely*, instead of comparing them always with white standards? Don't you believe that we should lead them to understand that the reason we adopt . . . criteria which are also adopted by the

Anglo Saxon is because these criteria are the *best* and not essentially because they are white?" (Du Bois 1973, 66, 94–95).

As did Du Bois, Fauset advocated a classical education (language, literature, grammar, history). Like her mentor, she believed that dependency and conformity, which the public education system encouraged in its students, stifled creativity. One of her earliest essays in *Crisis* praised the Montessori method, for Fauset understood that "the value of education consists not in what you take in but in what it brings out of you. If a person has to study hard to get his lessons and does it, he develops willpower, concentration and determination, and these are the qualities which he carries out into life with him" (Fauset 1920b, 306).

African American children should read not only the classics but also biographies about the achievers of their race; thus, Fauset included a reading list in each issue. "When I was a child," she recalled in an interview, "I used to puzzle my head ruefully over the fact that in school we studied the lives of only great white people. I took it that there simply have been no great Negroes, and I was amazed when, as I grew older, I found that there were.... There should be a sort of *Plutarch's Lives* of the Negro race" (Starkey 1932, 220).

In addition to working as a literary editor and columnist, Fauset traveled throughout Europe lecturing and reporting on global issues. Back home, in 1923, she spoke to a group of African American writers and teachers on the desperate need for role models for black children: "Do our colored pupils read the great writers and stylists? Are they ever shown the prose of Shaw, Galsworthy, Mrs. Wharton, Du Bois or Conrad, or that old master of exquisite phrase and imaginative incident—Walter Pater?" (quoted in Sylvander 1981, 107). Fauset's list is telling. Although she includes an African American male and an American woman, she fails to list any white American men.

During her tenure at *Crisis*, Fauset wrote the first of her four novels. It is troubling to see how modern critics have directed their commentary to Fauset's novels rather than to her well-crafted essays, especially since their responses have been, with rare exceptions, negative. Elizabeth Ammons, however, has praised the subtlety and complexity of the novels and how these works accurately portray an African American woman artist struggling to maintain her humanity while living in a racist society (1991, 159–60). Carol Allen, too, has found in Fauset's novels "the sweeping social forces such as segregation, capitalism, racial stereotypes, and rigid gender roles" that have shaped black middle-class America (1998, 49).

Fauset's first novel, *There Is Confusion* (1924), tells the story of a black woman, Joanna Marshall, who believes that she can succeed as

an artist without succumbing to racist expectancies. It was not that she wanted to forsake her own race, Joanna asserts: "Not at all. But I want to show us to the world. I am colored, of course, but American first. Why shouldn't I speak to all America?" (1924, 76). Ruthless and ambitious, she quickly advances in her vocation as a dancer but in the process alienates herself from the black community. In the end, Joanna turns her back on her career. She marries and has a child—and becomes human again. Many critics, including Charlotte Perkins Gilman, would argue that Joanna was selling out; however, to be a black artist and to be human involves, for Fauset, maintaining connections with the African American community (Ammons 1991, 151, 159–60).

In reading criticisms of Fauset's work, the reader can see how her novels are trapped in a double bind. Present-day critics censure them for being accommodationist; her contemporaries viewed them as propaganda that promoted white middle-class values. Both sides, it appears, miss the point. Sharon Lynn Moore writes that Fauset and other Harlem Renaissance writers were attempting to present a more realistic view of the black experience and black identity (1999, i). Fauset wanted to debunk the myth that all African Americans were either part of the urban poor or freewheeling, dancing, and drinking Harlemites (Christian 1985, 173). In the preface to *The Chinaberry Tree* (1931), Fauset explains that she wanted to make known "those breathing spells in-between spaces where colored men and women work and live and go their ways" (Fauset 1931, ix). Her work as a whole clearly indicates that she *did* accept middle-class values, not because they were *white* values but because they were the best. In truth, Fauset found white American culture "lacking." In a letter to Du Bois (April 17, 1919), she writes that African Americans should work together to create "a culture and civilization of [their] own which while affording many points of contact with white American culture shall yet preserve to [them] the things which [they] consider worth while."

In addition to mentoring and nurturing of rising black artists, writers, and poets, Fauset was actively involved in political and social organizations. During her early years in Washington, she worked with the NAACP. Later, in the 1920s, Fauset became associated with the National Association of Colored Women, which organized day care centers for children and care for the elderly, founded orphanages, reformatories, and community centers, and established scholarships for African American young people.

In 1921, Fauset attended the second Pan-African Congress, held in London. The first Congress was organized in 1919 by Du Bois in part to bring together black leaders from Africa and America to map

out a plan for progress and unification (Contee 1972, 13). He had hoped that the first conference would have a positive influence on the negotiations for the Treaty of Versailles, which would affect the destiny of African countries. Although Fauset reported on the second meeting for *Crisis*, she wrote nothing about her own contributions. However, European newspapers gave her speech positive reviews. Carol Allen writes that during this period of her life, Fauset embraced the ideal of "global citizenship," which she believed would allow people to compare and contrast the laws and doctrine of their own country with others. Not only would this bring countries closer together, but it would also stimulate social advancement on a global scale (Allen 1998, 54–55).

Fauset left *Crisis* in 1926. Her biographer, Carolyn Sylvander, writes that the reason for her leaving was never made clear. We can only speculate. Did she and Du Bois have a falling out? Their relationship appeared to cool after her departure from the journal. Seeking other employment, Fauset wrote to a friend for help in finding a job. Her only stipulation, she stated, was that she did not want a teaching position. Despite her experience in the field of publishing and writing, no other opportunity presented itself, and she was forced to accept a position teaching French at a junior high school (Sylvander 1981, 65). We cannot help but wonder why Du Bois or any of the other writers whose careers she launched failed to assist her.

Sadly, Fauset is an example of how history rewrites or obliterates the contributions of women intellectuals. Current studies focus on her novels rather than on her essays, on her discovery of Langston Hughes rather than on her overall contribution to American letters during this rich period in the nation's history. According to Sylvander,

> It is not possible to define . . . the inspiration provided by *There Is Confusion* in 1924, when the only other current Black novel in the bookstore was Jean Toomer's *Cane*. One can guess at what influence Fauset's many book reviews and articles must have had on young . . . writers; what encouragement and interest in arts was given young people by her lectures and her readings and her teaching. Finally it cannot be measured, but it can be surmised as to what extent dinners, parties, small art discussion groups, and poetry readings by the fireside contributed to an atmosphere of interest, inspiration, and stimulation for Black and white writers and readers alike during the last forty years of Jessie Redmon Fauset's life (1981, 84).

The above quote uses words and phrases such as "not possible to define," "one can guess," "it can be surmised." One need not ask how history silences great women.

There Is Confusion*

It was Joanna who first acquainted Peter with himself. But neither of the children knew this at the time. And although Peter came to realize it later it was many years before he told her so. For, though he went through many changes and though these two came to speak of many things, he kept a certain inarticulateness all his lifetime.

Joanna and all the older Marshalls went to a school in West Fifty-second Street, one after another like little steps, with Joanna at first quite some distance behind. They were known throughout the school. "Those Marshall children, you know those colored children that always dress so well and as though they had someone to take care of them. Pretty nice looking children, too, if only they weren't colored. Their father is a caterer, has that place over there on Fifty-ninth Street. Makes a lot of money for a colored man."

Peter, unlike Joanna, had gone to school, one might almost say, all over New York, and nowhere for any great length of time. Meriwether had stayed longest at Mrs. Reading's but as, in later years, he more and more went off on his runs without paying his bills, Mrs. Reading frequently refused to let Peter leave the house until his father's return.

"For all 1 know he may be joinin' his father on the outside and the two of them go off together. Then where'd I be? For them few rags that Mr. Bye keeps in his room wouldn't be no good to nobody."

This enforced truancy was the least of Peter's troubles. He did not like school,—too many white people and consequently, as he saw it, too much chance for petty injustice. The result of this was that Peter at twelve, possessed it is true of a large assortment of really useful facts, lacked the fine precision, if the doubtful usefulness, of Joanna's knowledge at ten. When Miss Susan settled in the Marshalls' neighborhood and brought Peter to the school in Fifty-second Street he was found to be lacking and yet curiously in advance. "We'll try him," said the principal doubtfully, "in the fifth grade. I'll take him to Miss Shanley's room."

Miss Shanley was Joanna's teacher. She greeted Peter without enthusiasm, not because he was colored but because he was clearly a problem. Joanna spied him immediately. He was too handsome with his brown-red skin, his black silky hair that curled alluringly, his dark,

*From Jesse Redmon Fauset, *There is Confusion* (Boston: Northeastern University Press, 1924). © 1924 by Boni & Liveright, Inc., renewed 1951 by Jesse Redmon Fauset. Reprinted by permission of Liveright Publishing Corporation.

almost almond-shaped eyes, to escape her notice. But she forgot about him, too, almost immediately, for the first time Miss Shanley called on him he failed rather ignominiously. Joanna did not like stupid people and thereafter to her he simply was not.

On the contrary, Joanna had caught and retained Peter's attention. She was the only other colored person in the room and therefore to him the only one worth considering. And though at that time Joanna was still rather plain, she already had an air. Everything about her was of an exquisite perfection. Her hair was brushed till it shone, her skin glowed not only with health but obviously with cleanliness, her shoes were brown and shiny, with perfectly level heels. She wore that first week a very fine soft sage-green middy suit with a wide buff tie. The nails which finished off the rather square-tipped fingers of her small square hands, were even and rounded and shining. Peter had seen little girls with this perfection and assurance on Chestnut Street in Philadelphia and on Fifth Avenue in New York, but they had been white. He had not yet envisaged this sort of thing for his own. Perhaps he inherited his great-grandfather Joshua's spiritless acceptance of things as they are, and his belief that differences between people were not made, but had to be.

Joanna clearly stood for something in the class. Peter noted a little enviously the quality of the tone in which Miss Shanley addressed her. To other children she said, "Gertrude, can you tell me about the Articles of Confederation?" Usually she implied a doubt, which Gertrude usually justified. But she was sure of Joanna. The tenseness of her attitude might be seen to relax; her mentality prepared momentarily for a rest. "Joanna will now tell us,—" she would announce. For Joanna, having a purpose and having been drilled by Joel to the effect that final perfection is built on small intermediate perfections, got her lessons completely and in detail every day.

It was at this time and for many years thereafter characteristic of Peter that he, too, wanted to shine, but did not realize that one shone only as a result of much mental polishing personally applied. Joanna's assurance, her air of purposefulness, her indifference intrigued him and piqued him. He sidled across to the blackboard nearest her—if they were both sent to the board—cleaned hers off if she gave him a chance, managed to speak a word to her now and then. He even contrived to wait for her one day at the Girls' entrance. Joanna threw him a glance of recognition, swept by, returned.

His heart jumped within him.

"If you see my sister Sylvia,—you know her?—tell her not to wait for me. I have to go early to my music-lesson. She'll be right out."

Sylvia didn't appear for half an hour and Peter should have been at the butcher's, but he waited. Sylvia and Maggie Ellersley came out laughing and glowing. Peter gave the message.

"Thanks," said Sylvia prettily. Maggie stared after him. She was still the least bit bold in those days.

"Ain't he the best looker you ever saw, Sylvia? Such eyes! Who is he, anyway? Not ever Joanna's beau?"

"Imagine old Joanna with a beau," Sylvia laughed. "He's just a new boy in her class. He is good looking."

Some important examinations were to take place shortly and Miss Shanley planned extensive reviews. She was a thorough if somewhat unimaginative teacher and she meant to have no loose threads. So she devoted two days to geography, two more to grammar, another to history, one to the rather puzzling consideration of that mysterious study, physiology. Perhaps by now the class was a bit fed up with cramming, perhaps the children weren't really interested in physiological processes. Joanna wasn't, but she always got lessons like these doggedly, thinking "Soon we'll be past all this," or "I'm going to forget this old stuff as soon as I grow up." Poor Miss Shanley was in despair. She could not call on Joanna for everything. Pupil after pupil had failed. Her eye roved over the room and fell on Peter's black head.

She sighed. He had not even been a member of the class when she had taught this particular physiological phenomenon. "Can't anyone besides Joanna Marshall give me the 'Course of the Food'?"

Peter raised his hand. "He looks intelligent," she thought. "Well, Bye, you may try it."

"I don't think I can give it to you the way the others say it,"—the children had been reciting by rote, "but I know what happens to the food."

She knew he would fail if he didn't know it her way, but she let him begin.

This was old ground for Peter. "Look, I can draw it. See, you take the food in your mouth," he drew a rough sketch of lips, mouth cavity and gullet, "then you must chew it, masticate it, I think you said." He went on varying from his own simplified interpretation of Meriwether Bye's early instructions, past difficult names like pancreatic juice and thoracic duct, and while he talked he drew, recalling pictures from those old anatomies; expounding, flourishing. Miss Shanley stared at him in amazement. This jewel, this undiscovered diamond!

"How'd you come to know it, Peter?"

"I read it, I studied it." He did not say when. "But it's so easy to learn things about the body. It's yourself."

She quizzed him then while the other children, Joanna among them, stared open-eyed. But he knew all the simple ground which she had already covered, and much, much beyond.

"If all the children," said Miss Shanley, forgetting Peter's past, "would just get their lessons like Peter Bye and Joanna Marshall."

She had coupled their names together! And after school Joanna was waiting for him. He walked up the street with her, pleasantly conscious of her interest, her frank admiration.

"How wonderful," she breathed, "that you should know your physiology like that. What are you going to be when you grow up, a doctor?"

"A surgeon," said Peter, forgetting his old formula and expressing a resolve which her question had engendered in him just that second. He saw himself on the instant, a tall distinguished-looking man, wielding scissors and knife with deft nervous fingers. Joanna would be hovering somewhere—he was not sure how—in the offing. And she would be looking at him with this same admiration.

"My, won't you have to study?" Joanna could have told an aspirant almost to the day and measure the amount of time and effort it would take him to become a surgeon, a dentist, a lawyer, an engineer. All these things Joel discussed about his table with the intense seriousness which colored men feel when they speak of their children's futures. Alexander and Philip were to have their choice of any calling within reason. They were seventeen and fifteen now and the house swarmed with college catalogues. Schools, terms, degrees of prejudice, fields of practice,—Joanna knew them all.

"Yes," said Peter, "I suppose I will have to study. How did you come to know so much—did your father tell you?"

"Why, I get it out of books, of course." Joanna was highly indignant: "I never go to bed without getting my lessons. In fact, all I do is to get lessons of some kind—school lessons or music. You know I'm to be a great singer."

"No, I didn't know that. Perhaps you'll sing in your choir?"

Then Joanna astonished him. "In my choir—I sing there already! No! Everywhere, anywhere, Carnegie Hall and in Boston and London. You see, I'm to be famous."

"But," Peter objected, "colored people don't get any chance at that kind of thing."

"Colored people," Joanna quoted from her extensive reading, "can do everything that anybody else can do. They've already done it. Some one colored person somewhere in the world does as good a job as anyone else,—perhaps a better one. They've been kings and queens and poets and teachers and doctors and everything. I'm going to be the

one colored person who sings best in these days, and I never, never, never mean to let color interfere with anything I really want to do."

"I dance, too," she interrupted herself, "and I'll probably do that besides. Not ordinary dancing, you know, but queer beautiful things that are different from what we see around here; perhaps I'll make them up myself. You'll see! They'll have on the bill-board, 'Joanna Marshall, the famous artist,'—" She was almost dancing along the sidewalk now, her eyes and cheeks glowing.

Peter looked at her wistfully. His practical experience and the memory of his father inclined him to dubiousness. But her superb assurance carried away all his doubts.

"I don't suppose you'll ever think of just ordinary people like me?"

"But you'll be famous, too—you'll be a wonderful doctor. Do be. I can't stand stupid, common people."

"You'll always be able to stand me," said Peter with a fervor which made his statement a vow.

III The Interwar Years

During the Progressive Era (1900–1914), journalists such as Ida Tarbell reported on the corruptive influence of big business in a capitalistic society. Yet the 1920s saw a dramatic shift as some of these same writers, including Tarbell, enthusiastically applauded the efforts of captains of industry. America had become a nation controlled by a corporate system in which the dollar symbolized success.

While America expanded its economic horizons, women continued in their struggle for greater opportunities and freedoms in their public and private lives. Many hoped that the passage of the Nineteenth Amendment in 1920 would give them not only the right to vote but also a sense of solidarity and economic independence. Such was not the case. Although organizations such as the League of Women Voters were created to unite women, there was dissension. For example, members of the National Association of Colored Women looked to the predominantly white membership of the National Woman's Party and the League of Women Voters for assistance in registering African American women to vote, but the two groups failed to respond.

World War I, too, it appeared, had little positive effect on offering women greater employment opportunities. After the war, white women obtained clerical and nursing jobs as well as factory, social, and domestic work; however, African American women were still limited to farm work, teaching, and domestic service. Yet, even these opportunities were reduced during the Great Depression. By 1932 twenty-five percent of the work force was unemployed. Surprisingly, some observers blamed women for the rising unemployment. Norman Cousins wrote that ten million American men were out of work and the same number of women held jobs. His solution: "Simply fire the women, who shouldn't be working anyway, and hire the men. Presto! No unemployment. No relief rolls. No depression" (1939, 14).

Between the depression and the end of World War II, the nation fluctuated between good times and hard times, between peace and war. Various cultural trends traversed both periods: the growth of government and the labor movement, the increasing number of women in the work force, and the expansion of national culture to all regions in

America as well as the decline of local government and the barring of Hispanics and Asians from society and institutions (L. Cohen 1999, 201–2).

Dorothy Thompson and Margaret Mead influenced these trends and played pivotal roles in shaping the nation's culture during the interwar years. Thompson, whose name was as recognizable as Eleanor Roosevelt's during the 1930s, wrote about World War II from the inside. She went to Europe in 1919 as an unemployed freelance journalist and returned as America's premier war correspondent and the first woman news bureau chief. Anthropologist Mead is best known for her study of primitive societies. Much of her work in social anthropology focused on the effect that culture had on personality. Mead's influence was enormous, both in her position as an intellectual role model for young women and as a social anthropologist.

7

American Cassandra

~

Dorothy Thompson


If only someone would speak.

—Dorothy Thompson


No woman, with the exception perhaps of Eleanor Roosevelt, held greater sway over the American public during the interwar years than did Dorothy Thompson. The readers of her newspaper column *On the Record* numbered almost eight million, and one can add to this figure the six million listeners to her weekly radio program. In 1939, Thompson appeared on the cover of *Time* magazine. Her influence, according to the feature article, lay not in what she thought but in who she was: "the embodiment of an ideal, the typical modern American woman [that most women] think they would like to be: emancipated, articulate and successful, living in the thick of one of the most exciting periods of history and interpreting it to millions" ("Cartwheel" 1939, 47). Thompson's power was unmistakable. *Time* reported that she could do more for a cause than anyone other than a government official, and she did so. With one radio broadcast, she raised $40,000 for German refugees (51).

Born in Lancaster, New York, in 1894, Dorothy Thompson was the daughter of a Methodist minister. Her mother died when she was eight, and her father remarried two years later. Tensions between the stepmother and stepdaughter resulted in Dorothy being raised by relatives in Chicago. She enrolled at Syracuse University to take advantage of the free tuition it offered to children of Methodist ministers. In 1914, Thompson received her degree and for the next five years worked at a variety of jobs, including in social work, copywriting for a Manhattan advertising agency, and in public relations for a medical-reform organization in Ohio. She was also employed for a time as a publicist and

lecturer for the woman's suffrage headquarters in Buffalo, New York, a job that taught her about politics, public relations, administration, and speech giving, all of which prepared her for her future career in journalism (Mengedoht 344).

After five years of working in the States, Thompson and a friend sailed for Europe with no job or promise of employment, simply a desire to become journalists. Thompson recalled that they arrived in Europe at a time when "everything . . . had been cut loose from its moorings." Democracy, socialism, and nationalism were all being redefined (Kurth 1990, 54). On shipboard, Thompson had met Zionist leaders who helped her get a job covering a Zionist conference in London. From there, she continued to take any assignments that were offered (51). Her big break into news journalism came by accident. On a trip to Ireland to visit relatives, Thompson interviewed Terrence MacSwiney, one of the leaders of the Sinn Fein rebellion. It turned out to be MacSwiney's final interview; he was arrested within the hour and later died in prison. As a result of her coup, Thompson was appointed Berlin Bureau chief for the *Philadelphia Public Ledger* in 1935, the first woman to be so named.

It was in Berlin that she met and married Nobel Prize-winning novelist Sinclair Lewis, her second husband. Her first husband, to whom she was married between 1923 and 1927, was Joseph Bard, a Hungarian poet and intellectual. After her marriage to Lewis in 1928, Thompson resigned from the *Ledger* to return to the States where she spent the next eight years lecturing and writing on international affairs. In 1931, Thompson went back to Germany to interview Adolf Hitler for *Cosmopolitan* magazine. In her book on that interview, *I Saw Hitler!* (1932), she first dismissed him, opining that he would "never come to power." Though harshly criticized for her lack of insight, Thompson was not the first person to underestimate Hitler. Her mistake, according to her biographer, Peter Kurth, "was not in minimizing Hitler, but rather in thinking that civilized people would have to realize, as she did. . . , that the Nazi menace was a world menace" (163). As a result of the book's publication, Thompson became the first foreign correspondent to be expelled from Germany on Hitler's orders, an event that made headlines and catapulted her into international fame.

In 1936, Thompson joined an elite group of New York columnists when she was contracted by Walter Lippmann to write a thrice-weekly column, *On the Record*, for the *New York Herald Tribune*. Although she was hired to address political and social problems, both domestic and global, in a way that the general reader could understand, Thompson elected instead to write columns that were sensational and opinionated as well as informative (41). She took the world as her subject

and examined every area of human life with a confidence and authority that her readers found impossible to resist (Fisher 1944, 20).

Thompson's editorials and news articles appeared in the country's foremost newspapers. Although politicians and statesmen sought her advice, her targeted audience was more often the general public. Moreover, between 1937 and 1957, she wrote a monthly column for the *Ladies' Home Journal*. In the 1930s and 1940s, Eleanor Roosevelt also wrote for the women's magazine, responding to questions of interest sent in by readers. Thompson's column differed in focus from that of the First Lady and from her own *Herald Tribune* essays. In *The Courage to Be Happy*, Thompson describes how writing for a journal with a more limited (female) audience differed from penning her newspaper columns (Thompson 1957, viii). For the *Ladies' Home Journal*, her topics focused on "more enduring things" (viii). In one column, she praised the job of homemaker. In responding to a friend who complained about listing her occupation as "Housewife" when filling out forms, Thompson reminded her of the power held by homemakers ("80 percent of American income is spent by 'housewives' "). If one were to put a monetary value on a homemaker's services, she wrote, one would have to pay six professionals (206). In reading over past *Ladies' Home Journal* columns as she was compiling them to put into book form, Thompson found them to reveal "how deeply rooted I am in my own country, . . . how all the experiences of my more adult years are checked and appraised against that background, how deeply skeptical I am of technological progress as the promise of human salvation and of many of the shibboleths that accompany it and promise by one means or another to bring about the millennium" (1938a, ix).

During her career, Thompson published several books of social commentary. In the introduction to *Dorothy Thompson's Political Guide* (1938), she describes the work as "a political dictionary—the intelligent Woman's Guide to Isms" (1938a, 13). In this brief text, she defines, for the lay person, such ideologies as collectivism, totalitarianism, communism, fascism, socialism, capitalism, and democracy. Although the book was written to educate, it was also clearly a call to action: "All my life I have been a pacifist. All my life I have hated war and loved peace. But today I seriously question whether our ways of seeking peace are not playing directly into the hands of those who love war" (33). In Thompson's view, other countries had taken America's neutrality policy as an excuse to "break treaties, invade other nations, bomb cities, blockade ports, starve women and children," since they could "count on our doing nothing" (36–37). In arguing passionately for America's involvement in the war, she quoted Ralph Waldo Emerson: "Nothing [could] bring . . . peace but the triumph of principle" (37).

As a journalist, essayist, and network broadcaster, Thompson had a variety of platforms from which to speak on a number of issues. Not surprisingly, her commentary often created controversy. Although she tried to maintain political objectivity, Thompson held strong political views, yet these strongly held views were subject to dramatic change. In the early 1930s, for example, Thompson supported Franklin D. Roosevelt's New Deal. Five years after its inception, however, she could not see any positive effect that the president's program had had on the nation's economy. She insisted that Washington could "not promote real recovery by pumping in government money to consumers' goods." Instead, "you must pump it into . . . capital goods, while seeing that workers' wages are maintained" (19). She worried that Roosevelt and his New Deal were leading America toward benevolent despotism, which she believed to be at the heart of fascism.

Lippmann hired her to write for his newspaper because of her conservative political views, even though she was touted as the spokesperson for liberal conservatism. Much to Lippmann's dismay, her views on Roosevelt underwent a dramatic shift during the war, as she became convinced that he was the best presidential choice for seeing Americans through the war. She feared that under a Republican administration there would be "the greatest concentration of political and economic power and military power that has ever occurred in our history. The industrialists of this country, engaged in making armaments, will not only be serving the state, they will be, to a great extent, the state" (Thompson 1940, 1). Her readers were shocked when she shifted her support from Wendell Willkie, the Republican candidate in the 1944 presidential election, to Roosevelt. Although Thompson admired Willkie personally, she believed that Roosevelt "kn[ew] the world better than any other living democratic head of state. . . . No new president could acquire this knowledge in weeks or in months or in four years" (quoted in Sanders 1973, 266–67). The response to her article in the *Herald Tribune* was swift and harsh. The owners of the conservative newspaper declined to renew her contract.

If there was one issue that Thompson addressed more than any other, it was the threat of fascism. In the foreword to *Let the Record Speak*, a collection of her *Herald Tribune* columns written between 1936 and 1939, she described facism as "a repudiation of the whole past of western man, . . . a complete break with Reason, with Humanism, and with Christian ethics," and a direct threat to democracy (1939, 2–3). America had a responsibility, she argued, to maintain world order and not to dismiss the dangers of fascism and Hitler's National Socialism. Despite her pacifism, Thompson believed that at some point

America would be forced to take a stand against the threat of Nazism, "since it [could] not be appeased; it [could] only be opposed" (3).

Above all, Thompson supported the democratic ideal and denounced any ideology that jeopardized it: "I know now that there are things for which I am prepared to die. I am willing to die for political freedom; for the right to give my loyalty to ideals above a nation and above a class; for the right to teach my child what I think to be the truth; for the right to explore such knowledge as my brains can penetrate; . . . for a society that seems to me becoming to the dignity of the human race" (1937). These ideas are articulated in the "Articles of Faith," her personal political creed, which she wrote to remind Americans, during this troubled period, of the true meaning of democracy and freedom (Kurth 1990, 329). At a dinner in her honor, Thompson announced that she would present subscribers to the "Articles" with a commemorative ring with the understanding that those who accepted the ring would then give it to two other people (329). The occasion marked the beginning of a grass-roots organization known as the Ring of Freedom, which later merged with other groups to form the Freedom House in New York City.

Linked to her fight for democracy was Thompson's interest in the refugee problem. During World War II she concentrated on the predicament of displaced European Jews and spoke out at a time when even Jewish organizations refused to do so for fear of reprisals. For Thompson, the refugee question was not really a "Jewish problem" but rather an economic, financial, and social issue (1938b, 377). Insisting that "charity [was] not enough," she proposed the creation of an international committee made up of members of democratic countries to address this issue. As a result, in part of her campaign for human rights, President Roosevelt organized an international conference that would create the Intergovernmental Committee on Refugees (Mengedoht 348).

Just as Thompson's politics were subject to change, so were her loyalties to specific refugee groups. Before World War II she championed Zionism, but after the war her sympathies were redirected toward the Palestinian Arabs, and she later served as president of the American Friends of the Middle East. As a result of her pro-Arab views, several newspapers dropped her column. The Jewish press, which had earlier lionized her, now labeled her a traitor and vilified her. Rumors about Thompson began to flourish: she had become an alcoholic; she had failed to show up for speaking engagements; she had taken bribes from King Faruk (Kurth 429–30).

Though urged by friends to use the court system to fight back, Thompson refused. Despite her enormous popularity and high salaries,

she openly risked both for a just cause. Thompson continued to speak out, not just for herself and not just for Arabs, but "for all those people who want to keep alive the right to disagree with the totality of the trends of the times. . . . I have written and said what I believe to be the limpid truth, with malice towards none. The test of the truth, in this question, as in all others, will be made by the developments of history" (quoted in Kurth 430).

Write It Down*

Write it down. On Saturday, February 12, 1938, Germany won the world war, and dictated, in Berchtesgaden, a peace treaty to make the Treaty of Versailles look like one of the great humane documents of the ages.

Write it down. On Saturday, February 12, 1938, Naziism started on the march across all of Europe east of the Rhine.

Write it down that the world revolution began in earnest—and perhaps the world war.

Write it down that what not even the leaders of the German army could stomach—they protested, they resigned, they lost their posts—so-called Christian and democratic civilization accepted, without risking one drop of brave blood.

Write it down that the democratic world broke its promises and its oaths, and capitulated, not before strength, but before terrible weakness, armed only with ruthlessness and audacity.

What happened?

On February 4, Hitler made a purge of his army. He ousted his chief of staff and fourteen other generals. Why? Because the army leadership refused to undertake a brazen *coup d'état* against an unarmed friendly country—their German-speaking neighbor, Austria. Why did they refuse? Because of squeamishness? Hardly. Because they thought that Britain and France would interfere? Perhaps. Or because they themselves feared the ultimate catastrophe that would be precipitated for the future by this move? I think the latter is the best guess.

A week later, Hitler, with his reorganized army, made his move. How did he make it? He called in the Chancellor of Austria, Doctor von Schuschnigg, and gave him an ultimatum. Sixty-six million people against six million people. German troops massed before Passau, on

*From Dorothy Thompson, "Write It Down" and "Freedom of Action" in *Let the Record Speak* (New York: Houghton Mifflin, 1939), 133–37, 327–31. © 1939 by Dorothy Thompson Lewis, renewed 1967 by Michael Lewis. Reprinted by permission of Houghton Mifflin Co. All rights reserved.

the Danube, before Kufstein and Salzburg in the Alps. Hitler's generals stood behind him as he interviewed the Austrian chancellor. Hitler taunted his victim: "You know as well as I know that France and Britain will not move a hand to save you." Under such circumstances there emerges what Hitler, on Sunday, will doubtless hail as a friendly reconciliation between two German-speaking peoples and the consolidation of peace in eastern Europe.

What does the Chancellor of Austria really think about Naziism?

He expressed himself hardly more than a month ago, on January 5, in the *Morning Telegraph* of London.

This is what he said:

"There is no question of ever accepting Nazi representatives in the Austrian cabinet. An absolute abyss separates Austria from Naziism. We do not like arbitrary power, we want law to rule our freedom. We reject uniformity and centralization. . . . Christendom is anchored in our very soil, and we know but one God: and that is not the State, or the Nation, or that elusive thing, Race. Our children are God's children, not to be abused by the State. We abhor terror; Austria has always been a humanitarian state. As a people, we are tolerant by predisposition. Any change now, in our *status quo*, could only be for the worse."

And he spoke in a room where hangs the death mask of his predecessor, Chancellor Engelbert Dollfuss, his own greatest friend, who was assassinated by the Nazis in 1934. And in the adjoining room, a lamp burns continually before a shrine, which belonged to Dollfuss, and is set on the spot where he fell.

In 1933, to please another despot, Mussolini, Dollfuss himself dissolved the Social Democratic Party and shot workmen in their own homes. Not to please Austria. To please Mussolini. And the little daughter of Dollfuss said to the child of a friend of mine: "Does your father cry all the time? Mine does."

Why does Germany want Austria? For raw materials? It has none of consequence. To add to German prosperity? It inherits a poor country with serious problems. But strategically, it is the key to the whole of central Europe. *Czechoslovakia is now surrounded. The wheat fields of Hungary and the oil fields of Rumania are now open. Not one of them will be able to stand the pressure of German domination.* One of them, and one only, might fight: Czechoslovakia. And that would mean: either another Spain or, immediately, a world war.

It is horror walking. Not that "Germany" joins with Austria. We are not talking of "Germany." We see a new Crusade, under a pagan totem, worshiping "blood" and "soil," preaching the holiness of the sword, glorifying conquest, despising the Slavs, whom it conceives to be its

historic "mission" to rule; subjecting all of life to a collectivist militarized state; persecuting men and women of Jewish blood, however diluted it may be; moving now into the historic stronghold of Catholic Christianity, into an area of mixed races and mixed nationalities, which a thousand years of Austro-Hungarian Empire could only rule tolerably with tolerance. And led by a patricide. For Adolf Hitler's first hatred was not Communism, but Austria-Hungary. Read "Mein Kampf." And he loathed it for what? For its tolerance! He wanted eighty million Germans to rule with an iron hand an empire of eighty million "inferiors"—Czechs, Slovaks, Magyars, Jews, Serbs, Poles and Croats.

Today, all of Europe east of the Rhine is cut off completely from the western world. The swastika banner, we are told, is the crusader's flag against Bolshevism! Madness! Only the signs of the flags divide them. Oswald Spengler wrote, in our times, "We shall see the era of world wars and of Caesarism." Ortega y Gasset wrote, "We shall see the rise of barbarism."

Both are here recorded—in the morning newspapers.

And it never needed to have happened. One strong voice of one strong power could have stopped it.

Tomorrow, one of two things can happen. Despotism can settle into horrible stagnation, through the lack of real leadership and creative brains. For the law of despotisms is that they decapitate the good, and the brave, and the wise. The Danubian Basin, into which Hitler now moves, has ruined many. And a wiser man than Hitler, Bismarck, fought his first war to break Germany loose from its headaches. Perhaps, then, all of Europe east of the Rhine will become, eventually, a no-man's-land of poverty, militarism and futility. But none the less a plague spot.

More likely the other law of despotism's nature—the law of perpetual aggressiveness—will cause it to move always, farther and onward, emboldened, and strengthened, by each success.

To the point where civilization will take a last stand. For take a stand it will. Of that there is not the slightest doubt.

Too bad that it did not take it this week.

February 18, 1938

Freedom of Action

This country wants peace, security and freedom to live its own life the way it wishes to live it. These three things may be compatible, but there are times in history when they are not. The second two are a

definition of the first. The absence of war, accompanied by a condition of extreme insecurity and with the conditions of life dictated by somebody else or some other nation or some combination of nations, is not peace. It is either an armistice between wars or permanent slavery.

This country has a very good chance of maintaining peace, security and freedom to live in the kind of society we ourselves wish to make. The condition of our maintaining these three, which together mean real peace, is freedom of action. Therefore we ought to repeal the Neutrality Act. We ought not to repeal it because we want to make the world safe for democracy. We ought not to repeal it because we want to stand behind the British and French. We ought not to repeal it because we want to be the Galahad of the world.

We ought to repeal it because through it we restrict our own actions, in a world where we cannot possibly know what is going to happen from one day to the next.

We ought, in the second place, to maintain our freedom of action by making no definite commitments at this time.

The present British policy is still not at all clear. Both the British and the French are still being run by exactly the same people and exactly the same cabinets who are responsible for the present state of affairs in their countries. It is very difficult to have faith that France will pursue a straightforward policy as long as M. Bonnet is foreign minister, or that Britain may not in some fashion repeat the procedure of September as long as Mr. Chamberlain is prime minister and Sir John Simon and Sir Samuel Hoare are in the cabinet and Anthony Eden is not.

Chamberlain's attempt at this time to unite all the small countries and Russia in an anti-aggression front—that is to say, to restore the system of collective security which he, Sir John Simon and Sir Samuel Hoare did so much to destroy—may succeed. But Mr. Chamberlain's changing his mind does not automatically create a new situation. It puts the Poles *and* the Russians in a very strong bargaining position, and exactly what the Polish policy is, is not at all clear from reading the Polish press.

Officially, judging from the press, Poland is still playing both ends against the middle. We still do not know whether Chamberlain has purchased a few days or months of armistice or laid the foundations of a new system strong enough to maintain peace.

The editorial of the London *Times* which hints that some concessions might be made has been officially repudiated, but so was that other *Times* editorial suggesting that it might be a good thing to detach the Sudetenland—at the same time that Mr. Chamberlain was repeating

his pledges to France and the French government was insisting on its intention of standing by Czechoslovakia.

There are two bills sponsored by Senator Pittman, and neither of them is wise. The provision that we should sell arms in time of war only to those nations that can pay cash and carry off the goods relegates the foreign policy of this country to a very low point of the grossest materialism. As a piece of legislation representing any permanent policy it is a fake.

His other bill, proposing that our government undertake in government plants to manufacture munitions for South America, tends to get us into a most terrible jam, for it puts our government itself into the business of supplying arms to South American countries who may possibly become embroiled with one another. And it may at some future date be the cause of subjecting our government to enormous pressures from outside.

Nor can I whole-heartedly concur with the proposal that the President of the United States shall be given the power to decide who is and who is not an aggressor, and on that basis control the supply of arms.

In the world at present there is no longer any criterion as to what is and what is not aggression, because there is nothing remotely approaching international law.

And, again, our policy will be determined by our vital interests. If, for instance, we had unquestionable information that Germany intended to seize the Azores, I think our navy would believe it to be in our vital interest to get there first. But the German government would certainly regard this as an act of wanton, aggressive imperialism.

I agree with Mr. Stimson that the world is in the most serious crisis in at least four hundred years. It is not at all certain that it is not the most serious crisis since the collapse of the Roman Empire. For we are dealing with a combination of military aggression plus revolution. And the revolution is one that cuts itself off from such conceptions of the State as have not been challenged since the fourth century—not even by Napoleon—and which works with political and propaganda methods which are unique to the modern world.

In a time like this one is forced to live from day to day. Therefore, it is suicidal to tie one's hands by legislation designed to deal with situations which cannot be foreseen. The Neutrality Act has already in its short existence been amended three times. It is safe to predict that if it is again amended it will be amended yet again and again—whenever some new situation arises.

Meanwhile, by the very nature of things, leadership in foreign affairs is, actually, in the hands of the President and the secretary of state. Day by day we take diplomatic action, Neutrality Act or no Neu-

trality Act, which leads us in a certain direction, and which will in the end be determining.

But while we live from day to day, the one rock on which our security stands is the maintenance of freedom of action. We ought to maintain that freedom on all three fronts: legislative, diplomatic and military.

Maintaining it on the legislative front means that we do not weaken our bargaining power or our competence to act quickly by tying our own hands by laws.

Maintaining it on the diplomatic front means that we do not make commitments in advance of a very exact knowledge of what we are committing ourselves to.

Maintaining it on the military front means that we adopt a policy and stick to it. That policy is determined, in the first place, by geography. Our immense advantage is to be a continental power on two oceans, with a northern neighbor with whom we have had no quarrel for more than a hundred years, and with such resources that we can certainly defend this continent and even this hemisphere.

We ought never to allow air bases to be established by any potentially hostile government within bombing distance from our shores, and if it is perfectly clear that any attempt to do so will most certainly evoke immediate action it is extremely unlikely that the attempt will ever be made.

But we are bound, again, in the nature of things, to entrust our safety to our State Department and to our armed forces, always with the restraining influence of a public opinion that is hostile to sentimental adventures and inexorably opposed to permanent alliances as between states.

This does not mean that we will not or should not collaborate on occasion and in crises with those whose interests are synonymous at the moment with ours. Washington never recommended that we should always and on all occasions avoid temporary alliances. He recommended that we should make no alliances that we cannot change at our own will and in accordance with our own interests. In other words, he recommended freedom of action.

April 7, 1939

8
An Unsuitable Job for a Woman
~
Margaret Mead

> I had no reason to doubt that brains were suitable for a woman.
> —Margaret Mead

Margaret Mead's career spanned fifty years. At the time of her death in 1978, she had written over forty books and more than one thousand articles on topics including cross-cultural communications, mental and spiritual health, comparative child psychology, world hunger, oceanic ethnology, pollution, military duty, city planning, population control, and alcoholism. In addition, she completed field studies in Samoa, New Guinea, and Bali as well as in other countries. Mead was also one of the first to use Freudian psychology in field studies and played a key role in forging links between anthropology and other disciplines. As Stephen Toulmin notes, Mead did not want to "fence off anthropology" (1999, xi). Instead, she sought to use it to understand the work in other disciplines. During her long career, she taught at Vassar College and Columbia University, lectured throughout the world, and worked in the Department of Anthropology at the Museum of Natural History in New York from 1926 until her death. Yet with all these accomplishments, there were major disappointments. Mead was not as successful as one would have expected of a scientist of such renown. Though the nation's leading anthropologist, she was not elected president of the American Anthropological Association until 1960, nor was she named curator of the Museum of Natural History until 1964. But perhaps most surprising, Columbia never offered her a full professorship (Lapsley 1999, 307).

Like all the women discussed thus far, Margaret Mead was a complex woman. Strong-willed and highly opinionated, she had stalwart advocates and opponents alike. In 1983, five years after her death, Derek Freeman published *Margaret Mead and Samoa: The Making*

and Unmaking of an Anthropological Myth based on his own study of Samoans in the 1960s. His book, however, is little more than a denunciation of Mead's groundbreaking study, *Coming of Age in Samoa* (1928). In *Margaret Mead and Samoa*, Freeman questions the "scientific adequacy" of Mead's portrayal of Samoan society. He finds her depiction "defective" and her assertion that "culture, or nurture, is all-important in the determination of adolescence and other aspects of human behavior [to be] . . . ungrounded and invalid" (Freeman 1983, 83). *Margaret Mead and Samoa* details the various differences in their separate findings. Whereas Mead described the Samoan girls as sexually permissive and Samoan adolescence as stress free, Freeman found a high rate of crime and delinquency. In his book, the first of four on this topic, Freeman stops short of accusing Mead of fraud, instead attributing the dismal failure of her study to her immaturity and inexperience, her inability to speak the language, the smallness of her sample, and her seeming inability to recognize that the Samoan youth were speaking not necessarily the truth but simply what Mead wanted to hear.

Freeman's assertions go well beyond collegial disagreements, however. The book is a cruel and caustic attack that uses Mead's alleged bisexuality to deface her credibility as an anthropologist. Mead, he asserts, exaggerated the case of cultural relativity to justify her own "deviant" sexual behavior (Obropta 1995, 34).

Response to Freeman has been mixed. Though asserting that Mead's perspective of island life was "romanticized" and that Mead failed to address "the political economy of colonialism" in her study, Eleanor Leacock asserts that many of Freeman's own arguments are both "ahistorical and contextless" (1992, 19, 7). For example, Freeman's study indicates that there is a high rate of delinquency and crime among Samoan youth—a quite different finding from Mead's in 1925. However, one must remember that Freeman's findings came forty years after Mead's. In addition, he asserts that Mead's description of the sexual permissiveness of Samoan youth was a "negative instance" when, in fact, Bronislaw Malinowski's published study on peoples of the Western Pacific supported Mead's finding (8).

Since 1983, Freeman has steadily continued his attack, the most recent salvo being *The Fateful Hoaxing of Margaret Mead: A Historical Analysis of Her Samoan Research* (1998). Also, not surprisingly, scientists and sociologists have continued to write about the Mead-Freeman conflict. Martin Gardner in 1993 labeled the feud as "the greatest controversy in one hundred years" (1993, 131–35). What is most disturbing about this feud is that Margaret Mead can no longer defend herself. No one stands in her corner on her behalf to say, "But

what about . . . ?" Indeed, she shares the experiences of many women in this study. Margaret Fuller and Charlotte Perkins Gilman, for example, were posthumously denounced; and, in Fuller's case, her very words were "rewritten" for public consumption by her editors. It is disheartening to read the ways in which these women intellectuals shaped public opinion during their lifetime and then to discover how quickly their contributions were rejected after their death.

Margaret Mead was born at the turn of the century in Philadelphia, the eldest of five children. She writes in her autobiography that the two greatest influences during her childhood were her mother and her paternal grandmother. Her mother, Emily Fogg Mead, believed that a woman should develop her "own intellectual life and to be a responsible citizen in a world in which there were many wrongs—wrongs to the poor and the downtrodden, to foreigners, to Negroes, to women—that had to be set right" (Mead 1972, 22). Her grandmother, Martha, gave "me my ease in being a woman" (43). She had been a college graduate and successfully juggled a career, a marriage, and a child, as Mead herself would later do when she and her third husband, Gregory Bateson, had a daughter, Mary Catherine. In childhood, Mead had encouraging teachers who helped her see that there was "no reason to doubt that brains were suitable for a woman" (54).

Mead's education was remarkable for its lack of cohesiveness. In her early years, her parents moved often; at times she attended public school while at other times her grandmother home-schooled her (71). Although Mead was a bright student, her father, Edward, a sociologist with a Victorian mindset, insisted that since she was destined for marriage, she would not need a college education—a surprising remark considering that he was married to a woman who worked on her doctorate when their daughter was born (34). Mead's mother persuaded her husband to let their daughter attend his alma mater, DePauw University, which she did for one disappointing year before transferring to Barnard College.

After graduating Phi Beta Kappa from Barnard, Mead continued her graduate work at Columbia University, receiving an M.A. in psychology and a Ph.D. in anthropology. As an undergraduate, she met Franz Boas, the brilliant but controversial chair of Columbia's Anthropology Department, and his assistant, Ruth Benedict, who would first serve as her mentor and later as her lover (Lapsley 1999, 1). Undecided in her career path, Mead sought advice from Benedict about whether to go into the field of sociology or psychology. Benedict advised neither and instead told her that she and Boas could offer her nothing "but an opportunity to do work that matters" (Mead 1972, 114).

Franz Boas had rejected theories that gave biological existence priority over social conditioning. The individual, he contended, could not be studied apart from his or her environs; rather, cultural knowledge is founded on the knowledge of individuals living in that society (Foerstel 1992, 56). As a graduate student studying under Boas, Mead knew that she "wanted to work on change: on the way in which new customs in a new country or new ways of life in an old country were related to older ones" (1972, 125). Boas had initially directed Mead to study Native Americans, but she resisted, wanting instead to work with a group that had not been the focus of so many anthropological studies (130). After much debate, she finally received permission from Boas and financing from her father. Mead left for Samoa to research the adolescent girl.

On the island, she studied sixty-eight girls between the ages of nine and twenty who lived in a community of six hundred people. Mead's research revealed Samoa to be "a place where no one play[ed] for very high stakes. No one pa[id] very heavy prices. No one suffer[ed] for his convictions or f[ought] to the death for special ends" (1928, 110). Samoa, she wrote, was a primitive and homogeneous society, the customs of which were slow to change (114). The results of her research, which would later become the best-seller, *Coming of Age in Samoa*, differed from other studies of the period in that it did not have an ethnocentric slant that favored Western cultural practices over those of the Samoans. In fact, the final two chapters of this seminal work focused on what Americans could learn from the Samoans.

Coming of Age is important for a number of reasons. It was one of the first studies to focus on adolescent girls. Boyce Rensberger writes that until Mead went to Samoa, most anthropologists ignored women and children (1988, 9, 27). Her work is also one of the earliest examples of applied anthropology, a field that for Mead involves working to change social conditions, either by acting as a government or voluntary consultant or as an eyewitness reporter on the scene (1969, 437). Thus, she hoped that her study would help sociologists understand the behavior of American youth. "As the traveler who has once been from home is wiser than he who has never left his own doorstep, so a knowledge of one other culture should sharpen our ability to scrutinize more steadily, to appreciate more lovingly, our own" (Mead, 1928).

Most important, perhaps, Mead's conclusions gave strength to the view that culture and not genetics was the primary influence in the development of an individual's personality. In 1904, G. Stanley Hall had written that an individual's racial past determined his or her behavior; moreover, in all cultures, adolescence was a stressful and turbulent time (1904, 827). In her own study, Mead wanted to answer the

question, "Were these difficulties due to being adolescent or to being adolescent in America?" (1928, 3). *Coming of Age* was obviously a polemical work that served both as an indictment of American society and as a tool for change, just as Lydia Maria Child's *The First Settlers of New-England* had one hundred years earlier.

At the time of the book's publication, eugenics—the science of racial improvement through better breeding—was being espoused politically as well as scientifically. Proponents of eugenics were able to enact laws in thirty states for the involuntary sterilization of the mentally ill or mentally retarded. Their efforts also led in 1924 to the passage of the Johnson Act, which dramatically restricted immigration. Mead, however, recognized that "as long as genetic markers—pigmentation, hair form, facial configuration—are used to identify, stigmatize, or glorify certain portions of the population in ways that give them differential access to education, to economic resources, and to deference, the biological knowledge of the inheritance and significance of such characteristics will be socially and politically important" (Mead et al. 1968, 169).

The publication in 1928 of *Coming of Age in Samoa* catapulted its author into fame. Why did Mead choose to publish her scientific research for the general public rather than for an academic audience? Lenora Foerstel and Angela Gilliam have observed that at Columbia during the 1920s, women scholars rarely became "intellectual stars." Therefore, women such as Mead who never held a position higher than adjunct professor looked beyond the university for professional recognition (1992, 109). Although Foerstel and Gilliam are correct in their assertion, perhaps the answer, at least in the case of Margaret Mead, is more complex and at the same time simpler.

Early in her life, Mead knew that she wanted to make a difference (1972, 111). In *Coming of Age* as in later works, such as *Male and Female: A Study of the Sexes in a Changing World* (1949), she avoided technical language to reach the general reader, thus blurring the boundaries between belletristic and scientific writing. In *With a Daughter's Eye*, Mead's daughter, Mary Catherine Bateson, writes that her mother used "evocative language" to make her findings accessible to expert and nonexpert alike, but the way she conveyed her message led readers to respond with their emotions as well as with their intellect (1984, 201).

Other women public intellectuals including Harriet Martineau, Margaret Fuller, and bell hooks have used this approach. Mead wanted her readers to use their acquaintance with Samoan culture to address problems confronting their own society. For "what is the point of studying the lives of peoples in other countries, [Stephen Toulmin writes,]

unless these studies could teach us something about the ways we ourselves live?" (1999, xi). This purpose was made clear in Mead's introduction to *Coming of Age*: "The strongest light [of this study] will fall upon the ways in which Samoan education . . . differs from our own. And from this contrast we may be able to turn . . . to judge anew and perhaps fashion differently the education we give our children" (1928, 13).

In 1931, Mead traveled to New Guinea to study sex roles in three major tribes. Her findings, which were later published in *Sex and Temperament in Three Primitive Societies* (1939), describe the cultures of the Arapesh, Mundugumor, and Tchambuli. As did her earlier work, this study also supported the view that patterns of social behavior were not innate but socially derived. Mead discovered that both men and women of the Arapesh played equal roles in childrearing. In the Mundugumor tribe, however, men and women were less nurturing, often leaving their children to take care of themselves or, if they were infants of the wrong sex (female), drowning them (279). Interestingly, the Tchambuli were matriarchal, with the woman as the dominant partner and the man the more emotionally dependent (279). Mead concluded that the customs of the three tribes suggest that "we no longer have any basis for regarding such aspects of behavior [women as dependent and passive and men as masculine and aggressive] as sex-linked" (280).

Male and Female continued Mead's exploration of gender roles. In *Coming of Age*, she had examined cultural factors, but in *Male and Female* she employed Freudian psychology in her search for biological determinants that would explain gender roles in a particular culture. In her study of Oceanic cultures, for example, Mead noted that boys appeared to suffer from womb envy. The boys' uncertainty about their role in procreation led them toward outward acts of creativity while young girls who fully understood their role in procreation concentrated "on being rather than doing" (1949, 87).

In *Male and Female*, Mead also explored the concept of national character, which involves studying cultures and countries at a distance to see if any shared characteristics existed. In her observations, she noticed that in American culture, adults expected their children, specifically their sons, to achieve higher goals and status than they themselves had attained. *Male and Female* is problematic in that Mead emphasizes woman's primary role as that of child-bearer. She also advises women not to enter fields defined by their culture as masculine since it "frightens" men and desexualizes women (331). Her comment is ironic in that, on the one hand, she asserts that behavior is not sex linked but, on the other hand, implies that it is or should be.

Another area of controversy in Mead's work is her creation of the National Character research program that served the war effort. In 1943 she wrote that it was of national importance for military leaders and tacticians to understand the behavior and attitudes of U.S.-born Japanese; this information would give insight into the mind of the Japanese soldier and his "special strengths and weaknesses" (1943, 139). Not only would the information help in the development of direct and psychological warfare, but it would also promote Allied cooperation and facilitate world reorganization once the war ended (137). Mead's work in this area continued after World War II but focused primarily on Eastern Europe and Communist countries.

As noted at the beginning of this chapter, Margaret Mead was a complex woman filled with contradictions. She argued for women's education, yet she also believed that women's primary role in society was biological. At times, writes Hillary Lapsley in *Margaret Mead and Ruth Benedict: The Kinship of Women*, Mead was irritated at being viewed as "a grandmotherly figure" to feminists. She associated the women's liberation movement with the previous generation, even though she was fully cognizant of current social forces that prevented women from succeeding in the workplace (1999, 307). Nonetheless, her work in diverse areas is united by a common theme. Mary Catherine Bateson remarks that "through my mother's writing echoes the question, 'What kind of world can we build for our children?' She thought in terms of building" (1984, 16). Margaret Mead believed that "a small group of thoughtful people could change the world. Indeed, it's the only thing that ever has."

Excerpts from *Blackberry Winter**

I wanted to make a contribution. It seemed to me then—as it still does—that science is an activity in which there is room for many degrees, as well as many kinds, of giftedness. It is an activity in which any individual, by finding his own level, can make a true contribution. So I chose science—and to me that meant one of the social sciences. My problem then was which of the social sciences?

*From Margaret Mead, *Blackberry Winter: My Earlier Years* (New York: HarperCollins, 1972), 111–13, 125–31, 292–93. © 1972 by Margaret Mead. Reprinted by permission of HarperCollins Publishers Inc.

I entered my senior year committed to psychology, but I also took a course on psychological aspects of culture given by William Fielding Ogburn, one of the first courses in which Freudian psychology was treated with respect. I had also to choose between the two most distinguished courses open to seniors—a philosophy course given by William Pepperell Montague and the course in anthropology given by Franz Boas. I chose anthropology. . . .

Boas was a surprising and somewhat frightening teacher. He has a bad side and a good side of his face. On one side there was a long dueling scar from his student days in Germany—an unusual pursuit for a Jewish student—on which his eyelid drooped and teared from a recent stroke. But seen from the other side, his face showed him to be as handsome as he had been as a young man. His lectures were polished and clear. . . .

Ruth Benedict was Boas's teaching assistant. She was tentative and shy and always wore the same dress. She spoke so hesitatingly that many students were put off by her manner, but Marie Bloomfield and I were increasingly fascinated. . . .

By the spring I was actively considering the possibility of entering anthropology, but I was already launched on my Master's essay in psychology. Then one day, when I was at lunch with Ruth Benedict and was discussing with her whether to go into sociology, as Ogburn wanted me to do, or into psychology, as I had already planned to do, she said, "Professor Boas and I have nothing to offer but an opportunity to do work that matters." That settled it for me. Anthropology had to be done *now*. Other things could wait. . . .

I knew that I wanted to do field work as soon as I had my degree. Fortunately, the library work for my dissertation was already well under way. Luther* proposed working out an adaptation that would allow him to pursue further studies that were open to him and, at the same time, allow me to go to the field. He would get a European travel fellowship for the next year, 1925–1926, and I would get a fellowship to take me to the field.

The choice of a field and a people and a problem on which to start work—all this was much more difficult. I wanted to work on change: on the way in which new customs in a new country or new ways of life in an old country were related to older ones.

*After graduating in 1923, Margaret Mead married Luther Cressman, a minister and archeologist. Their marriage ended in 1928. In the same year she married Dr. Reo Fortune, with whom she published *Growing Up in New Guinea* (1930).

The choice of where I went to the field and what problem I would work on was not mine alone to make. The final decision rested with Boas, and he wanted me to study adolescence.

He had reached one of those watersheds that occur in the lives of statesmen-scientists who are mapping out the whole course of a discipline. He felt that sufficient work had gone into demonstrating that peoples borrowed from one another, that no society evolved in isolation, but was continually influenced in its development by other peoples, other cultures, and other, differing, levels of technology. He decided that the time had come to tackle the set of problems that linked the development of individuals to what was distinctive in the culture in which they were reared. In the summer of 1924, when Ruth Bunzel said she wanted to go to Zuni, he suggested that she work on the role of the individual artist. Now he wanted me to work on adolescence, on the adolescent girl, to test out, on the one hand, the extent to which the troubles of adolescence, called in German *Sturm und Drang* and *Weltschmerz*, depended upon the attitudes of a particular culture and, on the other hand, the extent to which they were inherent in the adolescent stage of psychobiological development with all its discrepancies, uneven growth, and new impulses.

Scientists who are building a new discipline have to keep in mind the necessary next steps. In Boas' case, there were two additional considerations: first, the materials on which the new science depended were fast vanishing, and forever. The last primitive peoples were being contacted, missionized, given new tools and new ideas. Their primitive cultures would soon become changed beyond recovery. Among many American Indian groups the last old women who spoke a language that had developed over thousands of years were already senile and babbling in their cups; the last man who had ever been on a buffalo hunt would soon die. The time to do the work was *now*. And secondly, there were few sources of funds and very few people to do the work. In 1924 there were four graduate students in anthropology at Columbia and a mere handful in other universities. He had to plan—much as if he were a general with only a handful of troops available to save a whole country—where to place each student most strategically, so that each piece of work would count and nothing would be wasted and no piece of work would have to be done over.

Boas had a keen eye for the capabilities of his students although he confounded them by devoting his time to those whom he found least promising. As long as a student was doing well, he paid almost no attention to him at all. This was a loss. For good students it meant little person-to-person contact with Boas, and in some cases it led to serious errors in a student's self-estimate. With the exception of an

occasional course taught by an outsider from another institution, Boas taught everything. This meant that I saw him in classes every day. But I had only a few rare interviews with him. The first was when I told him that I wanted to do graduate work in anthropology and he advised me to go to Harvard. The second took place when I chose my thesis subject and he suggested that I compare different cultures within an area: I could work on Siberia (that would mean learning Chinese and Russian), or on the Low Countries (for which I would have to have a command of French, Dutch, German, and medieval Latin), or on Polynesia ("which you could do with only French and German"). I chose Polynesia. I gave a seminar report on one section of my work, and when I turned in my dissertation I was told to add another paragraph or so to the introduction. That was all. But now there was the question of fieldwork. . . .

I wanted to go to Polynesia, the area on which I had read so extensively. He thought it was too dangerous, and recited a sort of litany of young men who had died or been killed while they were working outside the United States. He wanted me to work among American Indians.

I wanted to study culture change, a subject that was not yet on his agenda, although it was soon to be. He wanted me to study adolescence.

Today a student would chafe against the restrictions with which we had to contend. Even then, some of my older contemporaries did chafe when Boas wanted them to work on the problems he thought came next, instead of following their own interests, like will-o'-the-wisps, wherever they led. But going to the field at all depended on his approval, for the only way to do it was to get one of the newly inaugurated graduate fellowships.

I was determined to go to Polynesia, but I was willing to compromise and study the adolescent girl, especially as the technology I had hoped to use in studying change had proved to be disappointingly inadequate. So I did what I had learned to do when I had to work things out with my father. I knew that there was one thing that mattered more to Boas than the direction taken by anthropological research. This was that he should behave like a liberal, democratic, modern man, not like a Prussian autocrat. It was enough to accuse him obliquely of exercising inappropriate authority to have him draw back. So I repeated over and over that by insisting that I work with American Indians he was preventing me from going where I wanted to work. Unable to bear the implied accusation that he was bullying me, Boas gave in. But he refused to let me go to the remote Tuamotu Islands; I must choose an island to which a ship came regularly—at least every three weeks. This was a restriction I could accept. . . .

At the same time, while I was bargaining with Boas, I told my father that Boas was trying to make me work with American Indians, already heavily contacted, instead of letting me go where things were interesting. My father, rivalrous as men often are in situations in which someone else seems to be controlling a person whom they believe they have the right—and may also have failed—to control, backed me up to the point of saying he would give me the money for a trip around the world. . . .

In 1925, when both Boas and my father let me have my way, I was simply gleeful. That was the year in which I wrote "Of Great Glee," a verse in which I expressed the sense I had of being invulnerable as long as I was moving in the right direction. . . .

Even now, when for fifty years intensive fieldwork on living primitive societies has been carried out with sophisticated methods, relatively few human scientists understand what our aims have been—and still are—or the nature of the materials that are available to them. Instead of making use of these beautiful materials, materials incorporating the fine details made possible by modern techniques of filming and taping, some of the most brilliant synthesizers still write about a kind of mythical primitive man, much as nineteenth-century armchair philosophers did, as Freud did. When I am given manuscripts to read, brilliant discussions organized with the intention of breaking through the limits of current social science theory, I find, for example, first-class biology but only rags and tatters of what is known and has been well recorded about primitive cultures and the people who embody them. . . .

When I was a graduate student I used to wake up saying to myself, "The last man on Raratonga who knows anything about the past will probably die today. I must hurry." That was when I still dimly understood anthropology as a salvage operation, and knew that we must get to the old men and old women who alone knew about the old way which, once destroyed, could never be reconstructed.

But I did not go to Samoa in 1925 to record the memories of old people about the way titles had once been distributed or how hieroglyphic taboos had been put on trees or to collect still other versions of the tales of Polynesian gods. I did not go as an antiquarian or as a representative of a discpline whose members were chiefly preoccupied with the peculiarities of kinship systems or with constructions based on primitive myths in which primitive peoples, treated as fossilized ancestors, served to prop up contemporary beliefs about the superiority or degeneration of Western society.

I went to Samoa—as, later, I went to the other societies on which I have worked—to find out more about human beings, human beings

like ourselves in everything except their culture. Through the accidents of history, these cultures had developed so differently from ours that knowledge of them could shed a kind of light upon us, upon our potentialities and our limitations, that was unique. No amount of experimental apparatus, however complex, can simulate what it is to be reared as a Samoan, an Arapesh, a Manus, or a Balinese. We can carry out innumerable carefully controlled experiments with university students and still know nothing about the kind of thing that studying peoples in different living cultures can teach us. But most people prefer to carry out the kinds of experiments that allow the scientist to feel that he is in full control of the situation rather than surrendering himself to the situation, as one must in studying human beings as they actually live.

The Significance of the Questions We Ask*

How are men and women to think about their maleness and their femaleness in this twentieth century, in which so many of our old ideas must be made new? Have we over-domesticated men, denied their natural adventurousness, tied them down to machines that are after all only glorified spindles and looms, mortars and pestles and digging sticks, all of which were once women's work? Have we cut women off from their natural closeness to their children, taught them to look for a job instead of the touch of a child's hand, for status in a competitive world rather than a unique place by a glowing hearth? In educating women like men, have we done something disastrous to both men and women alike, or have we only taken one further step in the recurrent task of building more and better on our original human nature?

These are questions which are being asked in a hundred different ways in contemporary America. Polls and tracts and magazine-articles speculate and fulminate and worry about the relationship between the sexes. In the moving pictures beautiful girls in tortoise-shell spectacles and flat-heeled shoes are first humiliated for competing with men, then they are forgiven, loved, and allowed to be glamorous only when

*From Margaret Mead, *Male and Female: A Study of the Sexes in a Changing World* (New York: HarperCollins, 1949), 3–4, 7–10, 12–13. © 1949 by Margaret Mead. Reprinted by permission of HarperCollins Publishers Inc.

they admit their error. In the advertisements on the billboards, men are now told how they, if they wear the right hat, may be the chosen one, the loved one—a role that used to be reserved for women. The old certainties of the past are gone, and everywhere there are signs of an attempt to build a new tradition, which like the old traditions that have been cast aside will again safely enfold growing boys and girls, so that they may grow up to choose each other, marry, and have children. The fashions bear the imprint of this uncertainty; the "new look" of 1947 partly captured the fleeting image of the mothers of a generation ago; the boys could again find the girls marriageable—as their mothers were—while those same girls gained a new femininity by suiting their swinging gait to the remembered feeling of ruffled skirts like those their mothers once wore. In every pair of lovers the two are likely to find themselves wondering what the next steps are in a ballet between the sexes that no longer follows traditional lines, a ballet in which each couple must make up their steps as they go along. When he is insistent, should she yield, and how much? When she is demanding, should he resist, and how firmly? Who takes the next step forward or the next step back? What is it to be a man? What is it to be a woman? . . .

The differences between the two sexes is one of the important conditions upon which we have built the many varieties of human culture that give human beings dignity and stature. In every known society, mankind has elaborated the biological division of labour into forms often very remotely related to the original biological differences that provided the original clues. Upon the contrast in bodily form and function, men have built analogies between sun and moon, night and day, goodness and evil, strength and tenderness, steadfastness and fickleness, endurance and vulnerability. Sometimes one quality has been assigned to one sex, sometimes to the other. Now it is boys who are thought of as infinitely vulnerable and in need of special cherishing care, now it is girls. In some societies it is girls for whom parents must collect a dowry or make husband-catching magic, in others the parental worry is over the difficulty of marrying off the boys. Some peoples think of women as too weak to work out of doors, others regard women as the appropriate bearers of heavy burdens, "because their heads are stronger than men's." The periodicities of female reproductive functions have appealed to some peoples as making women the natural sources of magical or religious power, to others as directly antithetical to those powers; some religions, including our European traditional religions, have assigned women an inferior role in the religious hierarchy, others have built their whole symbolic relationship with the supernatural world upon male imitations of the natural functions of

women. In some cultures women are regarded as sieves through whom the best-guarded secrets will sift; in others it is the men who are the gossips. Whether we deal with small matters or with large, with the frivolities of ornament and cosmetics or the sanctities of man's place in the universe, we find this great variety of ways, often flatly contradictory one to the other, in which the roles of the two sexes have been patterned.

But we always find the patterning. We know of no culture that has said, articulately, that there is no difference between men and women except in the way they contribute to the creation of the next generation; that otherwise in all respects they are simply human beings with varying gifts, no one of which can be exclusively assigned to either sex. We find no culture in which it has been thought that all identified traits—stupidity and brilliance, beauty and ugliness, friendliness and hostility, initiative and responsiveness, courage and patience and industry—are merely human traits. However differently the traits have been assigned, some to one sex, some to the other, and some to both, however arbitrary the assignment must be seen to be (for surely it cannot be true that women's heads are both absolutely weaker—for carrying loads—and absolutely stronger—for carrying loads—than men's), although the division has been arbitrary, it has always been there in every society of which we have any knowledge.

So in the twentieth century, as we try to re-assess our human resources, and by taking thought to add even a jot or a tittle to the stature of our fuller humanity, we are faced with a most bewildering and confusing array of apparently contradictory evidence about sex differences. We may well ask: Are they important? Do real differences exist, in addition to the obvious anatomical and physical ones—but just as biologically based—that may be masked by the learnings appropriate to any given society, but which will nevertheless be there? Will such differences run through all of men's and all of women's behaviour? Must we expect, for instance, that a brave girl may be very brave but will never have the same kind of courage as a brave boy, and that the man who works all day at a monotonous task may learn to produce far more than any woman in his society, but he will do it at a higher price to himself? Are such differences real, and *must* we take them into account? Because men and women have always in all societies built a great superstructure of socially defined sex differences that obviously cannot be true for all humanity—or the people just over the mountain would not be able to do it all in the exactly opposite fashion—must *some* such superstructures be built? We have here two different questions: Are we dealing not with a *must* that we dare not flout because it

is rooted so deep in our biological mammalian nature that to flout it means individual and social disease? Or with a *must* that, although not so deeply rooted, still is so very socially convenient and so well tried that it would be uneconomical to flout it—a *must* which says, for example, that it is easier to get children born and bred if we stylize the behaviour of the sexes very differently, teaching them to walk and dress and act in contrasting ways and to specialize in different kinds of work? But there is still the third possibility. Are not sex differences exceedingly valuable, one of the resources of our human nature that every society has used but no society has as yet begun to use to the full?

We live in an age when every inquiry must be judged in terms of urgency. Are such questions about the roles and the possible roles of the sexes academic, peripheral to the central problems of our times? Are such discussions querulous fiddling while Rome burns? I think they are not. Upon the growing accuracy with which we are able to judge our limitations and our potentialities, as human beings and in particular as human societies, will depend the survival of our civilization, which we now have the means to destroy. Never before in history has mankind had such momentous choices placed in its hands. . . .

The decisions we make now, as human beings, and as human beings who are members of groups with power to act, may bind the future as no men's decisions have ever bound it before. We are laying the foundations of a way of life that may become so world-wide that it will have no rivals, and men's imaginations will be both sheltered and imprisoned within the limits of the way we build. For in order to think creatively, men need the stimulus of contrast. We know by sad experience how difficult it is for those who have been reared within one civilization ever to get outside its categories, to imagine, for instance, what a language could be like that had thirteen genders. Oh, yes, one says, masculine, feminine, and neuter—and what in the world are the other ten? For those who have grown up to believe that blue and green are different colours it is hard even to think how any one would look at the two colours if they were not differentiated, or how it would be to think of colours only in terms of intensity and not of hue. Most American and European women simply cannot imagine what it would be like to be a happy wife in a polygamous family and share a husband's favours with two other women. We can no longer think of the absence of medical care as anything but a yawning gap to be filled at once. Inevitably, the culture within which we live shapes and limits our imaginations, and by permitting us to do and think and feel in certain ways makes it increasingly unlikely or impossible that we should do or think or feel in ways that are contradictory or tangential to it.

So, as we stand at the moment in history when we still have choice, when we are just beginning to explore the properties of human relationships, as the natural sciences have explored the properties of matter, it is of the very greatest importance which questions we ask, because by the questions we ask we set the answers that we will arrive at, and define the paths along which future generations will be able to advance.

IV Postwar America

Postwar America would best be described as a consumer culture. No longer having to ration food, gas, and other commodities, Americans made up for years of frugality with rampant spending. Seemingly overnight, the country had metamorphosed into a culture in which the production, marketing, and acquisition of consumer goods became the major influence in shaping social values. But despite the nation's affluence during the postwar years, not everyone was living the American dream. Having proved themselves as capable as men in the workforce during the war, women were relegated after the war ended to lower-paying positions or lost their jobs to returning veterans.

America faced conflicts both outside and inside its borders. In the 1940s its ally, the Soviet Union, rapidly gained control over much of Eastern Europe. The Cold War, the Korean War, and the conviction of Alger Hiss instilled in Americans fear of a Communist takeover. This national anxiety gave way to a deep paranoia best represented by the McCarthy witch trials. During the early 1950s, Republican Senator Joseph R. McCarthy conducted hearings at which he brought accusations of Communist Party affiliation against prominent individuals—unsubstantiated accusations that destroyed lives and careers and spread unease and distrust among citizens.

Confidence in the economy and the government began to falter. The Vietnam War fueled this general dissatisfaction and gave rise to antiwar protest rallies as well as to the Civil Rights movement. African Americans' radical protests for social and economic equality sparked the Women's Liberation movement, which sought to end women's oppression both inside and outside the home. By the 1950s the American Dream was founded in comfortable suburban living, which depended primarily upon the wife who had to juggle her roles as mother, chauffeur, cook, housekeeper, family manager, and sexual partner to keep the household running smoothly. By the 1960s, however, many women viewed this dream as a false front for oppression and began to question their sisters' limited domestic roles and low-paying jobs. In 1966, in response to this situation, the National Organization for Women (NOW) was formed. Its objectives were clear: to

prevent rape and domestic abuse, to achieve equal rights for women in education and employment opportunities, to exert greater influence in national and global politics, to provide child care, and to ensure the right to abortion on demand.

Both women intellectuals in this section—Cynthia Ozick and Susan Sontag—addressed various sociopolitical, class, racial, and gender issues confronting America during the 1960s and 1970s and continue to do so today. Ozick is a writer in the Judaic tradition, but her themes of social alienation and isolation are universal. Susan Sontag, perhaps America's best-known intellectual, has written on global conflicts in Vietnam and Bosnia as well as on the stigma of disease and the power of photography to control our experience.

9
Keeping Memory Alive
~
Cynthia Ozick

> In life, I am not free.
> —Cynthia Ozick

Described as a voracious reader and a "writer's writer," Cynthia Ozick is also an intellectual who speaks on cultural and social issues of the past and present through poetry, essays, novels, and drama as well as her short stories. Born in April 1928 to Russian immigrants who lived in the Bronx, Ozick grew up during the depression. Her essay, "A Drugstore in Winter," however, reveals that it little affected her life. Riding on the subway, she writes, "I don't know it's the Depression. . . . On the trolley. . . I see the children who live in the boxcar; . . . the lucky boxcar children dangle their stick-legs . . . and wave; how I envy them" (Ozick 1983, 300). She and her older brother helped her parents in their drugstore, but much of Cynthia's time was spent reading books checked out from the traveling library.

A pleasant life, it would appear, but being a Jew and a girl in New York during the 1930s proved difficult. When Ozick's grandmother took her to a rabbi for Hebrew instruction, the rabbi told her to return the child to her mother: "a girl doesn't have to study." The next day the grandmother went back, insisting that the rabbi accept Ozick as his pupil, which he did. Although Ozick proved to be an exceptional student, a "*golden kepele*" or "golden head," she points to this experience in early childhood as the beginning of her feminism (Lowin 1988, 3). Her early years in the public school system were also less than positive and left her feeling foolish and inferior. For example, she was humiliated in front of her classmates for being a Jew when she refused to sing Christmas carols. Nonetheless, Ozick recalls that these experiences led her at an early age to choose her future career. Her writing, she noted, was "buffeted into being by school hurts" (Ozick 1983, 304).

At Hunter College High School in Manhattan, Ozick at last found an environment that encouraged academic excellence. She attended New York University and graduated cum laude in 1949 with a degree in English and a Phi Beta Kappa key. Two years later, after writing her thesis on "Parable in the Later Novels of Henry James," she was awarded a Master of Arts degree from Ohio State University (6). Nineteenth-century author Henry James's influence had a deleterious effect on her writing career in its beginnings. In "The Lessons of the Master" she states that she "became Henry James," having chosen art over "ordinary human entanglement" (1996, 274). The next seven years of her life were spent working diligently on what she describes as "a cannibalistically ambitious" Jamesian novel, *Mercy, Pity, Peace, and Love*, which she eventually abandoned (278). During the six and one-half years that followed, she wrote her first novel, *Trust* (1966).

Ozick had married Bernard Hallote, a lawyer, in 1952. In the 1960s she taught for a short time, first at New York University and then at City College of New York. She retells these years in "Previsions of the Demise of the Dancing Dog." As an instructor of Freshman Composition, she discovered to her dismay that "to teach at a university is not simply to teach; the teacher is a teacher among students, but he is also a teacher among teachers. . . . I came to the university in search of the world. I had just finished an enormous novel, the writing of which had taken many more years than any novel ought to take. . . . I wanted Experience. . . . I came innocently. I had believed, through all those dark and hope-sickened years of writing, that it was myself . . . who was doing the writing" (1983, 265). What she found was that her colleagues believed "(1) that it was a 'woman' who had done the writing—not a mind—and that I was a 'woman writer'; and (2) that I was now not a teacher, but a 'woman teacher' " (266).

This incident, coupled with her earlier encounters with anti-Semitism, explains in part why Ozick rejects labels. Although many of her fictional protagonists are women and she typically writes of women's struggles as writers and survivors, Ozick disdains being called a "woman writer," viewing the term as anti-feminist: "My fundamental identity is writer . . . for the writerly brain is androgynous" (Reinstein 2000, 1). Interestingly, she is not opposed to being called a Jewish writer.

Ozick's earliest published works were poems. She began writing and publishing poetry in the 1950s and continued to submit works to the Yale Series of Younger Poets until she was forty. Ultimately, however, she gave up poetry to write the novels and short stories for which she is best known: "Writers who are artists either write poetry or have written poetry, but I don't think poets can be fiction writers" (quoted

in Bolick 1997, 1). A mixing of genres coupled with postmodern stylistic techniques complicates much of Ozick's writing. She weaves together magic realism, Judaic traditions, and Western history to create fictional works with a moral purpose.

In the introduction to one of her earlier works of fiction, *Bloodshed and Three Novellas,* Ozick describes the goal of the writer as being "to judge and interpret the world." In her own oeuvre, she achieves this goal in a manner reminiscent of Flannery O'Connor. Edmund White writes that "precisely on account of her style, Miss Ozick strikes me as one of the best American writers to have emerged in recent years. Her artistic strength derives from her moral energy, for Miss Ozick is not an aesthete. Judaism has given to her what Catholicism gave to Flannery O'Connor—authority, penetration and indignation" (White 1998, 87). Sarah Cohen also compares Ozick to O'Connor, noting that both were outsiders. While O'Connor's ironic worldview can be traced to her place as a Catholic living in the Bible Belt, Ozick's sardonic perspective is due in part to her being a Jew in a Christian society (1994, 4).

Ozick has fashioned herself as a witness to her Jewish faith and American literary history as well as to the failings of the present age. In 1970, in an address at the American-Israel Dialogue, she urged her Jewish audience to reject assimilation and embrace a "new literature of cultural rebirth" (284). And although she insists that her primary interest is in providing Jews with stories based on Judaic values and faith, she has dedicated her life to the preservation of Jewish culture (Klingenstein 1997, 56).

Faith and history are ways of making sense of the world, and this is the central concern in Ozick's work. In "Puttermesser: Her Work History, Her Ancestry, Her Afterlife," a New York lawyer, Ruth Puttermesser, Ozick's alter ego, struggles with her lost Jewish past; in the short story collection *Bloodshed*, artists must choose between God and art (Friedman 1991, 1). In *The Shawl*, Ozick responds to a question found in Ezekiel: "How is it possible to live after a destruction?" by asking, "How is it possible to bear witness to such a destruction?" (Gottfried 1994, 103). A Judaic understanding of memory, Ozick explains, "inform[s] my outlook. . . . History is the ground of our being, and together with imagination, that is what makes writing. Writing without history has been epidemic for some time now. It's a very strange American amnesiac development to put all experience in the present tense, without memory or history or a past. What is 'the past'? One damn thing after another. What is history? Judgment and interpretation" (quoted in Bolick 1997, 1). Deborah Weiner argues that Ozick sees the world divided into two parts, with the forces of each trying to

gain control of the individual: "Whether she terms it Nature versus History, Paganism versus Judaism, Pan versus Moses, or Magic versus Religion, she is talking about the same thing: the pull on the one hand of the easy life and the pull on the other of order, sense and clarification" (1983, 179).

Memory is the driving force in Ozick's fiction. *The Shawl* combines two previously published works: a short story and a novella, both of which appeared in *The New Yorker*. *The Shawl* tells the story of a Holocaust victim, Rosa, who survives the horrors of the concentration camp, the brutal death of her infant daughter, and repeated rapes by Nazi soldiers. The earlier short story, by the same name, ends with the death of the infant, Magda, who is thrown against an electric fence. The novella, entitled "Rosa," blends magic realism with history to follow Rosa after the war. It traces her move to America, her continued connection with the niece whom Rosa believes to be responsible for Magda's death, and her visions of Magda. Nevertheless, despite depression and madness, Rosa ultimately chooses life. Holocaust survivor and Nobel Laureate Elie Wiesel found Ozick's depiction of Rosa's Holocaust experience to be so real that he was forced to ask himself how Ozick could have "penetrate[d] Rosa's dark and devastated soul." The book's pages, he writes, are filled with "sadness and truth" (Wiesel 1989, 6).

These feelings of isolation and separateness, however, are not limited to Jews; Ozick's themes are universal and of critical import today. Fictional themes of social alienation and Western and Judaic tradition are also mirrored in Ozick's critical essays. The titles of her four major essay collections—*Art and Ardor* (1983), *Metaphor and Memory* (1991), *Fame and Folly* (1996), and *Quarrel and Quandary* (2000)—reflect the oppositional pulls to which Weiner refers. *Art and Ardor* offers insight into such writers as Henry James, John Updike, Harold Bloom, and Virginia Woolf. But within these same texts, Ozick expounds on language and history and memory.

Metaphor and Memory, which the *New York Times Book Review* described as revealing "the tug-of-war between written and spoken language; art as contrivance and art as moral imperative," is a collection of essays on writers such as Saul Bellow and Italo Calvino. Although Susan Sontag writes of the dangers of metaphor, Ozick explores its positive side, specifically the ways in which it can transform "memory into a principle of continuity" (Ozick 1991, 282). Sontag, however, would probably agree with Ozick's assertion that the metaphor is one of the fundamental "agents of our moral nature" (278).

The essays in *Fame and Folly* examine, not surprisingly, the fame and folly surrounding the lives and writings of famous authors such as

T. S. Eliot and Salman Rushdie (Ozick 1996, ix). The work also explores the losses that poetry has suffered in the last part of the century. In the final essay, "It Takes a Great Deal of History to Produce a Little Literature," Ozick comments on how most late twentieth-century writers view literature and writing. Today's writers speak of their task as " 'communication,' as if the meticulous making of a sentence, or the feverish uncovering of an idea, or the sting of a visionary jolt delivered by what used to be called the Muse, were no more artful than a ten-minute telephone conversation." Although literature may communicate, Ozick writes that its enduring power is "in the consummation . . . of life" (283–84).

In her most recent collection, *Quarrel and Quandary*, anger mixes with memory when she addresses such topics as the transmogrification by the media of Anne Frank or when in "Dostoyevsky's Unabomber" she compares Raskolnikov in *Crime and Punishment* to terrorist Theodore Kaczynski. Some essays reveal a certain moral urgency, such as "Who Owns Anne Frank." Here, she describes how Frank's story and diary have "been bowdlerized, distorted, transmuted, traduced, reduced; it has been infantilized, Americanized, homogenized, sentimentalized, falsified, kitschified and, in fact, blatantly and arrogantly denied" (2000, 77). History and film have made the young Jewish holocaust victim into an "all-American girl." To reject this image, Ozick lifts a line from Anne's diary—"I still believe in spite of everything, that people are truly good at heart"—and reminds the reader that this line was written *before* Anne was taken out of hiding and killed. For Ozick, "Jewish writers must retrieve the Holocaust freight car by freight car, town by town, road by road, document by document . . . [in order to] save it from becoming literature" (Ozick 1983, 19).

There is a very good reason why history should be saved from literature: "Fiction annihilates fact." In "The Rights of History and the Rights of Imagination," Ozick recalls that William Styron's *Sophie's Choice* (1979) was a popular choice among Jewish book clubs members. Ozick's concern with the novel is how it diverts attention from the "total annihilation of Jewish presence in a Poland that continues with its land, language, religion, and institutions intact" (Ozick 1999, 1). For Ozick, the past and the future, memory and the camera, become intertwined and disabused in fiction: "In the name of the autonomous rights of fiction, in the name of the sublime rights of the imagination, anomaly sweeps away memory; anomaly displaces history. In the beginning was not the word, but the camera—and at that time [World War II], in that place [Nazi Germany], the camera did not mislead. It saw what was there to see. The word came later, and in some instances it came not to illumine but to corrupt" (1).

In her interviews, Ozick describes how the essay genre is problematic, although she is a master of the form. In "She: Portrait of the Essay as a Warm Body," Ozick addresses the problem (and also that of labeling writers as mere essayists):

> Essayists are a species of metaphysician: they are inquisitive, and analytic, about the least grain of being.... It is probably an illusion that men are essayists more often than women, especially since women's essays have in the past frequently assumed the form of unpublished correspondence. (Here I should, I suppose, add a note about maleness and femaleness as a literary issue—what is popularly termed 'gender,' as if men and women were French or German tables and sofas. I should add such a note—it is the fashion, or, rather, the current expectation or obligation—but nothing useful can be said about any of it.) Essays are written by men. Essays are written by women. That is the long and the short of it (Ozick 1998, 1).

Yet, even though she asserts that an essay should not be used for social or political ends, one could hardly describe Ozick's writing as apolitical (Ozick 2000, ix–x).

In her essays as well as in her fiction Ozick challenges and calls into question political ideas and social beliefs that we in America would rather not confront. At times she dismisses her essays as diversionary, trivial, or unoriginal (Ozick 1983, x), and yet there are those rare exceptions: "Knowledge is not made out of knowledge. Knowledge swims up from invention and imagination—from ardor—and sometimes even an essay can invent, burn, guess, try out, dig up, hurtle forward, succumb to that flood of sign and nuance that adds up to intuition, disclosure, discovery" (xi).

It is surprising, then, that Ozick's most recent publications have been collections of her essays. In 1983 she had announced that the "notion of belles-lettres [was] profoundly dead," yet she continues in the genre in the hope that they might be of service. Perhaps it would be more accurate to say that she is trying to revive the genre and restore respectability to the professional "person-of-letters" (xi).

Most critics and readers view Ozick and her writing in terms of its Jewishness, but the label does Ozick a disservice. As Elaine Kauvar points out, her work has "less to do with her Jewish materials than with the quality of her art, and with her adamant refusal to simplify what is incontrovertibly complex" (1996, ix). Though a consummate artist, Ozick is an honest writer who connects the past and present of Jews and non-Jews and fearlessly explores the dark rooms of our psyche and history. What she finds in those dark rooms can be richly transformative.

We Are the Crazy Lady and Other Feisty Feminist Fables*

I: The Crazy Lady Double

A long, long time ago, in another century—1951, in fact—when you, dear younger readers, were most likely still in your nuclear-family playpen (where, if female, you cuddled a rag-baby to your potential titties, or, if male, let down virile drool over your plastic bulldozer), Lionel Trilling told me never, never to use a parenthesis in the very first sentence. This was in a graduate English seminar at Columbia University. To get into this seminar, you had to submit to a grilling wherein you renounced all former allegiance to the then-current literary religion, New Criticism, which considered that only the text existed, not the world. I passed the interview by lying, cunningly, and against my real convictions. I said that probably the world *did* exist—and walked triumphantly into the seminar room.

There were four big tables arranged in a square, with everyone's feet sticking out into the open middle of the square. You could tell who was nervous, and how much, by watching the pairs of feet twist around each other. Professor Trilling presided awesomely from the high bar of the square. His head was a majestic granite-gray, like a centurion in command; he *looked* famous. His clean shoes twitched only slightly, and only when he was angry.

It turned out he was angry at me a lot of the time. He was angry because he thought me a disrupter, a rioter, a provocateur, and a fool; also crazy. And this was twenty years ago, before these things were *de rigueur* in the universities. Everything was very quiet in those days. There were only the Cold War and Korea and Joe McCarthy and the Old Old Nixon, and the only revolutionaries around were in Henry James's *The Princess Casamassima*.

Habit governed the seminar. Where you sat the first day was where you settled forever. So, to avoid the stigmatization of the ghetto, I was careful not to sit next to the other woman in the class: the Crazy Lady.

At first the Crazy Lady appeared to be remarkably intelligent. She was older than the rest of us, somewhere in her thirties (which was why we thought of her as a Lady), with wild tan hair, a noticeably breathing bosom, eccentric gold-rimmed old-pensioner glasses, and a

*From Cynthia Ozick, "We Are the Crazy Lady and Other Feisty Feminist Fables," *MS.* 1 (Spring 1972): 40–44. Reprinted by permission of the author.

tooth-crowded wild mouth that seemed to get wilder the more she talked. She talked like a motorcycle, fast and urgent. Everything she said was almost brilliant, only not actually on point, and frenetic with hostility. She was tough and negative. She volunteered a lot and she stood up and wobbled with rage, pulling at her hair and mouth. She fought Trilling point for point, piecemeal and wholesale, mixing up queerly angled literary insights with all sorts of private and public fury. After the first meetings, he was fed up with her. The rest of us accepted that she probably wasn't all there, but in a room where everyone was on the make for recognition—you talked to save your life, and the only way to save your life was to be the smartest one that day—she was a nuisance, a distraction, a pain in the ass. The class became a bunch of Good Germans, determinedly indifferent onlookers to a vindictive match between Trilling and the Crazy Lady, until finally he subdued her by shutting his eyes, and, when that didn't always work, by cutting her dead and lecturing right across the sound of her strong, strange voice.

All this was before R. D. Laing had invented the superiority of madness, of course, and, cowards all, no one liked the thought of being tarred with the Crazy Lady's brush. Ignored by the boss, in the middle of everything she would suddenly begin to mutter to herself. She mentioned certain institutions she'd been in, and said we all belonged there. The people who sat on either side of her shifted chairs. If the Great Man ostracized the Crazy Lady, we had to do it too. But one day the Crazy Lady came in late and sat down in the seat next to mine, and stayed there the rest of the semester.

Then an odd thing happened. There, right next to me, was the noisy Crazy Lady, tall, with that sticking-out sighing chest of hers, orangey curls dripping over her nose, snuffling furiously for attention. And there was I, a brownish runt, a dozen years younger and flatter and shyer than the Crazy Lady, in no way her twin, physically or psychologically. In those days I was bone-skinny, small, sallow and myopic, and so scared I could trigger diarrhea at one glance from the Great Man. All this stress on looks is important. The Crazy Lady and I had our separate bodies, our separate brains. We handed in our separate papers.

But the Great Man never turned toward me, never at all, and if ambition broke feverishly through shyness so that I dared to push an idea audibly out of me, he shut his eyes when I put up my hand. This went on for a long time. I never got to speak, and I began to have the depressing feeling that Lionel Trilling hated me. It was no small thing to be hated by the man who had written "Wordsworth and the Rabbis" and *Matthew Arnold*, after all. What in hell was going on? I was in

trouble, because, like everyone else in that demented contest, I wanted to excel. Then, one slow afternoon, wearily, the Great Man let his eyes fall on me. He called me by name, but it was not my name—it was the Crazy Lady's. The next week the papers came back—and there, right at the top of mine, in the Great Man's own handwriting, was a rebuke to the Crazy Lady for starting an essay with a parenthesis in the first sentence, a habit he took to be a continuing sign of that unruly and unfocused mentality so often exhibited in class. And then a Singular Revelation crept coldly through me. Because the Crazy Lady and I sat side by side, because we were a connected blur of Woman, Lionel Trilling, master of ultimate distinctions, couldn't tell us apart. The Crazy Lady and I! He couldn't tell us apart! It didn't matter that the Crazy Lady was crazy! *He couldn't tell us apart!*

Moral 1: All cats are gray at night, all darkies look alike.

Moral 2: Even among intellectual humanists, every woman has a *Doppelgänger*—every other woman.

II: The Lecture, 1

I was invited by a women's group to be guest speaker at a Book-Author Luncheon. The women themselves had not really chosen me: the speaker had been selected by a male leader and imposed on them. The plan was that I would autograph copies of my book, eat a good meal and then lecture. The woman in charge of the programming phoned to ask me what my topic would be. This was a matter of some concern, since they had never had a woman author before, and no one knew how the idea would be received. I offered as my subject "The Contemporary Poem."

When the day came, everything went as scheduled—the autographing, the food, the welcoming addresses. Then it was time to go to the lectern. I aimed at the microphone and began to speak of poetry. A peculiar rustling sound flew up from the audience. All the women were lifting their programs to the light, like hundreds of wings. Confused murmurs ran along the walls. I began to feel very uncomfortable. Then I too took up the program. It read, "Topic: The Contemporary Home."

Moral: Even our ears practice the caste system.

III: The Lecture, 2

I was in another country, the only woman at a philosophical seminar lasting three days. On the third day, I was to read a paper. I had accepted

the invitation with a certain foreknowledge. I knew, for instance, that I could not dare to be the equal of any other speaker. To be an equal would be to be less. I understood that mine had to be the most original and powerful paper of all. I had no choice; I had to toil beyond my most extreme possibilities. This was not ambition, but only fear of disgrace.

For the first two days, I was invisible. When I spoke, people tapped impatiently, waiting for the interruption to be over with. No one took either my presence or my words seriously. At meals, I sat with my colleagues' wives.

The third day arrived, and I read my paper. It was successful beyond my remotest imaginings. I was interviewed, and my remarks appeared in newspapers in a language I could not understand. The Foreign Minister invited me to his home. I hobnobbed with famous poets.

Now my colleagues noticed me. But they did not notice me as a colleague. They teased and kissed me. I had become their mascot.

Moral: There is no route out of caste which does not instantly lead back into it.

IV: Propaganda

For many years, I had noticed that no book of poetry by a woman was ever reviewed without reference to the poet's sex. The curious thing was that, in the two decades of my scrutiny, there were *no* exceptions whatever. It did not matter whether the reviewer was a man or woman: in every case the question of the "feminine sensibility" of the poet was at the center of the reviewer's response. The maleness of male poets, on the other hand, hardly ever seemed to matter.

Determined to ridicule this convention, I wrote a tract, a piece of purely tendentious mockery, in the form of a short story. I called it "Virility."

The plot was, briefly, as follows: A very bad poet, lustful for fame, is despised for his pitiful lucubrations and remains unpublished. But luckily, he comes into possession of a cache of letters written by his elderly spinster aunt, who lives an obscure and secluded working-class life in a remote corner of England. The letters contain a large number of remarkable poems; the aunt, it turns out, is a genius. The bad poet publishes his find under his own name, and instantly attains worldwide adulation. Under the title *Virility*, the poems become immediate classics. They are translated into dozens of languages and are praised and revered for their unmistakably masculine qualities: their strength, passion, wisdom, energy, boldness, brutality, worldliness, robustness, authenticity, sensuality, compassion. A big, handsome, sweating man,

the poet swaggers from country to country, courted everywhere, pursued by admirers, yet respected by the most demanding critics.

Meanwhile, the old aunt dies. The supply of genius runs out. Bravely and contritely the poor poet confesses his ruse, and, in a burst of honesty, publishes the last batch under the real poet's name. The book is entitled *Flowers from Liverpool*. But the poems are at once found negligible and dismissed: "Thin feminine art," say the reviews, "a lovely girlish voice." Also: "Choked with female inwardness," and "The fine womanly intuition of a competent poetess." The poems are utterly forgotten.

I included this fable in a collection of short stories. In every review, the salvo went unnoticed. Not one reviewer recognized that the story was a sly tract. Not one reviewer saw the smirk or the point. There was one delicious comment, though. "I have some reservations," a man in Washington, D.C., wrote, "about the credibility of some of her male characters when they are chosen as narrators."

Moral: In saying what is obvious, never choose cunning. Yelling works better.

V: Hormones

During a certain period of my life, I was reading all the time, and fairly obsessively. Sometimes, though, sunk in a book of criticism or philosophy, I would be brought up short. Consider: here is a paragraph that excites the intellect. Inwardly, one assents passionately to its premises; the writer's idea is an exact diagram of one's own deepest psychology or conviction; one feels oneself seized as for a portrait. Then the disclaimer: "It is, however, otherwise with the female sex...." A rebuke from the World of Thinking, *I didn't mean you, lady*. In the instant one is in possession of one's humanity most intensely, it is ripped away.

These moments I discounted. What is wrong—intrinsically, psychologically, culturally, morally—can be dismissed.

But to dismiss in this manner is to falsify one's most genuine actuality. A Jew reading of the aesthetic glories of European civilization without taking notice of his victimization during, say, the era of the building of the great cathedrals, is self-forgetful in the most dangerous way. So would be a black who read of King Cotton with an economist's objectivity.

I am not offering any strict analogy between the situation of women and the history of Jews or colonialized blacks, as many politically radical women do (though the analogy with blacks is much the more frequent one). It seems to me to be abusive of language in the extreme

when some women speak, in the generation after Auschwitz, in the very hour of the Bengali horror, of the "oppression" of women. Language makes culture, and we make a rotten culture when we abuse words. We raise up rotten heroines. I use "rotten" with particular attention to its precise meanings: foul, putrid, tainted, stinking. I am thinking now especially of a radical women's publication, *Off Our Backs*, which not long ago presented Leila Khaled, terrorist and foiled murderer, as a model for the political conduct of women.

But if I would not support the extreme analogy (and am never surprised when black women, who have a more historical comprehension of actual, not figurative, oppression, refuse to support the analogy), it is anyhow curious to see what happens to the general culture when any enforced class in any historical or social condition is compelled to doubt its own self-understanding, when identity is extremely defined, when individual humanity is called into question as being different from "standard" humanity. What happens is that the general culture, along with the object of its debasement, is also debased. If you laugh at women, you play Beethoven in vain. If you laugh at women, your laboratory will lie.

We can read in Charlotte Perkins Gilman's 1912 essay, "Are Women Human Beings?", an account of an opinion current sixty years ago. Women, said one scientist, are not only "not the human race—they are not even half the human race, but a sub-species set apart for purposes of reproduction merely."

Though we are accustomed to the idea of "progress" in science, if not in civilization generally, the fact is that more information has led to something very like regression.

I talked with an intelligent physician, the Commissioner of Health of a middle-sized city in Connecticut, a man who sees medicine not discretely but as part of the social complex. He treated me to a long list of all the objective differences between men and women, including particularly an account of current endocrinal studies relating to female hormones. Aren't all of these facts? he asked. How can you distrust facts? Very good, I said, I'm willing to take your medically educated word for it. I'm not afraid of facts, I welcome facts—*but a congeries of facts is not equivalent to an idea*. This is the essential fallacy of the so-called "scientific" mind. People who mistake facts for ideas are incomplete thinkers; they are gossips.

You tell me, I said, that my sense of my own humanity as being "standard" humanity—which is, after all, a subjective idea—is refuted by hormonal research. My psychology, you tell me, which in your view is the source of my ideas, is the result of my physiology. It is not I who express myself, it is my hormones which express me. A part is equal

to the whole, you say. Worse yet, the whole is simply the issue of the part: my "I" is a flash of chemicals. You are willing to define all my humanity by hormonal investigation under a microscope. This you call "objective irrefutable fact," as if tissue-culture were equivalent to culture. But each scientist can assemble his own (subjective) constellation of "objective irrefutable fact," just as each social thinker can assemble his own (subjective) selection of traits that define "humanity." Who can prove what is "standard" humanity, and which sex, class, or race is to be exempted from whole participation in it? On what basis do you regard female hormones as causing a modification from normative humanity? And what better right do you have to define normative humanity by what males have traditionally apperceived than by what females have traditionally apperceived—assuming (as I, lacking presumptuousness, do not) that their apperceptions have not been the same? Only Tiresias—that mythological character who was both man and woman consecutively—is in a position to make the comparison and present the proof. And then not even Tiresias, because to be a hermaphrodite is to be a monster, and not human.

"Why are you so emotional about all this?" said the Commissioner of Health. "You see how it is? Those are your female hormones working on you right now."

Moral: Defamation is only applied research.

VI: Ambition

After thirteen years, I at last finished a novel. The first seven years were spent in a kind of apprenticeship—the book that came out of that time was abandoned without much regret. A second one was finished in six weeks and buried. It took six years to write the third novel, and this one was finally published.

How I lived through those years is impossible to recount in a short space. I was a recluse, a priest of Art. I read seas of books. I believed in the idea of masterpieces. I was scornful of the world of journalism, jobs, everydayness. I did not live like any woman I knew. I lived like some men I had read about—Flaubert, or Proust, or James—the subjects of those literary biographies I endlessly drank in. I did not think of them as men, but as writers. I read the diaries of Virginia Woolf, and biographies of George Eliot, but I did not think of them as women. I thought of them as writers. I thought of myself as a writer.

It goes without saying that all this time my relatives regarded me as abnormal. I accepted this. It seemed to me, from what I had read, that most writers were abnormal. Yet on the surface, I could easily have passed for normal. The husband goes to work, the wife stays

home—that is what is normal. Well, I was married. My husband went to his job every day. His job paid the rent and bought the groceries. I stayed home, reading and writing, and felt myself to be an economic parasite. To cover guilt, I joked that I had been given a grant from a very private, very poor, foundation—my husband.

But my relatives never thought of me as a parasite. The very thing I was doubtful about—my economic dependence—they considered my due as a woman. They saw me not as a failed writer without an income, but as a childless housewife, a failed woman. They did not think me abnormal because I was a writer, but because I was not properly living my life as a woman. In one respect we were in agreement utterly—my life was failing terribly, terribly. For me it was because, already deep into my thirties, I had not yet published a book. For them, it was because I had not yet borne a child.

I was a pariah, not only because I was a deviant, but because I was not recognized as the kind of deviant I meant to be. A failed woman is not the same as a failed writer. Even as a pariah I was the wrong kind of pariah.

Still, relations are only relations. What I aspired to, what I was in thrall to, was Art, was Literature, not familial contentment. I knew how to distinguish the trivial from the sublime. In Literature and in Art, I saw, my notions were not pariah notions. There, I inhabited the mainstream. So I went on reading and writing. I went on believing in Art, and my intention was to write a masterpiece. Not a saucer of well-polished craft (the sort of thing "women writers" are always accused of being accomplished at), but something huge, contemplative, Tolstoyan. My ambition was a craw.

I called the book *Trust*. I began it in the summer of 1957 and finished it in November of 1963, on the day President John Kennedy was assassinated. In manuscript, it was 801 pages divided into four parts: "America," "Europe," "Birth," and "Death." The title was meant to be ironic. In reality, it was about distrust. It seemed to me I had touched on distrust in every order or form of civilization. It seemed to me I had left nothing out. It was (though I did not know this then) a very hating book. What it hated above all was the whole—the whole—of Western Civilization. It told how America had withered into another Europe. It dreamed dark and murderous pagan dreams, and hated what it dreamed.

In style, the book was what has come to be called "mandarin": a difficult, aristocratic, unrelenting virtuoso prose. It was, in short, unreadable. I think I knew this. I was sardonic enough to say, echoing Joyce about *Finnegan's Wake*, "I expect you to spend your life at this." In any case, I had spent a decade-and-a-half of my own life at it. Though

I did not imagine the world would fall asunder at its appearance, I thought—at the very least—the ambition, the all-swallowingness, the wild insatiability of the writer would be plain to everyone who read it. I had, after all, taken History for my subject: not merely History as an aggregate of events, but History as a judgment on events. No one could say my theme was flighty. Of all the novelists I read (and in those days I read them all, broiling in the envy of the unpublished, which is like no envy on earth), who else had dared so vastly?

During that period, Françoise Sagan's first novel was published. I held the thin little thing and laughed. Women's pulp!

My own novel, I believed, contained everything—the whole world.

But there was one element I had consciously left out. Though on principle I did not like to characterize it or think about it much, the truth is I was thinking about it all the time. It was only a fiction-technicality, but I was considerably afraid of it. It was the question of the narrator's "sensibility." The narrator, as it happened, was a young woman; I had chosen her to be the eye—and the "I"—of the novel because all the other characters in some way focused on her. She was the one most useful to my scheme. Nevertheless, I wanted her not to live. Everything I was reading in reviews of other people's books made me fearful: I would have to be very cautious; I would have to drain my narrator of emotive value of any kind, because I was afraid to be pegged as having written a "woman's" novel. Nothing was more certain to lead to that than a point-of-view seemingly lodged in a woman, and no one takes a woman's novel seriously. I was in terror, above all, of sentiment and feelings, those telltale taints. I kept the fury and the passion for other, safer, characters.

So what I left out of my narrator entirely, sweepingly, with exquisite consciousness of what exactly I *was* leaving out, was any shred of "sensibility." I stripped her of everything, even a name. I crafted and carpentered her. She was for me a bloodless device, fulcrum or pivot, a recording voice, a language-machine. She confronted moment or event, took it in, gave it out. And what to me was all the more wonderful about this nameless fiction-machine I had invented was that the machine itself, though never alive, was a character in the story, without ever influencing the story. My machine-narrator was there for efficiency only, for flexibility, for craftiness, for subtlety, but never, never, as a "woman." I wiped the "woman" out of her. And I did it out of fear, out of vicarious vindictive critical imagination, out of the terror of my ambition, out of, maybe, paranoia. I meant my novel to be taken for what it really was. I meant to make it impossible for it to be mistaken for something else.

Publication. Review in *The New York Times* Sunday Book Review.

Review is accompanied by a picture of a naked woman seen from the back. Her bottom is covered by some sort of drapery.

Title of review: "Daughter's Reprieve."

Excerpts from review: "These events, interesting in themselves, exist to reveal the sensibility of the narrator." "She longs to play some easy feminine role." "She has been unable to define herself as a woman." "The main body of the novel, then, is a revelation of the narrator's inner, turbulent, psychic drama."

O rabid, rotten Western Civilization, where are you? O judging History, O foul Trust and fouler Distrust, where?

O Soap Opera, where did you come from?

(Meanwhile the review in *Time* was calling me a "housewife.")

Pause.

All right, let us take up the rebuttals.

Q. Maybe you *did* write a soap opera without knowing it. Maybe you only *thought* you were writing about Western Civilization when you were really only rewriting Stella Dallas.

A. A writer may be unsure of everything—trust the tale not the teller is a good rule—but not of his obsessions; of these he is certain. If I were rewriting Stella Dallas, I would turn her into the Second Crusade and demobilize her.

Q. Maybe you're like the blind Jew who wants to be a pilot, and when they won't give him the job he says they're anti-Semitic. Look, the book was lousy, you deserved a lousy review.

A. You mistake me, I never said it was a bad review. It was in fact an extremely favorable review, full of gratifying adjectives.

Q. Then what's eating you?

A. I don't know. Maybe the question of language. By language I mean literacy. See the next section, please.

Q. No Moral for *this* section?

A. Of course. If you look for it, there will always be a decent solution for female ambition. For instance, it is still not too late to enroll in a good secretarial school.

Q. Bitter, bitter! You mean your novel failed?

A. Perished, is dead and buried. I sometimes see it exhumed on the shelf in the public library. It's always there. No one ever borrows it.

Q. Dummy! You should've written a soap opera. Women are good at that.

A. Thank you. You almost remind me of a Second Moral: In conceptual life, junk prevails. Even if you do not produce junk, it will be taken for junk.

Q. What does that have to do with women?

A. The products of women are frequently taken for junk.

Q. And if a woman *does* produce junk. . . ?

A. Glory—they will treat her almost like a man who produces junk. They will say her name on television. Do please go on to the next section. Thank you.

VII: Conclusion, and a Peek

Actually I had two more stories to tell you. One was about Mr. Machismo, a very angry, well-groomed, *clean man* (what a pity he isn't a woman—ah, deprived of vaginal spray) who defines as irresponsible all those who do not obey him, especially his mother and sister. A highly morbid and titillating Gothic tale. The other story was about Mr. Littletable, the Petty Politician, at the Bankers' Feast—how he gathered up the wives in a pretty garland, threw them a topic to chatter over. A Bronx neighborhood where you can buy good lox, I think it was. Having set them all up so nicely, he went off to lick the nearest Vice-President-of-Morgan-Guaranty.

But these are long stories, Ladies and Gentlemen. No room up there for another Woman's Novel.

10

A Passionate Friend

~

Susan Sontag

> I was not looking for my dreams to interpret my life,
> but rather for my life to interpret my dreams.
> —Susan Sontag

An intellectual powerhouse for almost four decades, Susan Sontag has crossed borders to write on topics ranging from pornography to photography, cancer to AIDS, Vietnam to Havana, and fascism to democracy. In addition to her career as essayist and cultural critic, Sontag has worked as a screenwriter, activist, and film and theater director. She is the epitome of the amateur intellectual described by Edward Said: one who is "moved not by profit or reward but by love for and unquenchable interest in the larger picture, in making connections across lines and barriers, in refusing to be tied down to a specialty, in caring for ideas and values despite the restrictions of a profession" (Said 1994, 76). Though lacking degrees in either political science or sociology, Sontag has written voluminously on government policy and the U.S. position as a global power. Claiming the same authority as did Noam Chomsky in speaking out against the Vietnam War—that of an interested and informed spectator confronting and challenging the current wisdom—Sontag has openly addressed the most volatile issues of the last half of the twentieth century.

Born in New York City in 1933, Sontag spent her first years in the care of relatives while her parents traveled on business as fur traders. When her father died of tuberculosis, Sontag's mother returned to the States from China, taking her two daughters to live first in Arizona and then in California. Having been, in her own words, "psychologically abandoned" by her withdrawn and alcoholic mother, Susan retreated from family life into her books (Lacayo 1988, 88). Her only desire during these childhood years, she writes, was for her own room and "a door of my own" (Sontag 1987, 38).

Sontag graduated from high school at fifteen and enrolled in the University of California at Berkeley. The next semester she transferred to the University of Chicago where, two years later, she received a degree in philosophy. At Chicago, Sontag met and married Philip Rieff, a sociology professor. Following the birth of a son, she enrolled at Harvard (1951) and obtained Master of Arts degrees in both philosophy and English literature. Later, she took graduate courses at Harvard, Oxford, and the University of Paris but did not complete her dissertation. Returning from her studies in Europe, Sontag divorced her husband and settled in New York City with her son. She found work first as an editor at *Commentary*, a conservative journal, and then as a lecturer at Sarah Lawrence and City Colleges. Between 1960 and 1964 she also taught at Columbia University before turning to writing fulltime.

Although Sontag wrote two novels in the early 1960s, her critical essays are what brought her recognition. In 1964, "Notes from Camp" appeared, a work that in both subject and style prefigures what critics now call postmodernism ("Susan Sontag" 1992, 535). This piece, which praises camp's freedom and spontaneity, is less an "essay (with its claim to linear, consecutive argument)" and more a series of "jottings" reflecting postmodernist sensibilities (Sontag 1982, 106).

"Notes from Camp" is included with other essays on art, literature, and culture in *Against Interpretation, and Other Essays* (1966). As Sontag describes it, camp is a "mode of enjoyment, of appreciation—not judgment" (119). Because it is detached and "depoliticized" (107), camp debunks all things solemn and views "life as theatre" (116, 118). In her essay, she indicts the traditional Arnoldian criticism that dictates the meaning of a work of art to the reader/viewer. Rejecting critical analyses as the sole guide to understanding art and literature, Sontag instead espouses "transparency," that is, an intuitive response to art and literature and culture or, more specifically, "experiencing the luminousness of the thing in itself" (103). For Sontag, it is imperative for Americans to rediscover all of their senses: "We must learn to *see* more, to *hear* more, to *feel* more" (103). The function, then, of criticism in the midtwentieth century "should be to show *how it* [art or literature] *is what it is*, even *that it is what it is*, rather than to show *what it means*" (104).

In addition to critiquing art, literature, and pop culture over the past four decades, Sontag has written extensively on war and political conflicts, specifically the Vietnam War in the 1960s and 1970s and the more recent Serbian-Bosnian conflict. Her stance concerning these and other issues has been controversial and, not surprisingly, often unpopular with her American audiences. For example, "Trip to Hanoi: Notes on the Enemy Camp"—a fragmented travelogue covering Sontag's visit

to North Vietnam in the spring of 1968—presents a sympathetic portrait of Vietnamese culture. At the outset of the essay, Sontag questions the ability of Americans like herself to transcend their insular, ethnocentric worldview in order to develop a more tolerant and realistic global perspective. Because of their ethnocentric outlook, Americans cannot break free from their narrow image of other countries and thus are unable to see the "concrete reality" of a place (Sontag 1969, 209).

Since the essay is divided into three sections, the reader readily follows Sontag's line of thought as she moves from questioning both her reader's and her own ability to "see" Vietnam to attempting to objectively report on her experiences. As the essay unfolds, she slowly begins to dismantle cultural barriers as she tries to transcend her own ethnocentric worldview. At last she is able to see "North Vietnam as a real place" (235). With cultural blinders at least partially removed, she discovers a culture with "virtues that thoughtful people in this part of the world [America] simply don't believe in any more. They [the Vietnamese] also mix virtues that we consider incompatible. For instance, we think war to be by its very nature 'dehumanizing.' But North Vietnam is simultaneously a martial society . . . and a deeply civil society which places great value on gentleness and the demands of the heart" (257–58). In the final lines, Sontag arrives at an uneasy acceptance that an "American has no way of incorporating Vietnam into his consciousness"; all one can hope to do is to attempt to "understand what one is nevertheless barred from understanding" (271).

Sontag also employs this stream-of-consciousness technique in "Project for a Trip to China." Here, she speaks with anticipation of an upcoming visit to Asia, but fears, as in her Hanoi essay, that her preconceptions of China will alter her experience. Will her visit be destroyed by "a conflict with literature?" she asks (1982, 284). Will her previous readings pre-form biases and misperceptions? Through a series of one- and two-sentence paragraphs, Sontag "thinks aloud," concluding: "Perhaps I will write the book about my trip to China before I go" (286). She lets her mind flow freely as she moves from dilemma to solution in order to instruct both herself and her readers in how to liberate themselves from cultural constraints.

In recent years, Sontag has written about the conflict in Bosnia. Rather than focusing on the shelling and senseless killing, she presents scenes from daily life as a way of bringing the reality of war to Americans. In "Waiting for Godot in Sarajevo," Sontag describes how actors in a production of Samuel Beckett's absurdist drama *Waiting for Godot* rehearsed in the dark and suffered from fatigue ("Whenever I halted the run-through for a few minutes to change a movement or a

line reading, all the actors would instantly lie down on the stage"); how they felt little relief on hearing shells exploding (rather than being hit themselves) since they had left their spouses and children at home; how the stage crew were unable to find props (a suitcase, a piece of rope, a carrot); how Sontag scavenged stale rolls from the Holiday Inn to feed the actors; how the audience sat in an auditorium without access to water or bathrooms; how one actor's lunch, a piece of bread and a pear, was stolen (1994, 87–104). Sontag narrows the Serbian-Bosnian conflict to a stolen lunch, even though more than four thousand shells fell on Sarajevo in one day during her stay. The war was not only about the annihilation of a race, but it was also about families being separated and the inability to obtain even a short piece of rope for the play.

Sontag returned to Bosnia in 1995, her ninth visit. In an article for *The Nation*, she reprimanded those writers and intellectuals who failed to go to Sarajevo:

> No one can plead ignorance of the atrocities that have taken place in Bosnia since the war started in April 1992. Sanski Most, Stupni Do, Omarska and other concentration camps with their killing houses (for hands-on, artisanal butchery, in contrast to the industrialized mass murder of the Nazi camps), the martyrdom of East Mostar and Sarajevo and Gorazde, the rape by military order of tens of thousands of women throughout Serb-captured Bosnia, the slaughter of at least 8,000 men and boys after the surrender of Srebrenica—this is only a portion of the catalogue of infamy. And no one can be unaware that the Bosnian cause is that of Europe: democracy, and a society composed of citizens, not of the members of a tribe. Why haven't these atrocities, these values, aroused a more potent response? Why have hardly any intellectuals of stature and visibility rallied to denounce the Bosnian genocide and defend the Bosnian cause? (Sontag 1995).

Sontag finds the answers just as disturbing as the questions: ancient rivalries ("Haven't those folks always been slaughtering one another?") as well as anti-Muslim prejudice. As for intellectuals who refuse to see the reality of the war, Sontag compares them to the intellectuals of the 1930s and 1960s who, then as now, are "morosely depoliticized . . . with their cynicism always at the ready, their addiction to entertainment, their reluctance to inconvenience themselves for any cause, their devotion to personal safety." She concludes her chilling indictment with a quotation from French sociologist Emile Durkheim: "Society is above all the idea it forms of itself."

Sontag uses metaphors to talk about war, but she also has written on the misuse of socially contrived metaphors in talking about dis-

ease. *Illness as Metaphor* is the first of two books that focus on social perceptions of illness, in this case, cancer. In 1975, Sontag was diagnosed with breast cancer and told that she had a 10 percent chance of living two years. As she underwent treatment, she observed that her fellow sufferers, like herself, were victims of "stupid ideas." These ideas, extensions of society's skewed vision and those of treating physicians, manifest themselves in metaphorical tags, myths, and clichés associated with the disease (Cott 1995, 108). Sontag found these metaphors to be fatalistic in that they blame the victim for the disease. For example, tuberculosis and cancer are understood to be "diseases of passion": tuberculosis, thus is the result of too much passion (Sontag 1978, 20) and cancer the result of "insufficient passion" (21). Illness then becomes punishment for being too emotional or not emotional enough.

In 1989, Sontag published the second book on illness, *AIDS and Its Metaphors*. Again she examines how cultural myths surrounding certain illnesses alienate and stigmatize the patient. The HIV virus is an "invader" that seeks to destroy. The shame of AIDS is connected to "an imputation of guilt," and there are those in society who deem it as just punishment for social sins. As with tuberculosis in the nineteenth and cancer in the twentieth centuries, these views have been put into metaphorical terms. According to Sontag, "The most truthful way of regarding illness—and the healthiest way of being ill—is one most purified of, most resistant to, metaphoric thinking" (1978, 3).

While Sontag has spoken on behalf of the infirm, especially those with cancer and AIDS, her critical vision has also involved questioning phallocentric political institutions and social policies, although she has not openly aligned herself with the feminist movement. Nonetheless, her most recent fictional works have revolved around gender issues. Her bestselling novel, *The Volcano Lover* (1992), is an account of the love affair between Admiral Horatio Nelson and Emma Hamilton, the young wife of Sir William Hamilton, the British ambassador to Naples in the late eighteenth century. Although Sontag originally planned to focus on William Hamilton, she admits that "Emma kidnapped the book" (Span 1995, 263). Emma is a strong woman, yet she is also a victim of her own passions and beauty. In the end she dies in poverty. Passionate women with no power or authority often end up as victims. This statement could be said of a number of women, including Alice James, the sister of renowned philosopher William James and noted novelist Henry James. Sontag's 1993 play, *Alice in Bed*, is a fictionalized version of Alice James's life that depicts the "grief and anger of women" as well as the power of the imagination. The play, however, reminds its audience that imagination alone does not suffice (Sontag 1993, 117). In notes at the end of the play, Sontag writes that

Alice James was Virginia Woolf's Judith Shakespeare brought to life, a woman of genius who became a career invalid because no other opportunities were offered to her (115). Alice James was silenced, in part, because she received no encouragement or support from her illustrious family and because she was unable to create her own identity (113). Composed of eight scenes, the play raises questions about the cultural and patriarchal forces that constrain women intellectuals.

Sontag's latest novel also examines the constraints of the talented woman. *In America* is based on the life of Helena Modjeska, a Polish actress of the late nineteenth century, who found fame in the States. The protagonist Maryna, unlike *The Volcano Lover*'s Emma Hamilton, does not die. Instead, she becomes a victim of American superstardom, which offers her fame and fortune while at the same subverting and degrading her talents.

In 2000, the same year that *In America* appeared, Carl Rollyson and Lisa Paddock published their unauthorized biography of Sontag. *Susan Sontag: The Making of an Icon* is a reminder of the type of backlash that has impeded the progress of women intellectuals since long before the time of Byron's *Don Juan*, quoted at the beginning of this book. In his review of the biography for the *Village Voice*, Charles McNulty describes the work as a "pseudo-academic smear job," one that is apparently "more concerned with destroying Sontag's iconic status than in tracing her cultural development" (2000, 1). It focuses on Sontag and her publisher's apparent collusion to create her intellectual persona, suggesting that there is little beneath the marketing hype.

Many of the critical attacks on Sontag are reminiscent of the early nineteenth-century attacks on England's lionized intellectual Harriet Martineau as well as on such American women as Margaret Fuller and Dorothy Thompson. They center on her appearance and gender. In the appendix to *Susan Sontag*, Rollyson and Paddock include "A Brief Anthology of Quotations (Homage to S.S.)." Although there are a few laudatory quotes, most trivialize Sontag as they describe her as "a literary pinup," "our unofficial hostess of letters," and a "leftist vestal virgin" (2000, 305–7).

In an interview, Sontag said that she preferred to be called what the French term an *écrivain*, a writer without specialization. In the 1960s she wrote on European writers, avant-garde film, photography, and Vietnam; in the 1970s, on the metaphors of cancer while she struggled with the disease. In the 1980s and 1990s she has continued to write about the language of illness and the horrors of war. Through it all, she describes herself as a "fierce learner": "The Beginner's mind [she insists] is best" (1995a, 172).

AIDS and Its Metaphors*

Because of countless metaphoric flourishes that have made cancer synonymous with evil, having cancer has been experienced by many as shameful, therefore something to conceal, and also unjust, a betrayal by one's body. Why me? the cancer patient exclaims bitterly. With AIDS, the shame is linked to an imputation of guilt; and the scandal is not at all obscure. Few wonder, Why me? Most people outside of Sub-Saharan Africa who have AIDS know (or think they know) how they got it. It is not a mysterious affliction that seems to strike at random. Indeed, to get AIDS is precisely to be revealed, in the majority of cases so far, as a member of a certain "risk group," a community of pariahs. The illness flushes out an identity that might have remained hidden from neighbors, job-mates, family, friends. It also confirms an identity and, among the risk group in the United States most affected in the beginning, homosexual men, has been a creator of community as well as an experience that isolates the ill and exposes them to harassment and persecution.

Getting cancer, too, is sometimes understood as the fault of someone who has indulged in "unsafe" behavior—the alcoholic with cancer of the esophagus, the smoker with lung cancer: punishment for living unhealthy lives. (In contrast to those obliged to perform unsafe occupations, like the worker in a petrochemical factory who gets bladder cancer.) More and more linkages are sought between primary organs or systems and specific practices that people are invited to repudiate, as in recent speculation associating colon cancer and breast cancer with diets rich in animal fats. But the unsafe habits associated with cancer, among other illnesses—even heart disease, hitherto little culpabilized, is now largely viewed as the price one pays for excesses of diet and "life-style"—are the result of a weakness of the will or a lack of prudence, or of addiction to legal (albeit very dangerous) chemicals. The unsafe behavior that produces AIDS is judged to be more than just weakness. It is indulgence, delinquency—addictions to chemicals that are illegal and to sex regarded as deviant.

The sexual transmission of this illness, considered by most people as a calamity one brings on oneself, is judged more harshly than other means—especially since AIDS is understood as a disease not only of

*From Susan Sontag, *AIDS and its Metaphors* (New York: Farrar, Straus, and Giroux, 1988), 24–37. © 1989 by Susan Sontag. Reprinted by permission of Farrar, Straus, and Giroux, LLC.

sexual excess but of perversity. (I am thinking, of course, of the United States, where people are currently being told that heterosexual transmission is extremely rare, and unlikely—as if Africa did not exist.) An infectious disease whose principal means of transmission is sexual necessarily puts at greater risk those who are sexually more active— and is easy to view as a punishment for that activity. True of syphilis, this is even truer of AIDS, since not just promiscuity but a specific sexual "practice" regarded as unnatural is named as more endangering. Getting the disease through sexual practice is thought to be more willful, [and] therefore deserves more blame. Addicts who get the illness by sharing contaminated needles are seen as committing (or completing) a kind of inadvertent suicide. Promiscuous homosexual men practicing their vehement sexual customs under the illusory conviction, fostered by medical ideology with its cure-all antibiotics, of the relative innocuousness of all sexually transmitted diseases, could be viewed as dedicated hedonists—though it's now clear that their behavior was no less suicidal. Those like hemophiliacs and blood-transfusion recipients, who cannot by any stretch of the blaming faculty be considered responsible for their illness, may be as ruthlessly ostracized by frightened people, and potentially represent a greater threat because, unlike the already stigmatized, they are not as easy to identify.

Infectious disease to which sexual fault is attached always inspired fears of easy contagion and bizarre fantasies of transmission by nonvenereal means in public places. The removal of doorknobs and the installation of swinging doors on U.S. Navy ships and the disappearance of the metal drinking cups affixed to public water fountains in the United States in the first decades of the century were early consequences of the "discovery" of syphilis's "innocently transmitted infection"; and the warning to generations of middle-class children always to interpose paper between bare bottom and the public toilet seat is another trace of the horror stories about the germs of syphilis being passed to the innocent by the dirty that were rife once and are still widely believed. Every feared epidemic disease, but especially those associated with sexual license, generates a preoccupying distinction between the disease's putative carriers (which usually means just the poor and, in this part of the world, people with darker skins) and those defined—health professionals and other bureaucrats do the defining—as "the general population." AIDS has revived similar phobias and fears of contamination among *this* disease's version of "the general population": white heterosexuals who do not inject themselves with drugs or have sexual relations with those who do. Like syphilis a disease of, or contracted from, dangerous others, AIDS is perceived as afflicting, in greater proportions than syphilis ever did, the already

stigmatized. But syphilis was not identified with certain death, death that follows a protracted agony, as cancer was once imagined and AIDS is now held to be.

That AIDS is not a single illness but a syndrome, consisting of a seemingly open-ended list of contributing or "presenting" illnesses which constitute (that is, qualify the patient as having) the disease, makes it more a product of definition or construction than even a very complex, multiform illness like cancer. Indeed, the contention that AIDS is invariably fatal depends partly on what doctors decided to define as AIDS—and keep in reserve as distinct earlier stages of the disease. And this decision rests on a notion no less primitively metaphorical than that of a "full-blown" (or "full-fledged") disease.[1] "Full-blown" is the form in which the disease is inevitably fatal. As what is immature is destined to become mature, what buds to become full-blown (fledglings to become full-fledged)—the doctors' botanical or zoological metaphor makes development or evolution into AIDS the norm, the rule. I am not saying that the metaphor creates the clinical conception, but I am arguing that it does much more than just ratify it. It lends support to an interpretation of the clinical evidence which is far from proved or, yet, provable. It is simply too early to conclude, of a disease identified only seven years ago, that infection will always produce something to die from, or even that everybody who has what is defined as AIDS will die of it. (As some medical writers have speculated, the appalling mortality rates could be registering the early, mostly rapid deaths of those most vulnerable to the virus—because of diminished immune competence, because of genetic predisposition, among other possible co-factors—not the ravages of a uniformly fatal infection.) Construing the disease as divided into distinct stages was the necessary way of implementing the metaphor of "full-blown disease." But it also slightly weakened the notion of inevitability suggested by the metaphor. Those sensibly interested in hedging their bets about how uniformly lethal infection would prove could use the standard three-tier classification—HIV infection, AIDS-related complex (ARC), and AIDS—to entertain either of two possibilities or both: the less catastrophic one, that *not* everybody infected would "advance" or "graduate" from HIV infection, and the more catastrophic one, that everybody would.

It is the more catastrophic reading of the evidence that for some time has dominated debate about the disease, which means that a change in nomenclature is under way. Influential administrators of the way the disease is understood have decided that there should be no more of the false reassurance that might be had from the use of different acronyms for different stages of the disease. (It could never have been more

than minimally reassuring.) Recent proposals for redoing terminology—for instance, to phase out the category of ARC—do not challenge the construction of the disease in stages, but do place additional stress on the *continuity* of the disease process. "Full-blown disease" is viewed as more inevitable now, and that strengthens the fatalism already in place.[2]

From the beginning the construction of the illness had depended on notions that separated one group of people from another—the sick from the well, people with ARC from people with AIDS, them and us—while implying the imminent dissolution of these distinctions. However hedged, the predictions always sounded fatalistic. Thus, the frequent pronouncements by AIDS specialists and public health officials on the chances of those infected with the virus coming down with "full-blown disease" have seemed mostly an exercise in the management of public opinion, dosing out the harrowing news in several steps. Estimates of the percentage expected to show symptoms classifying them as having AIDS within five years, which may be too low—at the time of this writing, the figure is 30 to 35 percent—are invariably followed by the assertion that "most," after which comes "probably all," those infected will eventually become ill. The critical number, then, is not the percentage of people likely to develop AIDS within a relatively short time but the *maximum* interval that could elapse between infection with HIV (described as lifelong and irreversible) and appearance of the first symptoms. As the years add up in which the illness has been tracked, so does the possible number of years between infection and becoming ill, now estimated, seven years into the epidemic, at between ten and fifteen years. This figure, which will presumably continue to be revised upward, does much to maintain the definition of AIDS as an inexorable, invariably fatal disease.

The obvious consequence of believing that all those who "harbor" the virus will eventually come down with the illness is that those who test positive for it are regarded as people-with-AIDS, who just don't have it . . . yet. It is only a matter of time, like any death sentence. Less obviously, such people are often regarded as if they *do* have it. Testing positive for HIV (which usually means having been tested for the presence not of the virus but of antibodies to the virus) is increasingly equated with being ill. Infected *means* ill, from that point forward. "Infected but not ill," that invaluable notion of clinical medicine (the body "harbors" many infections), is being superseded by biomedical concepts which, whatever their scientific justification, amount to reviving the antiscientific logic of defilement, and make infected-but-healthy a contradiction in terms. Being ill in this new sense can have many practical consequences. People are losing their jobs when it is

learned that they are HIV-positive (though it is not legal in the United States to fire someone for that reason) and the temptation to conceal a positive finding must be immense. The consequences of testing HIV-positive are even more punitive for those selected populations—there will be more—upon which the government has already made testing mandatory. The U.S. Department of Defense has announced that military personnel discovered to be HIV-positive are being removed "from sensitive, stressful jobs," because of evidence indicating that mere infection with the virus, in the absence of any other symptoms, produces subtle changes in mental abilities in a significant minority of virus carriers. (The evidence cited: lower scores on certain neurological tests given to some who had tested positive, which could reflect mental impairment caused by exposure to the virus, though most doctors think this extremely improbable, or which could be caused—as officially acknowledged under questioning—by "the anger, depression, fear, and panic" of people who have just learned that they are HIV-positive.) And, of course, testing positive now makes one ineligible to immigrate everywhere.

In every previous epidemic of an infectious nature, the epidemic is equivalent to the number of tabulated cases. This epidemic is regarded as consisting *now* of that figure plus a calculation about a much larger number of people apparently in good health (seemingly healthy, but doomed) who are infected. The calculations are being made and remade all the time, and pressure is building to identify these people, and to tag them. With the most up-to-date biomedical testing, it is possible to create a new class of lifetime pariahs, the future ill. But the result of this radical expansion of the notion of illness created by the triumph of modern medical scrutiny also seems a throwback to the past, before the era of medical triumphalism, when illnesses were innumerable, mysterious, and the progression from being seriously ill to dying was something normal (not, as now, medicine's lapse or failure, destined to be corrected). AIDS, in which people are understood as ill before they are ill; which produces a seemingly innumerable array of symptom-illnesses; for which there are only palliatives; and which brings to many a social death that precedes the physical one—AIDS reinstates something like a premodern experience of illness, as described in Donne's *Devotions*, in which "every thing that disorders a faculty and the function of that is a sicknesse," which starts when we

> are preafflicted, super-afflicted with these jealousies and suspicions, and apprehensions of Sicknes, before we can cal it a sicknes; we are not sure we are ill; one hand askes the other by the pulse, and our

> eye asks our own urine, how we do. . . . we are tormented with sicknes, and cannot stay till the torment come. . . .

whose agonizing outreach to every part of the body makes a real cure chimerical, since what "is but an accident, but a symptom of the main disease, is so violent, that the Phisician must attend the cure of that" rather than "the cure of the disease it self," and whose consequence is abandonment:

> As Sicknesse is the greatest misery, so the greatest misery of sicknes is solitude; when the infectiousnes of the disease deterrs them who should assist, from comming; even the Phisician dares scarse come. . . . it is an Outlawry, an Excommunication upon the patient. . . .

In premodern medicine, illness is described as it is experienced intuitively, as a relation of outside and inside: an interior sensation or something to be discerned on the body's surface, by sight (or just below, by listening, palpating), which is confirmed when the interior is opened to viewing (in surgery, in autopsy). Modern—that is, effective—medicine is characterized by far more complex notions of what is to be observed inside the body: not just the disease's results (damaged organs) but its cause (microorganisms), and by a far more intricate typology of illness.

In the older era of artisanal diagnoses, being examined produced an immediate verdict, immediate as the physician's willingness to speak. Now an examination means tests. And being tested introduces a time lapse that, given the unavoidably industrial character of competent medical testing, can stretch out for weeks: an agonizing delay for those who think they are awaiting a death sentence or an acquittal. Many are reluctant to be tested out of dread of the verdict, out of fear of being put on a list that could bring future discrimination or worse, and out of fatalism (what good would it do?). The usefulness of self-examination for the early detection of certain common cancers, much less likely to be fatal if treated before they are very advanced, is now widely understood. Early detection of an illness thought to be inexorable and incurable cannot seem to bring any advantage.

Like other diseases that arouse feelings of shame, AIDS is often a secret, but not from the patient. A cancer diagnosis was frequently concealed from patients by their families; an AIDS diagnosis is at least as often concealed from their families by patients. And as with other grave illnesses regarded as more than just illnesses, many people with AIDS are drawn to whole-body rather than illness-specific treatments, which are thought to be either ineffectual or dangerous. (The dispar-

agement of effective, scientific medicine for offering treatments that are *merely* illness-specific, and likely to be toxic, is a recurrent misconjecture of opinion that regards itself as enlightened.) This disastrous choice is still being made by some people with cancer, an illness that surgery and drugs can often cure. And a predictable mix of superstition and resignation is leading some people with AIDS to refuse antiviral chemotherapy, which, even in the absence of a cure, has proved of some effectiveness (in slowing down the syndrome's progress and in staving off some common presenting illnesses), and instead to seek to heal themselves, often under the auspices of some "alternative medicine" guru. But subjecting an emaciated body to the purification of a macrobiotic diet is about as helpful in treating AIDS as having oneself bled, the "holistic" medical treatment of choice in the era of Donne.

Notes

1. The standard definition distinguishes between people with the disease or syndrome "fulfilling the criteria for the surveillance definition of AIDS" from a larger number infected with HIV and symptomatic "who do not fulfill the empiric criteria for the full-blown disease. This constellation of signs and symptoms in the context of HIV infection has been termed the AIDS-related complex (ARC)." Then follows the obligatory percentage. "It is estimated that approximately 25 percent of patients with ARC will develop full-blown disease within 3 years." Harrison's *Principles of Internal Medicine*, 11th edition (1987), p. 1394.

The first major illness known by an acronym, the condition called AIDS does not have, as it were, natural borders. It is an illness whose identity is designed for purposes of investigation and with tabulation and surveillance by medical and other bureaucracies in view. Hence, the unself-conscious equating in the medical textbook of what is empirical with what pertains to surveillance, two notions deriving from quite different models of understanding. (AIDS is what fulfills that which is referred to as either the "criteria for the surveillance definition" or the "empiric criteria": HIV infection plus the presence of one or more diseases included on the roster drawn up by the disease's principal administrator of definition in the United States, the federal Centers for Disease Control in Atlanta.) This completely stipulative definition with its metaphor of maturing disease decisively influences how the illness is understood.

2. The 1988 Presidential Commission on the epidemic recommended "de-emphasizing" the use of the term ARC because it "tends to obscure the life-threatening aspects of this stage of illness." There is some pressure to drop the term AIDS, too. The report by the Presidential Commission pointedly used the acronym HIV for the epidemic itself, as part of a recommended shift from "monitoring disease" to "monitoring infection." Again, one of the reasons given is that the present terminology masks the true gravity of the menace. ("This long-standing concentration on the clinical manifestations of AIDS rather than on all stages of HIV infection [i.e., from initial infection to seroconversion, to an antibody-positive asymptomatic stage, to full-blown AIDS] has had the unintended effect of misleading the public as to the extent of infection in the population. . . .") It does

seem likely that the disease will, eventually, be renamed. This change in nomenclature would justify officially the policy of including the infected but asymptomatic among the ill.

V America at the Millennium

Today, America has become a global society, defined by mass communication and a worldwide economic order. The shift between the 1960s and 2000s has been one of startling and dramatic changes, as John F. Kennedy's Camelot, along with the advances of the Civil Rights and Women's Liberation movements, yielded to one president's assassination and another's impeachment, the Gulf War, the AIDS epidemic, and acts of terrorism on American soil.

The Civil Rights and Women's Liberation movements, which reached their height in the 1970s, faced a backlash in the 1980s and 1990s and continue to do so today. The most revealing investigative report on these hostilities confronting women and other minorities is found in Susan Faludi's *Backlash* (1991), the title taken from a 1947 movie in which a woman is framed by her husband for a murder that he committed. Faludi explains that the backlash against the women's movement works in the same way: society accuses feminists of crimes of which it is guilty (1991, xxii). It has been highly destructive: "The backlash has succeeded in framing virtually the whole issue of women's rights in its own language. Just as Reaganism shifted political discourse far to the right and demonized liberalism, so the backlash convinced the public that women's 'liberation' was the true contemporary American scourge—the source of an endless laundry list of personal, social, and economic problems" (xviii).

Women have faced discrimination not only in society at large but also within their own feminist ranks. Rather than confront racial and class discrimination, the women's liberation organizations in the 1970s chose to concentrate their efforts almost solely on white middle-class concerns. As Sue Jewell notes, black feminists had broader goals, including the eradication of all types of social disparity that exist between blacks and whites, men and women, rich and poor (1997, 95). The gaps between the groups continue to grow. In 1978, Diana Pearcy coined the term "feminization of poverty" to describe women's increasingly high rate among the poor. As late as 1992, a woman was still 34 percent more likely to live in poverty than a man (McFadden 1997, 2.687).

The introduction to this section might sound more negative than earlier overviews in this book. Perhaps it is because the author lacks the necessary objectivity to define her own historical moment. However, most critics would agree that American culture is in decline, although observers such as E. D. Hirsch Jr. and bell hooks might disagree on the reasons why or on the solutions required to fix the problem. The women in the final section of this study address many of the issues confronting Americans today. Gloria Anzaldúa writes about people in the borderlands who are marginalized by race, class, and gender. bell hooks, like Anna Julia Cooper, sees the importance of education and the world as her classroom. One aspect of their work that unites both women is their effort to heal a divisive nation by engaging in dialogue that honors all people, that builds bridges between groups, and that leads toward a new America.

11
A New Mestiza Consciousness
~
Gloria Anzaldúa

> You have to commit yourself to your visions.
> —Gloria Anzaldúa

In her poetry and essays, Gloria Anzaldúa struggles to subvert and destroy dominant rule, as she re-imagines and restructures Chicana geographical, social, and personal identities (Arteaga 1997, 153). As a Chicana living in the borderlands, she experienced firsthand linguistic terrorism when she was punished for not speaking her name as it would be pronounced in English. Anzaldúa's life has been a struggle to find her voice. By studying her works and life, we can trace the evolution of an intellectual as she first positions herself geographically and from that position moves to create a new worldview that Anzaldúa terms a new mestiza consciousness. From this position, she is free to formulate a theory that "overlap[s] many 'worlds' " (Anzaldúa 1990a, xxv–xxvi). With this new world view, women of color can then topple the "tyranny of history" to change the way in which they view themselves and the world.

Anzaldúa's freedom project begins with her claiming a position from which to speak. For the Chicana there is only one place: the borderlands. Although the borderlands are an actual place—the Texas/U.S. Southwest-Mexican border—she expands their definition to include psychological, sexual, and spiritual limits as well: "In fact, the Borderlands are physically present wherever two or more cultures edge each other, where people of different races occupy the same territory, where under, lower, middle and upper classes touch, where the space between two individuals shrinks with intimacy" (Anzaldúa 1987, Preface). Anglocolonization also resides in the geographical, cultural, and spiritual borderlands; thus, Anzaldúa points out, they are often a place of violence where "the Third World grates against the first and bleeds.

And before a scab forms it hemorrhages again, the lifeblood of two worlds merging to form a third country—a border culture" (3).

The borderlands are not only a vantage point from which to observe and speak to the world; they are also a place where the processes for healing and rebuilding society and the self are most accessible, especially for persons of color. Indeed, Anzaldúa is a border woman raised within two cultures, Mexican and Anglo: "I have been straddling the *tejas*-Mexican border, and others, all my life. It's not a comfortable territory to live in, this place of contradictions." Still, for Anzaldúa, the margin is not a bad vantage point from which to view society, for there she has been able to find her place of cultural conflict and contradictions (Anglo-American, Mexican, Chicana), embrace its multiplicity, and create a new perspective that is neither Anglo-American nor Mexican—one that is more than just a synthesis of the two (Anzaldúa 1987, 46). This new mestiza or new perspective that both heals and protects is "a plural personality [that] operates in a pluralistic mode—nothing is thrust out, the good, the bad and the ugly, nothing rejected, nothing abandoned" (79). Out of the new mestiza arises a new consciousness. Yvonne Yarbro-Bejarano writes that Anzaldúa's borderlands represent the "articulation" that exists between two ideas or beliefs: one that acknowledges and accepts the Lacanian view that identity is defined by difference, and one that asks for a "new politics of difference" that reflects this new identity (1998, 18).

With a mestiza consciousness, Anzaldúa constructs a theory that she applies to language, literature, and politics. In *Making Face, Making Soul/Haciendo Caras: Creative and Critical Perspectives by Women of Color*, she writes that originally, "to have theory meant to hold considerable evidence in support of a formulated general principle explaining the operation of certain phenomena. Theory, then, is a set of knowledges" (Anzaldúa 1990b, xxv). However the "set of knowledges" needed in formulating theory has been denied some groups (xxv).

To be an intellectual, then, and also a woman of color, involves accepting the fact that one size does not fit all, that a theory that works for the dominant culture cannot always be readily applied to a marginalized group (xxv). According to Anzaldúa, intellectuals must develop a *teoría* (theory) that crosses borders so they can begin to decipher the world and start to find ways to improve relationships between diverse groups. This *teoría* mirrors the interaction "between inner, outer and peripheral 'I's within a person and between the personal 'I's and the collective 'we' of our ethnic communities" (xxv). The type of *teoría* that Anzaldúa advocates involves using race, class, and sex as "categories of analysis" to rewrite history. *Teoría* also has practical applications, such as in de-academizing theory to bring together the

community and the academy. "High" theory does not translate well, she argues, when one's intention is to communicate to masses of people made up of different audiences. "We need to give up the notion that there is a 'correct' way to write theory" (xxv–xxvi).

How does Anzaldúa apply this theory of the new mestiza consciousness to language, literature, and activism? First, language must be transformed into a source of healing rather than a source of strife. This *tipo del lengua*, however, can be difficult to read since it blends words from different cultures; thus one must be attentive to the speaker and her words. Nonetheless, this polyvocal way of writing and speaking gives voice to those people who are neither Spanish nor Anglo nor live where Spanish is the first language (Anzaldúa 1987, 55). Indeed, Anzaldúa asserts that for these individuals there is little choice except to create a "language which they can connect their identity to, one capable of communicating the realities and values true to themselves—a language with terms that are neither *español ni inglés* (Spanish nor English), but both. [Hence, they] speak a patois, a forked tongue, a variation of two languages" (55). The ultimate purpose of the language is to "heal the split," which is that duality of thought that separates people from each other, from themselves, and from nature.

In an interview with Donna Perry, Anzaldúa explains that the obvious reason for using a mixture of languages is that it best represents her childhood language and experience. It also debunks the "myth of monocultural U.S.," which forces people to see that America is a "mestiza country" (Perry 1993, 220).

> Because I, a mestiza,
> continually walk out of one culture
> and into another,
> because I am in all cultures at the same time,
> alma entre dos mundos, tres, cuatro,
> me zumba la cabeza con lo contradictorio.
> Estoy norteada por todas las voces que me hablán
> simultáneamente (Anzaldúa 1987, 77).

This poem, "Una lucha de fronteras/A Struggle for Borders," reveals a mestiza consciousness that straddles the border but at the same time struggles to move beyond not only geographical boundaries but gender, linguistic, and cultural ones as well (Freedman 1992, 215). Because the speaker is polyvocal and embraces her dual identities, she can move easily from one culture to the other. Diane Freedman writes that Anzaldúa's poetry "contains and disdains 'unnatural boundaries.' Like the mestiza, [it] . . . is a 'crossroads,' linking literal to figurative, stanza to stanza, life to art" (213).

The same could be said of her prose, which forces readers to reconsider genre as coming in neat, tidy packages. In her essay, "The Borderlands," Anzaldúa combines poetry and prose, changing voices and languages throughout the text (Perry 1993, 24). Alfred Arteaga maintains that key to Anzaldúa's freedom project has been the "erosion of the rule of genre." *Borderlands*, consequently, is a chaotic and difficult text (Arteaga 1997, 153). Freedman concurs, noting how Anzaldúa's blending of "genres and disciplines in an autobiographical literary-critical amalgam" lauds self-expression while it revolts against the traditional "voice of order" (1992, 211). The resulting work is a hybrid in both subject and structure as Anzaldúa spatially recreates new ways of seeing the United States and Mexico and relations between the two (Arteaga 1997, 153).

This Bridge Called My Back (1981), an anthology co-edited with Cherrie Moraga, is also an act of celebration and defiance. In the preface, Moraga and Anzaldúa write that the book is to be used as a "revolutionary tool" for people of color. This anthology addresses major concerns of Third World women, including "1) how visibility/invisibility as women of color forms our radicalism; 2) the ways in which Third World women derive a feminist political theory specifically from our racial/cultural background and experience; 3) the destructive and demoralizing effects of racism in the women's movement; [and] 4) the cultural, class, and sexuality differences that divide women of color" (Anzaldúa and Moraga 1983, xxiv).

Written nine years later, *Making Face, Making Soul/Haciendo Caras* (1990), is described by its editor as less of a revolutionary tool and "more of a bridge to other racial and ethnic groups." The audience for this work is not the Anglo one to which *This Bridge Called My Back* is directed; it is much broader and more inclusive (Perry 1993, 35). In the preface to *Making Face*, Anzaldúa aggressively confronts racism. She attacks the universities, identifying the academic world as a place where racism is widespread (Anzaldúa 1990b, xix). She also accuses white feminists of employing terms such as "diversity" and "difference" to avoid an honest and open discussion of racism. In an effort to create a united front, feminist groups have "blurred" racial disparities while emphasizing class differences (xxi). Although Anzaldúa argues that "all whites in the U.S. practice Racism" (xiv), she acknowledges that they, too, have been victimized and hurt by their own "white ideology." As for women of color, they, too, add to their own oppression by internalizing racism, which she describes as that "deadly pollen," the fruit of which "mutilate[s] our physical bodies, stunt[s] our intellects and make[s] emotional wrecks of us. Racism sucks out the life blood from our bodies, our souls" (xix).

Even the title of *Making Face, Making Soul/Haciendo Caras* embraces a mestiza consciousness—not only in its English/Spanish name but also in its face/mask metaphors. Making faces, Anzaldúa carefully explains, means distorting the face as well as making "political subversive gestures": " 'Face' is ... inscribed by social structures, marked with instructions on how to be mujer, macho, working class, Chicano. As mestizas—biological and/or culturally mixed—we have different surfaces for each aspect of identity, each inscribed by a particular subculture" (xv). To protect themselves, mestizas must alter their facial expressions, and yet to do so can have serious consequences. These "masks, las mascaras, we are compelled to wear, drive a wedge between our intersubjective personhood and the persona we present to the world. . . . After years of wearing masks we may become just a series of roles" (xv). We must tear off the masks we hide behind so that we may become "subjects in our own discourses" by revealing our own faces. Making faces is Anzaldúa's metaphor for the process of self-actualization: " '*Usted es el modeador de su carne tanto como el de su alma.*' You are the shaper of your flesh as well as of your soul" (xvi).

One way of removing masks is to form coalitions and build bridges. An important feature of coalition building in Anzaldúa's work is exploring the link between the "negative" traits or characteristics assigned to women of color by society and the social and historical "narratives" that perpetuate those stereotypes (Richards 1999, 16). Because of her own experience in graduate school where she found few if any Latino literary courses, she was able to clearly see the connection between the exclusion of women's stories (as in the case of Jessie Redmon Fauset) or the misrepresentation of their lives (as in the case of Ralph Waldo Emerson's rewriting of Margaret Fuller's memoirs) and the cultural modification of women through self-abnegation, self-blame, and self-loathing (16–17).

Bridges of Power begins with a Mexican proverb: "La gente hablando se entiende (People understand each other by talking)" (Anzaldúa 1990a, 216). In her speech, Anzaldúa goes on to describe four ways of building alliances. The first bridge links individuals to themselves, their own community, and Anglos (223). Second is the drawbridge that involves two options. The individual may either lower the bridge and engage with Anglos or raise the bridge and be "disengaged" in order to "regroup and recharge [her] energies, and nourish [herself] before wading back in the frontlines" (223). Anzaldúa's third approach is to "island" or totally withdraw. Finally, there is the "sandbar," in which the individual may choose to connect the island to the mainland or, during high tide, submerge herself in release from

service as "a perpetual bridge" (224). As a mediator, translator, and negotiator, Anzaldúa has placed herself in all four positions, yet in all of them the goal is the same: to "balance power relations and undermine and subvert the system of domination-subordination" (224–25).

In a recent interview with AnaLouise Keating, Anzaldúa spoke of how her illnesses caused by diabetes with its complications have impacted her life and writing. The diabetes, she confessed, has forced her to return to basics: "What do I want from Life? What do I really want to do?" The purpose of her work is still clear: "We must have very concrete, precisely worded intentions of what we want the world to be like, what *we* want to be like. . . . Before any changes can take place you have to say and intend them. It's like a prayer, you have to commit yourself to your visions" (Anzaldúa 2000, 290). Anzaldúa's revisioning of herself has forced her to develop empathy. Indeed, she advises others to "listen to people, be open to people. . . , stop being so busy that you don't have time to listen to other people and to the world" (291).

Anzaldúa's life has been her testimony to her bridge building. She was born in 1942 on a ranch in South Texas. Her parents were sharecroppers and field workers and she spent her childhood in poverty. She did not speak or write English until she was nine. After her father's death in 1956, Anzaldúa worked in the fields until completing her undergraduate studies. Since 1969, she has been teaching. Her first job was in San Juan, Texas, where she taught American literature to a class that was 90 percent Chicano. The students read only Anglo works, nothing by Chicano writers. When Anzaldúa began supplementing the course with Chicano/a stories and poems, the principal threatened to fire her. Later, as a graduate student at the University of Texas, she was denied her doctoral candidacy because she wanted to write on Chicano literature. She then transferred to the University of California at Santa Cruz and completed her doctoral studies there. Her life experiences could be seen as merely sources of isolation and despair. Yet, Anzaldúa has been able to take the "1,950 mile-long open wound/ dividing a pueblo, a culture,/running down the length of my body,/ staking fence rods in my flesh" (Anzaldúa 1987, 2), and transform her own being.

> And if going home is denied me,
> then I will have to stand and claim my space,
> making a new culture—una cultura mestiza—
> with my own lumber, my own bricks and mortar
> and my own feminist architecture.

How to Tame a Wild Tongue*

"We're going to have to control your tongue," the dentist says, pulling out all the metal from my mouth. Silver bits plop and tinkle into the basin. My mouth is a motherlode.

The dentist is cleaning out my roots. I get a whiff of the stench when I gasp. "I can't cap that tooth yet, you're still draining," he says.

"We're going to have to do something about your tongue." I hear the anger rising in his voice. My tongue keeps pushing out the wads of cotton, pushing back the drills, the long thin needles. "I've never seen anything as strong or as stubborn," he says. And I think, how do you tame a wild tongue, train it to be quiet, how do you bridle and saddle it? How do you make it lie down?

> Who is to say that robbing a people of its language is less violent than war?
> —Ray Gwyn Smith[1]

I remember being caught speaking Spanish at recess—that was good for three licks on the knuckles with a sharp ruler. 1 remember being sent to the corner of the classroom for "talking back" to the Anglo teacher when all I was trying to do was tell her how to pronounce my name. "If you want to be American, speak 'American.' If you don't like it, go back to Mexico where you belong."

"I want you to speak English. *Pa' hallar buen trabajo tienes que saber hablar el inglés bien. Qué vale toda tu educación si todavía hablas inglés con un* 'accent,'" my mother would say, mortified that I spoke English like a Mexican. At Pan American University, I, and all Chicano students were required to take two speech classes. Their purpose: to get rid of our accents.

Attacks on one's form of expression with the intent to censor are a violation of the First Amendment. *El Anglo con cara de inocente nos arrancó la lengua.* Wild tongues can't be tamed, they can only be cut out.

Overcoming the Tradition of Silence

Abogadas, escupimos el oscuro.
Peleando con nuestra propia sombra
el silencio nos sepulta.

*From Gloria Anzaldúa, "How to Tame a Wild Tongue," in *Borderlands/La Frontera: The New Mestiza* (San Francisco: Aunt Lute Books, 1987), 75–86. © 1987 by Gloria Anzaldúa. Reprinted by permission of Aunt Lute Books.

En boca cerrada no entran moscas. "Flies don't enter a closed mouth" is a saying I kept hearing when I was a child. *Ser habladora* was to be a gossip and a liar, to talk too much. *Muchachitas bien criadas*, well-bred girls don't answer back. *Es una falta de respeto* to talk back to one's mother or father. I remember one of the sins I'd recite to the priest in the confession box the few times I went to confession: talking back to my mother, *hablar pa' 'trás, repelar. Hocicona, repelona, chismosa,* having a big mouth, questioning, carrying tales are all signs of being *mal criada*. In my culture they are all words that are derogatory if applied to women—I've never heard them applied to men.

The first time I heard two women, a Puerto Rican and a Cuban, say the word *"nosotras,"* I was shocked. I had not known the word existed. Chicanas use *nosotros* whether we're male or female. We are robbed of our female being by the masculine plural. Language is a male discourse.

> And our tongues have become dry, the wilderness has dried out our tongues and we have forgotten speech. —Irena Klepfisz[2]

Even our own people, other Spanish speakers *nos quieren poner candados en la boca*. They would hold us back with their bag of *reglas de academia*.

Oyé como ladra: el lenguaje de la frontera

> *Quien tiene boca se equivoca.*
> —Mexican saying

"*Pocho*, cultural traitor, you're speaking the oppressor's language by speaking English, you're ruining the Spanish language," I have been accused by various Latinos and Latinas. Chicano Spanish is considered by the purist and by most Latinos deficient, a mutilation of Spanish.

But Chicano Spanish is a border tongue which developed naturally. Change, *evolución, enriquecimiento de palabras nuevas por invención o adopción* have created variants of Chicano Spanish, *un nuevo lenguaje. Un lenguaje que corresponde a un modo de vivir*: Chicano Spanish is not incorrect, it is a living language.

For a people who are neither Spanish nor live in a country in which Spanish is the first language; for a people who live in a country in which English is the reigning tongue but who are not Anglo; for a people who cannot entirely identify with either standard (formal, Castillian) Spanish nor standard English, what recourse is left to them but to create their own language? A language which they can connect

their identity to, one capable of communicating the realities and values true to themselves—a language with terms that are neither *español ni inglés*, but both. We speak a patois, a forked tongue, a variation of two languages.

Chicano Spanish sprang out of the Chicanos' need to identify ourselves as a distinct people. We needed a language with which we could communicate with ourselves, a secret language. For some of us, language is a homeland closer than the Southwest—for many Chicanos today live in the Midwest and the East. And because we are a complex, heterogeneous people, we speak many languages. Some of the languages we speak are:

1. Standard English
2. Working-class and slang English
3. Standard Spanish
4. Standard Mexican Spanish
5. North Mexican Spanish dialect
6. Chicano Spanish (Texas, New Mexico, Arizona and California have regional variations)
7 Tex-Mex
8. *Pachuco* (called *caló*)

My "home" tongues are the languages I speak with my sister and brothers, with my friends. They are the last five listed, with 6 and 7 being closest to my heart. From school, the media and job situations, I've picked up standard and working-class English. From Mamagrande Locha and from reading Spanish and Mexican literature, I've picked up Standard Spanish and Standard Mexican Spanish. From *los recién llegados*, Mexican immigrants, and *braceros*, I learned the North Mexican dialect. With Mexicans I'll try to speak either Standard Mexican Spanish or the North Mexican dialect. From my parents and Chicanos living in the Valley, I picked up Chicano Texas Spanish, and I speak it with my mom, younger brother (who married a Mexican and who rarely mixes Spanish with English), aunts and older relatives.

With Chicanas from Nuevo México or Arizona I will speak Chicano Spanish a little, but often they don't understand what I'm saying. With most California Chicanas I speak entirely in English (unless I forget). When I first moved to San Francisco, I'd rattle off something in Spanish, unintentionally embarrassing them. Often it is only with another Chicana *tejana* that I can talk freely.

Words distorted by English are known as *anglicisms* or *pochismos*. The *pocho* is an anglicized Mexican or American of Mexican origin who speaks Spanish with an accent characteristic of North Americans

and who distorts and reconstructs the language according to the influence of English.[3] Tex-Mex, or Spanglish, comes most naturally to me. I may switch back and forth from English to Spanish in the same sentence or in the same word. With my sister and my brother Nune and with Chicano *tejano* contemporaries I speak in Tex-Mex.

From kids and people my own age I picked up *Pachuco*. *Pachuco* (the language of the zoot suiters) is a language of rebellion, both against Standard Spanish and Standard English. It is a secret language. Adults of the culture and outsiders cannot understand it. It is made up of slang words from both English and Spanish. *Ruca* means girl or woman, *vato* means guy or dude, *chale* means no, *simón* means yes, *churo* is sure, talk is *periquiar*; *pigionear* means petting, *que gacho* means how nerdy, *ponte águila* means watch out, death is called *la pelona*. Through lack of practice and not having others who can speak it, I've lost most of the *Pachuco* tongue.

Chicano Spanish

Chicanos, after 250 years of Spanish/Anglo colonization, have developed significant differences in the Spanish we speak. We collapse two adjacent vowels into a single syllable and sometimes shift the stress in certain words such as *maíz/maiz, cohete/cuete*. We leave out certain consonants when they appear between vowels: *lado/lao, mojado/mojao*. Chicanos from South Texas pronounced *f* as *j* as in *jue* (*fue*). Chicanos use "archaisms," words that are no longer in the Spanish language, words that have been evolved out. We say *semos, truje, haiga, ansina*, and *naiden*. We retain the "archaic" *j*, as *jalar*, that derives from an earlier *h* (the French *halar* or the Germanic *halon* which was lost to standard Spanish in the 16th century), but which is still found in several regional dialects such as the one spoken in South Texas. (Due to geography, Chicanos from the Valley of South Texas were cut off linguistically from other Spanish speakers. We tend to use words that the Spaniards brought over from Medieval Spain. The majority of the Spanish colonizers in Mexico and the Southwest came from Extremadura—Hernán Cortés was one of them—and Andalucía. Andalucians pronounce *ll* like a *y*, and their *d*'s tend to be absorbed by adjacent vowels: *tirado* becomes *tirao*. They brought *el lenguaje popular, dialectos y regionalismos*.[4])

Chicanos and other Spanish speakers also shift *ll* to *y* and *z* to *s*.[5] We leave out initial syllables, saying *tar* for *estar*, *toy* for *estoy*, *hora* for *ahora* (*cubanos* and *puertorriqueños* also leave out initial letters or some words). We also leave out the final syllable such as *pa* for *para*. The intervocalic *y*, the *ll* as in *tortilla, ella, botella*, gets replaced

by *tortia* or *tortiya*, *ea*, *botea*. We add an additional syllable at the beginning of certain words: *atocar* for *tocar*, *agastar* for *gastar*. Sometimes we'll say *lavaste las vacijas*, other times *lavates* (substituting the *ates* verb endings for the *aste*).

We use anglicisms, words borrowed from English: *bola* from ball, *carpeta* from carpet, *máchina de lavar* (instead of *lavadora*) from washing machine. Tex-Mex argot, created by adding a Spanish sound at the beginning or end of an English word such as *cookiar* for cook, *watchar* for watch, *parkiar* for park, and *rapiar* for rape, is the result of the pressures on Spanish speakers to adapt to English.

We don't use the word *vosotros/as* or its accompanying verb form. We don't say *claro* (to mean yes), *imagínate*, or *me emociona*, unless we picked up Spanish from Latinas, out of a book, or in a classroom. Other Spanish-speaking groups are going through the same, or similar, development in their Spanish.

Linguistic Terrorism

> *Deslenguadas. Somos los del español deficiente.* We are your linguistic nightmare, your linguistic aberration, your linguistic *mestizaje*, the subject of your *burla*. Because we speak with tongues of fire we are culturally crucified. Racially, culturally and linguistically *somos huérfanos*—we speak an orphan tongue.

Chicanas who grew up speaking Chicano Spanish have internalized the belief that we speak poor Spanish. It is illegitimate, a bastard language. And because we internalize how our language has been used against us by the dominant culture, we use our language differences against each other.

Chicana feminists often skirt around each other with suspicion and hesitation. For the longest time I couldn't figure it out. Then it dawned on me. To be close to another Chicana is like looking into the mirror. We are afraid of what we'll see there. *Pena*. Shame. Low estimation of self. In childhood we are told that our language is wrong. Repeated attacks on our native tongue diminish our sense of self. The attacks continue throughout our lives.

Chicanas feel uncomfortable talking in Spanish to Latinas, afraid of their censure. Their language was not outlawed in their countries. They had a whole lifetime of being immersed in their native tongue: generations, centuries in which Spanish was a first language, taught in school, heard on radio and TV, and read in the newspaper.

If a person, Chicana or Latina, has a low estimation of my native tongue, she also has a low estimation of me. Often with *mexicanas y*

latinas we'll speak English as a neutral language. Even among Chicanas we tend to speak English at parties or conferences. Yet, at the same time, we're afraid the other will think we're *agringadas* because we don't speak Chicano Spanish. We oppress each other trying to out-Chicano each other, vying to be the "real" Chicanas, to speak like Chicanos. There is no one Chicano language just as there is no one Chicano experience. A monolingual Chicana whose first language is English or Spanish is just as much a Chicana as one who speaks several variants of Spanish. A Chicana from Michigan or Chicago or Detroit is just as much a Chicana as one from the Southwest. Chicano Spanish is as diverse linguistically as it is regionally.

By the end of this century, Spanish speakers will comprise the biggest minority group in the U.S., a country where students in high schools and colleges are encouraged to take French classes because French is considered more "cultured." But for a language to remain alive it must be used.[6] By the end of this century English, and not Spanish, will be the mother tongue of most Chicanos and Latinos.

So, if you want to really hurt me, talk badly about my language. Ethnic identity is twin skin to linguistic identity—I am my language. Until I can take pride in my language, I cannot take pride in myself. Until I can accept as legitimate Chicano Texas Spanish, Tex-Mex and all the other languages I speak, I cannot accept the legitimacy of myself. Until I am free to write bilingually and to switch codes without having always to translate, while I still have to speak English or Spanish when I would rather speak Spanglish, and as long as I have to accommodate the English speakers rather than having them accommodate me, my tongue will be illegitimate.

I will no longer be made to feel ashamed of existing. I will have my voice: Indian, Spanish, white. I will have my serpent's tongue—my woman's voice, my sexual voice, my poet's voice. I will overcome the tradition of silence.

> My fingers
> move sly against your palm
> Like women everywhere, we speak in code.
> —Melanie Kaye Kantrowitz[7]

"*Vistas,*" *corridos, y comida*: My Native Tongue

In the 1960s, I read my first Chicano novel. It was *City of Night* by John Rechy, a gay Texan, son of a Scottish father and a Mexican mother. For days I walked around in stunned amazement that a Chicano could write and could get published. When I read *I Am Joaquín*[8] I was sur-

prised to see a bilingual book by a Chicano in print. When I saw poetry written in Tex-Mex for the first time, a feeling of pure joy flashed through me. I felt like we really existed as a people. In 1971, when I started teaching High School English to Chicano students, I tried to supplement the required texts with works by Chicanos, only to be reprimanded and forbidden to do so by the principal. He claimed that I was supposed to teach "American" and English literature. At the risk of being fired, I swore my students to secrecy and slipped in Chicano short stories, poems, a play. In graduate school, while working toward a Ph.D., I had to "argue" with one advisor after the other, semester after semester, before I was allowed to make Chicano literature an area of focus.

Even before I read books by Chicanos or Mexicans, it was the Mexican movies I saw at the drive-in—the Thursday night special of $1.00 a carload—that gave me a sense of belonging. "*Vámonos a las vistas*," my mother would call out and we'd all—grandmother, brothers, sister and cousins—squeeze into the car. We'd wolf down cheese and bologna white-bread sandwiches while watching Pedro Infante in melodramatic tear-jerkers like *Nosotros los pobres*, the first "real" Mexican movie (that was not an imitation of European movies). I remember seeing *Cuando los hijos se van* and surmising that all Mexican movies played up the love a mother has for her children and what ungrateful sons and daughters suffer when they are not devoted to their mothers. I remember the singing-type "westerns" of Jorge Negrete and Miguel Aceves Mejía. When watching Mexican movies, I felt a sense of homecoming as well as alienation. People who were to amount to something didn't go to Mexican movies, or *bailes* or tune their radios to *bolero*, *rancherita*, and *corrido* music.

The whole time I was growing up, there was *norteño* music, sometimes called North Mexican border music, or Tex-Mex music, or Chicano music, or *cantina* (bar) music. I grew up listening to *conjuntos*, three- or four-piece bands made up of folk musicians playing guitar, *bajo sexto*, drums and button accordion, which Chicanos had borrowed from the German immigrants who had come to Central Texas and Mexico to farm and build breweries. In the Rio Grande Valley, Steve Jordan and Little Joe Hernández were popular, and Flaco Jiménez was the accordion king. The rhythms of Tex-Mex music are those of the polka, also adapted from the Germans, who in turn had borrowed the polka from the Czechs and Bohemians.

I remember the hot, sultry evenings when *corridos*—songs of love and death on the Texas-Mexican borderlands—reverberated out of cheap amplifiers from the local *cantinas* and wafted in through my bedroom window.

Corridos first became widely used along the South Texas/Mexican border during the early conflict between Chicanos and Anglos. The *corridos* are usually about Mexican heroes who do valiant deeds against the Anglo oppressors. Pancho Villa's song, "*La cucaracha,*" is the most famous one. *Corridos* of John F. Kennedy and his death are still very popular in the Valley. Older Chicanos remember Lydia Mendoza, one of the great border *corrido* singers who was called *la Gloria de Tejas*. Her "*El tango negro,*" sung during the Great Depression, made her a singer of the people. The ever-present *corridos* narrated one hundred years of border history bringing news of events as well as entertaining. These folk musicians and folk songs are our chief cultural mythmakers, and they made our hard lives seem bearable.

I grew up feeling ambivalent about our music. Country-western and rock-and-roll had more status. In the 50s and 60s, for the slightly educated and *agringado* Chicanos, there existed a sense of shame at being caught listening to our music. Yet I couldn't stop my feet from thumping to the music, could not stop humming the words, nor hide from myself the exhilaration I felt when I heard it.

There are more subtle ways that we internalize identification, especially in the forms of images and emotions. For me food and certain smells are tied to my identity, to my homeland. Woodsmoke curling up to an immense blue sky; woodsmoke perfuming my grandmother's clothes, her skin. The stench of cow manure and the yellow patches on the ground; the crack of a .22 rifle and the reek of cordite. Homemade white cheese sizzling in a pan, melting inside a folded *tortilla*. My sister Hilda's hot, spicy *menudo, chile colorado* making it deep red, pieces of *panza* and hominy floating on top. My brother Carito barbecuing *fajitas* in the backyard. Even now and 3,000 miles away, I can see my mother spicing the ground beef, pork and venison with *chile*. My mouth salivates at the thought of the hot steaming *tamales* I would be eating if I were home.

Si le preguntas a mi mamá "¿Que eres?"

> Identity is the essential core of who we are as individuals, the conscious experience of the self inside.
> —Kaufman[9]

Nosotros los chicanos straddle the borderlands. On one side of us, we are constantly exposed to the Spanish of the Mexicans, on the other side we hear the Anglos' incessant clamoring so that we forget our language. Among ourselves we don't say *nosotros los americanos,* or *nosotros los españoles,* or *nosotros los hispanos*. We say *nosotros los*

mexicanos (by *mexicanos* we do not mean citizens of Mexico; we do not mean a national identity, but a racial one). We distinguish between *mexicanos del otro lado* and *mexicanos de este lado*. Deep in our hearts we believe that being Mexican has nothing to do with which country one lives in. Being Mexican is a state of soul—not one of mind, not one of citizenship. Neither eagle nor serpent, but both. And like the ocean, neither animal respects borders.

> *Dime con quien andas y te diré quien eres.*
> (Tell me who your friends are and I'll tell you who you are.)
> —Mexican saying

Si le preguntas a mi mamá, "¿Que eres?" te dirá, "Soy mexicana." My brothers and sister say the same. I sometimes will answer "*soy mexicana*" and at others will say "*soy chicana*" or "*soy tejana*." But I identified as "*Raza*" before I ever identified as "*mexicana*" or "Chicana."

As a culture, we call ourselves Spanish when referring to ourselves as a linguistic group and when copping out. It is then that we forget our predominant Indian genes. We are 70 to 80 percent Indian.[10] We call ourselves Hispanic[11] or Spanish-American or Latin American or Latin when linking ourselves to other Spanish-speaking peoples of the Western hemisphere and when copping out. We call ourselves Mexican-American[12] to signify we are neither Mexican nor American, but more the noun "American" than the adjective "Mexican" (and when copping out).

Chicanos and other people of color suffer economically for not acculturating. This voluntary (yet forced) alienation makes for psychological conflict, a kind of dual identity—we don't identify with the Anglo-American cultural values and we don't totally identify with the Mexican cultural values. We are a synergy of two cultures with various degrees of Mexicanness or Angloness. I have so internalized the borderland conflict that sometimes I feel like one cancels out the other and we are zero, nothing, no one. *A veces no soy nada ni nadie. Pero hasta cuando no lo soy, lo soy.*

When not copping out, when we know we are more than nothing, we call ourselves Mexican, referring to race and ancestry; *mestizo* when affirming both our Indian and Spanish (but we hardly ever own [up to] our Black ancestry); Chicano when referring to a politically aware people born and/or raised in the U.S.; *Raza* when referring to Chicanos; *tejanos* when we are Chicanos from Texas.

Chicanos did not know we were a people until 1965 when Cesar Chavez and the farmworkers united and *I Am Joaquín* was published and *la Raza Unida* party was formed in Texas. With that recognition,

we became a distinct people. Something momentous happened to the Chicano soul—we became aware of our reality and acquired a name and a language (Chicano Spanish) that reflected that reality. Now that we had a name, some of the fragmented pieces began to fall together— who we were, what we were, how we had evolved. We began to get glimpses of what we might eventually become.

Yet the struggle of identities continues, the struggle of borders is our reality still. One day the inner struggle will cease and a true integration will take place. In the meantime, *tenemos que hacerla lucha. ¿Quién está protegiendo los ranchos de mi gente? ¿Quién está tratando de cerrar la fisura entre la india y el blanco en nuestra sangre? El chicano, sí, el chicano que anda como un ladrón en su propia casa.*

Los chicanos, how patient we seem, how very patient. There is the quiet of the Indian about us.[13] We know how to survive. When other races have given up their tongue, we've kept ours. We know what it is to live under the hammer blow of the dominant *norteamericano* culture. But more than we count the blows, we count the days, the weeks, the years, the centuries, the eons until the white laws and commerce and customs will rot in the deserts they've created, lie bleached. *Humildes* yet proud, *quietos* yet wild, *nosotros los mexicanos-chicanos* will walk by the crumbling ashes as we go about our business. Stubborn, persevering, impenetrable as stone, yet possessing a malleability that renders us unbreakable, we, the *mestizas* and *mestizos*, will remain.

Notes

1. Ray Gwyn Smith, *Moorland Is Cold Country*, unpublished book.
2. Irena Klepfisz, "*Di rayze abeym*/The Journey Home," in *The Tribe of Dina: A Jewish Women's Anthology*, Melanie Kaye/Kantrowitz and Irena Klepfisz, eds. (Montpelier, VT: Sinister Wisdom Books, 1986), 49.
3. R. C. Ortega, *Dialectología del Barrio*, trans. Hortencia S. Alwan (Los Angeles, CA: R. C. Ortega, 1977), 132.
4. Eduardo Hernández-Chávez, Andrew D. Cohen, and Anthony E. Beltramo, *El Lenguaje de los Chicanos: Regional and Social Characteristics of Language Used by Mexican Americans* (Arlington, VA: Center for Applied Linguistics, 1975), 39.
5. Hernández-Chávez, xvii.
6. Irena Klepfisz, "Secular Jewish Identity: Yidishkayt in America," in *The Tribe of Dina*, Kaye/Kantrowitz and Klepfisz, eds., 43.
7. Melanie Kaye/Kantrowitz, "Sign," in *We Speak in Code: Poems and Other Writings* (Pittsburgh, PA: Motheroot Publications, 1980), 85.
8. Rodolfo Gonzales, *I Am Joaquín / Yo Soy Joaquín* (New York: Bantam Books, 1972). It was first published in 1967.
9. Kaufman, 68.
10. Chávez, 88–90.

11. "Hispanic" is derived from *Hispanis* (*España*, a name given to the Iberian Peninsula in ancient times when it was a part of the Roman Empire) and is a term designated by the U.S. government to make it easier to handle us on paper.

12. The Treaty of Guadalupe Hidalgo created the Mexican-American in 1848.

13. Anglos, in order to alleviate their guilt for dispossessing the Chicanos, stressed the Spanish part of us and perpetrated the myth of the Spanish Southwest. We have accepted the fiction that we are Hispanic, that is, Spanish, in order to accommodate ourselves to the dominant culture and its abhorrence of Indians. Chávez, 88–91.

12
Talking Back

~

bell hooks

> Usually, when people talk about the "strength" of black women . . . they ignore the reality that to be strong in the face of oppression is not the same as overcoming oppression, that endurance is not to be confused with transformation.
>
> —bell hooks

Cornel West compares bell hooks's contribution to black American intellectual life and thought to a "polyphonic 'song of the great composite democratic individual' yearning for a principled connectedness that promotes the distinctive self-development of each and every one of us. And she sings this song in the antiphonal, syncopated, and rhythmic forms bequeathed to her by her African foremothers and forefathers who refused to be silent in a strange land of pharaonic treatment" (hooks and West 1991, 63). hooks began composing her polyphonic song at an early age. Her first book, *Ain't I a Woman* (1981), was written when its author was nineteen and a student at Stanford University. At Stanford, hooks developed her voice and discovered ways in which it could be used as a tool for resistance.

Since 1981, she has written more than sixteen other books as well as numerous essays and reviews that can well be described as acts of resistance. Their titles reveal both the diversity of topics and the breadth of hooks's knowledge: *Feminist Theory: From Margin to Center* (1984), *Black Looks: Race and Representation* (1992), *Outlaw Culture: Resisting Representations* (1994), *Teaching to Transgress: Education as the Practice of Freedom* (1994), *Art on My Mind: Visual Politics* (1995), *Real to Real: Race, Sex, and Class at the Movies* (1996), and *All about Love: New Visions* (2000).

hooks was born Gloria Jean Watkins in 1952 in the town of Hopkinsville, Kentucky, where she lived with her father, a postal service custodian, her mother, a homemaker, and six siblings. In *Bone*

Black: Memories of Girlhood (1996), she describes the effect that living in poverty and growing up in a patriarchal household had on her development as a writer and intellectual. Inspiration came from women in the church community and from her grandmothers, all strong female role models. In fact, she took her pen name, bell hooks, from her great-grandmother to honor this woman who "spoke her mind, . . . [and] was not afraid to talk back." Both grandmothers left her a "legacy of defiance, of will, of courage" (hooks 1989, 9).

hooks drew from her grandmothers' legacy while attending school during the days of the Civil Rights movement. In *Teaching to Transgress*, she describes her early school years. When desegregation policies were implemented, she tells how, at sixteen, she went to school accompanied by National Guardsmen. Following high school, hooks left Kentucky to attend Stanford, where she graduated with a bachelor's degree in English. Later, after a stint at Yale, she received her doctorate from the University of California at Santa Cruz. Since then she has taught in African American Studies, Women's Studies, and English departments at several universities. At present she is on the faculty at City College of New York.

Four years ago, I heard bell hooks lecture at the University of North Carolina at Chapel Hill. In her talk, she explored a theme found in many of her writings. To speak of race, class, or gender, she said, one must speak of all three and not of any particular one in isolation. For example, we can no longer presume that art has no race or gender or class, for each, individually and collectively, shapes art practices. Issues of race, class, and gender are interwoven, and each one has a powerful influence on the others. For this reason, hooks has harshly criticized a number of groups, including white feminist organizations, because they often exclude discussion of race or class issues as they relate to feminism.

To be effective, the public intellectual must be able to observe the age at which she lives with "fifty pairs of eyes," to quote Virginia Woolf, for only then can she discover the "locked chambers of possibility" as well as what June Jordan describes as the "intimate face of universal struggle" (quoted in Rich 1993, xiv, 216). The multiple sites of struggle, if not the universality of a single struggle, have forced late twentieth-century women public intellectuals to broaden their audience to include members of all races, nationalities, classes, and genders. Some male intellectuals such as George Will, Harold Bloom, and William Buckley, continue to speak from elitist positions of power and authority to small and narrowly defined groups. hooks, however, in her teachings, lectures, and writings, engages her audience. She asserts that "the engaged voice must never be fixed and absolute but

always changing, always evolving in dialogue with a world beyond itself" (hooks 1994b, 11).

Open dialogue between writer and audience is key to dismantling barriers that separate us from other cultures and peoples: "To engage in dialogue [hooks argues] is one of the simplest ways we can begin as teachers, scholars, and critical thinkers to cross boundaries, the barriers that may or may not be erected by race, gender, class, professional standing, and a host of other differences" (130). By incorporating dialogue in a variety of settings—the classroom, interviews, the lecture circuit, and town meetings—hooks can more readily address such thorny issues as racial and class intolerance. She often reminds her listeners and readers that for a meaningful conversation between differing individuals to take place, each must be willing to accept the concept of "other." Both sides should "embrace difference and sameness at the same time without feeling the need to negate one or the other" (hooks 1994c, 143). This is the same challenge that Martin Luther King Jr. gave to the nation in the 1960s: to live in harmony, we "must transcend our race, our tribe, our class, and our nation."

Tolerance, however, is not the same as conformity. In *Teaching to Transgress*, hooks asserts that in America, the intellectual "has often been assimilated and [has] betrayed revolutionary concerns in the interest of maintaining class power. . . . It is [therefore] necessary for insurgent black intellectuals to have an ethics of struggle" that informs their relationship to subjugated African Americans (1994b, 54). This type of engaged dialogue shifts social discourse away from the privileged and toward the oppressed, thus decolonizing and freeing the minds of those who have been victims of oppression (hooks and West 1991, 150).

Another way of shifting discourse, hooks argues, is to apply political, economic, social, and intellectual thought and theory to the everyday, that is, to put theory into practice. Namulundah Florence maintains that the separation of theory from practice, which occurs often in the classroom, leads to reification and promotion of an uncritical reflection of social reality (1998, 101). This separation encourages class elitism. Members of both the dominant and dominated groups participate in marginalization when they "deny the power of liberatory education or critical consciousness" (hooks 1994b, 69). The role and responsibility of the public intellectual, then, is to act as "catalyst for personal and communal transformation," so that all peoples—men, women, and children—can live "fully" (71). For this reason, hooks often incorporates personal anecdotes into her work to explain theoretical concepts. "When you tell a story about how you use an abstract idea or a bit of theory in a concrete situation," she stated in an interview,

"it just feels more real to people" (Olson and Hirsh 1995, 106). Fulfilling her mission as a public intellectual has meant, for hooks, addressing issues that confront people day-to-day in modern society, whether the topic be the newest Spike Lee movie or the pedagogical theories of late Brazilian educator Paulo Freire.

hooks has written extensively on the role and responsibilities of the intellectual in late twentieth-century society. She contends that to become a black intellectual is "an act of self-imposed marginality" (hooks and West 1991). Yet, the life of the mind she chose for herself was more a calling than a vocation. It was also a way of surviving a painful childhood, one in which she was punished for being too talkative and asking too many questions. As a young girl, she developed a detachment that allowed her to withdraw from the present and to analyze her situation. "The life of the mind," she writes, became a "refuge, a sanctuary where I could construct my own subject" (hooks and West 1991). Thus, critical thought became a healing force in her life.

Not surprisingly, bell hooks perceives herself as an intellectual rather than an academic, arguing that while an academic simply trades in ideas, an intellectual "trades in ideas by transgressing discursive frontiers," from rap to racism to economic policies. As does Terry Eagleton in *The Significance of Theory* and Edward Said in *Representations of the Intellectual*, hooks, too, envisions intellectuals as "creative thinkers, explorers in the realm of ideas who are able to push to the limits and beyond" (hooks and West 1991, 152), where they then can ask challenging questions that confront tradition and dogma.

Public intellectuals do not have the luxury of living as philosopher kings since part of their work entails, or at least *should* entail, establishing community. In "Simple Living: An Antidote to Hedonistic Materialism," hooks argues that the primary goal of public intellectuals, specifically African American ones, should be the "collective well-being of black people in the diaspora" (hooks 1999, 127). At the present time, most black geniuses (the term Walter Mosley uses to describe the contributors to *Black Geniuses* in which "Simple Living" is included) have little contact with the general black populace (129). Most public intellectuals, hooks has noticed, "do not choose to be dissident voices challenging imperialist, white supremacist, capitalist patriarchy" (130). Instead, they accept the accolades and the money, having overlooked the fact that the "insurgent intellectual . . . speaks to a diverse audience, to masses of people with different class, race, or educational backgrounds." Only in this way do we become "part of communities" (hooks and West 1991).

The ideal place to begin community building is in the classroom, where students of different races, classes, and gender are united in

their "desire to learn—to receive actively knowledge that enhances our intellectual development and our capacity to live more fully in the world" (hooks 1994b, 40). In *Teaching to Transgress*, hooks echoes the messages of Anna Julia Cooper and Jessie Redmon Fauset when she campaigns for literacy and a democratic education. Tom Fox has commented on the ways in which hooks has connected "activism and literacy" and has pressed other intellectuals to acknowledge and respond to those connections (1994, 111). However, as does Gloria Anzaldúa, hooks, too, understands that education can be a two-edged sword—a political force for either liberation or domination. Although, as practiced in the university, education has become a tool for justifying and perpetuating "white supremacy, imperialism, sexism, and racism," it should, in truth, be about "the practice of freedom" (29). Instead, schools in the United States practice what Paulo Freire termed the "banking system of education," in which students memorize information given to them by the teacher and then regurgitate it for the final exam.

For education to become a practice of freedom in which truth is pursued and knowledge shared, educators, asserts hooks, must practice an engaged pedagogy in which students become active participants and not passive consumers (14). They must dismantle the archaic idea that the teacher is the only dynamic in the classroom and acknowledge that learning is a "collective effort" (8). The goal then is to develop a learning community in which everyone influences the classroom dynamic and everyone contributes (hooks 1994b, 8). Students and teachers, "though necessarily unequal," may have a reciprocal relationship.

Engaged pedagogy develops voice and speech as well as both self- and political awareness. To speak is to be engaged in self-transformation and in moving oneself from object to subject; it means decolonizing and liberating the mind. In developing her own voice, hooks discovered it to be neither monologist nor static but multidimensional. As hooks has done in her own life, so, too, students and teachers, in finding their voices, must, as Anzaldúa urges them to do in *Borderlands*, "claim all the tongues in which we speak."

bell hooks has written of her disappointment in those educators who allow students to compose in a single voice, whether it be in standard English or in the black vernacular. Students need to acquire the skills and the knowledge to use a variety of voices. As educator Lisa Delpit suggests, students of color "need access to dominant Discourses to (legally) have access to economic power." Yet, they also need to develop the skills required to "transform dominant Discourse for liberatory purposes" (Delpit 1992, 292). Language conveys power, a

theme often found in Adrienne Rich's work as well as in bell hooks's: "Moving from silence into speech is for the oppressed, the colonized, the exploited, and those who stand and struggle side by side a gesture of defiance that heals, that makes new life and new growth possible. It is that act of speech, of 'talking back' that is no mere gesture of empty words, that is the expression of our movement from object to subject—the liberated voice" (hooks 1989, 9).

In the classroom, hooks assists students in finding their voices by encouraging the use of polyphonic language, one that includes "academic talk, standard English, vernacular patois, [as well as] the language of the street" (1994a, 7). This vernacular is both a celebration and affirmation of "insurgent intellectual cultural practice" and an invitation to enter a space of changing thought . . . [which] is the heartbeat of cultural revolution" (7). In encouraging polyvocal dialogue in and outside the classroom, the teacher takes the first step not only in allowing students to be their own witnesses but also in teaching them the importance of tolerating differences. In addition, hooks also requires that students be able to write in more than one voice and has given her Anglo students the task of composing their assignments in standard English and then rewriting them in the vernacular.

Critics have harshly criticized hooks for her liberated writing style. They have dismissed her writing as nonacademic since she rarely uses footnotes and citations. As Namulundah Florence notes, this omission puts the demand on the reader to be conversant with cited texts (Florence 1998, xxi). In addition, to engage the widest audience, hooks rarely employs academe-speak, choosing instead to use a language which her hearers can understand: "To know our audience, to know who listens, we must be in dialogue. We must be speaking with and not just speaking to" (hooks 1989, 16). Yet, critic Adolph Reed contends that hooks's efforts have resulted in an incomprehensible blend of "bombast, clichés, and psychobabble" (1995, 31).

Nevertheless, despite the criticism of publishers and fellow academics as well as the racial and gender barriers that she has confronted throughout her life, hooks has preserved her intellectual integrity and become a strong voice for the oppressed. She has given vent to her anger at society's mistreatment of women, African Americans, and the poor while presenting herself to white males as a catalyst for their own transformation. Her rage has also given her, in her own words, "a radical political commitment to ending domination that is powerful enough, and a love of justice that is intense enough, that it makes me want to . . . [do] work that I feel will have a meaningful impact and raise consciousness" (1989, 16).

In recent years, hooks has redirected her energy, which she used to convey her anger in the 1980s. Her most recent book, *All About Love*, focuses on forgiveness and love. Here she describes how individuals in modern society have misplaced the love ethic which, throughout history, has always played a central role in the great movements for social justice (hooks 2000, xix). hooks offers a concise strategy on how a person can restore the love ethic in their life and in their world so as to heal social injustices as well as our own wounds. In many ways, Gloria Anzaldúa also presents a message of love and inclusion as ways of healing social and inner injuries. hooks writes: "As our cultural awareness of the ways we are secluded away from love, away from the knowledge that love heals gains recognition, our anguish intensifies. But so does our yearning. The space of our lack is also the space of possibility. As we yearn, we make ourselves ready to receive the love that is coming to us, as gift, as promise, as earthly paradise" (2000, 221).

Seeing and Making Culture: Representing the Poor*

Cultural critics rarely talk about the poor. Most of us use words such as "underclass" or "economically disenfranchised" when we speak about being poor. Poverty has not become one of the new hot topics of radical discourse. When contemporary Left intellectuals talk about capitalism, few if any attempts are made to relate that discourse to the reality of being poor in America. In his collection of essays *Prophetic Thought in Post-modern Times*, black philosopher Cornel West includes a piece entitled "The Black Underclass and Black Philosophers" wherein he suggests that black intellectuals within the "professional-managerial class in U.S. advanced capitalist society" must "engage in a kind of critical self-inventory, a historical situating and positioning of ourselves as persons who reflect on the situation of those more disadvantaged than us even though we may have relatives and friends in the black underclass." West does not speak of poverty or being poor in his essay. And I can remember once in conversation with him referring to my having come from a "poor" background; he corrected me and stated

*From bell hooks, *Outlaw Culture: Resisting Representations* (New York: Routledge, 1994), 165–72.

that my family was "working class." I told him that technically we *were* working class, because my father worked as a janitor at the post office; however, the fact that there were seven children in our family meant that we often faced economic hardship in ways that made us children at least think of ourselves as poor. Indeed, in the segregated world of our small Kentucky town, we were all raised to think in terms of the haves and the have-nots, rather than in terms of class. We acknowledged the existence of four groups: the poor, who were destitute; the working folks, who were poor because they made just enough to make ends meet; those who worked and had extra money; and the rich. Even though our family was among the working folks, the economic struggle to make ends meet for such a large family always gave us a sense that there was not enough money to take care of the basics. In our house, water was a luxury and using too much could be a cause for punishment. We never talked about being poor. As children we knew we were not supposed to see ourselves as poor but we felt poor.

I began to see myself as poor when I went away to college. I never had any money. When I told my parents that I had scholarships and loans to attend Stanford University, they wanted to know how I would pay for getting there, for buying books, for emergencies. We were not poor, but there was no money for what was perceived to be an individualistic indulgent desire; there were cheaper colleges closer to family. When I went to college and could not afford to come home during breaks, I frequently spent my holidays with the black women who cleaned in the dormitories. Their world was my world. They, more than other folks at Stanford, knew where I was coming from. They supported and affirmed my efforts to be educated, to move past and beyond the world they lived in, the world I was coming from.

To this day, even though I am a well-paid member of what West calls the academic "professional-managerial class," in everyday life, outside the classroom, I rarely think of myself in relation to class. I mainly think about the world in terms of who has money to spend and who does not. Like many technically middle-class folks who are connected in economic responsibility to kinship structures where they provide varying material support for others, the issue is always one of money. Many middle-class black folks have no money because they regularly distribute their earnings among a larger kinship group where folks are poor and destitute, where elder parents and relatives who once were working class have retired and fallen into poverty.

Poverty was no disgrace in our household. We were socialized early on, by grandparents and parents, to assume that nobody's value could be measured by material standards. Value was connected to integrity, to being honest and hardworking. One could be hardworking and still

be poor. My mother's mother Baba, who did not read or write, taught us—against the wishes of our parents—that it was better to be poor than to compromise one's dignity, that it was better to be poor than to allow another person to assert power over you in ways that were dehumanizing or cruel.

I went to college believing there was no connection between poverty and personal integrity. Entering a world of class privilege which compelled me to think critically about my economic background, I was shocked by representations of the poor learned in classrooms, as well as by the comments of professors and peers that painted an entirely different picture. They almost always portrayed the poor as shiftless, mindless, lazy, dishonest, and unworthy. Students in the dormitory were quick to assume that anything missing had been taken by the black and Filipina women who worked there. Although I went through many periods of shame about my economic background, even before I educated myself for critical consciousness about class (by reading and studying Marx, Gramsci, Memmi, and the like), I contested stereotypical negative representations of poverty. I was especially disturbed by the assumption that the poor were without values. Indeed, one crucial value that I had learned from Baba, my grandmother, and other family members was not to believe that "schooling made you smart." One could have degrees and still not be intelligent or honest. I had been taught in a culture of poverty to be intelligent, honest, to work hard, and always to be a person of my word. I had been taught to stand up for what I believed was right, to be brave and courageous. These lessons were the foundation that made it possible for me to succeed, to become the writer I always wanted to be, and to make a living in my job as an academic. They were taught to me by the poor, the disenfranchised, the underclass.

Those lessons were reinforced by liberatory religious traditions that affirmed identification with the poor. Taught to believe that poverty could be the breeding ground of moral integrity, of a recognition of the significance of communion, of sharing resources with others in the black church, I was prepared to embrace the teachings of liberatory theology, which emphasized solidarity with the poor. That solidarity was meant to be expressed not simply through charity, the sharing of privilege, but in the assertion of one's power to change the world so that the poor would have their needs met, would have access to resources, would have justice and beauty in their lives.

Contemporary popular culture in the United States rarely represents the poor in ways that display integrity and dignity. Instead, the poor are portrayed through negative stereotypes. When they are lazy and dishonest, they are consumed with longing to be rich, a longing so

intense that it renders them dysfunctional. Willing to commit all manner of dehumanizing and brutal acts in the name of material gain, the poor are portrayed as seeing themselves as always and only worthless. Worth is gained only by means of material success.

Television shows and films bring the message home that no one can truly feel good about themselves if they are poor. In television sitcoms the working poor are shown to have a healthy measure of self-contempt; they dish it out to one another with a wit and humor that we can all enjoy, irrespective of our class. Yet it is clear that humor masks the longing to change their lot, the desire to "move on up" expressed in the theme song of the sitcom *The Jeffersons*. Films which portray the rags-to-riches tale continue to have major box-office appeal. Most contemporary films portraying black folks—*Harlem Nights, Boomerang, Menace II Society*, to name only a few—have as their primary theme the lust of the poor for material plenty and their willingness to do anything to satisfy that lust. *Pretty Woman* is a perfect example of a film that made huge sums of money portraying the poor in this light. Consumed and enjoyed by audiences of all races and classes, it highlights the drama of the benevolent, ruling-class person (in this case a white man, played by Richard Gere) willingly sharing his resources with a poor white prostitute (played by Julia Roberts). Indeed, many films and television shows portray the ruling class as generous, eager to share, as unattached to their wealth in their interactions with folks who are not materially privileged. These images contrast with the opportunistic avaricious longings of the poor.

Socialized by film and television to identify with the attitudes and values of privileged classes in this society, many people who are poor, or a few paychecks away from poverty, internalize fear and contempt for those who are poor. When materially deprived teenagers kill for tennis shoes or jackets they are not doing so just because they like these items so much. They also hope to escape the stigma of their class by appearing to have the trappings of more privileged classes. Poverty, in their minds and in our society as a whole, is seen as synonymous with depravity, lack, and worthlessness. No one wants to be identified as poor. Teaching literature by African American women writers at a major urban state university to predominantly black students from poor and working-class families, I was bombarded by their questioning as to why the poor black women who were abused in families in the novels we read did not "just leave." It was amazing to me that these students, many of whom were from materially disadvantaged backgrounds, had no realistic sense about the economics of housing or jobs in this society. When I asked that we identify our class backgrounds, only one student—a young single parent—was willing

to identify herself as poor. We talked later about the reality that although she was not the only poor person in the class, no one else wanted to identify with being poor for fear this stigma would mark them, shame them in ways that would go beyond our class. Fear of shame-based humiliation is a primary factor leading no one to want to identify themselves as poor. I talked with young black women receiving state aid, who have not worked in years, about the issue of representation. They all agree that they do not want to be identified as poor. In their apartments they have the material possessions that indicate success (a VCR, a color television), even if it means that they do without necessities and plunge into debt to buy these items. Their self-esteem is linked to not being seen as poor.

If to be poor in this society is everywhere represented in the language we use to talk about the poor, in the mass media, as synonymous with being nothing, then it is understandable that the poor learn to be nihilistic. Society is telling them that poverty and nihilism are one and the same. If they cannot escape poverty, then they have no choice but to drown in the image of a life that is valueless. When intellectuals, journalists, or politicians speak about nihilism and the despair of the underclass, they do not link those states to representations of poverty in the mass media. And rarely do they suggest by their rhetoric that one can lead a meaningful, contented, and fulfilled life if one *is* poor. No one talks about our individual and collective accountability to the poor, a responsibility that begins with the politics of representation.

When white female anthropologist Carol Stack looked critically at the lives of black poor people more than twenty years ago and wrote her book *The Culture of Poverty*, she found a value system among them which emphasized the sharing of resources. That value system has long been eroded in most communities by an ethic of liberal individualism, which affirms that it is morally acceptable not to share. The mass media have been the primary teacher bringing into our lives and our homes the logic of liberal individualism, the idea that you make it by the privatized hoarding of resources, not by sharing them. Of course, liberal individualism works best for the privileged classes. But it has worsened the lot of the poor who once depended on an ethic of communalism to provide affirmation, aid, and support.

To change the devastating impact of poverty on the lives of masses of folks in our society we must change the way resources and wealth are distributed. But we must also change the way the poor are represented. Since many folks will be poor for a long time before those changes are put in place that address their economic needs, it is crucial to construct habits of seeing and being that restore an oppositional value system affirming that one can live a life of dignity and integrity in the

midst of poverty. It is precisely this dignity Jonathan Freedman seeks to convey in his book *From Cradle to Grave: The Human Face of Poverty in America*, even though he does not critique capitalism or call for major changes in the distribution of wealth and resources. Yet any efforts to change the face of poverty in the United States must link a shift in representation to a demand for the redistribution of wealth and resources.

Progressive intellectuals from privileged classes who are themselves obsessed with gaining material wealth are uncomfortable with the insistence that one can be poor, yet lead a rich and meaningful life. They fear that any suggestion that poverty is acceptable may lead those who have to feel no accountability towards those who have not, even though it is unclear how they reconcile their pursuit with concern for and accountability towards the poor. Their conservative counterparts, who did much to put in place a system of representation that dehumanized the poor, fear that if poverty is seen as having no relation to value, the poor will not passively assume their role as exploited workers. That fear is masked by their insistence that the poor will not seek to work if poverty is deemed acceptable, and that the rest of us will have to support them. (Note the embedded assumption that to be poor means that one is not hardworking.) Of course, there are many more poor women and men refusing menial labor in low-paid jobs than ever before. This refusal is not rooted in laziness but in the assumption that it is not worth it to work a job where one is systematically dehumanized or exploited only to remain poor. Despite these individuals, the vast majority of poor people in our society want to work, even when jobs do not mean that they leave the ranks of the poor.

Witnessing that individuals can be poor and lead meaningful lives, I understand intimately the damage that has been done to the poor by a dehumanizing system of representation. I see the difference in self-esteem between my grandparents' and parents' generations and that of my siblings, relatives, friends and acquaintances who are poor, who suffer from a deep-seated, crippling lack of self-esteem. Ironically, despite the presence of more opportunity than that available to an older generation, low self-esteem makes it impossible for this younger generation to move forward even as it also makes their lives psychically unbearable. That psychic pain is most often relieved by some form of substance abuse. But to change the face of poverty so that it becomes, once again, a site for the formation of values, of dignity and integrity, as any other class positionality in this society, we would need to intervene in existing systems of representation.

Linking this progressive change to radical/revolutionary political movements (such as eco-feminism, for example) that urge all of us to

live simply could also establish a point of connection and constructive interaction. The poor have many resources and skills for living. Those folks who are interested in sharing individual plenty as well as working politically for redistribution of wealth can work in conjunction with individuals who are materially disadvantaged to achieve this end. Material plenty is only one resource. Literacy skills are another. It would be exciting to see unemployed folks who lack reading and writing skills have available to them community-based literacy programs. Progressive literacy programs connected to education for critical consciousness could use popular movies as a base to begin learning and discussion. Theaters all across the United States that are not used in the day could be sites for this kind of program where college students and professors could share skills. Since many individuals who are poor, disadvantaged or destitute are already literate, reading groups could be formed to educate for critical consciousness, to help folks rethink how they can organize life both to live well in poverty and to move out of such circumstances. Many of the young women I encounter—black and white—who are poor and receiving state aid (and some of whom are students or would-be students) are intelligent, critical thinkers struggling to transform their circumstances. They are eager to work with folks who can offer guidance, know-how, concrete strategies. Freedman concludes his book with the reminder that "it takes money, organization, and laws to maintain a social structure but none of it works if there are not opportunities for people to meet and help each other along the way. Social responsibility comes down to something simple—the ability to respond." Constructively changing ways the poor are represented in every aspect of life is one progressive intervention that can challenge everyone to look at the face of poverty and not turn away.

Afterthoughts

> One must distinguish the desire for power from the need to become empowered—that is, seeing oneself as capable of and having the right to determine one's life. Such empowerment is partially derived from a knowledge of history.
> —Barbara Christian

In formulating his definition of the intellectual, Edward Shils wrote, "In every society . . . there are some persons with an unusual sensitivity to the sacred, an uncommon reflectiveness about the nature of their universe, and the rules which govern their society" (Said 1994, 26). Does that mean that the intellectual must be an Old Testament Jeremiah, one who transcends his audience and his culture? Or is Stephen Carter correct in saying that "what makes one an intellectual is the drive to learn, to question, to criticize, not as a means to an end but as an end in itself"? Or is Cynthia Ozick accurate in portraying the intellectual, and specifically the public intellectual, as a dual creature with one foot in the past and the other in the present?

According to Ozick, public intellectuals must acknowledge the past; they cannot merely respond to the current social climate. Instead, they must sift through the chaos and confusion to seek out "cognitive and historic patterns" that produce climate changes (Ozick 1995, 355). History is part of both the past and the present. The public intellectuals understand that "history is where we swim, that we are *in* it, that we can't see over or around it, that it is our ineluctable task to go through it; and that we may not murmur, Look: the past came through; so will we. The difference, then between public intellectuals and others, must lie in activism" (355).

In his definition of the term "intellectual," John Mepham includes a list of the intellectual's social responsibilities. They include

> the responsibility to encourage people to live with an eye to more than their own narrow interests and pleasures, to live something larger than themselves; the responsibility to name, refine, revitalize those values in attachment to which we make our lives transcend the narrowness of self-interest, values of equality, democracy and freedom;

... and the responsibility of truth-telling, of "naming," of finding vocabularies and creating perspectives through which hidden or unspoken things can be voiced, as well as the responsibility to contribute to the process of political dreaming, which means the formulation through political imagination of aspirations and projects for alternative futures (Mepham 1996, 18).

The intellectual, therefore, must understand the history of the past, have a grasp on the future, but be firmly grounded in the present.

Over forty years ago, Hannah Arendt asserted that in Western thought there is, and historically has been, a marked difference between intellect and everyday life: "In its concern with ... contemplating what was eternal, beyond the reach of human achievement, and unchanged by human actions, the life of the mind served as a compelling ideal in which the demands of the body and the needs of mortal existence might be left behind and the possibility of participating in the realm of transcendence realized" (Arendt 1958a 7). What the public intellectual today is trying to do—or should be attempting to do—is to erase the distinction.

Today, bell hooks writes that the "every day" has become a major issue for her as an intellectual. Recognizing that feminist and intellectual theories rarely "provide actual strategies for altering everyday lives," she asserts that what is needed is a "public framework," one that encourages practical applications of theoretical thought to quotidian life (hooks 1993, 40-41). Relying on personal experiences, Barbara Erhenreich and bell hooks, like their "great-aunts" Lydia and Jessie, speak to and for women and African Americans as well as for other oppressed groups by applying their political and educational theories to everyday experience.

Though not their daughters, late twentieth-century public intellectuals such as Cynthia Ozick and Gloria Anzaldúa bear striking similarities to women intellectuals of the past. bell hooks was drawn, as was Anna Julia Cooper, to a life of knowledge by a passion for critical thinking. In "Trip to Hanoi," Susan Sontag passionately opposed the Vietnam War at a time when it was unpopular to do so, just as Margaret Fuller positioned herself in opposition to popular opinion during Italy's fight for democracy. The women of this study reveal that being an intellectual does not mean removing one's self from life. Each was or is actively involved with the quotidian while producing the work of the mind.

A woman who embarks on the life of a public intellectual faces a monumental task, one filled with direct confrontations and hidden dangers. Audre Lorde spoke of these difficulties in "Litany for Survival":

> and when we speak we are afraid
> our words will not be heard
> nor welcomed
> but when we are silent
> we are still afraid.
> So it is better to speak
> remembering
> we were never meant to survive (1978, 35).

In *Revolution from Within*, Gloria Steinem, one of Elizabeth Cady Stanton's numerous nieces, recalls the old feminist adage, the personal is political. She acknowledges that she "create[s] much of the outer world [as well as her] political essays," from within herself (Steinem 1992, 8). Many of the intellectuals in this study, especially Margaret Fuller, Susan Sontag, and Gloria Anzaldúa, have incorporated their personal experiences in their writing to guide the readers and society at large toward self-realization and self-definition.

Those women intellectuals, past and present, who speak as their own witnesses often pay a heavy price. James Allan, a nineteenth-century critic, describes them as "monster[s] more horrible than that created by Frankenstein" (1890, 124). Moreover, despite women's advances, the blacklash that Susan Faludi wrote about in the early 1990s persists. This powerful counterattack has convinced the general populace that the women's movement was the "true contemporary American scourge" (Faludi 1991, xviii). This backlash has moved steadily toward one goal: to return women to their domestic sphere (xxii). *Voices Unbound* is filled with examples of attempts to silence thinking women, from Margaret Fuller to bell hooks. For instance, Jessie Redmon Fauset, one of the founders of the Harlem Renaissance, was accused by the black literati of not being "black enough" (Ammons 1991, 194). Describing the critical response to her first book, *Ain't I a Woman*, bell hooks describes how its force was so intense that it seemed to possess the power "to crush the spirit, to push one into silence" (hooks 1989, 8).

In this study, I have attempted to do what Adrienne Rich has done throughout her career for women poets and writers—to give voice to women intellectuals who, after overcoming overwhelming odds, moved forward to transcend what Nancy Mairs describes as a "destructive past which binds and suffocates the present, foreseeing a future that is uncertain and potentially dangerous, but necessary for survival" (1994, 63). Here we find the beginnings of a fascinating lineage of aunts and nieces, which, linked together, form a nontraditional heritage. The connection is indirect, almost tangential, but it is less constraining an

influence than that of the mother or father. *Voices Unbound* is a first step toward developing a women's intellectual tradition for those, such as myself, who long for its possibilities.

Selected Readings

Albert, Judith Strong. "Currents of Influence: The Electrical, Magnetic Element in Woman. . . ." *Margaret Fuller: Visionary of the New Age.* Edited by Marie Mitchell Olesen Urbanski. Orono, ME: Northern Lights, 1994. 199–239.

Alexander, Elizabeth. " 'We Must Be about Our Father's Business': Anna Julia Cooper and the In-Corporation of the Nineteenth-Century African-American Woman Intellectual." *In Her Own Voice: Nineteenth Century American Women Essayists.* Edited by Sherry Lee Linkon. New York: Garland, 1997. 61–81.

Allan, James McGrigor. *Women Suffrage: Wrong in Principle and Practice.* London: Remington, 1890.

Allen, Carol. *Black Women Intellectuals: Strategies of Nation, Family, and Neighborhood in the Works of Pauline Hopkins, Jessie Fauset, and Marita Bronner.* New York: Garland, 1998.

Allen, Margaret Vanderhaar. *The Achievement of Margaret Fuller.* University Park: Pennsylvania State University Press, 1979.

Ammons, Elizabeth. *Conflicting Stories: American Women Writers at the Turn into the Twentieth Century.* New York: Oxford University Press, 1991.

Anthony, Susan B. *The Life and Work of Susan B. Anthony; Including Public Addresses, Her Own Letters and Many from Her Contemporaries during Fifty Years.* 3 vols. Edited by Ida Husted Harper. Indianapolis: Bowen-Merrill Company, 1898–1908.

Anzaldúa, Gloria. *Borderlands/La Frontera: The New Mestiza.* San Francisco: Aunt Lute, 1987.

———. "Bridge, Drawbridge, Sandbar or Island: Lesbians-of-Color Hacienda Alianzas." *Bridges of Power: Women's Multicultural Alliances.* Edited by Lisa Albrecht and Rose Brewer. Philadelphia: New Society Publishers, 1990a.

———, ed. *Making Face, Making Soul/Haciendo Caras: Creative and Critical Perspectives by Women of Color.* San Francisco: Aunt Lute, 1990b.

———. *Interviews/Entrevistas.* Edited by AnaLouise Keating. New York: Routledge, 2000.

———, and Cherríe Moraga. *This Bridge Called My Back: Writings by Radical Women of Color.* 2d ed. Latham, NY: Kitchen Table: Women of Color Press, 1981.

Arendt, Hannah. *The Human Condition*. Chicago: University of Chicago Press, 1958.
Aronowitz, Stanley. *Dead Artists, Live Theories, and Other Cultural Problems*. New York: Routledge, 1994.
Arteaga, Alfred. *Chicano Poetics, Heterotexts and Hybridities*. Cambridge: Cambridge University Press, 1997.
Auerbach, Nina. *Woman and the Demon: The Life of a Victorian Myth*. Boston: Harvard University Press, 1982.
_____. "Engorging the Patriarchy." *Feminist Issues in Literary Scholarship*. Edited by Shari Benstock. Bloomington: Indiana University Press, 1987.
Baer, Helen. *The Heart Is Like Heaven: The Life of Lydia Maria Child*. Philadelphia: University of Pennsylvania Press, 1964.
Baham, Eva Semien. "Anna Julia Hayward Cooper: A Stream Cannot Rise Higher than Its Source: The Vanguard as the Panacea for the Plight of Black America." Ph.D. diss., Purdue University, 1997.
Baker-Fletcher, Karen. *A "Singing Something": Womanist Reflections on Anna Julia Cooper*. New York: Crossroad, 1994.
Banner, Lois. *Elizabeth Cady Stanton: A Radical for Woman's Rights*. Boston: Little, Brown, 1980.
_____. *Women in Modern America: A Brief History*. San Diego: Harcourt Brace, 1984.
Barstow, Jane Missner. *One Hundred Years of American Women Writing, 1848– *. Lanham, MD: Scarecrow, 1997.
Bartlett, Elizabeth Ann. *Liberty, Equality, Sorority*. Brooklyn: Carlson, 1994.
Bates, Geraldine Washington. "Womanist Aesthetic Theory: Building a Black Feminist Literary Critical Tradition, 1892–1994." Ph.D. diss., University of Pennsylvania, 1997.
Bateson, Mary Catherine. *With a Daughter's Eye: A Memoir of Margaret Mead and Gregory Bateson*. New York: Morrow, 1984.
Baxter, Nicky. "For Whom the Bell Tolls" (Review of *Killing Rage* by bell hooks). *MetroActive Books. Metro's Literary Quarterly* (February 15–21, 1996).
Baym, Nina. *American Women Writers and the Work of History, 1790–1860*. New Brunswick, NJ: Rutgers University Press, 1995.
Bean, Judith. "Conversation as Rhetoric in Margaret Fuller's Woman in the Nineteenth Century." *In Her Own Voice: Nineteenth Century American Women Essayists*. Edited by Sherry Lee Linkon. New York: Garland, 1997. 27–40.
_____. " 'A Presence among Us': Fuller's Place in Nineteenth-Century Oral Culture." *ESQ: A Journal of the American Renaissance* 44 (1998): 79–123.

Benda, Julian. *The Treason of the Intellectual.* New York: Norton, 1928.
Berkson, Dorothy. " 'So We All Became Mothers': Harriet Beecher Stowe, Charlotte Perkins Gilman, and the New World of Women's Culture." *Feminism, Utopia, and Narrative.* Edited by Libby Falk Jones and Sarah Webster Goodwin. Knoxville: University of Tennessee Press, 1990. 100–115.
Berubé, Michael. "Public Academy." *The New Yorker* (January 9, 1995): 73–80.
Blain, Virginia. "Thinking Back through Our Aunts: Harriet Martineau and Tradition in Women's Writing." *Women: A Cultural View* 1 (Winter 1990): 223–39.
Blanchard, Paula. *Margaret Fuller: From Transcendentalism to Revolution.* New York: Delacorte Press, 1978.
Bloom, Harold, ed. *Modern Critical Views: Cynthia Ozick.* New York: Chelsea House, 1986.
Bolick, Katie. "The Many Faces of Cynthia Ozick." Interview. *The Atlantic Unbound,* May 15, 1997. http://www.theatlantic.com/unbound/factfict/ozick.htm/
Boynton, Robert S. "The New Intellectuals." *Atlantic Monthly* 275 (March 1995): 53–71.
Braun, Frederick Augustus. *Margaret Fuller and Goethe.* New York: Henry Holt and Company, 1910.
Brownson, Orestes A. "Miss Fuller and Reformers." *Critical Essays on Margaret Fuller.* Edited by Joel Myerson. Boston: G. K. Hall, 1980. 19–25.
Burstein, Janet Handler. "Cynthia Ozick and the Transgressions of Art." *American Literature* 59 (1987): 85–101.
Byron, George Gordon Byron, Baron. *Don Juan.* Introduction by Louis Kronenberger. New York: Modern Library, 1949.
Capper, Charles. *Margaret Fuller: An American Romantic Life: The Private Years.* New York: Oxford University Press, 1992.
Carby, Hazel. *Reconstructing Womanhood: The Emergence of the Afro-American Woman Novelist.* New York: Oxford University Press, 1987.
Carlyle, Thomas. *Carlyle's Complete Works.* 20 vols. Boston: Estes and Lauriat, 1884.
Carnes, Marc C. "The Rise and Consolidation of Bourgeois Culture." *Encyclopedia of American Social History.* Edited by Mary Kupiec Cayton, Elliott J. Gorn, and Peter W. Williams. New York: Charles Scribner's Sons, 1993. 467–82.
"Cartwheel Girl." *Time* 33.24 (June 12, 1939): 47–51.
Cassidy, Robert. *Margaret Mead: A Voice for the Century.* New York: Universe, 1992.

Cayton, Mary Kupiec, Elliott J. Gorn, and Peter W. Williams, eds. *Encyclopedia of American Social History*. 3 vols. New York: Charles Scribner's Sons, 1993.

Chafe, William H. *The Unfinished Journey: America since World War II*. 2d ed. New York: Russell Sage Foundation, 1999.

Chevigny, Belle Gale. *The Woman and the Myth: Margaret Fuller's Life and Writings*. Old Westbury, NY: Feminist Press, 1976. Revised ed. Boston: Northeastern University Press, 1993.

Child, Lydia Maria. *Hobomok and Other Writings on Indians*. Edited by Carolyn L. Karcher. New Brunswick, NJ: Rutgers University Press, 1986 (1824).

_____. *The First Settlers of New-England: or, Conquest of the Pequods, Narragansets and Pokanokets, as related by a mother to her children. By a Lady of Massachusetts*. Boston: Munroe and Francis, 1829a.

_____. *The Frugal Housewife*. Boston: March & Capen and Carter & Hendee, 1829b. 2d ed., *The American Frugal Housewife*. Boston: Carter & Hendee, 1832. Boston: Applewood Books, 1985.

_____. *An Appeal in Favor of That Class of Americans Called Africans*. Boston: Allen and Ticknor, 1833. Reprint, with an introduction by Carolyn L. Karcher. Amherst: University of Massachusetts Press, 1996.

_____. "Woman in the Nineteenth Century." Review. *Broadway Journal* 1 (February 15, 1845): 97.

_____. *Letters from New York*. New York: C. S. Francis, 1843. Rpt. Freeport, NY: Books for Libraries, 1970.

_____. "The Equality of the Sexes." *Woman's Journal* (August 5, 1876): 252.

_____. *Lydia Maria Child: Selected Letters, 1817–1880*. Edited by Milton Meltzer, Patricia Holland, and Francine Krasno. Amherst: University of Massachusetts Press, 1982.

_____. *A Lydia Maria Child Reader*. Edited by Carolyn L. Karcher. Durham: Duke University Press, 1997.

Christian, Barbara. "The Rise and Fall of the Proper Mulatta." *Black Women Novelists: The Development of a Tradition, 1892–1976*. Westport, CT: Greenwood Press, 1980.

_____. *Black Feminist Criticism: Perspectives on Black Women Writers*. New York: Pergamon Press, 1985.

Clifford, Deborah Pickman. *Crusader for Freedom: A Life of Lydia Maria Child*. Boston: Beacon Press, 1992.

Cohen, Lisabeth. "The Great Depression and World War II." *Encyclopedia of American Social History*. Edited by Mary Kupiec Cayton, Elliott J. Gorn, and Peter W. Williams. New York: Charles Scribner's Sons, 1993. 189–203.

Cohen, Sarah Blacher. "The Fiction Writer as Essayist: Ozick's Metaphor and Memory." *Judaism* 39 (1990): 276–81.

———. "Cynthia Ozick: Prophet for Parochialism." *Women of the Word: Jewish Women and Jewish Writing*. Edited by Judith R. Baskin. Detroit: Wayne State University Press, 1994. 283–98.

Cole, Diane. "Cynthia Ozick." *Twentieth-Century American-Jewish Fiction Writers*. Edited by Daniel Walden. Vol. 28. *Dictionary of Literary Biography*. Detroit: Gale Research, 1984. 213–25.

Conrad, Susan Phinney. *Perish the Thought: Intellectual Women in Romantic America, 1830–1860*. New York: Oxford University Press, 1976.

Contee, Clarence G. "DuBois, the NAACP and the Pan-African Congress of 1919." *Journal of Negro History* (January 1972): 13–28.

Cooper, Anna Julia. *A Voice from the South by a Black Woman of the South*. Oxford: Oxford University Press, 1988 (1892).

———. *The Social Settlement: What It Is and What It Does*. Pamphlet. Washington, DC: Murray Brothers, 1913.

———. "The Higher Education of Women." *Black Women in Nineteenth Century American Life: Their Words, Their Thoughts, Their Feelings*. Edited by Bert James Lowenberg and Ruth Bogan. University Park: Pennsylvania State University Press, 1976.

———. "Womanhood: A Vital Element in the Regeneration and Progress of a Race." *I Am Because We Are: Readings in Black Philosophy*. Edited by Fred Lee Hord. Amherst: University of Massachusetts Press, 1995. 231–42.

———. "The Intellectual Progress of the Colored Women in the United States since the Emancipation Proclamation: A Response to Fannie Barrier Williams." *The Voice of Anna Julia Cooper*. Edited by Charles Lemert and Esme Bhan. Lanham, MD: Rowman, 1998.

Cott, Jonathan. "Susan Sontag: The Rolling Stone Interview." *Conversations with Susan Sontag*. Edited by Leland Poague. Jackson: University Press of Mississippi, 1995. 106–36.

Cott, Nancy F. *The Bonds of Womanhood: Woman's Sphere in New England, 1780–1835*. 2d ed. New Haven: Yale University Press, 1997 (1977).

Cousins, Norman. "Will Women Lose Their Jobs?" *Current History and Forum* 41 (September 1939): 14.

Crapol, Edward. *Women and American Foreign Policy: Lobbyists, Critics, and Insiders*. New York: Greenwood Press, 1987.

Culley, Margo, ed. *American Women's Autobiography: Fea(s)ts of Memory*. Madison: University of Wisconsin Press, 1992.

"Cynthia Ozick." *Great Women Writers*. Ed. Frank N. McGill. New York: Holt, 1994.

Darder, Antonia, and Rodolfo D. Torres, eds. *The Latino Studies Reader: Culture, Economy, and Society*. Malden, MA : Blackwell, 1998.

Davidson, Cathy, and Linda Wagner-Martin, eds. *The Oxford Companion to Women's Writing in the United States*. New York: Oxford University Press, 1995.

Davidson, Harriet. "Adrienne Rich." *Modern American Women Writers*. Edited by Elaine Showalter et al. New York: Collier, 1993 (1991). 295–304.

Davis, Ann. "Class Gender and Culture: A Discussion of Marxism, Feminism, and Postmodernism." *Gender and Political Economy*. Edited by Ellen Mutari, Heather Boushy, and William Fraher IV. Armonk, NY: M. E. Sharpe, 1997. 92–114.

Davis, Thadious M. "Jessie Redmon Fauset." *Black Women in America*. Vol. 1. Edited by Darlene Clark Hine. Brooklyn: Carlson, 1993.

Deegan, Mary Jo. Introduction. *With Her in Ourland: Sequel to Herland*. By Charlotte Perkins Gilman. Edited by Mary Jo Deegan and Michael R. Hill. Westport, CT: Praeger, 1997.

Degler, Carl. "Charlotte Perkins Gilman on the Theory and Practice of Feminism." *American Quarterly* 8.1 (Spring 1956): 21–39.

_____. Introduction. *Women and Economics*. By Charlotte Perkins Gilman. New York: Harper, 1966.

Delgado, Richard, and Jean Stefancic, eds. *The Latino/a Condition: A Critical Reader*. New York: New York University Press, 1998.

Delpit, Lisa D. "Acquisition of Literate Discourse: Bowing before the Master?" *Theory into Practice* 31 (Fall 1992): 292–302.

De Simone, Deborah M. "Charlotte Perkins Gilman and the Feminization of Education." *The Women in Literature and Life Assembly* 4 (Fall 1995). <http://scholar.lib.vt.edu/ejournals/WILLA/fall95/DeSimone.html>.

_____. "Charlotte Perkins Gilman and Educational Reform." *Charlotte Perkins Gilman: Optimist Reformer*. Edited by Jill Rudd and Val Gough. Iowa City: University of Iowa Press, 1999. 127–50.

Dickenson, Donna. *Margaret Fuller: Writing A Woman's Life*. New York: St. Martin's Press, 1993.

Du Bois, Ellen. "The Limitations of Sisterhood: Elizabeth Cady Stanton and Division in the American Suffrage Movement, 1875–1902." *Women and the Structure of Society*. Edited by Barbara J. Harris and JoAnn K. McNamara. Durham, NC: Duke University Press, 1984. 160–69.

Du Bois, W. E. B. "The True Brownies." *Crisis* 18 (1919): 285–86.

_____. *The Correspondence of W. E. B. DuBois*. Ed. Herbert Aptheker. Amherst: University of Massachusetts Press, 1973.

_____. "The Talented Tenth." *Writings by W. E. B. DuBois in Non-Periodical Literature Edited by Others*. Edited by Herbert Aptheker. Mellwood, NY: Kraus-Thomson, 1982. 17–29.

duCille, Ann. *The Coupling Convention: Sex, Text, and Tradition in Black Women's Fiction*. New York: Oxford University Press, 1993.

Duckworth, Victoria C. "Women and Economics." *Women's Studies Encyclopedia*. Vol. 2. Edited by Helen Tierney. New York: Greenwood Press, 1991. 483–84.

Eagleton, Terry. "Nationalism: Irony and Commitment." *Nationalism, Colonialism, and Literature*. Edited by Terry Eagleton, Fredric Jameson, and Edward Said. Minneapolis: University of Minnesota Press, 1990. 23–39.

Emerson, Ralph Waldo. William Henry Channing, and James Freeman Clarke, eds. *Memoirs of Margaret Fuller Ossoli*. 2 vols. Boston: Phillips, Sampson, 1852.

———. *The Journals and Miscellaneous Notebooks of Ralph Waldo Emerson*, 16 vols. Edited by William Gillman et al. Cambridge: Belknap Press, Harvard University Press, 1960–1982.

Faludi, Susan. *Backlash: The Undeclared War Against Women*. New York: Crown, 1991.

Farley, Reynolds. *The New American Reality: Who We Are, How We Got Here, Where We Are Going*. New York: Russell Sage Foundation, 1996.

Fauset, Jessie Redmon. "The Sleeper Awakes." *Crisis* 20 (August 1920a): 168–73; 20 (September 1920): 226–29; 20 (October 1920): 267–74.

———. "The Montessori Method." *The Brownies Book* (October 1920b): 306.

———. "Impressions of the Second Pan-African Congress." *Crisis* 22 (November 1921): 12–18.

———. *There Is Confusion*. Boston: Northeastern University Press, 1989 (1924).

———. *The Chinaberry Tree*. New York: AMS Press, 1931.

———. *Comedy, American Style*. College Park, MD: McGrath, 1969 (1933).

Filler, Louis. "Lydia Maria Child." *Notable American Women, 1608–1950: A Biographical Dictionary*. 3 vols. Edited by James T. Edward. Cambridge: Harvard University Press, 1971.

"Finding Fact from Fiction." *The Guardian* (London). May 27, 2000. <http://www.guardianunlimited.co.uk/>.

Fink, Steven. "Margaret Fuller: The Evolution of a Woman of Letters." Edited by Steven Fink and Susan S. Williams. *Reciprocal Influence: Literary Production, Distribution, and Consumption in America*. Columbus: Ohio State University Press, 1999.

Fisher, Charles. *The Columnists: A Surgical Survey*. New York: Howell Soskin, 1944.

Fishkin, Shelley Fisher. "Reading Gilman in the Twenty-first Century." *The Mixed Legacy of Charlotte Perkins Gilman*. Edited by Catherine

Golden and Joanna Schneider Zangrandio. Newark: University of Delaware Press, 2000. 209–20.

Fleischmann, Fritz, ed. *Margaret Fuller's Cultural Critique: Her Age and Legacy*. New York: Peter Lang, 2000.

Flexner, Eleanor, and Ellen Fitzpatrick. *Century of Struggle: The Woman's Rights Movement in the United States*. Cambridge, MA: Belknap Press of Harvard University Press, 1996.

Florence, Namulundah. *bell hooks' Engaged Pedagogy: A Transgressive Education for Critical Consciousness*. Westport, CT: Bergin and Garvey, 1998.

Foerstel, Lenora. "Margaret Mead from a Cultural-Historical Perspective." *Confronting the Margaret Mead Legacy: Scholarship, Empire, and the South Pacific*. Edited by Lenora Foerstel and Angela Gilliam. Philadelphia: Temple University Press, 1992. 55–73.

———, and Angela Gilliam, eds. *Confronting the Margaret Mead Legacy: Scholarship, Empire, and the South Pacific*. Philadelphia: Temple University Press, 1992.

"Follow Up: Freeman Responds about Mead-Freeman Controversy." Letters of Response from Derek Freeman, James Cote, and Paul Shankman. *Skeptical Inquirer* (May/June 1999): 60–61.

Foss, Karen A., Sonja K. Foss, and Cindy L. Griffin. *Feminist Rhetorical Theories*. Thousand Oaks, CA: Sage, 1999.

Foster, Frances Smith. *Written by Herself: Literary Production of African American Women, 1746–1892*. Bloomington: Indiana University Press, 1993.

Fowler, Lois J., and David H. Fowler. *Revelations of Self: American Women in Autobiography*. Albany: State University of New York Press, 1990.

Fowlkes, Diane L. "Moving from Feminist Identity Politics to Coalition Politics through a Feminist Materialist Standing of Intersubjectivity in Gloria Anzaldúa's *Borderlands/La Frontera: The New Mestiza*." *Hypatia* 12 (Spring 1997): 105–24.

Fox, Tom. "Literacy and Activism: A Response to bell hooks." *Philosophy, Rhetoric, Literary Criticism: (Inter)views*. Edited by Gary A. Olson. Carbondale: Southern Illinois University Press, 1994.

Freedman, Diane P. "Writing in the Borderlands: The Poetic Prose of Gloria Anzaldúa and Susan Griffin." *Constructing and Reconstructing Gender: The Links among Communication, Language, and Gender*. Edited by Linda Perry, Lynn Turner, and Helen Sterk. Albany: State University of New York Press, 1992. 211–17.

Freeman, Derek. *Margaret Mead and Samoa: The Making and Unmaking of an Anthropological Myth*. Cambridge: Harvard University Press, 1983.

———. *The Fateful Hoaxing of Margaret Mead: A Historical Analysis of Her Samoan Research*. Boulder, CO: Westview Press, 1998.
Friedman, Lawrence. *Understanding Cynthia Ozick*. Columbia: University of South Carolina Press, 1991.
Fuller, Margaret. *Woman in the Nineteenth Century*. London: Clark, 1845.
———. "Rev. of Schoolcraft Jones, Ellen: Or Forgive and Forget." *New York Tribune* (January 10, 1846): 1.
———. *Papers on Literature and Art*. Parts I and II. New York: Wiley and Putnam, 1846.
———. *Memoirs of Margaret Fuller Ossoli*. 2 vols. Boston: Phillips, Samson, 1852.
———. *At Home and Abroad: or, Things and Thoughts in America and Europe*. Edited by Arthur B. Fuller. Boston: Crosby, Nichols, 1856.
———. *The Letters of Margaret Fuller*. 5 vols to date. Edited by Robert Hudspeth. Ithaca, NY: Cornell University Press, 1983–.
———. "Narrative of the Life of Frederick Douglass." Review. *Margaret Fuller's New York Journalism: A Biographical Essay and Key Writings*. Edited by Catherine C. Mitchell. Knoxville: University of Tennessee Press, 1995. 136–38.
———, et al. "The Editors to the Readers." *The Dial* (July 1840): 1–4.
Gabel, Leona Christine. *From Slavery to the Sorbonne and Beyond: The Life and Writings of Anna J. Cooper*. Northampton, MA: Department of History of Smith College, 1982.
Garcia, Alma. *Chicana Feminist Thought: The Basic Historical Writings*. New York: Routledge, 1997.
Gardner, Martin. "The Great Samoan Hoax." *Skeptical Inquirer* 17 (Winter 1993): 131–35.
Garrison, William Lloyd. "Mrs. Child." *Genius of Universal Emancipation* (November 20, 1829): 85.
Giddings, Paula. *When and Where I Enter: The Impact of Black Women on Race and Sex in America*. New York: Bantam Books, 1984.
Gilbert, James. *Another Chance: Postwar America, 1945–1985*. 2d ed. Chicago: Dorsey Press, 1986.
Gilman, Charlotte Perkins. "The Yellow Wallpaper." *New England Magazine* 5 (January 1892): 647–59.
———. *Women and Economics: A Study of the Economic Relation between Men and Women as a Factor in Social Evolution*. Edited by Michael Kimmel and Amy Aronson. Berkeley: University of California Press, 1998 (1898).
———. *Human Work*. New York: McClure, Phillips and Co., 1904.
———. "A Suggestion on the Negro Problem." *American Journal of Sociology* 14 (1908): 78–85.

———. "Masculine Literature." *Forerunner* 1 (March 1910): 18–22.
———. *Our Brains and What Ails Them*. Serialized in *Forerunner* 3 (April 1912a): 22–26, 49–54, 77–82, 104–9, 133–39, 161–67, 189–95, 216–21, 245–51, 273–309, 301–7, 328–34.
———. "Two Great Pleasures." *Forerunner* 3.4 (1912b): 103.
———. "Why I Wrote 'The Yellow Wallpaper.' " *Forerunner* 4.9 (September 1913): 271.
———. *Herland*. Serialized in *Forerunner* 6 (1915). Reprint, with an introduction by Ann J. Lane. New York: Pantheon Books, 1979.
———. "Feminism and Social Progress." *Problems of Civilization*. Edited by Baker Brounell. New York: D. Van Nostrand, 1929. 115–42.
———. "Sex and Race Progress." *Sex in Civilization*. Edited by V. F. Calverton and Samuel D. Schmalhausen. New York: Macaulay, 1929. 109–26.
———. "Parasitism and Civilised Vice." Woman's Coming of Age, a Symposium. Edited by Samuel D. Schmalhausen and Victor F. Calverton. New York: H. Liveright, 1931.
———. *The Living of Charlotte Perkins Gilman: An Autobiography*. Foreword by Zona Gale. New York: D. Appleton-Century Co., 1935.
———. *A Charlotte Perkins Gilman Reader: The Yellow Wallpaper and Other Fiction*. Edited with an introduction by Ann J. Lane. New York: Pantheon Books, 1980.
———. *Charlotte Perkins Gilman: A Nonfiction Reader*. Edited with an introduction by Larry Ceplair. New York: Columbia University Press, 1991.
———, and Peter McLaren, eds. *Between Borders: Pedagoy and the Politics of Cultural Studies*. New York: Routledge, 1994.
Giroux, Henry A. "Writing the Space of the Public Intellectual: Afterword to *Women Writing Culture*." Edited by Gary Olson and Elizabeth Hirsh. Albany: State University of New York Press, 1995.
Golden, Catherine J. "Charlotte Perkins Gilman." *Nineteenth Century American Women Writers: A Bio-Bibliographical Critical Sourcebook*. Edited by Denise D. Knight. Westport, CT: Greenwood Press, 1997. 11–26.
———, and Joanna Schneider Zangrando, eds. Introduction. *The Mixed Legacy of Charlotte Perkins Gilman*. Newark: University of Delaware Press, 2000.
Gonzales, Maria. *Contemporary Mexican-American Women Novelists: Toward a Feminist Identity*. New York: Peter Lang, 1996.
Gordon, Ann D. "The Political Is the Personal: Two Autobiographies of Woman Suffragists." *American Women's Autobiography: Fea(s)ts of Memory*. Edited by Margo Culley. Madison: University of Wisconsin Press, 1992. 111–27.

Gottfried, Amy. "Fragmented Art and the Liturgical Community of the Dead in Cynthia Ozick's 'The Shawl.'" *Studies in American Jewish Literature* 13 (1994): 39–51.

[Greeley, Horace]. "Death of Margaret Fuller." *New York Tribune* 23 June 1850.

Greer, Germaine. "Flying Pigs and Double Standards." *Times Literary Supplement* (July 26, 1974): 784.

Griffith, Elisabeth. *In Her Own Right: The Life of Elizabeth Cady Stanton*. New York: Oxford University Press, 1984.

Gunther, John. "A Blue-Eyed Tornado." *New York Herald Tribune* January 13, 1935.

Guy-Sheftall, Beverly. "Anna Julia Cooper." *Women Educators in the United States, 1820–1993: A Bio-Bibliographical Sourcebook*. Edited by M. S. Seller. London: Green Wood Press, 1994. 161–67.

Hall, G. Stanley. *Adolescence*. New York: D. Appleton, 1904.

Haraway, Donna. Interview by Gary Olson. *Women Writing Culture*. Edited by Gary Olson and Elizabeth Hirsh. Albany: State University of New York Press, 1995.

Harley, Sharon. "Anna J. Cooper: A Voice for Black Women." *The Afro-American Woman: Struggles and Images*. Edited by Sharon Harley and Rosalyn Terborg-Penn. Port Washington, NY: Kennikat Press, 1978. 87–96.

_____. "Black Women in the District of Columbia, 1890–1920." Ph.D. diss., Howard University, 1982.

Harris, Sharon. *American Women Writers to 1800*. New York: Oxford University Press, 1996.

Harris, Susan K. *Nineteenth-Century American Women's Novels: Interpretive Strategies*. New York: Cambridge University Press, 1990.

Harris, Violet Joyce. "*The Brownie's Book*: Challenge to the Selective Tradition in Children's Literature." Ph.D. diss., University of Georgia (Athens). 1986.

Helsinger, Elizabeth, Robin Lauterbach Sheets, and William Veeder. *The Woman Question: Society and Literature in Britain and America, 1837–1883*. 3 vols. New York: Garland, 1983.

Herndl, Diane Price. "The Writing Cure: Charlotte Perkins Gilman, Anna O., and 'Hysterical' Writing." *NWSA Journal* 1 (1988): 52–74.

Higginson, Thomas Wentworth. "Lydia Maria Child." *Contemporaries*, Vol. II. *Of the Writings of Thomas Wentworth Higginson*. Boston: Houghton, 1900.

Hill, Mary A. "Charlotte Perkins Gilman: A Feminist's Struggle with Womanhood." *The Massachusetts Review* 23.3 (1980): 503–26.

_____. *Charlotte Perkins Gilman: The Making of a Radical Feminist, 1860–1896*. Philadelphia: Temple University Press, 1980.

Hines, Darlene Clark, ed. *Black Women in America: An Historical Encyclopedia*. Brooklyn: Carlson, 1993.
Holland, Patricia G. "Lydia Maria Child as a Nineteenth-Century Professional Author." *Studies in the American Renaissance* (1981): 157–67.
_____. "Legacy Profile: Lydia Maria Child." *Legacy* 5 (Fall 1988): 45–53.
Holloway, John. *The Victorian Sage: Studies in Argument*. New York: Norton, 1953.
Holmes. Lowell Don. *Quest for the Real Samoa: The Mead/Freeman Controversy and Beyond*. South Hadley, MA: Bergen and Garvey, 1987.
Honig, Bonnie, ed. *Feminist Interpretations of Hannah Arendt*. University Park: Pennsylvania State University Press, 1995.
hooks, bell. *Talking Back: Thinking Feminist, Thinking Black*. Boston, MA: South End Press, 1989.
_____. "Let's Get Real about Feminism: The Backlash, the Myths, the Movement." (Panel Discussion) by Naomi Wolf, bell hooks, Gloria Steinem, and Urvashi Vaid. *Ms. Magazine* 4 (September/October 1993): 34–.
_____. *Outlaw Culture: Resisting Representations*. New York: Routledge, 1994a.
_____. *Teaching to Transgress: Education as the Practice of Freedom*. New York: Routledge, 1994b.
_____. "How Souls Unfold: Pain and Politics Are Essential to Creativity." *Utne Reader* (November–December 1994c): 143.
_____. *Art on My Mind: Visual Politics*. New York: The New Press, 1995.
_____. *Killing Rage: Ending Racism*. New York: Henry Holt, 1995.
_____. *Bone Black: Memories of Girlhood*. New York: Henry Holt, 1996.
_____. "Simple Living." *Black Genius: African American Solutions to African American Problems*. Edited by Walter Mosley, Manthia Diwara, Clyde Taylor, and Regina Austin. New York: Norton, 1999.
_____. *All about Love: New Visions*. New York: William Morrow, 2000.
_____, and Cornel West. *Breaking Bread: Insurgent Black Intellectual Life*. Boston: South End Press, 1991.
Howard, Jane. *Margaret Mead: A Life*. New York: Simon and Schuster, 1984.
Huggins, Nathan. *Harlem Renaissance*. New York: Oxford University Press, 1971.
Hughes, Langston. *The Big Sea: An Autobiography*. Introduction by Arnold Rampersad. New York: Hill and Wang, 1993.
Huszar, George B. de, ed. *The Intellectuals: A Controversial Portrait*. Glencoe: Free Press, 1960.
Hutchinson, Louise Daniel. "Anna Julia Cooper." *Black Women in America*. Vol. 1. Edited by D. C. Hine. Brooklyn: Carlson, 1993. 275–81.

Hutner, Gordon, ed. *American Literature, American Culture*. New York: Oxford University Press, 1999.
Jacoby, Russell. *The Last Intellectuals*. New York: Basic Books, 1987.
Jelinek, Estelle C. *The Tradition of Women's Autobiography: From Antiquity to the Present*. Boston: Twayne Publishers, 1986.
Jewell, Sue. "Black Feminism." *Women's Issues*. Edited by Margaret McFadden. Vol. 1 of 3. Pasadena, CA: Salem Press, 1997. *Present*. Boston: G. K. Hall, 1986.
Johnson, Abby Arthur. "Literary Midwife: Jessie Redmon Fauset and the Harlem Renaissance." *Phylon* (June 1978): 143–53.
Johnson, Karen Ann. "Uplifting the Women and the Race: A Black Feminist Theoretical Critique of the Lives, Works, and the Educational Philosophies of Anna Julia Cooper and Nannie Helen Burroughs." Ph.D. diss., University of California–Los Angeles, 1977.
Karcher, Carolyn. "Censorship, American Style: The Case of Lydia Maria Child." *Studies in the American Renaissance* (1986a): 283–303.
———. *First Woman in the Republic: A Cultural Biography of Lydia Maria Child*. Durham: Duke University Press, 1994.
———. Preface to *An Appeal in Favor of That Class of Americans Called Africans*. By Lydia Maria Child. Amherst: University of Massachusetts Press, 1996.
———. Introduction to *A Lydia Maria Child Reader*. By Lydia Maria Child. Ed. Carolyn L. Karcher. Durham: Duke University Press, 1997.
———, ed. Introduction to *Hobomok and Other Writings on Indians*. By Lydia Maria Child (1922). New Brunswick, NJ: Rutgers University Press, 1986b.
Karpinski, Joanne, ed. *Critical Essays on Charlotte Perkins Gilman*. Boston: G. K. Hall, 1992.
Kauvar, Elaine. *Cynthia Ozick's Fiction: Tradition and Invention*. Bloomington: Indiana University Press, 1993.
———. "An Interview with Cynthia Ozick." *Contemporary Literature* 34 (1993): 359–94.
———. Introduction to *A Cynthia Ozick Reader*. By Cynthia Ozick. Edited by Elaine M. Kauvar. Bloomington: Indiana University Press, 1996. vii–xxix.
Keating, AnaLouise. "Myth Smashers, Myth Makers: (Re)Visionary Techniques in the Works of Paul Gunn Allen, Gloria Anzaldúa and Audre Lorde." *Critical Essays: Gay and Lesbian Writers of Color*. Edited by Emmanuel S. Nelson. New York: Haworth Press, 1993. 73–95.
———. *Women Reading, Women Writing: Self-invention in Paula Gunn Allen, Gloria Anzaldúa, and Audre Lorde*. Philadelphia: Temple University Press, 1996.

Kennedy, Liam. "Precocious Archeology: Susan Sontag and the Criticism of Culture." *Journal of American Studies* 24 (1990): 23–39.

———. *Susan Sontag: Mind as Passion*. Manchester, UK: Manchester University Press, 1995.

Kern, Kathi L. "Rereading Eve: Elizabeth Cady Stanton and *The Woman's Bible*, 1885–1896." *Women's Studies* 19 (1991): 371–83.

Kessler, Carol Farley. "Charlotte Perkins Gilman." Edited by Elaine Showalter, Lea Baechler, and Walton Litz. *Modern American Women Writers*. New York: Collier, 1993 (1991): 97–108.

———. *Charlotte Perkins Gilman: Her Progress toward Utopia with Selected Writings*. New York: Syracuse University Press, 1995.

Kilcup, Karen L. " 'Essays of Invention': Transformations of Advice in Nineteenth-Century American Women's Writing." *Nineteenth-Century American Women Writers: A Critical Reader*. Edited by Karen L. Kilcup. Malden, MA: Blackwell, 1998.

Kimmel, Michael, and Amy Aronson. Introduction. *Women and Economics*. By Charlotte Perkins Gilman. Berkeley: University of California Press, 1998 (1898).

Klingenstein, Susanne. " 'In Life I Am Not Free': The Writer Cynthia Ozick and Her Jewish Obligations." *Daughters of Valor: Contemporary Jewish American Women Writers*. Edited by Jay L. Halio and Ben Siegel. Newark: University of Delaware Press, 1997.

Kolodny, Annette. "Inventing a Feminist Discourse: Rhetoric and Resistance in Margaret Fuller's *Woman in the Nineteenth Century*." *New Literary History* 25 (Spring 1994): 355–82.

Kurth, Peter. *American Cassandra: The Life of Dorothy Thompson*. Boston: Little, Brown and Company, 1990.

Lacayo, Richard. "Stand Aside, Sisyphus." *Time* (October 24, 1988): 86–88.

Lacy, Suzanne, ed. *Mapping the Terrain: The New Genre Public Art*. Seattle: Bay Press, 1995.

Lakritz, Andrew. "Cynthia Ozick at the End of the Modern." *Chicago Review* 40:1 (1994): 98–117.

Landow, George P. "Aggressive (Re)interpretations of the Female Sage: Florence Nightingale's Cassandra." *Victorian Sages and Cultural Discourse*. Edited by Thais Morgan. New Brunswick, NJ: Routledge, 1990. 32–45.

Lane, Ann. Introduction to *A Charlotte Perkins Gilman Reader: The Yellow Wallpaper and Other Fiction*. By Charlotte Perkins Gilman. New York: Pantheon Books, 1980.

———. *To Herland and Beyond: The Life and Work of Charlotte Perkins Gilman*. New York: Pantheon Books, 1990.

Lanser, Susan S. "Feminist Criticism, 'The Yellow Wallpaper,' and the Politics of Color in America." *Feminist Studies* 51.3 (Fall 1989): 415–42.

Lapsley, Hillary. *Margaret Mead and Ruth Benedict: The Kinship of Women*. Amherst: University of Massachusetts Press, 1999.

Leacock, Eleanor. "Anthropologists in Search of a Culture: Margaret Mead, Derek Freeman, and All the Rest of Us." *Confronting the Margaret Mead Legacy: Scholarship, Empire, and the South Pacific*. Edited by Lenora Foerstel and Angela Gilliam. Philadelphia: Temple University Press, 1992. 3–30.

Lemert, Charles. "Anna Julia Cooper: The Colored Woman's Office." *The Voice of Anna Julia Cooper*. Edited by Charles Lemert and Esme Bhan. Lanham, MD: Rowman, 1998. 1–51.

Lerner, Gerda. *The Majority Finds Its Past: Placing Women in History*. New York: Oxford University Press, 1979.

———. *The Creation of Patriarchy*. New York: Oxford University Press, 1986.

———. *The Creation of Feminist Consciousness: From the Middle-Ages to Eighteen-Seventy*. New York: Oxford University Press, 1993.

Levinson, Melanie. "Anna Julia Cooper." *Nineteenth-Century American Women Writers: A Bio-bibliographical Critical Sourcebook*. Edited by Denise D. Knight. Westport, CT: Greenwood Press, 1997.

Linkon, Sherry Lee, ed. *In Her Own Voice: Nineteenth-Century American Women Essayists*. New York: Garland, 1997.

Lipset, Seymour Martin. *Political Man*. New York: Doubleday, 1960.

Lloyd, Tess. "Transcendentalist Women: Professionalization and Popular Culture." Ph.D. diss., University of North Carolina–Chapel Hill, 1996.

Locke, Alain. *The New Negro*. New York: Atheneum, 1992 (1925).

Logan, Shirley Wilson. *"We Are Coming": The Persuasive Discourse of Nineteenth-Century Black Women*. Carbondale: Southern Illinois University Press, 1999.

Lorde, Audre. *Black Unicorn: Poems*. New York: Norton, 1978.

Lowin, Joseph. *Cynthia Ozick*. Boston: Twayne, 1988.

Lugones, Maria. "On Borderlands/La Frontera: An Interpretive Essay." *Hypatia* (Fall 1992): 31–38.

Lunsford, Andrea A. "Toward a Mestiza Rhetoric: Gloria Anzaldúa on Composition and Postcoloniality." *Race, Rhetoric, and the Postcolonial*. Edited by Gary A. Olson and Lynn Worsham. Albany: State University of New York Press, 1999.

Lutz, Alma. *Created Equal: A Biography of Elizabeth Cady Stanton*. New York: Octagon, 1974.

Mairs, Nancy. *Voice Lessons*. Boston: Beacon Press, 1994.

"Margaret Mead." *Handbook of American Women's History.* Edited by Angela Howard Zophy. New York: Garland, 1990.

Martin, Jane Roland. *Reclaiming a Conversation: The Ideal of the Educated Woman.* New Haven: Yale University Press, 1985.

Marzolf, Marion. *Up from the Footnote: A History of Women Journalists.* New York: Hastings House, 1977.

Maslow, Abraham. *Toward a Psychology of Being.* Princeton, NJ: Von Nostrand Reinhold, 1968.

Matthiessen, F. O. *American Renaissance: Art and Expression in the Age of Emerson and Whitman.* New York: Oxford University Press, 1941.

McCoy, Beth A. "Is This Really What You Wanted Me to Be?" *Modern Fiction Studies* 40 (Spring 1994): 101–18.

McDowell, Deborah E. "The Neglected Dimension of Jessie Fauset." *Conjuring: Black Women, Fiction, and Literary Tradition.* Edited by Marjorie Pryse and Hortense Spillers. Bloomington: Indiana University Press, 1985. 86–104.

McDowell, Linda, and Joanne P. Sharp, eds. *Space, Gender, Knowledge: Feminist Readings.* London: J. Wiley, 1997.

McFadden, Margaret, ed. *Women's Issues.* 3 vols. Pasadena, CA: Salem Press, 1997.

McLendon, Jacquelyn. *The Politics of Color in the Fiction of Jessie Fauset and Nellie Larsen.* Charlottesville: University of Virginia Press, 1995.

McNulty, Charles. "Susan Sontag: The Making of an Icon" (Review). *The Village* (July 5–11, 2000). <http://www.villagevoice.com/issues/0027/booksup.shtml>.

McRobbie, Angela. *Postmodernism and Popular Culture.* Edited by Leland Poague. London: Routledge, 1994.

———. *Conversations with Susan Sontag.* Jackson: University Press of Mississippi, 1995.

Mead, Margaret. *Coming of Age in Samoa: A Psychological Study of Primitive Youths for Western Civilisation.* New York: Morrow, 1928.

———. *From the South Seas: Studies of Adolescence and Sex in Primitive Societies.* New York: Morrow, 1939.

———. *And Keep Your Powder Dry.* New York: Morrow, 1942.

———. "Anthropological Techniques in War and Psychology." *Bulletin of the Menninger Clinic* 7 (1943): 137–40.

———. *Male and Female: A Study of the Sexes in a Changing World.* New York: Morrow, 1949.

———. *Sex and Temperament in Three Primitive Societies.* New York: Morrow, 1963.

———. "The Evolving Ethics of Applied Anthropology." *Applied Anthropology.* Edited by George Foster. Boston: Little, Brown, 1969.

———. *Blackberry Winter: My Earlier Years.* New York: Morrow, 1972.

———. *Letters from the Field, 1925–1975.* New York: Harper and Row, 1979.

———, et al. *Science and the Concept of Race.* New York: Columbia University Press, 1968.

Mengedoht, Jo R. "Dorothy Thompson." *American Newspaper Journalists, 1926–50.* Vol. 29. *Dictionary of Literary Biography.* 343–49.

Mepham, John. "The Intellectual as Heroine: Reading and Gender." *Image and Power: Women in Fiction in the Twentieth Century.* Edited by Gail Sceats and Gail Cunningham. London: Longman, 1996. 17–28.

Meyering, Sheryl L., ed. *Charlotte Perkins Gilman: The Woman and Her Work.* Ann Arbor: UMI Research Press, 1989.

Michael, John. *Anxious Intellects: Academic Professionals, Public Intellectuals, and Enlightenment Values.* Durham: Duke University Press, 2000.

Miller, Bradford. *Returning to Seneca Falls: The First Woman's Rights Convention and Its Meaning for Men and Women Today.* Hudson, NY: Lindisfarne Press, 1995.

Mills, Bruce. *Cultural Reformations: Lydia Maria Child and the Literature of Reform.* Athens: University of Georgia Press, 1994.

Mills, C. Wright. *Power, Politics, and People: The Collected Essays of C. Wright Mills.* Edited by Irving Louis Horowitz. New York: Ballantine, 1963.

Mitchell, Catherine C. *Margaret Fuller's New York Journalism.* Knoxville: University of Tennessee Press, 1995.

Moers, Ellen. *Literary Women.* Garden City, NY: Doubleday, 1976.

Moore, Sharon Lynn. " 'I Can Never Be that Wretched, Diffident, Submissive Girl Again': (Un)veiling the Black, Feminist, Modernist Aesthetic of Jessie Redmon Fauset." Ph.D. diss. University of Georgia, 1999.

Moritz, Frederic A. "Margaret Fuller: A Man's Mind and a Woman's Heart?" *Exposing World Crimes: American Human Rights Reporting as a Global Watchdog.* 1997. <http://www.worldlymind.org/fuller.htm>

Neverdon-Morton, C. *Afro-American Women of the South and the Advancement of the Race, 1895–1925.* Knoxville: University of Tennessee Press, 1989.

Newman, Louise M. "Coming of Age, but Not in Samoa: Reflections of Margaret Mead's Legacy for Western Liberal Feminism." *American Quarterly* 48.2 (June 1996): 233–72.

Obropta, Mary. *Hunters and Gatherers: American Women Working in the Documentary Arts, 1928–1939.* Unpublished dissertation. State University of New York at Buffalo, 1995.

Olsen, Gary A., and Elizabeth Hirsh. "Feminist *Praxis* and the Politics of Literacy: A Conversation with bell hooks." *Women Writing Culture.* Albany: State University of New York Press, 1995. 105–40.

———, and Lynn Worsham, eds. *Race, Rhetoric, and the Postcolonial.* Albany: State University of New York Press, 1999.

Opfermann, Suzanne. "Lydia Maria Child, James Fenimore Cooper, and Catharine Maria Sedgwick: A Dialogue on Race, Culture, and Gender." *Soft Canons: American Women Writers and Masculine Tradition.* Edited by Karen L. Kilkup. Iowa City: University of Iowa Press, 1999. 27–47.

Osborne, William. *Lydia Maria Child.* Boston: Twayne, 1980.

Ozick, Cynthia. *Bloodshed and Three Novellas.* New York: Knopf, 1976.

———. *Art and Ardor.* New York: Knopf, 1983.

———. *The Shawl.* New York: Vintage, 1990.

———. *Metaphor and Memory: Essays.* New York: Vintage, 1991.

———. "Public and Private Intellectuals." *American Scholar* (Summer 1995): 353–58.

———. *Fame and Folly: Essays.* New York: Knopf, 1996.

———. *The Puttermesser Papers.* New York: Knopf, 1997.

———. "She: Portrait of the Essay as a Warm Body." *Atlantic Monthly* 282 (April 1998). 3 pgs. http://proquest.umi.com/pqdweb.

———. "The Rights of History and the Rights of Imagination." *Commentary* 107 (March 1999). 6 pgs. ProQuest. <http://proquest.umi.com/pqdweb>.

———. *Quarrel and Quandary: Essays.* New York: Knopf, 2000.

Pellow, David W. H. "Anna Julia Cooper." *Notable Black American Women.* Edited by Jessie Carney Smith. Detroit: Gale, 1992. 218–24.

Perry, Donna. *Backtalk: Women Writers Speak Out: Interviews.* New Brunswick, NJ: Rutgers University Press, 1993.

Peyser, Thomas. *Utopia and Cosmopolis: Globalization in the Era of American Literary Realism.* Durham: Duke University Press, 1998.

Reed, Adolph L., Jr. " 'What Are the Drums Saying, Booker?' The Current Crisis of the Black Intellectual." *Village Voice* (April 11, 1995): 31–36.

Reinstein, Gila. Interview with Cynthia Ozick. *Yale Bulletin and Calendar* 28 (March 3, 2000). Online. <http://www.yale.edu/opa/v28.n23/story7.html>.

Rensberger, Boyce. "Margaret Mead: The Nature-Nurture Debate." *Anthropology, 1988–1989.* Edited by Ellovich Angeloni. Guilford, CT: Dushkin, 1988. 25–30.

Reynolds, David S. *Beneath the American Renaissance: The Subversive Imagination in the Age of Emerson and Melville.* New York: Knopf, 1988.

Reynolds, Larry, and Susan Belasco Smith. *"These Sad But Glorious Days": Dispatches from Europe, 1846–1850.* New Haven: Yale University Press, 1991.

Rich, Adrienne. "When We Dead Awaken: Writing as Re-Vision." *On Lies, Secrets, and Silence: Selected Prose*. New York: Norton, 1979. 33–50.

———. *What Is Found There: Notebooks on Poetry and Politics*. New York: Norton, 1993.

Richards, Judith. "Gloria Anzaldúa." *Significant Contemporary American Feminists: A Biographical Sourcebook*. Edited by Jennifer Scanlon. Westport, CT: Greenwood Press, 1999. 14–21.

Rollyson, Carl, and Lisa Paddock. *Susan Sontag: The Making of an Icon*. New York: Norton, 2000.

Rose, Elizabeth. "Cynthia Ozick's Liturgical Postmodernism: The Messiah of Stockholm." *Studies in American Jewish Literature* 9 (1990): 93–107.

Ross, Jean W. "An Interview with Cynthia Ozick." *Dictionary of Literary Biography Yearbook: 1983*. Edited by Mary Bruccoli. Detroit: Gale Research, 1984. 35–36.

Russell, Roberta Joy. *Margaret Fuller: The Growth of a Woman Writer*. Ph.D. diss., University of Connecticut, 1983.

Said, Edward. *Representations of the Intellectual*. New York: Pantheon Books, 1994.

Saldivar Hull, Sonia. "Feminism in the Border: From Gender Politics to Geopolitics." *Criticism in the Borderlands: Studies in Chicano Literature, Culture, and Ideology*. Edited by Hector Calderon and Jose Saldivar. Durham, NC: Duke University Press, 1991.

Sanders, Marion K. *Dorothy Thompson: A Legend in Her Time*. Boston: Houghton Mifflin, 1973.

Sato, Hiroko. "Under the Harlem Shadow: A Study of Jessie Fauset and Nella Larson." *The Harlem Renaissance Remembered*. Edited by Arno Bontemps. New York: Dodd, Mead, 1972.

Scanlon, Jennifer. *Significant Contemporary American Feminists: A Biographical Sourcebook*. Westport, CT: Greenwood Press, 1999.

Scharnhorst, Gary. *Charlotte Perkins Gilman*. Boston: Twayne Publishers, 1985.

———. "Historicizing Gilman: A Bibliographer's View." *The Mixed Legacy of Charlotte Perkins Gilman*. Edited by Catherine Golden and Joanna Schneider Zangrandio. Newark: University of Delaware Press, 2000. 65–76.

Schlor, Esther H. "Susan Sontag." Edited by Elaine Showalter et al. *Modern American Women Writers*. New York: Colliers, 1993. 321–34.

Schockley, Ann Allen. "Jessie Redmon Fauset Harris." *Afro-American Women Writers, 1746–1933: An Anthology and Critical Guide*. Boston: G. K. Hall, 1988.

Sheean, Vincent. *Dorothy and Red*. Boston: Houghton Mifflin, 1963.

Shils, Edward. *"The Intellectuals and the Powers" and Other Essays*. Chicago: University of Chicago Press, 1972.

Showalter, Elaine. *A Literature of Their Own: British Women Novelists from Bronte to Lessing*. Princeton: Princeton University Press, 1977.

Siemerling, Wilfred, and Katrin Schwenk, eds. *Cultural Difference and the Literary Text: Pluralism and the Limits of Authenticity in North American Literatures*. Iowa City: Iowa University Press, 1996.

Sims, Janet L. "Jessie Redmon Fauset: A Selected Annotated Bibliography." *Black American Literature Forum* 14 (Winter 1980): 147–50.

Smith, Sidonie. "Resisting the Gaze of Embodiment: Women's Autobiography in the Nineteenth Century." *American Women's Autobiography: Fea(s)ts of Memory*. Edited by Margo Culley. Madison: University of Wisconsin Press, 1992. 75–110.

Sontag, Susan. *Against Interpretation, and Other Essays*. New York: Farrar, Straus, and Giroux, 1966.

———. *Styles of Radical Will*. New York: Farrar, Straus, and Giroux, 1969.

———. *On Photography*. New York: Farrar, Straus, and Giroux, 1977.

———. *Illness as Metaphor*. New York: Farrar, Straus, and Giroux, 1978.

———. *A Susan Sontag Reader*. New York: Farrar, Straus, and Giroux, 1982.

———. "Pilgrimage." *The New Yorker* (December 21, 1987): 38–54.

———. *AIDS and Its Metaphors*. New York: Farrar, Straus, and Giroux, 1989.

———. *The Way We Live Now*. New York: Farrar, Straus, and Giroux, 1991.

———. *The Volcano Lover: A Romance*. New York: Farrar, Straus, and Giroux, 1992.

———. *Alice in Bed*. New York: Farrar, Straus, and Giroux, 1993.

———. "Waiting for Godot in Sarajevo." *Performing Arts Journal* 47 (1994): 87–106.

———. *Conversations with Susan Sontag*. Edited by Leland Poague. Jackson: University Press of Mississippi, 1995a.

———. " 'There' and 'Here': A Lament for Bosnia." *The Nation* 261 (December 25, 1995b). Rpt. <http://www.amber.ucsf.edu/homes/ross/public_html/bosnia_/sontag.txt>.

———. "Singleness." *Who's Writing This? Notations on the Authorial I with Self-Portraits*. Hopewell, NJ: Ecco, 1995c. 170–74.

Span, Paula. "Susan Sontag, Hot at Last." *Conversations with Susan Sontag*. Edited by Leland Poague. Jackson: University Press of Mississippi, 1995. 261–66.

Spender, Dale. *Women of Ideas and What Men Have Done to Them: From Aphra Behn to Adrienne Rich*. London: Routledge, 1982.

Stanton, Elizabeth Cady. "Manhood Suffrage." *Revolution* (December 24, 1868): 392.

———. *Eighty Years and More: Reminiscences of Elizabeth Cady Stanton.* London: T. Fisher Unwin, 1898.

———. "Educated Suffrage." NAWSA Convention, Washington, DC, February 12–18, 1902. The Papers of Elizabeth Cady Stanton and Susan B. Anthony (microfilm). 45 reels. Edited by Patricia G. Holland and Ann D. Gordon. Wilmington, DE: Scholarly Resources, 1991. 33:643–44.

———. *Elizabeth Cady Stanton As Revealed in Her Letters, Diary, and Reminiscences.* 2 vols. Edited by Theodore Stanton and Harriet Stanton Blatch. New York: Harper, 1922.

———, et al. *The Concise History of Woman Suffrage: Selections from the Classic Work of Stanton, Anthony, Gage, and Harper.* Edited by Mari Jo and Paul Buhle. Urbana: University of Illinois Press, 1978.

———, and Susan B. Anthony. *Correspondence, Writings, Speeches.* Edited by Ellen Carol Dubois. New York: Schocken Books, 1981.

———, and Susan B. Anthony. *The Selected Papers of Elizabeth Cady Stanton and Susan B. Anthony: In the School of Anti-Slavery, 1840–1866.* Vol. 1. Edited by Ann D. Gordon. New Brunswick, NJ: Rutgers University Press, 1997.

———, and the Revising Committee. *The Woman's Bible.* 2 vols. (1895–98). Seattle: Coalition Task Force on Women and Religion, 1974 (1895–1898).

Starkey, Marion L. "Jessie Fauset." *Southern Workman* 61 (May 1932): 217–20.

Steinem, Gloria. *Revolution from Within: A Book of Self Esteem.* Boston: Little, Brown, and Company, 1992.

———. *Moving beyond Words.* New York: Simon and Schuster, 1994.

Strandberg, Victor. "Cynthia Ozick." *American Writers: A Collection of Literary Biographies.* Supplement V. Edited by Jay Parini. New York: Scribner's, 1998.

"Susan Sontag." *Current Biography Yearbook.* Edited by Judith Graham. New York: H. W. Wilson, 1992. 533–38.

Sutherland, John. "The Girl Who Would Be James" (Review). *The New York Times on the Web.* October 8, 2000. <http://www.nytimes.com>.

Sylvander, Carolyn Wedlin. *Jessie Redmon Fauset: Black American Writer.* Troy, NY: Whitson, 1981.

Tate, Claudia. *Domestic Allegories of Political Desire: The Black Heroine's Text at the Turn of the Century.* New York: Oxford, 1992.

Teicholz, Tom. "Cynthia Ozick." *Paris Review* 102 (Spring 1987): 154–90.

Thompson, Dorothy. *I Saw Hitler!* New York: Farrar and Rinehart, 1932.
_____. "A New Definition of Democracy." *New York Tribune* (October 1, 1937): 21.
_____. *Dorothy Thompson's Political Guide: A Study of American Liberalism and Its Relationship to Modern Totalitarian States.* New York: Stackpole, 1938a.
_____. "Refugees: A World Problem." *Foreign Affairs* 16 (April 1938b): 375–87.
_____. *Let the Record Speak.* Boston: Houghton Mifflin, 1939.
_____. "Letter from Dorothy Thompson: Seven Reasons Why She Is Voting for President Franklin D. Roosevelt." October 25, 1940. Published by the New York State Independent Voters Committee for Roosevelt and Wallace.
_____. *The Courage to Be Happy.* Boston: Houghton Mifflin, 1957.
Tingley, Stephanie. " 'Thumping against the Glittering Wall of Limitations': Lydia Maria Child's 'Letters from New York.' " *In Her Own Voice: Nineteenth-Century American Women Essayists.* Edited by Sherry Lee Linkon. New York: Garland, 1997. 41–60.
Toulmin, Stephen. Introduction to *Continuities in Cultural Evolution.* By Margaret Mead. New Brunswick: Transaction Publishers, 1999. xi–xxxiv.
Traub, Lindsey. "Woman Thinking: Margaret Fuller, Ralph Waldo Emerson, and the American Scholar." *Soft Canons: American Women Writers and Masculine Tradition.* Edited by Karen L. Kilcup. Iowa City: University of Iowa Press, 1999. 281–305.
Trujillo, Carla, ed. *Living Chicana Theory.* Berkeley, CA: Third Woman Press, 1998.
Urbanski, Marie Mitchell Oleson. *Margaret Fuller's Woman in the Nineteenth Century: A Study of Form and Content.* Westport, CT: Greenwood Press, 1980.
_____, ed. *Margaret Fuller: Visionary of the New Age.* Orono, ME: Northern Lights, 1994.
Vogel, Todd. "The Master's Tools Revisited: Foundation Work in Anna Julia Cooper." *Criticism and the Color Line: Desegregating American Literary Studies.* Edited by Henry Wonham. New Brunswick, NJ: Rutgers University Press, 1966. 158–70.
von Mehren, Joan. "Margaret Fuller: Woman of Letters." *Margaret Fuller: Visionary of the New Age.* Edited by Marie Mitchell Olesen Urbanski. Orono, ME: Northern Lights, 1994. 18–51.
Waggenspack, Beth M. *The Search for Self-Sovereignty: The Oratory of Elizabeth Cady Stanton.* Great American Orators Series. New York: Greenwood Press, 1989.

Walker, Alice. *In Search of Our Mothers' Gardens*. San Diego: Harcourt, Brace, 1983.
Wall, Cheryl A. *Women of the Harlem Renaissance*. Bloomington: Indiana University Press, 1995.
Wallinger, Hanna. "The Five Million Women of My Race: Negotiations of Gender in W. E. B. DuBois and Anna Julia Cooper." *Soft Canons: American Women Writers and Masculine Tradition*. Edited by Karen L. Kilkup. Iowa City: University of Iowa Press, 1999. 262–80.
Ware, Susan, ed. *Modern American Women*. 2d ed. New York: McGraw-Hill, 1997.
Warhol, Robyn, and Diane Price Herndl. *Feminisms: An Anthology of Literary Theory and Criticism*. New Brunswick, NJ: Rutgers University Press, 1997.
Washington, Mary Helen. "Anna Julia Cooper: The Black Feminist Voice for the 1890's." *Legacy* 4.2 (Fall 1987): 3–15.
———. Introduction to *A Voice from the South*. By Anna Julia Cooper. Oxford: Oxford University Press, 1990 (1892). Xxix–xxx.
Weiner, Deborah Heiligman. "Cynthia Ozick: Pagan vs. Jew (1966–76)." *Studies in American Jewish Literature: Jewish Women Writers and Women in Jewish Literature*. Vol. 3. Edited by Daniel Walden. Albany: State University of New York Press, 1983. 179–93.
West, Cornel. *The American Evasion of Philosophy: A Genealogy of Pragmatism*. Madison: University of Wisconsin Press, 1989.
White, Edmund. "Images of a Mind Thinking" (excerpt). *Jewish Women Fiction Writers*. Edited by Harold Bloom. Philadelphia: Chelsea House, 1998. 86–87.
Whitehead, Kim. *The Feminist Poetry Movement*. Jackson: University Press of Mississippi, 1996.
Whittier, John Greenleaf, ed. *Letters of Lydia Maria Child*. Boston: Houghton-Mifflin, 1882.
Wiesel, Elie. "Ozick Asks Whether There Can be Life after Auschwitz." Translated by Martha Liptzin Hauptman. *Chicago Tribune* (Books) September 17, 1989: 6.
Willis, Lucindy. *Womanist Intellectuals: Developing a Tradition*. Unpublished doctoral dissertation. University of North Carolina-Greensboro, 1996.
Winkler, Allan M. *Modern America: The United States from World War II to the Present*. New York: Harper and Row.
Yarbro-Bejarano, Yvonne. "Gloria Anzaldúa's *Borderlands/La Frontera*: Cultural Studies, 'Difference,' and the Non-Unitary Subject." *Contemporary American Women Writers: Gender, Class, Ethnicity*. London: Longman, 1998. 11–31.

Zwang, Christina. *Feminist Conversations: Fuller, Emerson, and the Task of Reading*. Ithaca: Cornell University Press, 1994.

Index

Adams, John Quincy, 12
Addams, Jane, on education and democracy, 53–54
African Americans: after Emancipation Proclamation, 63; Cooper's work and activism with, 65–66; during era of New Woman, 63; and First National Conference of Colored Women, 67; Gilman's social theories about, 56; granting of citizenship and enfranchisement of black males, 38; Great Depression, impact of, 89; and Jim Crow era, 63; lynchings of, 33; and New Black Woman, model of, 63; and Pan-African Conference, 67; role of black children in *The Brownies' Book*, 79; second Pan-African Congress, 81; Stanton's activities for rights of, 37–38; training model in schools of, 64; World War I, impact on black women's roles, 89
AIDS epidemic, 145–52, 153
Alcott, Bronson, experimental school of, 4
Alcott, Louisa May, 26
Allan, James, 189
Allen, Carol, on Fauset's novels, 80, 81
American Anthropological Association, 103
American Anti-Slavery Society, 36
American Friends of the Middle East, 95
American Revolution, influence on women, 1
American Woman Suffrage Association (AWSA), 38
Ammons, Elizabeth, on Fauset's novels, 80
Anthony, Susan B.: activities in women's movement, 37, 40; formation of National Woman's Suffrage Association (NWSA), 38, 39; founding of Working Woman's Association, 39
Anzaldúa, Gloria, 155–71; birth of, 160; on access to "set of knowledges," 156; "The Borderlands" by, 157; *Borderlands/La Frontera: The New Mestiza* by, 157, 161–71, 177; *Bridges of Power* by, 159; career in teaching, 160; developing a *teoría*, 156–57; experience with linguistic terrorism, 155, 165–66; on feminist groups and racial disparities, 158; on forming coalitions, 159; graduate and doctoral studies of, 160; "How to Tame a Wild Tongue" by, 161–71; impact of diabetes on, 160; *Making Face, Making Soul/Haciendo Caras: Creative and Critical Perspectives by Women of Color* by, 156, 157–58; as new mestiza and perspective, 156; position in borderlands, 155–56; on racism in academic world, 158; *This Bridge Called My Back,* co-edited by, 157; on transforming language into source of healing, 157, 179; "Una lucha de fronteras/A Struggle for Borders" by, 157; use of various genres, 68
Arendt, Hannah, 188
Arteaga, Alfred, on Anzaldúa's freedom project, 158
Asian population, barring from society and institutions, 90

Banner, Lois, 1
Bard, Joseph, 92
Barnard College, 105

Bateson, Gregory, marriage to Margaret Mead, 105
Bateson, Mary Catherine, 105, 107, 109
Bean, Judith, on Fuller's writing style, 6
Beckett, Samuel, 141
Bellow, Saul, 124
Benedict, Ruth, 105, 110
Black Geniuses, 176
Blacks. *See* African Americans
Black Women of America, 63
Blanchard, Paula, on Fuller's contributions, 10
Bloom, Harold, 124, 174
Boas, Franz, 105–6, 110–13
Bontemp, Arno, and Harlem Renaissance, 77, 79
Bosnia, conflict in, 120, 140, 141–42
Boston Athenaeum Library, 24
The Brownies' Book, 79
Brownson, Orestes, on *Woman of the Nineteenth Century,* 7, 8
Buckley, William, 174
Burroughs, Nannie Helen, educational standards of, 67–68

Cady, Daniel, 36
Calvino, Italo, 124
Carter, Stephen, 187
Channing, William: and editing of Fuller's *Memoirs,* 5; influenced by Child's *An Appeal,* 24
Child, Lydia Maria, 21–31; *An Appeal in Favor of That Class of Americans Called Africans* by, 21, 23–24; campaign about Indian Question, 21, 22, 23; children's novels by, 21; columns in *New York Tribune* and *Boston Courier,* 22, 24; as editor of *National Anti-Slavery Standard,* 24; on educating the masses, 25; "Emancipation and Amalgamation: A Letter from L. Maria Child" to *New York Tribune,* 27–31; encounter with William Lloyd Garrison, 23; "The Equality of the Sexes" by, 25–26; establishment of journalistic sketch, 21; *The First Settlers of New-England* by, 21, 22–23, 107; as friend and mentor of Margaret Fuller, 26; *The Frugal Housewife* by, 21, 25; *The History of the Condition of Women, in Various Ages and Nations* by, 21; *Hobomok, A Tale of Early Times* by, 21, 22; "new narratives of slavery," 24; *Letters from New York* by, 24, 25; resignation from abolitionist movement, 24; participation in Fuller's "Conversations," 5; *The Progress of Religious Ideas* by, 26; publications of, 21; questioning American foreign policy, 21, 23; slavery, campaign against, 23, 24; writings on women's history *versus* women's movement, 35; life in poverty and death of, 27
Chomsky, Noam, on Vietnam War, 139
City College of New York, 140, 174
Civil Rights movement, 119, 153
Clarke, James, and editing of Fuller's *Memoirs,* 5
Cohen, Sarah, on Ozick's writing, 123
Cold War, 119
Collegiate Institute, 64
Colonna, Victoria, 18
Columbia University, 65, 105, 107, 127, 140
Commentary, 140
Committee to Study the Georgia Convict System, 67
Communist Party, 119
Congress of Representative Women, 66
Conrad, Susan, on Stanton's contributions, 35, 37
Cooper, Anna Julia, 34, 63–75; birth of, 64; studies at St. Augustine's Normal School and Collegiate Institute, 64; early teaching career of, 64; activities for African American women's rights, 66–67; marriage to George Cooper, 54; studies at Oberlin College, 64; teaching post at M Street High School, 64; dismissal and reinstatement at Dunbar High School, 64; doctorate studies of, 65; as

president of Frelinghuysen University, 65; speaking at Pan-African Conference, 67; as speaker at First National Conference of Colored Women, 67; as member of Committee to Study the Georgia Convict System, 67; founding of Southwest Settlement House, 68; as first African American "womanist theorist," 68; role in Negro Women's Club movement, 69; "The Higher Education of Women" by, 69–75; on literacy and democratic education, 177; as model for New Black Woman, 63; "The Negro Problem in America" by, 67; on role as teacher, 54; use of various genres, 68; *A Voice from the South* by, 65, 68, 69–75; on women as key to social progress, 53

Cooper, George, 64

Cornell University, 78

Cosmopolitan, 92

Cousins, Norman, 89

Crapol, Edward, on Child's contributions, 21

Cressman, Luther, 110

Crime and Punishment (Dostoyevsky), 125

Crisis: A Record of the Darker Races, 34, 78

Cullen, Countee, and Harlem Renaissance, 79

Dall, Caroline: participation in Fuller's "Conversations," 5; against racial bigotry, 26

Darwin, Charles, 53, 55

Declaration of Sentiments, at Seneca Falls, 36–37

Degler, Carl, on Gilman's social theories, 56

DePauw University, 105

De Simone, Deborah, on Gilman's vision, 51

The Dial: A Magazine for Literature, Philosophy and Religion, 5, 6

Don Juan (Byron), 144

Du Bois, W. E. B.: *Crisis,* journal by, 78; efforts against racism, 33;

founding of *The Brownies' Book,* 79; role in Harlem Renaissance, 78; "The Talented Tenth," 67

Dunbar High School, 64, 78

Eagleton, Terry, 176

Eaton, Annette, on Cooper's role in education, 64

Eliot, T. S., 125

Emerson, Ralph Waldo, 93; comments about Margaret Fuller, 4, 5; as editor of *The Dial,* 5; in Transcendentalist discussion group, 4

Erhenreich, Barbara, 188

Faludi, Susan, 189; *Backlash,* 153

Fauset, Jessie Redmon, 34, 77–87; birth of, 77; death of mother and siblings, 77; acceptance at Cornell, 78; teaching post at M Street High School, 78; studies at University of Pennsylvania, 78; as literary editor of *Crisis,* 34, 78, 79, 80, 82; Du Bois as mentor, 78; as managing editor of *The Brownies' Book,* 79; work with NAACP, 81; activities with National Association of Colored Women, 81; *The Chinaberry Tree* by, 81; contributions to Harlem Renaissance, 77; educational philosophy of, 79–80; on literacy and democratic education, 177; praise of Montessori method, 80; role in Harlem Renaissance, 78; "The Sleeper Awakes" by, 78; *There Is Confusion* by, 77, 80–81, 82, 83–87

Fauset, Redmon, 77

"Feminization of poverty," 153

Fifteenth Amendment, 38

First National Conference of Colored Women, 67

Florence, Namulundah, 175, 178

Foerstel, Lenora, 107

Forerunner, 51

Fortune, Reo, 110

Fourteenth Amendment, 38

Fox, Tom, 177

Frank, Anne, 125

Freedman, Diane, on poetry by Anzaldúa, 157
Freedom House, 95
Freeman, Derek, studies in Samoa by, 103–5; denounces Margaret Mead, 104
Freire, Paulo, 176, 177
Frelinghuysen University, 65
Fuller, Margaret, 3–19; birth of, 3; childhood education of, 3; teaching career at Temple School, 4; entry into Transcendentalist discussion group, 4; as editor of *The Dial*, 5, 8, 21; "Conversations" series, 5–6; as literary editor of *New York Tribune*, 8, 9; as first female foreign correspondent, 9; relationship with Ossoli, 9; birth of son, 9; support of Italian Unification Movement, 9–10, 188; articles on social issues in *New York Tribune*, 9; befriended by Lydia Maria Child, 26; continuing Child's genre, 25; critical attacks on, 144; criticism of traditional education of women, 6; and development of pluralistic dialogue, 8; on dichotomy of men and women, 6; end of Transcendentalism with death of, 3; "The Great Lawsuit: Man *versus* Men: Woman *versus* Women" by, 5, 6; *Memoirs* by, 5; on men's attitude toward women and slaves, 13; review of *Narrative of the Life of Frederick Douglass*, 9; as one of the "first great voices of American feminism," 7; *Woman in the Nineteenth Century* by, 6, 7, 8, 10–19; writing for experts and nonexperts, 107; death of, 10, 26

Gage, Matilda Joslyn, activities in women's movement, 40
Gardner, Martin, on Freeman-Mead controversy, 104
Garrison, William Lloyd, encounter with Lydia Maria Child, 21, 23
Gates, Henry Louis, Jr., on *A Voice from the South*, 68
Gilded Age, 33

Gilliam, Angela, 107
Gilman, Charlotte Perkins, 34, 51–61; on achieving autonomy, 53; "Are Women Human Beings?" by, 132; autobiography of, 52; development of New Woman, 51; on domestic bondage, 54–55; *With Her in Ourland* by, 55; *Herland* by, 55; ideas on women's issues and race, 56; linking gender and economics, 56; "Locked Inside" by, 57; marriage to Charles Stetson, 52; postpartum depression experience of, 52; divorce from Stetson, 52; marriage to Houghton Gilman, 52; *Moving the Mountain* by, 55; on patriarchal society conditioning, 53; reconceiving idea of womanhood, 51; on role of and changes needed in education, 53–54; on social evolution, 55; studies at Rhode Island School of Design, 54; "A Suggestion on the Negro Problem" by, 56; utopian novels by, 55; "Women and Economics" by, 51, 56, 57–61; on women as key to social progress, 53; writing social theories in fiction form, 52; "The Yellow Wallpaper" by, 51, 52
Gilman, Houghton, marriage to Charlotte Stetson, 52
Great Depression, impact on roles of black women, 89
Greeley, Horace: advancing *New York Tribune* as international, 9; on contributions of Margaret Fuller, 3; move to New York, 8
Grimké, Angelina Weld: on influence of Child's *An Appeal*, 26; work supported by Fauset, 77
Gulf War, 153

Hall, G. Stanley, 106
Hallote, Bernard, 122
Hamilton, Emma, 143, 144
Hamilton, William, 143
Harlem Renaissance, 34, 77, 189
Harper, Frances Watkins, and work for African American rights, 63
Harvard University, 140

Hawthorne, Nathaniel, on women authors, 1, 8
Haywood, George Washington, 64
Higginson, Thomas Wentworth, influenced by *An Appeal,* 24
Hirsch, E. D., Jr., 154
Hispanic population, barring from society and institutions, 90
Hiss, Alger, 119
Hitler, Adolf, 92
hooks, bell, 173–85; birth name Gloria Jean Watkins, 173; attending desegregated school, 174; *Ain't I a Woman* by, 173, 189; *All about Love: New Visions* by, 173, 179; on applying theory to the everyday, 175–86, 188; *Art on My Mind: Visual Politics* by, 173; *Black Looks: Race and Representation* by, 173; *Bone Black: Memories of Girlhood* by, 173–74; criticism of some feminist organizations, 174; doctorate studies of, 174; *Feminist Theory: From Margin to Center* by, 173; on importance of open dialogue, 175; liberated writing style of, 178; on literacy and democratic education, 177; *Outlaw Culture: Resisting Representations* by, 173, 179–85; pen name, origin of, 174; *Real to Real: Race, Sex, and Class at the Movies* by, 173; "Seeing and Making Culture: Representing the Poor" by, 179–85; in "self-imposed marginality," 176; "Simple Living: An Antidote to Hedonistic Materialism" by, 176; on strong female role models in childhood, 174; studies at Stanford, 173, 174; on subjects of race, class, or gender, 174; teaching career of, 174; *Teaching to Transgress: Education as the Practice of Freedom* by, 173, 174, 175, 177; writing for experts and nonexperts, 107
Hughes, Langston, 34; "Fairies," 79; and Harlem Renaissance, 77, 78, 82
Hughes, Percy, 64

Hull House, 54
Hunter College High School, 122

Industrial Revolution, influence on women, 1
Intergovernmental Committee on Refugees, 95
Italian Unification Movement, 9

James, Alice, 143–44
James, Henry, 124, 127, 143; Ozick influenced by, 122
James, William, 143
Jameson, Anna Brownell, 19
Jewell, Sue, 153
Jewish population, World War II refugees of, 95
Jim Crow laws, 63
Johnson, Georgia Douglass, and influence of Fauset, 79
Johnson, Karen, on Cooper's educational standards, 67–68
Johnson Act, 107
Johnstown Academy, 36
Jordan, June, 174
Juvenile Miscellany, 24, 26

Kaczynski, Theodore, 125
Karcher, Carolyn, on contributions of Child, 21, 23, 24
Kauvar, Elaine, on Ozick's writing, 126
Keating, AnaLouise, interview with Anzaldúa, 160
Kennedy, John F., 153
Kessler, Carol, on Gilman's writings, 52, 55–56
King, Martin Luther, Jr., 175
Kolodny, Annette, 7
Korean War, 119
Ku Klux Klan, post-Civil War resurgence, 33
Kurth, Peter, 92

Ladies' Home Journal, 93
Lapsley, Hillary, 109
Larsen, Nella, work supported by Fauset, 77
Leacock, Eleanor, 104
League of Women Voters, 89
Lee, Spike, 176

Lemert, Charles, on *A Voice from the South*, 68
Lerner, Gerda: on opportunities for women in pre-Civil War era, 1; on Stanton's rewriting of Bible, 40
Lewis, Sinclair, 92
Lippmann, Walter, 92, 94
Locke, Alain, and Harlem Renaissance, 77
Logan, Shirley, 67
Lorde, Audre, 188–89
Love, John, 64

MacSwiney, Terrence, 92
Mairs, Nancy, 189
Malinowski, Bronislaw, 104
Martineau, Harriet: critical attacks on, 144; on educating the masses, 25; writing for experts and nonexperts, 107
Matthiessen, F. O., 3
Mazzini, Giuseppe, 9
McCarthy, Joseph, 119
McNulty, Charles, 144
Mead, Edward, 105
Mead, Emily Fogg, 105
Mead, Margaret, 90, 103–18; birth of, 105; *Blackberry Winter* by, 109–14; *Coming of Age in Samoa* by, 104, 107–8; creation of National Character program, 109; field studies by, 103, 106–7, 108, 113; on genetic markers and social recognition, 107; *Growing Up in New Guinea* by, 110; influence of Ruth Benedict, 105, 109, 110; *Male and Female: A Study of the Sexes in a Changing World* by, 107, 108, 114–18; marriage to Luther Cressman, 110; marriage to Reo Fortune, 110; marriage to Gregory Bateson, 105; birth of daughter, Mary Catherine, 105; as president of American Anthropological Association, 103; *Sex and Temperament in Three Primitive Societies* by, 108; studies with Franz Boas, 105–6, 110–13; work at Museum of Natural History, 103; death of, 103; posthumous denouncement of, 103–5
Mead, Martha, 105
Mepham, John, 187–88
Mitchell, S. Weir, 52
Modjeska, Helena, 144
Moore, Sharon Lynn, on Harlem Renaissance writers, 81
Moraga, Cherrie, 158
Mosley, Walter, 176
Mott, Lucretia, abolitionist activities of, 36
M Street High School, 64, 78

Narrative of the Life of Frederick Douglass, 9
The Nation, 142
National Anti-Slavery Standard, 24
National Association for the Advancement of Colored People (NAACP), 78
National Association of Colored Women, 81, 89
National Organization for Women (NOW), 119–20
National Woman's Party, 89
National Woman's Suffrage Association (NWSA), 38, 39
Negro Women's Club, 69
Nelson, Horatio, 143
New Black Woman, 63
New Deal, 94
"New Negro," era of, 77
Newsome, Effie Lee, and influence of Fauset, 79
New Woman: era of, 63; Gilman's role in, 51
The New Yorker, 124
New York Herald Tribune, 92
New York Times Book Review, 124
New York Tribune, 8, 9, 22, 24, 27–31
New York University, 122
Nineteenth Amendment, 89

Oberlin College, 64
O'Connor, Flannery, 123
Ohio State University, 122
Ossoli, Giovanni Angelo, 9
Ozick, Cynthia, 121–37; birth of, 121; childhood education and Hebrew instruction, 121; as *golden kepele*, 121; attendance at Hunter College High School, 122;

marriage to Bernard Hallote, 122; studies at New York University and Ohio State University, 122; writing and publishing poetry, 122; address at American-Israel Dialogue, 123; *Art and Ardor* by, 124; *Bloodshed and Three Novellas* by, 123; "Dostoyevsky's Unabomber" by, 125; "A Drugstore in Winter" by, 121; on duality of public intellectual, 187; *Fame and Folly* by, 124–25; "It Takes a Great Deal of History to Produce a Little Literature" by, 125; *Mercy, Pity, Peace, and Love* by, 122; *Metaphor and Memory* by, 124; "Parable in the Later Novels of Henry James" by, 122; "Previsions of the Demise of the Dancing Dog" by, 122; "Puttermesser: Her Work History, Her Ancestry, Her Afterlife" by, 123; *Quarrel and Quandary* by, 124, 125; reviving "person-of-letters," 126; "The Rights of History and Rights of Imagination" by, 125; "Rosa" by, 124; on saving history from literature, 125; *The Shawl* by, 123, 124; "She: Portrait of the Essay as a Warm Body" by, 126; on teaching and writing as a woman, 122; *Trust* by, 122, 134; "We Are the Crazy Lady and Other Feisty Feminist Fables" by, 127–37; "Who Owns Anne Frank" by, 125; writing techniques and mixing of genres, 123

Paddock, Lisa, 144
Pan-African Conference, 67
Pan-African Congress, 81
Peabody, Elizabeth, participation in Fuller's "Conversations," 5
Pearcy, Diana, 153
Perry, Donna, interview with Anzaldúa, 157
Peyser, Thomas, on Gilman's social thought, 55–56
Philadelphia Public Ledger, 92
Progressive Era, 33, 89

Putnam, George, in Transcendentalist discussion group, 4

Reed, Adolph, 178
Rensberger, Boyce, on *Coming of Age,* 106
Revolution, 38, 39
Reynolds, David S., 3
Reynolds, Larry, on Fuller's dispatches from Europe, 9
Rhode Island School of Design, 54
Rich, Adrienne, 178, 189
Rieff, Philip, 140
Ring of Freedom, 95
Ripley, George, in Transcendentalist discussion group, 4
Ripley, Sophia, and correspondence from Margaret Fuller, 5
Rollyson, Carl, 144
Romanticism, 4
Roosevelt, Eleanor, 90, 91, 93
Roosevelt, Franklin D., 94
Rushdie, Salman, 125

Said, Edward, 139, 176
Sarah Lawrence College, 140
Seneca County Courier, 36
Shils, Edward, 187
Showalter, Elaine, on Emerson's writing, 5
Sinn Fein, 92
Slavery: American Anti-Slavery Society, 36; Child's antislavery treatise, 21, 23, 24; narratives by slaves in works by Child, 24; *National Anti-Slavery Standard,* 24; in pre-Civil War era, 1
Smith, Susan, on Fuller's dispatches from Europe, 9
Sontag, Susan, 139–52; birth of, 139; "psychologically abandoned" in childhood, 139; university studies by and degrees of, 140; marriage to Philip Rieff, 140; Master's degree from Harvard, 140; divorce from Rieff, 140; as editor at *Commentary,* 140; *AIDS and Its Metaphors* by, 143, 145–52; *Alice in Bed* by, 143–44; *In America* by, 144; as *écrivain,* 144; on dangers of metaphor, 124; diagnosed with

Sontag, Susan (*continued*)
 breast cancer, 143; *Illness as a Metaphor* by, 143; *Against Interpretation, and Other Essays* by, 140; "Notes from Camp" by, 140; "Project for a Trip to China" by, 141; on the Serbian-Bosnian conflict, 140, 141–42; topics written by, 139; "Trip to Hanoi: Notes on the Enemy Camp" by, 140–41, 188; visit to North Vietnam, 140–41; *The Volcano Lover* by, 143, 144; "Waiting for Godot in Sarajevo" by, 141; writing on war and political conflicts, 140; unauthorized biography of, 144
Sorbonne, 65
Southwest Settlement House, 68
Soviet Union, 119
Spender, Dale, on *History of Woman Suffrage*, 40
St. Augustine's Normal School, 64
Stanford University, 173
Stanley, Hannah, 64
Stanton, Elizabeth Cady, 34, 35–49; birth of, 35; death of brothers, 36; childhood education of, 35–36; studies at Johnstown Academy and Troy Female Seminary, 36; marriage to Henry Stanton, 36; abolitionist activities of, 36; organization of first women's rights convention, 36; work on rights for African Americans, 37; activities for national suffrage amendment, 38; formation of National Woman's Suffrage Association (NWSA), 38, 39; articles in *Revolution*, 38, 39; denouncement of Fifteenth Amendment, 38; racist comments about African Americans, 38–39; founding of Working Woman's Association, 39; *The Woman's Bible* by, 40–41; autobiography of, 41; formation of Revising Committee, 41; on contributions of Margaret Fuller, 3; "Educated Suffrage" by, 39; *Eighty Years and More* by, 41; *History of Woman Suffrage* by, 40; on literacy as social equalizer, 39; major projects of, 40; participation in Fuller's "Conversations," 5, 37; Address to New York State Legislature (1860) by, 42–49
Stanton, Henry, 36
Steinem, Gloria, 189
Stern, Madeleine, 51
Stetson, Charles Walter, 52
Stone, Lucy, work on suffrage, 38
Styron, William, 125
Sylvander, Carolyn, biography of Fauset, 82
Syracuse University, 91

Tarbell, Ida, 89
Terrell, Mary, activism for African American rights, 63
Terrorism, on American soil, 153
Thompson, Dorothy: birth of, 91; university studies of, 91; job with woman's suffrage headquarters, 91–92; journalism assignments in Europe, 92; as bureau chief of *Philadelphia Public Ledger*, 92; marriage to Joseph Bard, 92; interview of Adolf Hitler, 92; marriage to Sinclair Lewis, 92; concern with refugees during World War II, 95; as president of American Friends of the Middle East, 95; "Articles of Faith" by, 95; changes in political support, 94; *Courage to Be Happy* by, 93; critical attacks on, 144; *Dorothy Thompson's Political Guide* by, 93; founding of Ring of Freedom, 95; "Freedom of Action" by, 98–101; *I Saw Hitler!* by, 92; *Let the Record Speak* by, 94, 96–101; monthly column in *Ladies' Home Journal*, 93; *On the Record* column by, 91, 92; role in interwar years, 90, 91–101; view of New Deal, 94; "Write It Down" by, 96–98
Time, 91
Tingley, Stephanie, on Child's contributions, 25
Toomer, Jean: and Harlem Renaissance, 77; *Cane*, 82

Toulmin, Stephen, on Margaret Mead, 103, 107–8
Train, George Francis, founding of *Revolution,* 38
Transcendentalists, 3
Trilling, Lionel, 127
Troy Female Seminary, 36

University of California at Berkeley, 140
University of California at Santa Cruz, 160, 174
University of Chicago, 140
University of Paris, 65
University of Pennsylvania, 78
University of Texas, 160
Updike, John, 124
Urbanski, Marie, on Fuller's contributions, 3

Vietnam War: American involvement in, 119, 120; Chomsky speaking out against, 139; Sontag on, 139, 140
Village Voice, 144

Ward, Lester Frank, influences on Gilman, 53, 55
Waring, Laura Wheeler: artwork in *The Brownies' Book,* 79; and Harlem Renaissance, 77
Washington, Booker T.: efforts against racism, 33; training model in African American schools, 64
Washington, Mary Helen, 65, 68
Watkins, Gloria Jean. *See* hooks, bell
Weiner, Deborah, on Ozick's writing, 123–24

West, Cornel, on hooks's contributions, 173
Whately, Richard, 7
White, Edmund, 123
Whittier, John Greenleaf, on life of Child, 27
Wiesel, Elie, on Ozick's "Rosa," 124
Will, George, 174
Williams, Fannie Barrier, 67
Willkie, Wendell, 94
Women's Liberation movement, 119, 153
Women's Rights movement: *Declaration of Sentiments,* 36–37; organization at Seneca Falls, 34, 35, 36; with participation of women public intellectuals, 35; on rights of African American women, 37–38
Women's suffrage: activities and work by Stanton, 38; beginnings pre-Civil War, 33; impact of World War I, 33; work by Stone, 38
Woolf, Virginia: on "fifty pairs of eyes," 174; on financial independence, 35; Ozick's essay about, 124; on role of critics, 8
Working Woman's Association, founding of, 39
World War I, impact on women's rights, 89
World War II, increase of women in labor force, 89

Yale Series of Younger Poets, 122
Yarbro-Bejarano, Yvonne, 156